NEWSPEAK

NEWSPEAK

BRITISH ART NOW

~~Designed by:~~ Barnbrook
First published in 2010 by Booth-Clibborn Editions
in the United Kingdom
www.booth-clibborn.com

The Inaugural Newspeak Exhibition
The State Hermitage Museum, St Petersburg, Russia
25th October 2009 – 17th January 2010

The Saatchi Gallery, London June 2010

A cataloging-in-publication record for this book is available from the publisher
// ISBN 978-1-86154-314-1 // Printed and bound in Hong Kong

~~The Saatchi Gallery would also like to thank:~~
Alexia Goethe Gallery, Alison Jacques Gallery, All Visual Arts, Allsopp
Contemporary, Andrew Kreps Gallery, Annely Juda Fine Art, Beaconsfield,
Carl Freedman Gallery, Carter Presents, Cell Project Space, Charlie Smith
London, David Kordansky Gallery, David Risley, Dicksmith Gallery, Faye
Flemming & Partner, Fine Art Society, Frith Street Gallery, Galerie Dennis
Kimmerich, Herald Street, Hotel, Ibid Projects, Irena Hochman Fine Art,
Karsten Schubert, Kate MacGarry, Limoncello, Mary Mary Gallery, Maureen
Paley, Max Wigram, Michael Hoppen Contemporary, MOT International,
New Contemporaries, One in the Other, Paradise Row, Rod Barton Gallery,
Rokeby, Simon Lee Gallery, Sorcha Dallas, Stuart Shave, Thomas Dane Gallery,
Tim Taylor Gallery, Victoria Miro Gallery, Vilma Gold, Wilkinson Gallery

~~The Saatchi Gallery~~

~~Corporate Partner~~

PHILLIPS
de PURY & COMPANY

~~Gallery Patron~~

CHANEL

~~Founding Patron~~

Dinesen

~~Media Partner~~

THE SUNDAY TIMES

~~Education Patrons:~~
Deutsche Bank / • / Google / • / Lille 3000 / • / Magic of Persia

~~Corporate Patrons~~:
Allford Hall Monaghan Morris / • / Arup
ClearChannel Outdoor / • / ERCO / • / Goedhuis & Co
Jackson Coles / • / Knight Harwood / • / Vitra / • / Walker Morris

~~The Saatchi Gallery gratefully acknowledges the~~
~~following photographers who have contributed images~~:
Alexander Brammal, Rebecca Warren, Dennis Schoenberg,
Esther Teichmann & Spartacus Chetwynd (artists collaboration for Wallpaper
magazine), Francesca Martinuzzi, Justin Piperger, Sam Drake, William
Burlington, Ximena Garrido-Lecca, Alex Delfanne, Andy Keate, Fred Dolt,
Lothar Schnepf, Galerie Dennis Kimmerich / Ivo Faber, Adrian van der Spelt,
Frans van Mieris, George Hinz, Stephen White, Farzad Owrang

Newspeak: **British Art Now**
from The Saatchi Gallery, London

2010: A COMPLETE GRAMMATOLOGY OF PANIC

~~PATRICIA ELLIS~~

Man is a creature who lives not upon bread alone,
but primarily by catchwords – ~~Robert Louis Stevenson~~

Words have no power to impress the mind without the exquisite
horror of their reality – ~~Edgar Allan Poe~~

It's summer inferno on the Costa DelBoy[1] and chavs[2] have infiltrated the southern sands with their Burberry-bikinied army. To the north Neds[3] descend upon the Glaswegian Riviera[4] to do their bit on the Gaza Strip[5]. The last heathen retreats for refugees who couldn't manage a Stelios[6]. A nation demarcated where vomit meets surf, geographically encircled by froth. Inland, city streets are invaded by tourists. Merchants barricaded in shops, foxholed in market stalls, blitzing Americans, Japanese with stockpiled cheap-as-chips[7] wares and cheeky-chappy[8] spiels. In steel-glass towers mockney[9] city boys launch subversive operations, exploding economies with the push of a button. Union Jack flies over Buckingham Palace, fortified with franchise ramparts of M&S[10], Top Shop[11], Habitat[12] and Costa[13], fenced in by the front-line infantry of toffee-mongers and bagpiping buskers. Up and down The Mall[14] Met wagons fill with shutterbugs caught snapping the bill[15], nicked[16] by the oxymoron of Terror Law[17]. ———————— In Dickensian suburbs New British[18] rule, their influence and infiltration evident in a Jafaikan[19] next-generation. Pants round knees they idle purposefully, yeah innit[20], in petrol-sticky doorways, flogging[21] all things halal[22], skunk-like[23], and whisky-related[24]; their proximity so close that their rich curry aromas and bombastic base-line vibrations filter through the soap white townhouses nearby. On CCTV[25] corners knife-wielding hoodies[26] linger by offies[27], sharing alcopops[28] with pramfaces[29] chubby and orange[30]. Indoors The Mummy Brigade[31] rampage with quinoa[32]-centric manifestos from the smoke-free-all-organic depths of latte HQs, their Chelsea tractor[33] platoon, tanked up and alarmed, standing ready for the 3 o'clock school run. Council jobsworths[34], Elf and Safety[35] dayglo clad, can be seen sorting through rubbish bins, in search of unspecified evidence. On screens present everywhere – in bars, train stations, buses, and phones – digiTV[36] streams instant feedback of muck-common banality: barrow-boy magnates[37] pit wide boys[38] against toffs[39] in competitions for scarce Credit-Crunch[40] jobs, and all manner of zelebrities[41] give instruction on cooking and cleaning, dressing, home ownership, edutaining[42] the masses on basic life skills. Class tourism[43] and property porn[44] promote social reform: celebrating parking wardens and rat catchers, open-plan living and loft conversion, pressing the urgent necessity for more shades of beige[45]. Interactive fame beacons with talent competitions and game shows, viewer call-in discussions, phone vote, text-in, e-say, and red button[46], everyone a karaoke contender for Heat[47] magazine glory. The glossies are awash with Peter and Jordan[48], Macca-Mucca[49], Wacko[50], and Wino[51]. The Sun runs the headline: FATTIES CAUSE GLOBAL WARMING, while broadsheets scream PANDEMIC, CYBERBEAST[52], SUBO[53] IN PRIORY[54]. Hysteria so instantly comforting.

1 Cos-ta Del Boy – *n*. England's answer to the Costa Del Sol, can be used to describe any host of downtrodden seaside loctions, Margate and Weston-Super-Mare being amongst the most notable. Del Boy is a character from 80s sitcom Only Fools and Horses, renowned for his dodgy* business practices and comic attempts to appear to be middle class. See also: Wide Boy. ***Dodgy** – *adj*. An object or person of low quality.
2 Chav – *adj*. A style of fashion that is simultaneously trashy and glamorous or embarrassingly nouveau riche as exemplified by Victoria Beckham, Colleen Rooney, and Jennifer Lopez. See also: WAG. **Chav** – *n*. People who attempt to achieve this look on limited budget. Identifiable by preference for baseball caps, Croydon face lifts*, track suits, knock-off Burberry and Louis Vuitton accessories, and over indulgence of gold-plated jewellery, diamante, and fake tan. ***Croydon Face Lift** – *n*. A style of ponytail where the hair is pulled back so tight it physically distorts the wearer's facial features. **3 Ned** – *Scottish. n*. uNEducated Delinquent. For visuals see: Littlewhitehead. **4 Glas-we-gian Riv-i-er-a** – *n*. Blackpool, Lancashire. Described by the local tourist board as "Britain's most popular holiday destination and provides more thrills and excitement than any other." Once a glorious family-orientated resort, "excitement"isnowgenerallyunderstood to mean binge-drinking*, fighting, lewd sex antics, wearing sleazy themed fancy dress, and staying in ex-council flat B&Bs with Regency themes. Stag and hen* capital of the UK, many unique services are offered, such as fire-engine limousines replete with firemen strippers, girl-boy-girl-girl jelly wrestling, and entire candy stores dedicated to genitalia-shaped confectionaries. Book now at ≠.visitblackpoolcom. * **Binge-drinking** – *n*. Drinking copious amounts of alcohol with the sole intent of getting para*. ***Stag and Hen** – *n*. Stag nights are bachelor parties, hen nights are bridal showers. These are traditionally celebrated by wearing sexually provocative costumes (favourites: naughty nuns, naughty police officers, French maids, and Amy Winehouse; the bride's accessorised with a driver's learning permit badge), getting completely wasted, and having as many one last flings as possible in a weekend. * **Para** – *adj*. So drunk or stoned as to become paralytic. **5 Ga-za Strip** – *Blackpudlian. n*. Specifically The Strand, Blackpool, but includes the entire city centre territory ranging from The Promenade beach front to Funny Girls night club to the north and Syndicate – the UK's biggest night club – to the South. Named for its panoramic views of human carnage. Not quite Jabalia, but close enough. **6 Stel-i-os** – *n*. Sir Stelios Haji-Ioannou, founder of Easyjet. His name can be used to describe any low-cost flight, with the exception of Ryanair, which is universally referred to as Hell. **7 Cheap-as-chips** – *adj*. Really low price. With chips now retailing at 80p for medium portion, this isn't meant literally. **8 Cheeky-chappy** – *adj*. A charm offensive tactic based on exaggerated aping of Dick Van Dyke's Chim Chim Cher-ee performance in Mary Poppins. **9 Mock-ney** – *adj*. A fake cockney accent affected by posh*people trying to sound cool. E.g. Guy Ritchie, most of the cast of EastEnders. ***Posh** – *adj*. Upper-class, or at least more upper-class than you. **10 Marks and Spen-cer** – *n*. The Nation's favourite department store, best known for its quality underpants and 'gourmet' readymeals*. ***Read-y-meal** – *n*. microwavable TV dinners. This is pretty much the exclusive diet for the whole of the country. **11 Top Shop** – *n*. A highstreet clothing chain, known for selling Kate Moss's own discount label. **12 Hab-i-tat** – *n*. A furniture store. Exactly the same as Ikea, but more expensive. **13 Cost-a** – *n*. The UK's answer to Starbucks. As there isn't 50 yards of British space that doesn't have a Costa, they are currently looking to expand internationally. Applications for franchise can be obtained at: _http://www.costa.co.uk/international_franchise.aspx_. **14 The Mall** – *n*. [pronounced nasally as 'Maaal' not 'moll']. The road extending from Trafalgar Square to Buckingham Palace; the Queen's driveway. **15 The Bill** or **The Old Bill** – *n*. The police. Origin: widely debated, most likely to be in reference to King William IV and his constables. **16 Nick** – *v*. 1.To be arrested. 2. To steal. E.g. He got nicked for nicking the gear*. ***Gear**. – *n*. 1. Equipment, stuff, belongings. 2. Drugstash. **17 Ter-ror Law** – *n*. Laws introduced to combat terrorism which potentially instil greater terror than they prevent. **18 New Brit-ish** – *n*. Immigrants, 1st generation British. **19 Ja-fai-kan** – 1. *n*. Fake Jamaican. Teenagers of all races who speak with a Caribbean accent even though they've never set foot outside of Acton. 2. *adj*. An obviously phony Jamaican accent utilised by hip-hop aficionados. **20 Yeah In-nit** – *interj*. Technically: Yes, Isn't it. In practice means absolutely nothing. Can be inserted anywhere into any sentence on any topic, preferably as much as possible, to boost street cred. For alteration and variety, Yanowamsayin* is an acceptable substitute.***Ya-no-wam-say-in** – *interj*. You know what I'm saying. Will ensure that everyone knows what you are talking about even though people who use this type of language are by and large totally incomprehensible. **21 Flog** – *v*. To sell. **22 Hal-al** – *adj*. Technically: any object or action sanctioned under Islamic law. In practice: usually associated with meat products found in close proximity to things which are distinctly haraam*. ***Haraam** – *adj*. Not sanctioned under Islamic law. **23 Skunk** – *n*. Super-strength marijuana. Often purchased at or near the local halal butcher's. **24 Whis-key** – *n*. Whiskey and Soda. Cockney rhyming slang for Voda a brand of mobile phone service. Stolen handsets available next door to butcher. **25 CCTV** – *n*. Closed Circuit Television, surveillance camera. **26 Hood-ie** – *n*. 1. A hooded jacket. 2. Teenagers who wear hooded jackets to avoid recognition by eyewitnesses and CCTV cameras while they practise all manner of petty crime. 3. Anyone wearing a hooded jack so as to give the impression that they might be cool enough to commit petty crimes. **27 Of-fie** – *n*. Off-licence: a store primarily selling

alcohol, though also specialising in crisps, cigarettes, phone cards, and condoms. **28 Al-co-pop** – *n*. Candy-coloured and sugary-tasting alcoholic beverages favoured by the under-14 crowd. **29 Pram-face** – *n*. Teenage mothers. Britain has the highest teenage pregnancy rate in Europe. Youngest mum so far: 11. Recently attention has turned to the issue of daddy-babies* with the story of 13-year-old Alfie Patton, a boy who looks no older than 8. In the end Alfie turned out not to be the dad of his 15-year-old girlfriend's child after DNA tests taken from all of her 5 lovers cleared him of responsibility. *****Dad-dy-ba-by** – *n*. Teenage father. **30** Hazard of extreme use of spray tan. **31 The Mum-my Bri-gade** – *n*. Essentially giant girl-gangs of new middle-aged yuppy mothers who declare turf war by barricading themselves with masses of prams into any public place with latte-making facilities. Quickly becoming a radical fringe organisation with absurd demands that the rest of society should care about their child as much as they do. **32 Qui-noa** – *n*. A seed with extremely healthy properties. See also: Superfood. **33 Chel-sea Trac-tor** – *n*. 4×4 all-terrain vehicles driven by The Mummy Brigade. Preferably armour-plated with bullet-proof glass, baby can never be too safe. Chelsea is a posh district in London. **34 Jobs-worth** – *n*. Any worker who does less than nothing in the most bureaucratic way possible, usually found in public service. See Elf and Safety. **35 Elf and Safe-ty** – *n*. Health and Safety. Increasingly absurd local government and workplace regulations designed to ensure absolute safety under any circumstance, such as chopping down trees in case a nut falls on somebody. **36 Di-gi-TV** – *n*. Digital television. This nifty invention gives the BBC the right to charge every single man, woman, and child £142.50/year even if they don't own a TV. If you own/use a computer, mobile phone, or DVD recorder you are a viewer. **37 Sral-an** – *n*. Sir Alan Sugar, 71st most minted* man on The Sunday Times Rich List, host of The Apprentice, a popular TV programme where city types compete for a job in his company. Poor diction somehow appearing to be a prerequisite for obtaining a £100K/year corporate position, contestants pronounce hisname as one condensed word. * **Mint-ed** – *adj*. Rich, having money. Origin: Mint – *n*. A place that manufactures money. **38 Wide Boy** – *n*. Someone who engages in questionable business practices, a wheeler-dealer, a hustler, or scammer. **39 Toff** – *n*. Someone who's Toffee-nosed. Upper-class and snobbish. **40 Cred-it Crunch** – *n*. Global Economic Crisis. **41 Ze-le-bri-ty** – *n*. 1. Z-list celebrity. 2. Celebrities that no one's ever heard of. 3. Celebrities that are inexplicably famous, have done nothing, have no talent. E.g. Peaches Geldof. **42 Ed-u-tain-ment** – *n*. Education + Entertainment. Is similar though distinctly separate from Infotainment (Inform + Entertain). A documentary is infotainment, where as programmes such as Jamie Oliver's Ministry of Food, How Clean Is Your House?, Gok's Fashion Fix, and House Doctor are specifically devised to teach people to fry an egg, use a hoover, wear belts, and choose carpet that isn't

blinding. That a significant portion of the population doesn't know how to do these things is evidenced in their weekly case studies. **43 Class Tour-ism** – *n*. Documentary programmes about working-class jobs that provide endless fascination with how ordinary people live. Popular subjects have included: garbage collectors, airport baggage handlers, exterminators, debt collectors, meter-maids, livestock inseminators, and hotel porters. **44 Prop-er-ty Porn** – *n*. Documentary programmes about buying and redecorating houses, always shot in wide angle pans with soft sensuous lighting, lingering on titillating details of period fixtures and ultra modern bathroom fittings, with obscene and breathy voiceovers which say things like "At only £595,000 Nigel and Brenda will have more than enough money left over for the pool-side 4-bedroom villa in Spain." **45 Neu-tral Tones** – *n*. According to House Doctor Ann Maurice, beige is the only colour in existence that guarantees to give a warm inviting feel to a home, while simultaneously raising its value by 35% on the current market. Luckily with thousands of mushroom / buttermilk / terracotta /sandstone shades available, it's possible to ensure a sense of unique individual identity that will personalise and enhance any space. **46 Red But-ton** – *n*. The red button on remote-control devices that allows for interactive activities with your TV, such as changing the camera angle or voting for game show contestants. **47 Heat** – *n*. Weekly celebrity news magazine, big on pictures, low on text, longest word ever printed: cellulite. Top stories from May 2009: OMFG!* Katie and Peter are OFFICIALLY splitting up!, Let's check out the outfits from Hollyoaks* Charity Ball, and Oooh, Big Dinner or Baby Bump*? For gripping reading, go to: *www.heatworld.com*. * **OMFG** – *interj*. Oh My Fucking God! * **Hol-ly-oaks** – *n*. An afternoon soap opera primarily for teenagers. * **Ba-by Bump** – *n*. A pregnant woman's stomach. **48** Australian singer Peter Andre and British page 3 girl* Jordan aka Katie Price. A couple who notoriously met on a reality TV show, and have made careers out of living their lives in the media. * **Page 3 Girl** – *n*. A woman who appears topless on page 3 of The Sun newspaper, which is exclusively dedicated to showcasing Britain's best breasts. To be fair, Jordan's more than just a page 3 girl – she's gone on to do Playboy – as well as develop her own line of clothing, own brand credit card, record a pop album, have 10 documentary TV series, author 4 autobiographies, an impressive series of children's books, and two novels. She's estimated to be worth £30 million – not bad for a large-chested girl from Brighton. **49 Mac-ca and Muc-ca** – *n*. Paul McCartney and Heather Mills McCartney. Lady McCartney is referred to as Mucca because of her past stints as a glamour model* and disfavour in British media. *****Glam-our mod-el** – *n*. Lingerie or topless model. See also: Page 3 Girl. **50 Wack-o** – *n*. Michael Jackson. Was originally Jacko, but changed to Wacko when he became truly freakish. **51 Wi-no** – **n**. 1. A homeless alcoholic. 2. Amy Winehouse. **52 Cy-ber-beast** – *n*. Internet sex fiends. **53 Su-bo** – *n*. Susan Boyle, aka the Hairy Fairy. Runner up contestant

The
UK today is less
a place than an image,
a collective neurosis projected onto an
island. Its strange brew of glocalisation[55] and parochial nostalgia[56]
played out through incessant media frenzy, reinventing itself by the
minute. Hitting the nerve of what it is to be British now, this collec-
tion of 65 artists forges a sublimely contemporary vision, laser-sharp
in its mirror reflection. More than a decade after Sensation and the
advent of Blair's Opportunity Society[57], their work reflects a new social
order. Defined by trepidation, acquiescence, and analysis: of class
homogenisation, consumerist gentrification, the phenomenon of instant
success culture. The unnerving tingle of evaporating history haunts
each and every one of these works. Thought inextricably determined
by semiotic parameters, theirs is a language recycled, appended,
suavely overwriting the past. Through sculpture and painting, pho-
tography and installation they present a fractured and restless world-
view. Articulated as doublespeak, they hand-make the virtual,
cite history in fugue fervour, and find the poetic and enduring in
the cacophony of pop cultural din. They create grounding and
logic from this state of confusion; the contradictory meanings
all true. Delivered with the wry wit of distinctly British
vernacular – the interface between idea and experience – its
playfully convoluted slang, so irreverent, so now and
so hip. So revealing of its underlying anxiety.

This isn't just newspeak, this is
British Now Newspeak. The
sign at Terminal 5[58] says
NOW OPEN.

spectacle boasts like a national emblem: hoodie-pack
in a corner, both menacing and humorously punitive,
elevating happyslapping[59] to the epic of white cube sublime.
Sanitised, frozen, they beacon viewer complicity, with the realisa-
tion that outrage is cleaved to fascination and admiration, a guilty affection
and pathos for scourge. ■

Dick Evans's *Black Grape*, quoting Hokusai poetics, swells like a seething
volcanic island. Made from industrial abrasive, its liquid form is pure grit, lit-
tered with fag butt and soda can. It's a towering tsunami of desire and grief,
sheer beauty and aggression as pitch tidal void. Inspired by the artist's Murder
Mile[60] 'hood the title is taken from an imported soft drink favoured amongst
certain elements. ■

We are at war and we have always been at war. Exactly with whom
or with what is uncertain. It's the chatter in cafs[61], boozers[62], bookies[63] and
unis[64], analysed from all sides[65] on the box[66]. There's General Jeremy Vile[67] with
his lager louts[68], scroungers[69], slappers[70] and wasters[71], shaggers[72] and doggers[73],
pikeys[74], gippos[75], and soc-ex[76]; cowboys[77] and strippers, fences[78] and dealers, asylum
seekers[79], DSS[80], and those on the game[81]; asbos[82], paros[83], compos[84], in care[85], breeders[86],
psychos and yobbos[87], and propagatious regiment of kedheads[88], special needs[89], and
duffers[90]. All at home watching The Wright Stuff[91] talk life and death: the property
ladder[92], congestion charge[93], higher-rate taxes[94]. IVF[95], exams[96], divorce, Swissthanasia[97].
Superbugs[98] and superfoods[99], plastic surgery and rexis[100]. Bohos[101] and WAGs[102], Madonnadoption[103]
and chakras, pilates and acupuncture; have-a-go-heroes[104] and girl bands[105]. From Auntie[106]
flows an endlessly middling assault: Middle East, Middle England, middle management,
middle-aged. Newscasters flirt awkwardly, casually posed on red sofas: age-defying,
age-defining, and frumpy. Violence and leisure are inextricably entwined, their contaminating
influence extending. ■

It's us v. them as Scott King's *Pink Cher* incites uprising, the futility of proletariat
struggle consumerised. Utopia achieved via brand recognition: Che Guevera,
Dysmorphic[107] star, and Warhol. His liberty-cum-logo is the new revolution of
choice, freedom as seen on TV. Silk-screened on canvas, its mass-pro-
duced aura seals commodity fate as indelible, calculating a
finite truth that there's no Left or left out, only
the levelling spectre of
luxury.

on Britain's Got Talent TV show who shocked the nation with proof that ugly people have value. See: *http://www.youtube.com/watch?v=RxPZh4AnWyk*. **54 Pri-o-ry** – *n*. Top celebrity rehab guaranteed to bring publicity, column inches, a guaranteed cure-all for nervous exhaustion and substance abuse. **55 Glo-cal-i-sa-tion** – *n*. Individuals or groups who participate in globalism from a position of locality. **56** As exemplified by the hermetically 'real' worlds of EastEnders and Coronation Street*. * **Soap Op-er-a** – *n*. Unlike soap operas throughout the rest of the world, British soap operas are the opposite of escapist glamour. They try to mirror reality as closely as possible by setting the locations in London's East End or inner-city Manchester. Characters are sympathetically slightly worse off than the average Brit, with crummy jobs as market-sellers or underwear factory workers, and plot lines are devised to closely follow what's happening in tabloid current affairs. Their effect is something like a romanticised version of what post-war Britain would be like today. **57 Op-por-tun-ity So-ci-e-ty** – *n*. Blair government mission to induct the working and welfare classes to middle-class values and aspirations. **58 Ter-min-al 5** – *n*. The newly built 5th terminal at Heathrow Airport, which upon its opening in 2008 proved not-fit-for-purpose* as over 300 flights had to be cancelled due to baggage-handling backlogs and employees and customers being unable to find the parking lot. The chaos lasted 5 days with as many as 20000 bags lost including Kate Moss's. People now pronounce Terminal 5 with an inferred irony of terminal meaning 'the end' or 'fatal'. *__Not Fit For Purpose__ – *adj*. Something which is scornfully inadequate. The British never complain, so in order to be not fit for purpose it has to be really, really, REALLY, UNBELIEVABLY, INCOMPREHENSIBLY crap.

59 Hap-py Slap-ping – *v*. Beating somebody up while your mates film it on their mobile phones so it can be broadcast on YouTube. A phenomenon developed and sophisticated from 1990s Tango* adverts featuring a face slapping nappy-wearing* orange man. **Tang-o** – *n*. A brand of soft drink. **Nap-py** – *n*. Diaper.

60 Mur-der Mile – *n*. The area of London extending between Hackney and Clapton. **61 Caf** – *n*. Cafe. This word however is used exclusively for greasy spoons, and never cafes. Cafes are tea houses or coffee shops. **62 Booz-er** – *n*. Pubs and working men's clubs. **63 Book-ie** – *n*. Legal betting agencies. Also known as Turf Accountant. **64 Uni** – *n*. University. **65 Side** – *n*. Television channel. **66 Box** – *n*. Television. **67 Jer-e-my Vile** – *n*. Daytime talk-show host Jeremy Kyle. Referred to as vile because of his low-life guests and dislikeable persona. **68 La-ger lout** – *n*. Men who mix their drinking with fighting or other boisterous, loud, and thuggish behaviour. **69 Scroun-ger** – *n*. 1. People who don't work, never have worked, never will work, have made careers out of negotiating the welfare system. 2. People who live by sponging*. *__Sponge__ – *v*. To borrow money or goods with no intent of returning them. **70 Slap-per** – *n*. A tarty girl. **71 Wast-er** – *n*. Like a scrounger, but less ambitious. Where a scrounger is

always trying to obtain more, a waster just pisses things away through being not bothered*. * **Not Both-er-ed** – *v*. To not care. **72 Shag** – 1. *v*. To have sex. **73 Dog-ging/Dog-ger** – 1 *v*. Having sex outdoors in public places so other people can watch. 2. *n*. People who engage in dogging, such as EastEnders's Steve McFadden. **74 Pi-key** – *n*. Formerly a derogatory term for a gypsy, but now can be applied to low-class people in general with equally derogatory effect. **75 Gip-po** – *n*. A derogatory term for gypsy. Gypsies should be referred to respectfully as Travellers. **76 Soc-Ex** – *n*. Socially excluded. **77 Cow-boy** – *n*. People who pose as qualified tradesmen but have no skill whatsoever and cause more damage than they repair. **78 Fence** – *n*. A person who specialises in selling stolen goods. **79 A-sy-lum Seek-er** – *n*. Someone applying for UK citizenship under regulations that ensure that anyone facing genuine threat of violence or persecution in their home country will not be turned away. 2) Someone applying for citizenship with false claims of asylum. **80 DSS** – *n*. 1. Department of Social Services. 2. People who use these services (such as welfare, child protection, care in the community, etc).

81 On the game – *adj*. Working as a prostitute. **82 As-bo** – *n*. 1. Anti-Social Behaviour Order. Legislation that allows the courts to implement restrictions on people's unsavoury behaviour such as playing loud music or drinking in public*. 2. People who are under restriction of Asbos. *Though these laws were devised to ensure harmonious living for all, they have also become subject to absurd use. E.g. 13-year-old musician Andrew Caulfield was threatened with an asbo for practicing his bagpipes; Caroline Sheppard who received one preventing her from answering her door in her knickers; and farmer Brian Hagan who was issued one because his pigs kept escaping into his neighbour's garden. All that is needed for asbo implementation is the word of a police officer or a letter from a busybody neighbour. 98.5% of all requests are granted. **83 Par-o** – *n*. 1. Parenting Order. Often comes with asbos given to under-16s, forcing parents to take legal responsibility for their child's anti-social behaviour. Parents may face prison if their child is truant or wayward. 2. People who have been issued with parenting orders. **84 Com-po** – *n*. 1 Benefits, esp. health-related compensation. 2. People on benefits. **85 In care** – *adj*. Children who've been removed from their family situations because of abuse or neglect, wards of the state. **86 Breed-er** – *n*. People who have too many children and can't take care of them properly, yet keep having more. **87 Yob** – *n*. A loutish or ill-mannered person. Origin: early 20th-c back-slang for boy. **88 Ked-head** – *n*. Drug addict, specifically one with a preference for Special K*. * **Special K** – *n*. 1. A breakfast cereal. 2. Ketamine. **89 Spe-cial Needs** – *adj*. 1. A patronising term for people with physical or learning disabilities. 2. People who don't have learning difficulties but are just annoyingly stupid or demanding. **90 Duff-er** – *n*. A scruffy old man, usually found in the pub with a scruffy old dog. **91 TWS** – *n*. Morning current events talk show hosted by Matthew Wright. **92 Pro-per-ty Lad-der** – *n*. Measurement of home ownership status.

The 1st rung is invariably a one-bedroom hovel or anything ex-council*, 2nd the transitional home – always purchased with the intent of staying there 5 years or less – until you can afford level 3, the house you actually wouldn't mind living in. Multiple property acquisition is necessary to rise to levels past 5. To not be on or actively trying to get on the property ladder is unthinkable. *Ex-coun-cil** – *n*. Cheap purpose-built flats for low-income families or people on benefits. Many of these are now privately owned though retain the stigma of poor quality and social status. **93 Con-ges-tion Charge** – *n*. A tax levied on all cars entering central London with the intention of eradicating traffic jams by making less affluent people take the bus. Currently £8 / day. **94 Higher Rate Taxes** – *n*. Recent 10% increase in taxes for those earning more than £50K/year. Outrageous. **95 IVF** – *n*. 1. In Vitro Fertilisation. 2. In(dia) Vitro Fertilisation, where for as low as £4000 you can have your own inseminated egg implanted in an Asian woman's womb and collect the baby 9 months later. Order now at: *www.indianmedguru.com*. **96 Exams** – *n*. In the UK, exams are the single most important thing anyone will ever do. They are the gateway to good school entrance, good uni degree, good job. If you blow it when you're 6, you're screwed. **97 Swissthanasia** – *n*. Legalised euthanasia in Switzerland. Increasingly popular final holiday destination. **98 Superbug** – *n*. Mutated viruses that no drugs can combat, resulting from filthy hospitals and poor hygiene in general. There is currently a government sponsored TV ad running to instruct the public on how to blow their nose properly: Always use a clean tissue, throw it away afterwards, and wash your hands. **99 Superfood** – *n*. Foods high in phytonutrients that are deemed especially healthy, such as apples, beans, and tomatoes. Phytonutrients are chemicals which naturally occur in plants, so superfood simply means 'vegetable', though you can't sell a vegetable for 12 quid* at a health-food boutique. *Quid* – *n*. One pound currency. **100 Rexi** – *n*. An anorexic. **101 Bo-ho** – *adj*. A style of bohemian or hippy fashion favoured by wealthy scenesters* such as Kate Moss and Sienna Miller. Boho is distinctive from normal tattered and ratty second hand wear as it is designer and costs tons of dosh*. **Bo-ho** – *n*. People who emulate this style. Often found in Notting Hill or Primrose Hill districts of London. See also: Trustifarian. *Dosh* – *n*. Money. *Scenester* – *n*. Trendy people, people on the scene. **102 WAG** – *n*. Wives and Girlfriends of famous footballers, who've gained or enhanced their celebrity because of their relationships; are most noted for shopping and wooing paparazzi. E.g. Posh Spice, Colleen Rooney, Cheryl Cole. **103 Ma-don-na-dop-tion** – *n*. The ethical debate of leaving a child to grow up in a 3rd world orphanage in abject poverty with a life expectancy of 38 or to allow a child to live with a wealthy and clean-living – albeit somewhat controlling – international superstar. **104 Have-a-go** – *n*. To have a try at something. Root source to: * **Have-a-go-he-ro** – *n*. Members of the public who take law enforcement into their own hands, vigilantes. **105** Intrinsically linked to WAGs via the Spice Girls and Girls Aloud. **106 Aun-tie** – *n*. The BBC.

107 Dys-mor-phia – *n*. A psychological disorder strongly associated with plastic surgery where people have a grossly distorted perception of their own image. See also: Wacko. **108 Schools** – *n*. In most developed countries people send their kids to school. That's it. Somewhere near the home preferably. Not so in the UK: there's grammar and comprehensive, faith, state and Montessori, private and public, even schools for specific talents such as drama. Getting into a 'good' school is essential, people actually move and convert religion to get their sprogs* onto a favourable register. Mrinal Patel of Harrow, is currently standing trial for misrepresenting her home address on her 5-year-old son's kindergarten application form. A good school's worth going to jail for. See also: Exams. *Sprog* – *n*. Offspring. **109 Ho-spi-tals** – *n*. With the popularity of the school choice craze, its only logical that the same theory be applied to healthcare. Because when you've got cancer, need surgery, have a car crash, or are bleeding to death, the first thing on your mind will be "I hope there's wifi* in the ambulance so I can check out the NHS rating bands.". * **Wi-fi** – *n*. Wireless internet. **110 Re-cy-cling** – *v*. With steep fines for failure to comply, and rubbish spies sorting through bins just to be sure, no recycling really is no longer an option. However, the plethora of coloured bags and their correct usage is a minefield unto itself. Michael Reeves of South Wales was fined £200 because an item of paper was found in a green bag instead of a white one. **111 Five-A-Day** – *n*. Cigarette lingo adapted by the National Health System to promote eating fruits and vegetables. **112 Li-von-elle** – *n*. Morning-after pill. Now advertised on TV. **113 Smear Test** – *n*. Gynaecological test for cervical cancer. After the tragic and probably preventable death of Big Brother star Jade Goodie, women have been going to the doctor's in droves. **114 MMR jabs** – *n*. Inoculation against Measles, Mumps, and Rubella. Is mandatory by law, but rumoured to be associated with Autism. **115 Lor-raine Kel-ly** – *n*. TV presenter and journalist, grand dame of Middle-England opinion. **116** Advertisement for Aviva Bank. **117** Advertisement for Country Life. Children, not knowing The Sex Pistols, think of John Lyden strictly in association with diary products. **118** Advertisement for Quickcover, pulled after scandalous discovery that Quickcover actually won't insure musicians. **119** Irving Welsh doesn't endorse Welch grape juice, but he did write *Trainspotting*. **120 Wi-ki-ped-ia** – *n*. An online interactive encyclopaedia where content is developed and edited by the public. No expertise needed. **121 An-ti-ques Road Show** – *n*. Sunday afternoon television programme where the public bring their antiques goods to be evaluated by experts. **122 Flog It!** – *n*. Hosted by Paul Martin, this is a game show were contestants compete to get the most money by selling their unwanted junk... er, antiques. **123 Time Team** – *n*. A programme where an aristocrat's lawn is dug up weekly in search of Iron-Age/Bronze-Age/Druid/Roman/Elizabethan relics. Often accompanied with period recipes. **124 Cash In The At-tic** – *n*. Almost exactly the same as Flog It! but hosted by John Sencio. Instead of

\\\\ *FREEDOM IS SLAVERY* ////

¯ \ ¯ \ ¯ \ ¯ / ¯ / ¯ / ¯

o

Money speaks sense in a language all
nations understand – ~~Aphra Behn~~

Choice is the buzzword on politician lips: choose
schools[108], choose hospitals[109], choose recycling[110] and
rehab; paper bags, lactose-free, lo-sugar and salt; transfat
ban, five-a-day[111], Nicorette and Viagra. Durex, Livonelle[112],
Nurofen; choose smear tests[113] and MMR jabs[114], Catholic schools,
and Range Rover; Yakult, Dettol, Oral B, and Lorraine Kelly[115]. Buy it on
Ebay/Amazon/Tesco.com: Alice Cooper[116] mortgage, Johnny Rotten butter[117],
Iggy Pop insurance[118], (Irving) Welch[119] grape juice: 'Choose life'.

Choose kiddie-style porn with Barry Reigate's tittie fetish paintings,
his cartoon Mickey Mouse sculptures so pervy. Get off on their ghetto-black
sleaze. S&M's all the rage with Jonathan Baldock's bread dough heads, Leigh Bowery
fashion meets whole grain organics. Matthew Darbyshire's shelves stocked with fantastic-
plastic allure, and Steve Bishop's design-perfect wildlife; the artifice of display trumping
museums and showrooms with their genuine devotional aura. Forget about Clairol, Oil of
Ulay, and Chanel, Karla Black's cosmetic constructions are truly rejuvenating; lotions
and lipsticks and shampoos and bath creams redefine formalism via home-baked
post-feminist aspiration. Defy nature with Mustafa Hulusi's *Exstacy Blossoms*,
their GM trippy trance artificially sweet, flawlessly painted to advert ideals,
chillingly, engulfingly empty. Toby Ziegler's *The Grand Cause*, a tumultuous
gold-plated heaven, an apocalyptic vision of 24-carat nirvana; while Arif
Ozakca's suburban streets burn in race-riot hell, old masters v. Persian
miniatures cast as yobs on pub carpet. Buy real estate as it oughta
be, Pablo Bronstein's hand-drafted sketches remodel architecture
from all the best bits. Own the future, space tourism, Fergal
Stapleton style, enshrined domestic galaxies of debris in
60-watt glow. Choose mode of death in alphabetical
sequence from Donald Urquhart's lexis primer,
a model argot of fontology and graffiti. Design
and crime so inextricably linked.

\ = \ ≠ \ = \ ~~IGNORANCE IS STRENGTH~~ / = / ≠ / = /

- - ¬ - ¬ - ¬ - ¬ - ¬ - ¬ -

Language is a wonderful thing.
It can be used to express thoughts, to conceal thoughts,
but more often, to replace thinking – ~~Kelly Fordyce~~

Wow, your history's so old – ~~unnamed American tourist~~

History's vaporised, colourised, Wikified[120] and instant,
its constant newness dazzling to behold. Not appropriated or
borrowed, revisited or revised, but amnesiac, rejuvenated and fresh.
Antiques Road Show[121] and Flog It![122], Time Team[123], Cash In the Attic[124], one thousand
documentaries about Hitler[125]. History is cash, get rich quick, and sheer terror, watched
in rerun on Realplayer. It's adaptable and modernised, re-enacted with dramatic licence at
Hastings[126] and Orgreave[127], on Jack the Ripper tours[128] and Guy Fawkes Day[129], by women beefeaters[130]
and the Queen's Guard[131]. No. 221b Baker Street[132] exists, and so does London Bridge, though
it's now somewhere in Arizona[133]. Blue heritage plaques dot old houses of note, like some weird
actualisation of Googlemap. Anne Hathaway's[134] an actress, Churchill's[135] a talking dog, and the
Jordanian Civil War[136] will be won by the red tops[137]. Lethe is succumbing, entrancing with its
oblivious force, making way for progressive inventions. Yet somehow it clings tenuously – uncomfortably
and perturbing – like a malignant rot to the new. ▬▬▬▬▬▬▬▬▬▬▬▬

▬▬▬▬▬▬▬ Based on Thomas Phillips' 1807 portrait of poet William Blake, William Daniels' version
is zombie decrepit. The sitter, long dead, was substituted by a model meticulously crafted from paper.
Its grey-scale palette and cubist suggestion evoke a haunting of tradition and reverence. ▬▬▬▬▬

▬▬▬▬▬▬ On Jonathan Wateridge's canvases guerrilla warfare and jungle wreckage appear so familiarly
remote. The dislocation of reportage meticulously painted, their kitsch-canny effect equally deadened
and invigorating. Bracing with the thrill of serial adventure, they conceive historical epic with virtual
aesthetics, suggesting the flattened illumination of plasma screens. ▬▬▬▬▬▬▬▬

▬▬▬▬▬▬▬ Sigrid Holmwood's peasant scenes are anachronistically brilliant, her neon pigment elixirs
concocted from ancient-like recipes. Their studied opulence intoxicating, seductive, surreal, oscillating
between Flanders and cyberspace. ▬▬▬▬▬▬▬▬▬▬▬

▬▬▬▬▬▬▬ The sheer phobia of history, its disquiet lingering, becomes raw material for use. Its mere
signification is cause for alarm. A constant reminder of failure and nagging prospect of overlooked
truths, linear progression is so strictly untrustworthy. Instead history's approached as web-surfing,
channel-flicking, Woolie's pick 'n' mix[138], Lucky Dip[139]; the more obscure and unverifiable the
better. It's stuff for anoraks[140] and boffins[141] on myfacespacebook[142], swotting up for the
Sunday night pub quiz[143]. What's prized are the lies of history's malleable meaning, its promise
of glory and power. To author, rewrite, one's own version of events, to stamp out any last
vestiges of certainty. ▬▬▬▬▬▬▬▬▬▬▬▬

▬▬▬▬▬▬▬ Steve Claydon's heroic bust poses cast copper dust and resin as bronze,
creating authentic deception; the patina derogatorily induced with piss. Mirroring
the logic of J.G. Frazer's anthropological theses, the portrait is a composite
of three 19th c. political figures, each embodying radically opposing
beliefs. A hybrid relic of theology, science and fashion, it cites genetic
engineering and post-modern eclecticism as plausible validation
for discredited and distasteful theories.

ompeting against others for sales, individuals try to make as much money
 possible to fund a special project that they otherwise wouldn't be able to
fford: like a holiday, a new wheelchair, or a duck pond for their back garden.
25 Hit-ler – *n.* A national obsession, there's a new documentary – sometimes
 or 3 – each week. It's not that we like Nazis, they just make us feel like
inners all over again. **126 Hast-ings** – *n.* A pretty seaside town, landmark
 the Battle of Hastings, which is re-enacted yearly in mid-October by
ousands of history buffs from all over the globe, making it possibly
e largest pre-gunpowder military restaging in the world. **127** Possibly
e most contemporary re-enactment, Jeremy Deller and Mike Figgis's 2001
ocumentary film restaged The Battle of Orgreave, one of the most violent
vents of the 1984 Miner's Strike, filtering even living memory into fiction.
28 This popular attraction advertises: "As the night sets in and the long
adows fall, we delve into the crooked, cobbled alleyways of Whitechapel
 follow the Ripper's bloodstained trail of terror. Step by bloodcurdling step
ou are spirited back to that spine-chilling era of gaslit
orror, to join the Victorian police as they hunt
e Ripper through a warren of crumbling
ackstreets." Exactly how veritas is achieved
 the very trendy neon lit curry-house and
die music quarters of Brick Lane isn't
ally clear, but sounds like fun. Book-
le at: *www.jack-the-ripper-walk.co.uk*.
29 Guy Fawkes Day – *n.* November
 is the commemoration of Guy
awkes's failure to blow up the
ouses of Parliament in 1605. Faithfully
-enacted en mass by the whole of
e country with lager, bonfires, and
reworks, and effigy burning. Cele-
rations begin around the end of
eptember and carry on well through
rimbo*. Elf and Safety out in full force.
Crim-bo – *n.* Christmas. **130** Natasha
ollard became the first woman Yeoman of the
uard in 2007. **131** Though the Changing of the
uard dates back to 1485, its contemporary practice
 just for show, with performances doubled during
urist season. April – July held daily at 11.30 am. **132**
he home of fictional character Sherlock Holmes can be visited
tangible manifestation replete with English-Heritage plaque to mark
s authenticity. Tours given by Holmes and Watson lookalikes. Tickets
vailable at: *www.sherlock-holmes.co.uk*. **133** Lake Havasu City to be precise.
34 Anne Hath-a-way – *n.* 1. Hollywood actress best known for her role
 The Devil Wears Prada. 2. Shakespeare's wife. **135 Church-ill** – *n.* 1.
he canine spokes-mutt for Direct Line Insurance, brown and white British
ulldog, speaks with Yorkshire accent. 2. Sir Winston Leonard Spencer
hurchill, Prime Minister of Britain 1940–5 and 1951–5. **136 Jor-dan-i-an**
iv-il War – *n.* 1. The civil conflict in the country of Jordan between
70–1. 2. Katie and Peter's highly publicised divorce. **137 Red
ops** – *n.* Tabloid newspapers. **138 Woolie's Pic 'n' Mix** – *n.* Unpackaged
ndy purchased by the ounce at Woolworth's departments store chain.
oolie's was closed in early 2009, one of the most high-profile casualties

of the Credit Crunch. The last ever bag of pick'n' mix was sold on
e-bay for £14500. **139 Lucky Dip** – *n.* 1. A ticket for the UK
National Lottery where numbers are chosen randomly by a computer. Players
can choose their own numbers or ask for a 'Lucky Dip' or 'Quick
Pick'. 2. A selection by chance. **140 An-or-ak** – *n.* 1. A winter coat.
2. An obsessively devoted hobbyist. **141 Bof-fin** – *n.* A geek or academic.
142 My-face-space-book – *n.* Any social networking site E.g. MySpace,
Facebook, Bebo, Twitter. **143 Pub Quiz** – *n.* Organised trivia competitions
played by teams in pubs. **144** Actually 3.6 million people watched it last
year, but this is significantly down from previous series. Only 2.6 million
viewers were recorded for week one of the 2009 series. **145
Big Bro-ther** – *n.* 1. The personified face of George Orwell's totalitarian
regime in the novel 1984. 2. A long-running game show where socially
dysfunctional people are imprisoned in a house for 10 weeks and have to
perform humiliating tasks for food. **146 BBLB** – *n.* Big Brother's Little
Brother, a show analysing the Big Brother TV show.
147 BBBM – *n.* Big Brother's Big Mouth.
An interactive discussion progamme about
the Big Brother TV show. **148 CBB** – *n.*
Celebrity Big Brother. A programme
where celebrities put themselves through
obsessive public scrutiny to rekindle or
jumpstart their careers. Sadly no longer
aired due to a live broadcast race row*
where a WAG, a singer, and a media
darling bullied* a Bollywood actress in
the 2007 series. * **Race row** – *n.* Conflict
fuelled by racism. *__Bul-ly__ – *v.* To
abuse or belittle with malicious intent.
149 En-de-mol – *n.* A TV production
company specialising in reality TV and
game shows such as Big Brother, Extreme
Makeover, and Deal or No Deal. **150 Ag-ro**
– *adj.* Aggressive. **151 Ming-ing** – *adj.*
ugly, filthy, disgusting, or repulsive* **Ming-er**
– *n.* An ugly person. **152 Punk** – *adj.* 1. Ill,
sickly. 2. A style of music. *n.* 1. A ruffian. 2. A
prison bitch. **153 Jell-ied Eels** – *n.* 1. A traditional
delicacy of cold eels in gelatine, sold by street vendors in
East and South London. 2. Cockney rhyming-slang for 'Deal'.
E.g It was a jelly at that price. **154 Pong** – *n.* A bad or strong smell.
155 Ce-le-sti-al church – *n.* An East African fundamentalist Christian
denomination that merges Christian doctrine with voodoo ritual and
theatrics, found in run-down residential or abandoned industrial sites
throughout London. **156 Per-sil** – *n.* A brand of washing-up liquid and
washing powder. **157 Lit-tle Chef** – *n.* A chain of service station restaurants
renowned for their terrible food. Wacky celebrity chef Heston Blumenthal
was brought in to revamp the ailing menu of scampi and bangers* in 2008,
with his reputation for delicacies such as snail porridge and quail jelly*.
*__Bang-er__ – *n.* Sausage. *__Jel-ly__ – *n.* Gelatine-based dessert, not a breakfast
condiment. **158** On 29 April 2009, Mobile phone company T-mobile hosted
a free concert in Trafalgar Square where thousands of people turned up to be
filmed singing along to Beatles and Britney Spears* songs for a series of

adverts that convey a contemporary Woodstock-like vibe. * **Brit-ney** – *n*. Cockney rhyming slang for beer. **159 Di-a-mond** – *adj*. Genuine. **160 Spi-key** – 1. *n*. Violent protesters. **161 Fluf-fy** – 1. *n*. Non-violent protesters. **162 Crust-y** – *adj*. A style of unkempt appearance associated with hippies, homeless people, backpackers, and festival goers, often entailing filthy clothes, poor personal hygiene, beards, dreadlocks, and military or Rastafarian apparel. **Crust-y** – *n*. A person who adopts this fashion. **163 Ecowarrior** – *n*. Environmental activist. **164 Vegan** – 1. *n*. A person who does not eat any animal or animal by-product foods. 2. *Adj*. Referring to an animal-free diet. **165 Hunt Sab** – *n*. An animal-rights protester who disrupts fox hunts. **166 Hooligan** – *n*. 1. A person who leisurely engages in violence. 2. Specifically a person who engages in violence at football matches, often a member of a firm*. * **Firms** – *n*. Organised gangs of football hooligans. **167 Squatter** – *n*. Someone who occupies a vacant building or house illegally. In England, if a squatter is not evicted within 10 years, they get to keep the property. **168 Trustifarian** – *n*. Trust fund + Rastafarian. Someone who adopts a hippy, impoverished, or squatter lifestyle but is in reality financially well off. **169 Fathers For Justice** – *n*. A radical fringe organisation for men lobbying for 'fairer' paternity rights in divorce settlements. Known for dressing up like superheroes and climbing national monuments. **170 Women's Institute** – *n*. A very respectable and conservative ladies social club, known for their charitable works. **171 Jamie Oliver** – *n*. Cheeky-chappy celebrity chef best known for Sainsbury's supermarket adverts and his crusade to serve healthy meals in schools. His School Dinners programme – implemented by the government in 2005 for £280 million – caused outrage amongst students and parents who demanded the return of Turkey Twizzlers* and chips.* **Turkey Twizzlers** – *n*. A fried twisty-shaped reconstituted meat product manufactured by Bernard Matthews. **172 Zone 2** – *n*. London is divided into 6 Zones with the numbers indicating distance from the city centre. It takes less time to get to Italy than to Zone 5. **173** In July 2006, opposition leader David Cameron famously gave a speech coining the "Hug a Hoodie" catchphrase with the intent of approaching anti-social youths with more tolerance and understanding. Days later he was photographed being assaulted by a hoodie. See: *www.dailymail.co.uk/news/article-455507/Hardline-Dave-denies-said-hug-hoodie.html*. **174 Orange** – *n*. Mobile phone service provider. "The future is bright, the future is orange" is the bi-line of its inaugural ad campaign which ran from 1994–2001. Orange, in partnership with Pedagogue, has developed the next generation of municipal policing, OCTV. Unlike CCTV which requires cables, Open Circuit Television operates on mobile technology to enable the placement of surveillance cameras literally anywhere.

~~BIG BROTHER~~
\\\\ ~~IS WATCHING YOU~~ ////

_ / _] _ [o] _] _ \ _

A mind enclosed in language
is in prison – ~~Simone Weil~~

System's House's multi-panelled structures command with allusion to technological supremacy. Their minimalist forms, executed with design prototype efficiency, evoke solar powered surveillance; affluence, ethics, and global/self-preservation intrinsically melded to fear. With centre-stage prominence and sinister allure, their purpose is overtly deceptive, recording-transmitting desire's fixation and function through two-way mirror lenses cum screens. ━━━━━━

━━━━━━ In the middle of nowhere, nailed to a tree, is a portrait of Walt Whitman topping himself. It's the end of Transcendentalism, the end of utopianism, possibly the end of nature itself; the event forensically preserved in Ged Quinn's *God Knows Where This Is*. His vast new world landscape, originally documented in a Carleton Watkins's photograph, looms with the intense focus of appropriated surveillance. The scene is Yosemite Park, once sacred hunting ground, the watchful eye of spirits replaced by Watkins' all truthful lens, their slippery powers magnified and immortalised through Quinn's fictional historical account. ━━━

━━━━━━ Big Brother's watching you, but nobody's[144] watching Big Brother[145]. Or BBLB[146], BBMB[147], CBB[148], or any other of its Endemol[149] spin-offs. Producers are nervous, glossies are cautious, but the tabloids can always fill pages: with the language of revolution, the stuff of the masses, its wiry vibe agro[150] and permeating. Through minging[151] back-allies punk[152] with jellied eel[153] stench and the pong[154] of Celestial's[155] jah-sticks, to the Persil[156]-pastoral commuter belt villages nestling Little Chefs[157] between thatch-roofed cottages. Past the tourist sign-posted gates of artistocrat's theme-park estates gift shop replete and publicly funded; beyond the crags and glens, dales, moors and fens, and out over the white cliffs of Dover. ━━━

━━━━━━ In Trafalgar Square activists are protesting for a mobile phone ad[158], their festival spirit absolute diamond[159]: spikies[160] and fluffies[161], crusties[162] and ecowarriors[163], vegans[164] and hunt sabs[165]; hooligans[166], squatters[167], trustifarians[168]. FFJs[169], WI matrons[170], and kids emaciated on Jamie Oliver[171] dinners, dressed in their 9 to 5 guises. From Prada and Paul Smith, Gieves and Hawkes, L.K. Bennett, the veneer of young professional respectability. They sing John Lennon's Hey Jude in harmonious unison, their contagious sound spreading like fire, picked up in Zone 2[172] then High Barnet. Chanted in Black Country, John O'Groats and Penzance, and like a resurrection everyone remembers the words. Beach-bound chavs sing along, and even neds hum the tune, Jafaikans bootleg it as grime remix. The Mummy Brigade run lattes in hand to hug hoodies[173] as merchants close up shop and the tourists, bags packed, head home, their quest for exotic adventure fulfilled. A billboard at Gatwick announces departures with airport déjà vu. Beneath its peeling surface can be seen a prophetic message from a not so long distant past: 'The future is bright, the future is Orange[174]', it says, in the synthetic colour of fake tans.

in the centenary year of Futurism, against the backdrop of the globalisation of art and global warming • The work of these heirs to Marinetti is usually described, rather pretentiously, as an art-process that is confidently and successfully pursued in several large metropolises, London undoubtedly being one of the foremost • Furthermore, the first decade of the 21st century has witnessed a pseudo-critical balance-shift: today large contemporary art galleries and Kunsthalle are able to put on huge, expensive exhibitions to museum standard • And museums are trying hard not to be left behind, showing contemporary artists alongside their established collections – something the galleries cannot yet rival (with the odd exception like the Chapman brothers' palimpsest technique of working directly on top of the 'old masters') • The very beginning of the 21st century was marked by a series of such momentous exhibitions, when the venerable gates of hallowed institutions were opened to admit tough and uncompromising art-projects •

The Louvre exhibited Jan Fabre

(http://www.louvre.fr/media/repository/ressources/sources/pdf/src_document_53708_v2_m56577569831203088.pdf),

Versailles – Jeff Koons

(http://www.jeffkoonsversailles.com/fr/),

the Rijksmuseum – Damien Hirst's diamond skull

(http://www.rijksmuseum.nl/tentoonstellingen/hirst) •

and the Hermitage presented the project *USA Today*

(http://www.hermitagemuseum.org/html_En/04/2007/hm4_1_173.html) •

This all bore witness to a barely perceptible but nonetheless real institutional regeneration of museums: they enhanced their status, becoming not just repositories of the nation's treasures but institutions that presented the latest tendencies in art – thereby acquiring once again the role of initiators of the most significant events in a country's or city's artistic life • For a museum show is more important than the bulky folio editions that analyse the twentieth century for the hundredth time, describing events in a historically formulaic way • An impressive art-event strives to break free from mass culture, which rapidly swallows up every new phenomenon and publication, spitting it out in the form of a 15-line survey of new titles destined to lie dormant on the bookstore shelf between gaudy coffee-table books and weighty non-fiction • In the context of this monotonous mass culture the number of active visitors to a museum's exhibition-event has bearing on the collection's value • What is important is not who owns the art, but who can now see it • Contemporary artists are responding to this by turning to old techniques and technology to create 'material' works of art – painting on canvas, sculpture and so forth • New art is reworking the experience of old art in its own language – a language that is not necessarily shared by installations, video and other contemporary media-technologies • New words loudly declaim their necessity • Metaphors of the unconscious and empyreal visions seek a new, precise materialisation • Pop culture is repeatedly confined to the straitjacket of antediluvian cultural interpretations... These questions were crystallised, in the process of selecting works with the Saatchi Gallery for the Hermitage 20/21 project *Newspeak*, in five separate but interconnected themes •

A declaration

of all

this •

as neo-passéism of the veterans of postmodernism • Distracted liberals contemptuously screw up their eyes, convinced that 'all this so-called contemporary art' isn't worth a brass farthing, despite the 'absurdly inflated prices' • That it's all hurtling towards the abyss • That the feeling for form is being irretrievably lost • That live art-events are not fit to hold a candle to genuine post-contemporary values • That today's flashmobs and other impromptu art-activities are only pale imitations of Seventies 'happenings', and so on •

Unfortunately postmodernists, too, have turned out to be run-of-the-mill idealists, who, like generations before them, not only set forth their ideals but also doggedly defend them • Idols decay, heroes grow old, leaders grumble with increasing intransigence •

Is this leap back to the painting and sculpture of the old masters a concession to past taste, or is it just the latest ruse of the inexorably perfidious art-market? *Newspeak* presents a number of paintings that clearly reveal their source • The new language of old paintings sometimes pays respectful homage to its prototypes, sometimes copies the language of its predecessors with carefree impudence, and sometimes simply refers directly back to long-defunct prototypes of fairly dubious value • **Arif Ozakca** mixes eastern and western culture in one canvas • Riders from Persian miniatures and western-European models battle it out in his work, a perhaps fairly untypical encounter in the real world • **Ged Quinn** finds inspiration in the paintings of Claude Lorrain and other landscape artists: as though motifs from an entirely different world have somehow cunningly crept into his old landscape paintings • Similarly, in acidic tones, **Sigrid Holmwood** studies peasant themes in nineteenth-century painting • Are these artists making fun of their illustrious predecessors or interpreting them anew? Either way, does it prevent this renewal of old art from becoming good art? Who, anyway, should decide what is or isn't good art? Where do these questions end? And is it a good thing that this new contemporary painting asks more questions than it answers? **Jonathan Wateridge** turns to the global theme of catastrophe, inventing disasters where they don't exist • His vast paintings raise the whole question of the concept of 'the big picture' – in every sense of the word: direct, opposite, metaphorical and so on • **William Daniels** speculates in old-master delusion •

His pictures cannot, nor are they meant to, escape the effect of grand pictoriality: from cheap little pictures they are suddenly transformed into strange maps of an unknown location made out of cheap tin-foil • The painting breaks down into tin sections which acquire a sense of volume, and then, in concentrated and amended form, reassemble on the apparently unremarkable pictorial surface •

This play with the 'oldspeak' of old-master painting is better than art-process by business-plan, the cold calculation of art dealers, or the stroke of genius that saw the boxer Vitaly Klichko become art curator (http://www.ukrainianpavilion2009.org); but it is not the same as understanding the need to experience the old myths within oneself and to begin to live beyond them, beyond their frames • Without this there can be no life, no creativity, and all that will remain is a constant animated grumbling about the art of the old masters being impervious to change •

Yes they are eternal and magnificent, but if only they are magnificent, then the only honest conclusion is immediate death • But then a trip to the museum is not the same as the flashmob imperative, rather

that we should above all focus on those things that are susceptible to change –
as Aristotle affirms, as Lars Svendsen affirms in the pages of his *Philosophy of Boredom* •
Is pop-culture – 'always new' and 'eternally young' – susceptible to change, or is it just an eternally melancholy nothingness?
Is it only pop-performers with their pop-hits and pop-worshippers who are interested in pop-culture, or has everyday consumer culture become integrally bound up within it and all its output – the mass-media with its eternal problem of what to headline; 24-hour TV with its headline banners; fashion journals with their
relentless testers? Pop-culture
is not viable without the passive
consumer and unimaginable without the commercial success
of its projects • If for one day nothing happens in the world of pop culture, something has to be urgently invented •
In her blog, the singer Madonna addressed, in Russian, her 'Russian ventilators' – the translation programme's rendition
of 'Russian fans' • Similar results occurred in Bulgarian, Polish, Dutch and other languages •
An amusing incident which elicits a smile and keeps Russian internet-users busy for a couple of minutes,
suggesting that Madonna 'should learn Albanian' • These couple of minutes turn into a daily way of life, surreptitiously expanding and
crowding out of existence the enormous second that separates the future from the past • But if genuine values are replaced by
pseudo-cultural pop-guises, and old art is petrified in its immutability, where do we find a true foundation? Do these contemporary British
artists have the answer? **Scott King** creates an icon of pop-culture, deliberately combining the incompatible •
Donald Urquhart conjures
up catalogues and alphabets of cultural individuals • **Spartacus Chetwynd** fashions hyper-pop-cultural monsters in the acidic garb
of Ku Klux Klan-aboriginals • **Barry Reigate** studies the hyper-merriment of cartoon characters • Everything is fantastic, unbelievable,
wonderful to the enth degree • • • Is there some kind of melancholy behind it all? – No • Is there something left unsaid? – No •

Pop culture simply generates itself and consumes itself • Art enters its frame of reference in the language
of parody, first landing a knock-out punch so that the viewer, as he's being counted out, has to stop in his tracks
and step aside from the stream of daily pop-culture noise • In any case, Madonna's ventilators have entered folklore and
become, in Russia, (pop-) cultural reality • Similarly, the dictionary of contemporary English usage is regularly augmented by hundreds of
new words • 'Chav' – 'a young working-class person who dresses in casual sports clothing' • 'Adultescent' – 'an adult still actively
interested in youth culture' • 'Brand Nazi' – 'a person who insists on buying one particular brand of clothing or other commodity'
(http://news.bbc.co.uk/2/hi/uk_news/4074760.stm) • This is not just frivolous slang but concepts which
describe the new phenomena of daily occurrence (see Patricia Ellis's essay in this volume, and
'The Principles of Newspeak' by George Orwell) • The development of contemporary art can be described in terms of
the creation of visual realities, similar to those that language sets up for the same purpose • • • • • • • • • • •
The work of the successors to Damien Hirst and Tracey Emin
frequently seems to avoid style in the old, classical sense of the word – as an essential constituent of artistic practice • It avoids
respect for the religious • It avoids the 'dialogue between myself and eternity',
avoids even the love for such a dialogue and the love for its own love of this dialogue • The reason for this lies in
the artists' total focus on the creation of a new language that can give
adequate visual 'utterance' to the world that surrounds them • Whether this language is based on parody or free form-creation, it makes no
attempt to undermine our foundations and overturn authority • It is more interested in naming these new realities • •
And by naming them, the world that is constantly hurtling in some unknown direction can be understood, and
the straitjacket – which has for so long been known as culture – can be re-tailored and fitted to it anew •
There is no guarantee,

however

that it is possible to

by such architects as Albert Speer and Bruno Taut, Vladimir Shchuko and Vladimir Gelfreikh, **and** describe totalitarianism, the threat of which Orwell directly anticipates in his anti-utopian novel *1984*, as a necessary condition of good architectural style • • • • The apparently unfinished nature of the principal examples of totalitarian architecture can be explained by the essentially unrealizable nature of the utopian idea • • It is nonetheless the utopian Tower of Babel which excites the imagination – because of the grandeur of its concept and the endless possibilities for artistic approach • Careful study of any such design results in an obstructive multiplicity of artistic languages and truth gets lost, dissolving in the inevitable complexities and contradictions of translation • Questions remain unanswered and a **result** turn in on themselves, for, as Derrida might say : 'You should never leave unasked a question about language, for language is used **to** ask the question about language and to translate a discourse about translation' • Architecture, meanwhile, persists in its attempt to assemble the Tower of Babel bit by bit, while artists endeavour to capture the essence of architecture, reading between the lines the texts of a multiplying and towering language • **Pablo Bronstein** assembles architectural fragments scattered here and there, inventorizing them and finding an appropriate arrangement • • • • • • • • **Alistair MacKinven** creates architecturally shaped constructions that raise questions about the grammar of language and the tectonics of materials • London is one of the best places in the world to study architectural theory and practice, such as the severe architectural monsters of the 1930s, among them the prototype for the towers of Orwell's four ministries – Minitrue, Minipax, Miniluv and Miniplenty • Minitrue (see The University of London's Senate House: http://www.geograph.org.uk/photo/169284) is a **300**-metre pyramidal construction piercing the London skyline, **in** which workers, including Winston Smith, the hero of *1984*, tirelessly and successfully monitor the progress of language, reducing it to the absolute minimum • Nobody is against, everyone is for • • • • As the Futurist Ilia Zdanevich wrote in 1916, 'do not be confused, remember that this is Albanian' • The significance of these words

in effect from all of them • Artists come to London not just from the former British colonies that extended across all three parts of the globe – Eurasia, Eastasia and Oceania – but from other countries too • Indicative of this are the vivid, non-English-sounding names in the *Newspeak* catalogue • • London attracts them as a unique art-space, as a place where they can be free of any particular sense of belonging ―― - *xvii* - national, religious, political and so forth • Precisely for this reason many of the works in *Newspeak* strive to declare a certain identity, and each study of contemporary British art turns into a discussion about form creation and artistic ideas within a global Atlantic art-space • • • • Through this coming together of various cultural worlds, this melting pot of styles and countries, of techniques and technologies, of the material and the invisible, the creation of the expressive materials of a new language is achieved, woven together from disparate parts in an extraordinary way • **Dick Evans's** enormous wave is grandiose in the manner **of** Hokusai's (1760−1849) *Great Wave off Kanagawa* and prosaic as a heap of rubbish • **Jonathan Baldock's** heads reference the ancient clay masks of the Mediterranean, but in a gallery of contemporary art look ambiguous, like ritual objects intended for royal burials that have been turned into theatre props • • • **Daniel Silver**, on the other hand, seems to refer entirely to the art of classical antiquity, seeking – after so many historical attempts – to discern something new in it • **Steven Claydon** looks to the same source, but his classical antiquity turns into a world of fantasy, the invention of a time machine and psychological experiments about identity, compelling the viewer to look for some dirty trick in the pseudo-historical objects arranged on light tables • **Hurvin Anderson** focuses on the history of genre painting – from New Objectivity to Edward Hopper (1882–1967) – with the result that his images manage to convey both a certain melancholy and a penetrating quality • **Ryan Mosley's** strange mini-kingdom of dolls, butterflies and princelings is exuberant in its endless individual formations, while **Tessa Farmer** literally plunges the viewer into the fantastic world of the entomological microcosm • Each work loudly declaims, striving more and more stridently to declare its unique individuality, to drown out its neighbour in this clamour of voices, this roar of waves, this buzzing of insects (http://www.linguistics.berkeley.edu/phonlab/annual_report/documents/2008/lau.pdf) • Like Henry Higgins and Colonel Pickering, *Newspeak* aims to bring some order to this noisy chaos, this 'collective flow of consciousness and formless substance, in which politics and gossip, art and pornography, virtue and money, the glory of heroes and fame of murderers are all mixed up' – as John Seabrook summarised it in his book *Nowbrow*·· The study of this substance and dissection of its constituent elements entails

the theme of Derridian deconstruction • In **contemporary** British

art time plays a secondary role •

There is past and future, but the present as such – as objective

,

present reality – is absent • It is there only as an echo of the past, which leaves its mark on it; or as a flare of the future, sketching out

its fantastical outline

These phantoms of a present that has overcome time

are also characteristic of the world described in *1984* • In the novel there is no reality of the present, there is no reality

at all as such • • Both past and future are equally unreal: in paradoxical

fashion the past is constantly

rewritten in terms of the **bright future** to come – a future that is absolute since it has already arrived •

Time, on the other hand,

is entirely relative, its function being only to log the succession of video-recordings in the 24-hour CCTV cameras – in the

telescreen in Winston's flat • Big Brother is watching you!

'Does he exist like you or me?' Winston asks, to which the reply is '

Newspeak You do not exist' • • • • The timeless weightlessness of culture forces the - *xviii* -

artists to use explosive pop-culture effects:

constructing metaphorical fireworks or turning to old illusions

similar to the optical visions of the anti-utopian Aldous Huxley •

The visually enigmatic makes an appeal to the unconscious, which in turn seeks out and receives

empyreal revelations • **Toby Ziegler** experiments with geometry and light,

Mustafa Hulusi draws up tables of optical effects • **Fergal Stapleton** creates phantasmagorical worlds of ambiguous

movement-allusions which are intended to intrigue and confuse at the same time • In mock-heroic fashion,

2008 Turner-prize candidate **Goshka Macuga** (http://www.tate.org.uk/britain/turnerprize/turnerprize2008/artists/macuga.shtm)

paints the icon of occultism **,**

Madame Blavatsky, suspended in the circus weightlessness of the bogus psychic's **own cheap stunt •**

Is there a palliative to all this strange reality that has fallen out

· – // – — / · of time and is filled with unfeasibly complex references to a consumer culture

that is empty at its core **?** Probably • But *Newspeak* is not the panacea • It becomes a placebo,

(http://en.wikipedia.org/wiki/Placebo)

hurrying to lay itself bare, for what could be more inappropriate than to show a deliberately

serious face in such a complex situation as a large museum art-project • • Underlying this new language is an emptiness;

behind the people standing in a corner in the work of the **Littlewhitehead** duo,

'It happened in the corner', there is nothing • Some of the artists in *Newspeak* are already well known,

others not yet • One can only surmise that this

art awaits its future • • The language of culture changes so imperceptibly and so materially that every

day entails a reinvention of how to act in what seem, on the face of it, unchanged conditions • • • • •

This is why reading, listening to and carefully studying works of contemporary art is key to helping us keep up with the

present, so that one fine ordinary groundhog day we don't find ourselves, with forced jollity, pretending to understand this

newspeak that everyone around us is speaking •

And this is why I believe it is a good sign that *Newspeak: British Art Now* was shown in the

Nikolaevsky Hall of the Winter Palace,

where such ground-breaking projects (for their time) as • • • • • · // – — // · • · ·

Contemporary Art from the USA, Fernando Botero, Pierre Soulages and

Art of the Australian Aborigines were shown

The process

of

· · · ·

viewing **conveys us to**

· ·　　　　·

···

·

UNTITLED | 2008
Oil on canvas
30.4 × 25.2 см

UNTITLED | 2007
Oil on canvas
101.5 × 76 см

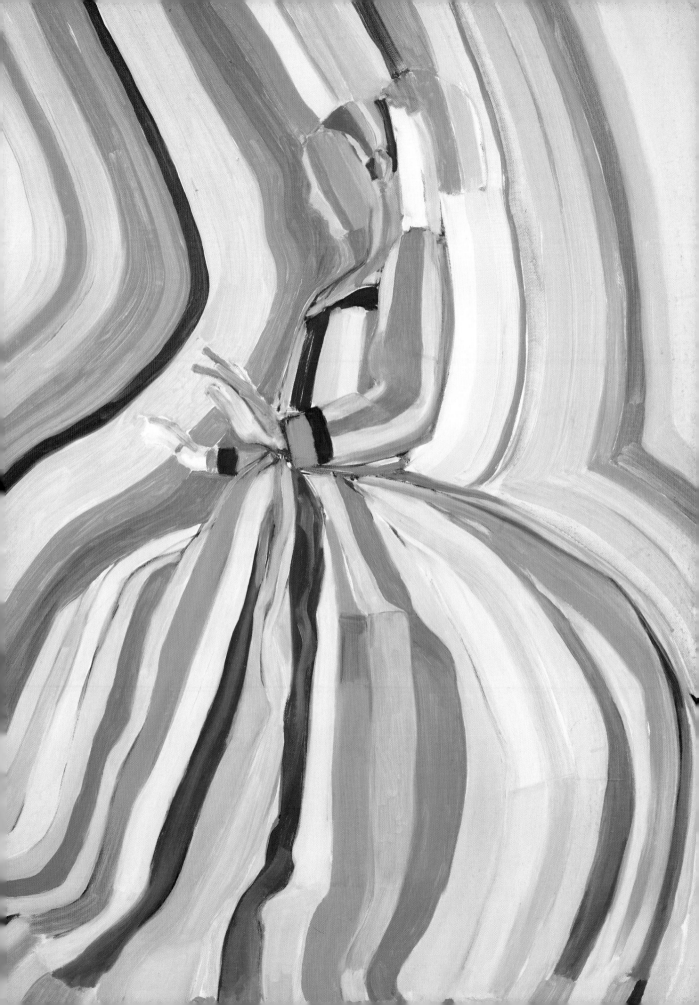

UNTITLED | 2008
Oil on canvas
111 × 161 см

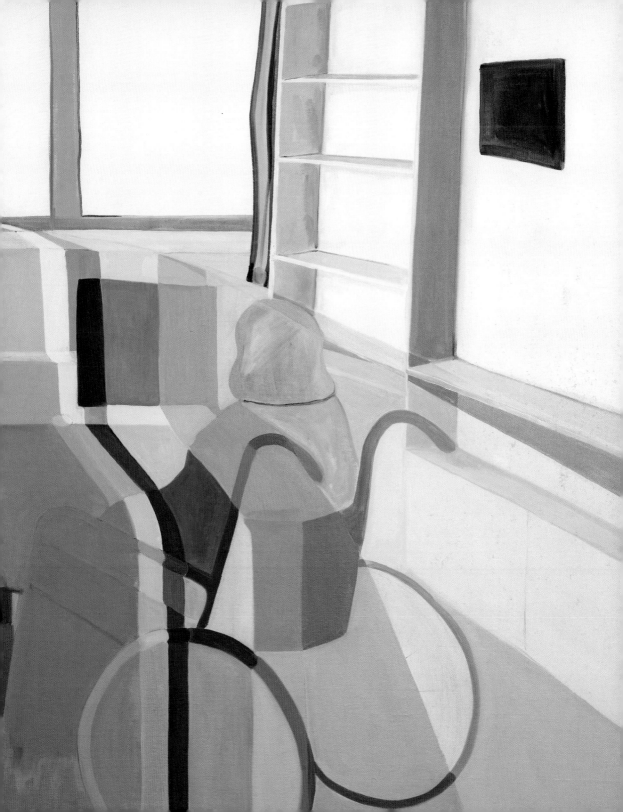

AFROSHEEN | 2009
Oil on canvas | 250 × 208 см

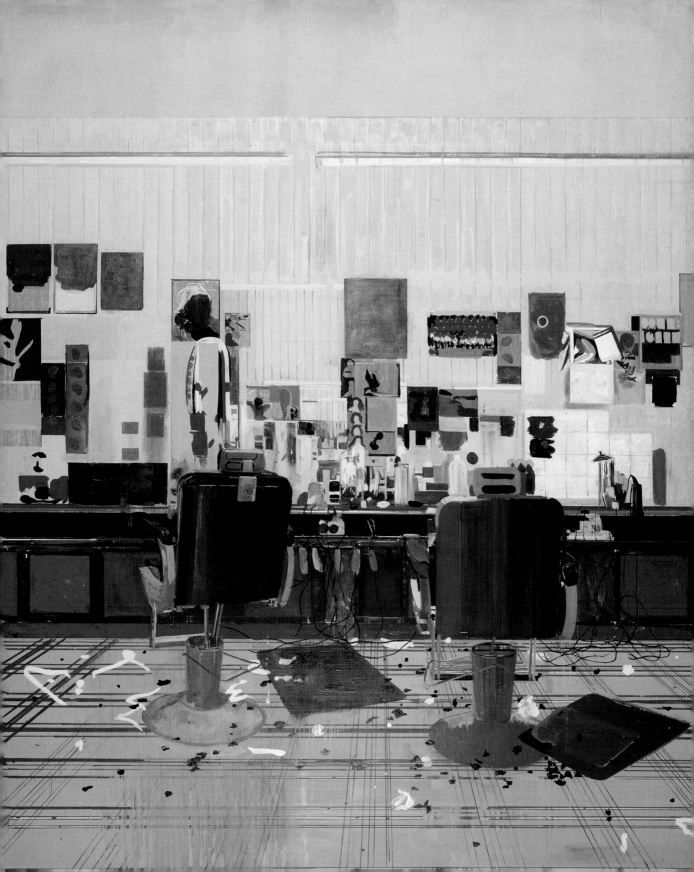

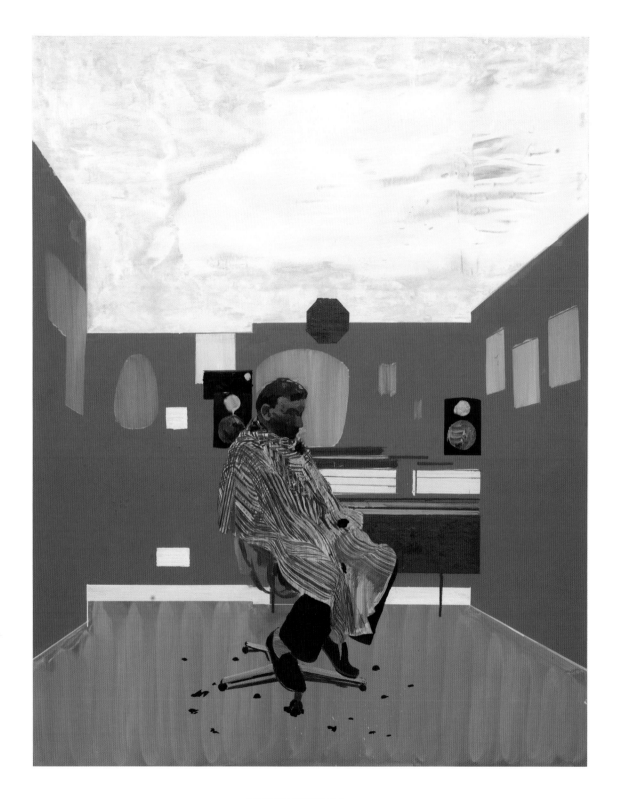

PETER'S SITTERS 3 | 2009
Oil on canvas | 187 × 147 см

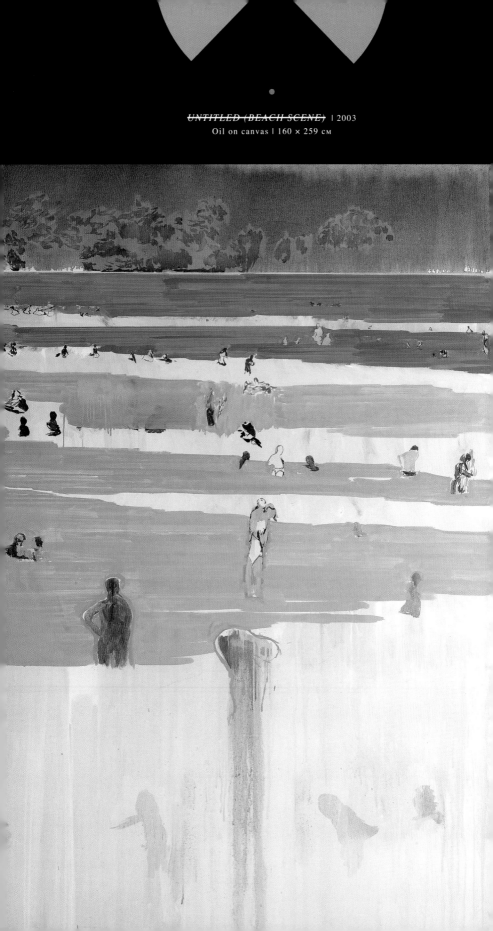

UNTITLED (BEACH SCENE) | 2003
Oil on canvas | 160 × 259 см

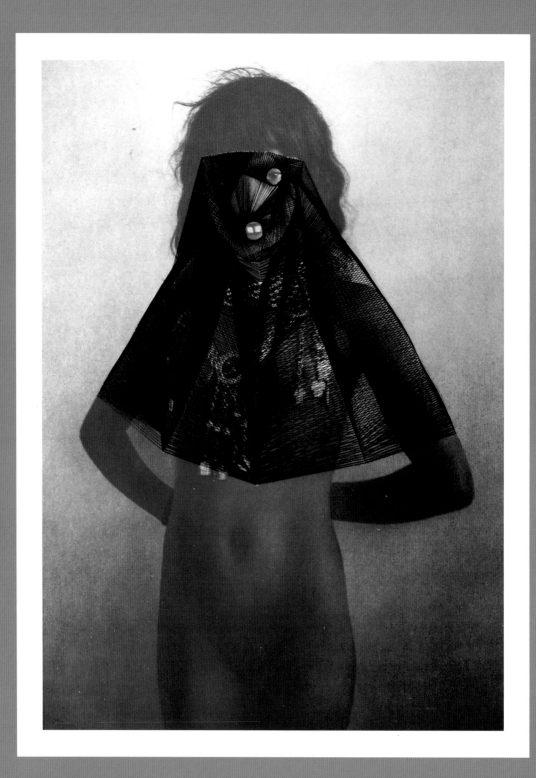

ROUND MIDNIGHT | 2009
Embroidery on print
62 × 45 см

GIOVANNI | 2009
Photographic print with embroidery
51 × 41 см

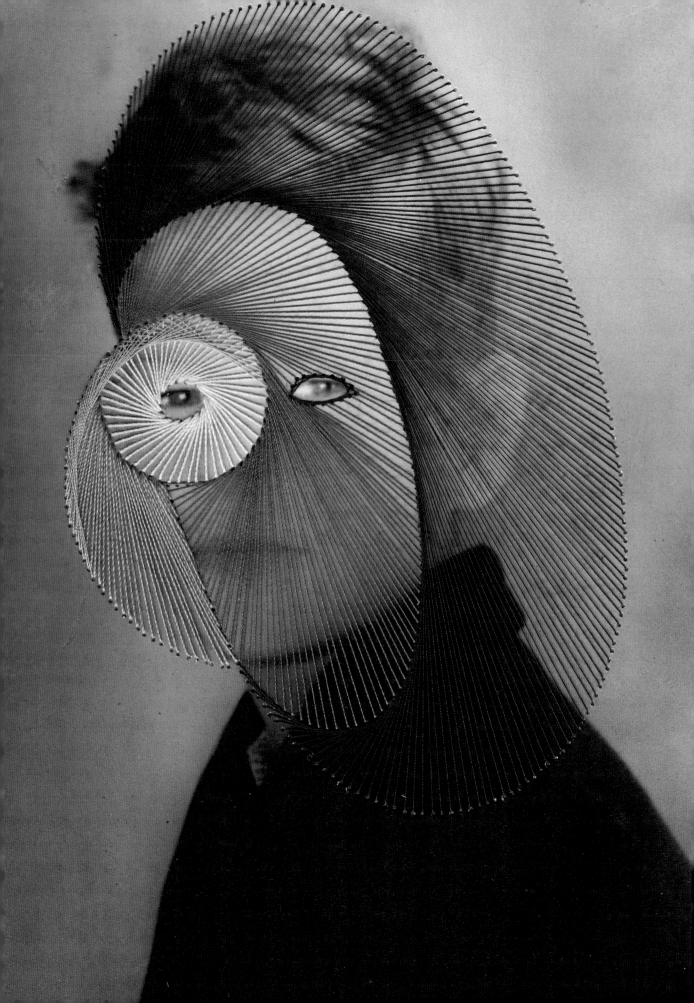

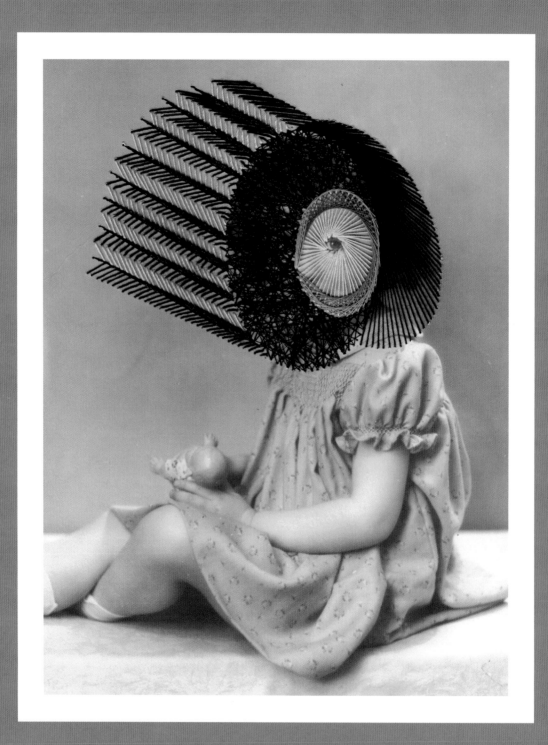

REBECCA I 2009
Embroidery on found photograph
20.5 × 15.5 см

PENNY | 2009
Embroidery on found photograph
24 × 13 см

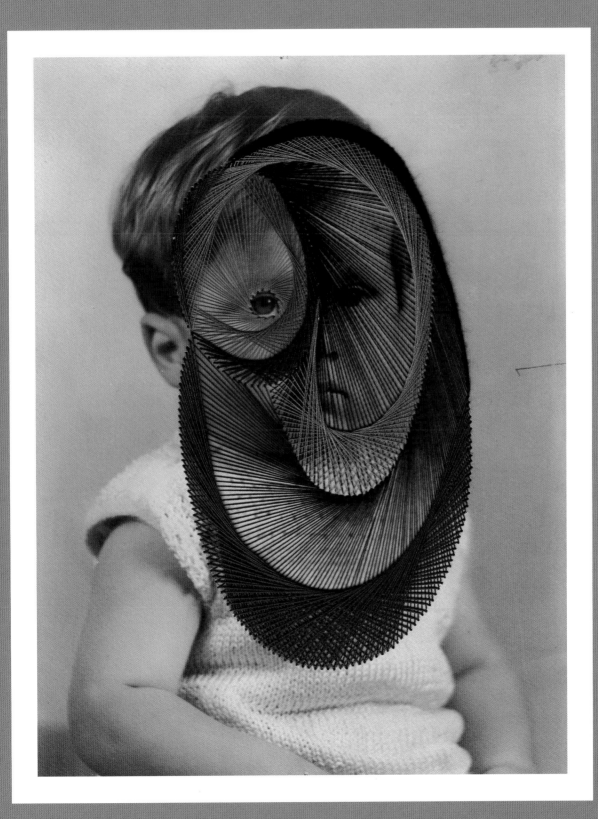

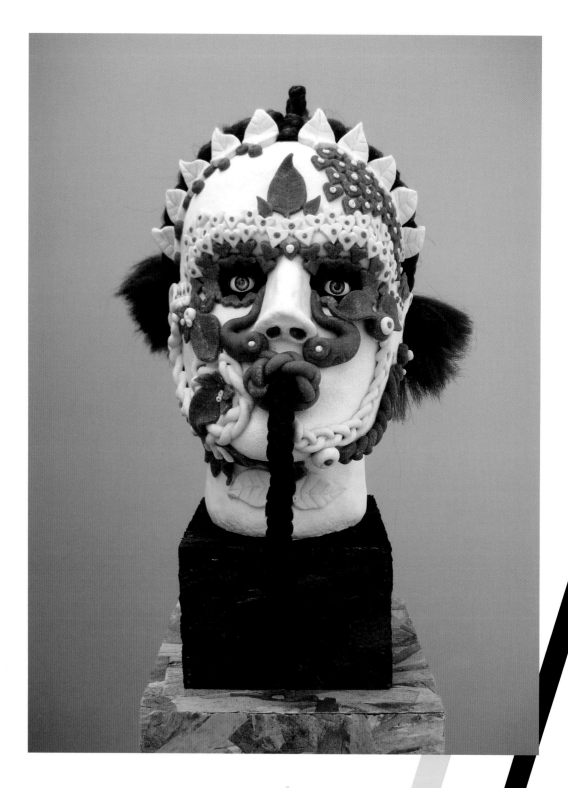

ANDROMEDA | 2007
Salt-dough, pins, ribbon, dolls eyes,
polystyrene, colouring, paint, synthetic hair
29 × 42 × 26 см

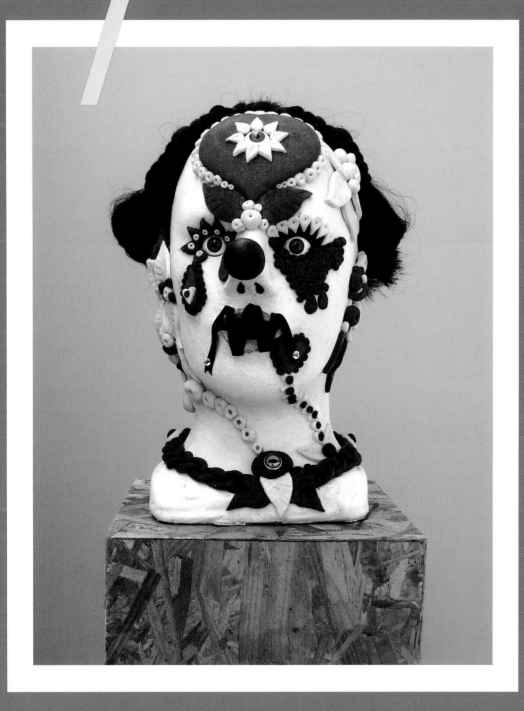

ADRIANA | 2007
Salt-dough, pins, ribbon,
dolls eyes, polystyrene, colouring,
paint, synthetic hair
22 × 34 × 34 см

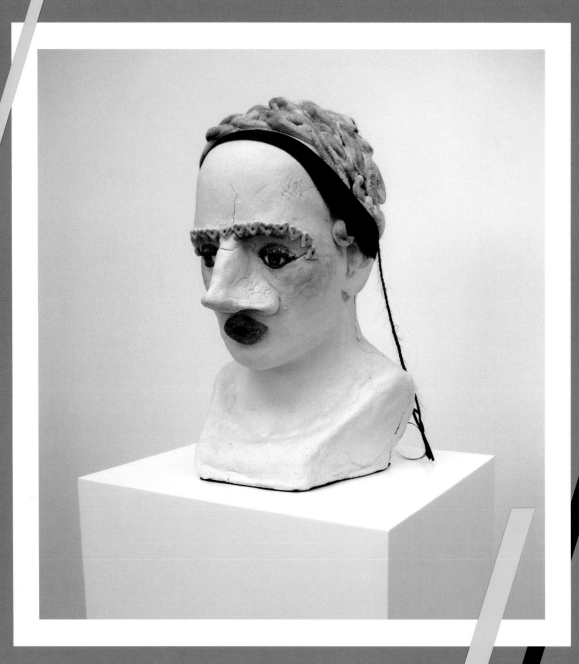

BETTY CROCKER (I MISS YOU) | 2007
Salt-dough, pins,ribbon, dolls eyes, polystyrene,
colouring, paint, synthetic hair
22 × 34 × 34 см

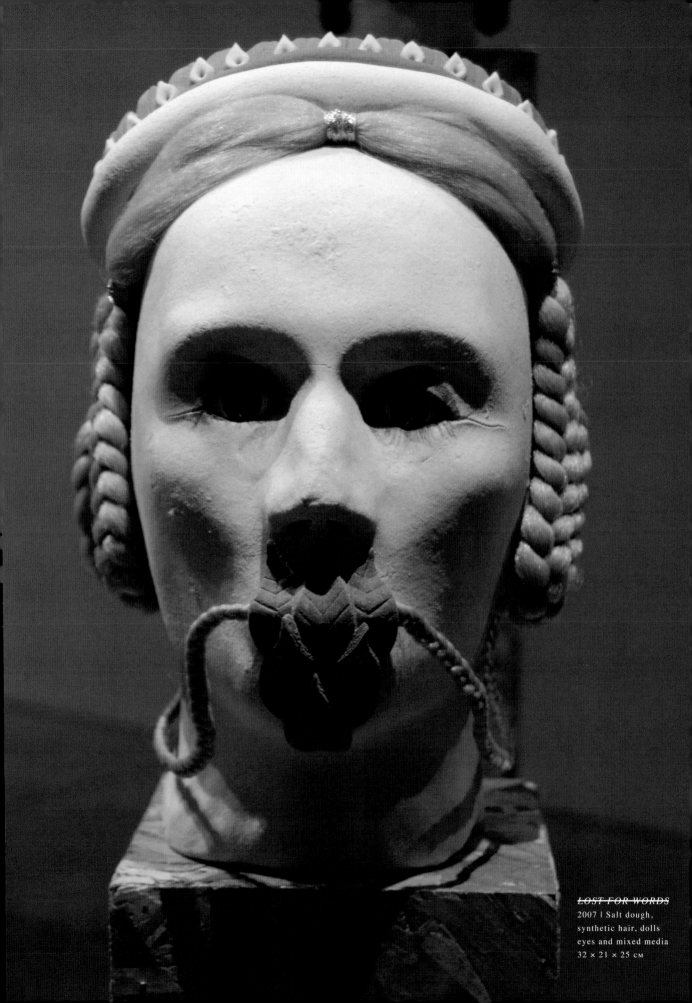

LOST FOR WORDS
2007 | Salt dough,
synthetic hair, dolls
eyes and mixed media
32 × 21 × 25 см

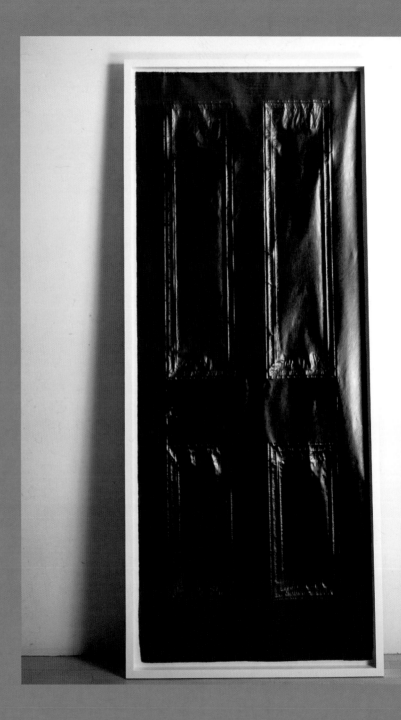

DOOR | 2004
Pencil on paper
208.5 × 88 × 6 см

BLACK WARDROBE | 200.
Tape on wardeobe
177.8 × 70 × 40 см

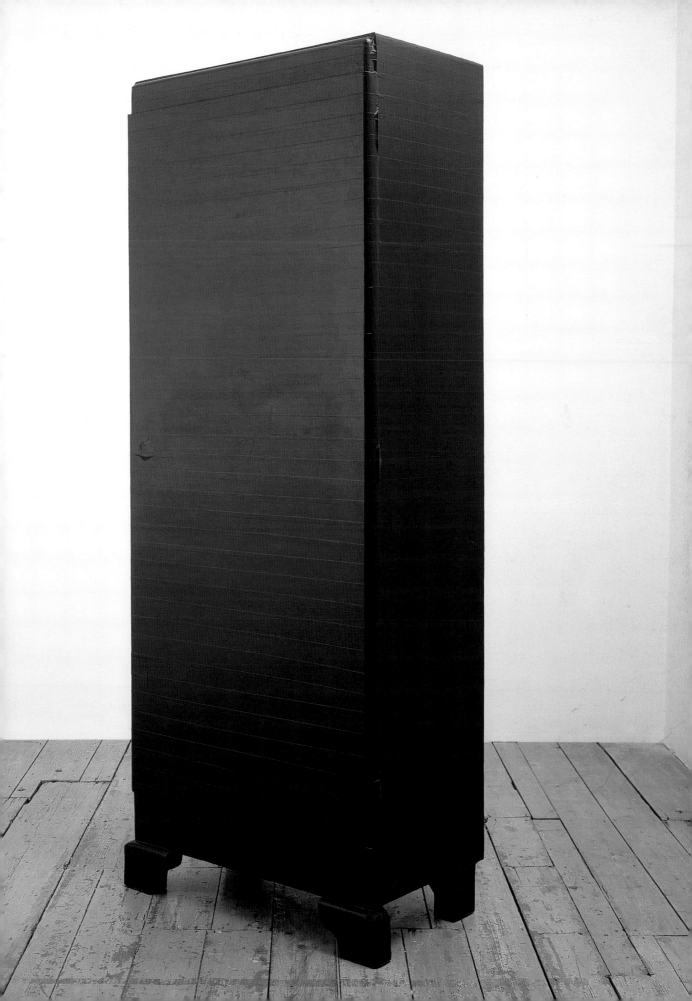

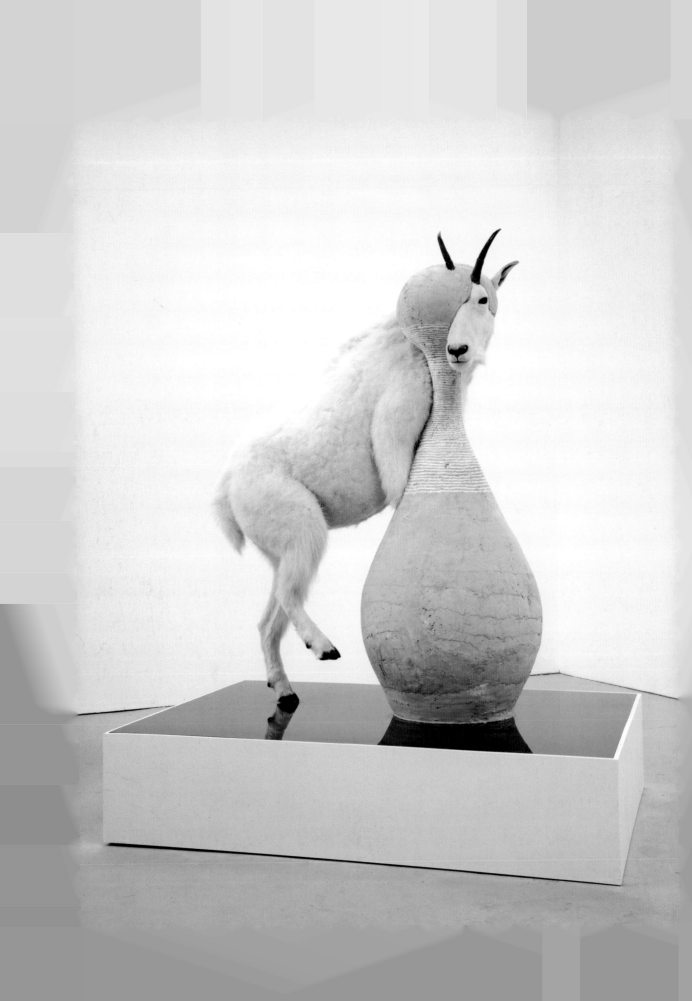

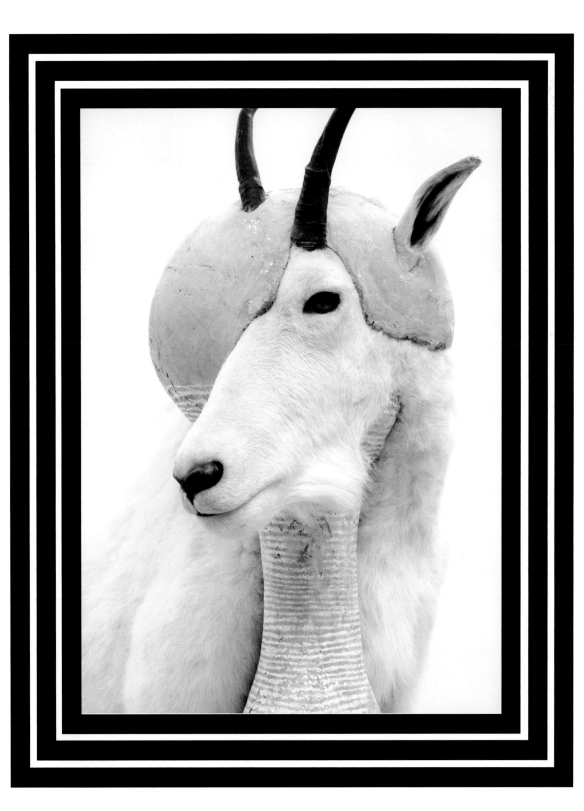

CHRISTIAN DIOR - J'ADORE (MOUNTAIN GOAT) | 2008
Taxidermied goat, concrete, chalk | 170 × 105 × 144 см (with base)

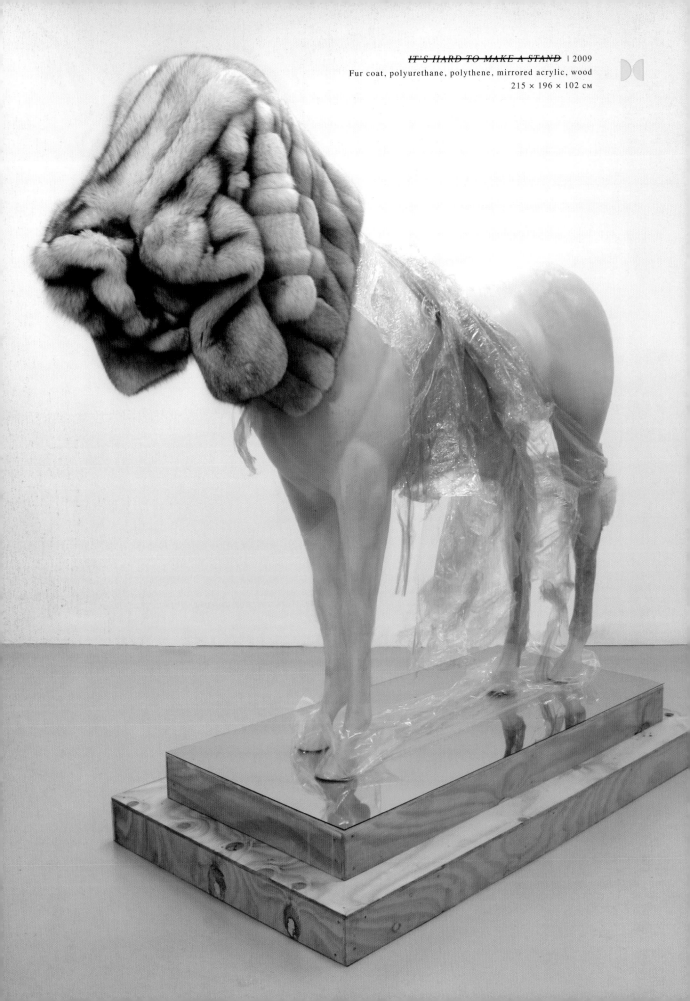

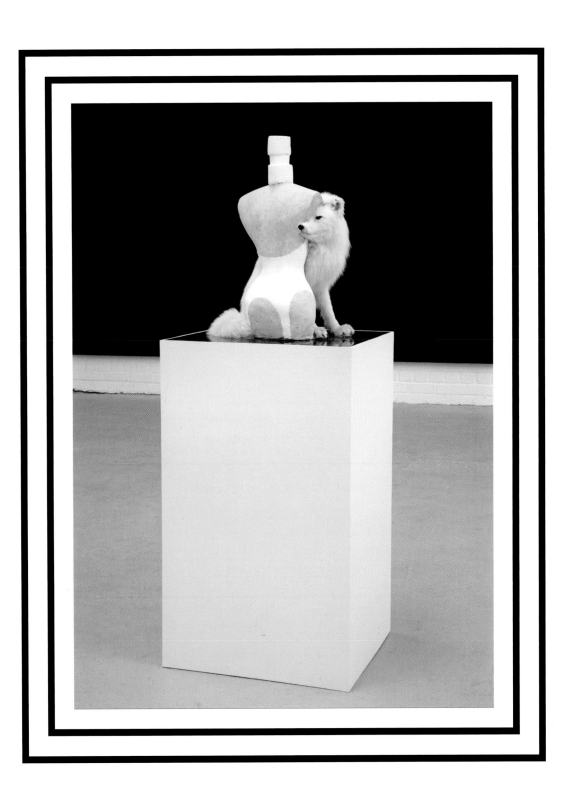

NOTHING IS A MUST | 2009
Sugar paper, chalk, ribbon, lipstick, glitter hairspray
312 × 300 × 182 см

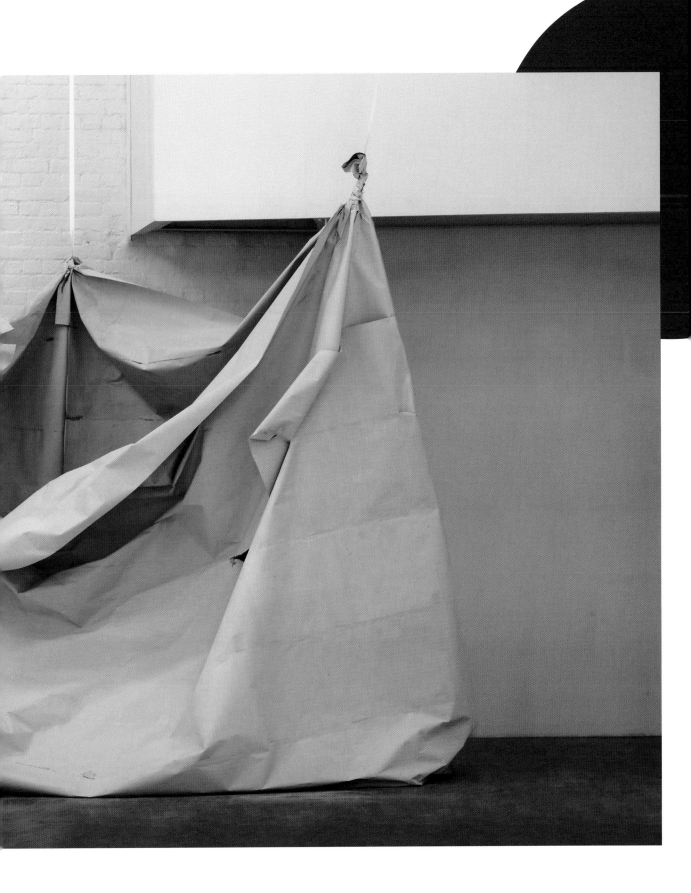

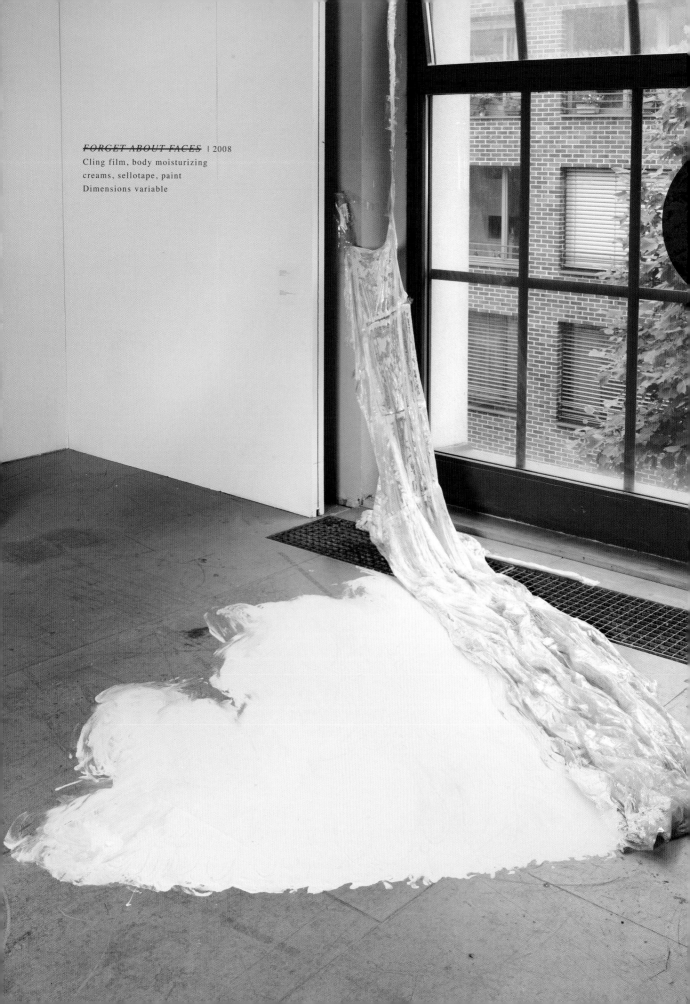

FORGET ABOUT FACES | 2008
Cling film, body moisturizing
creams, sellotape, paint
Dimensions variable

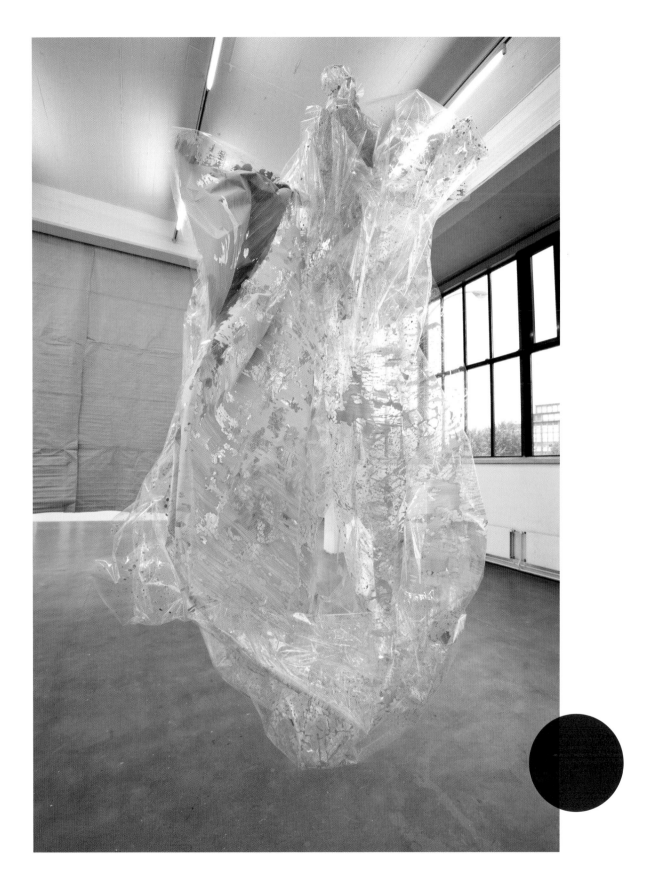

PLEASER | 2009 | Cellophane, paint, sellotape, thread | 250 × 200 см

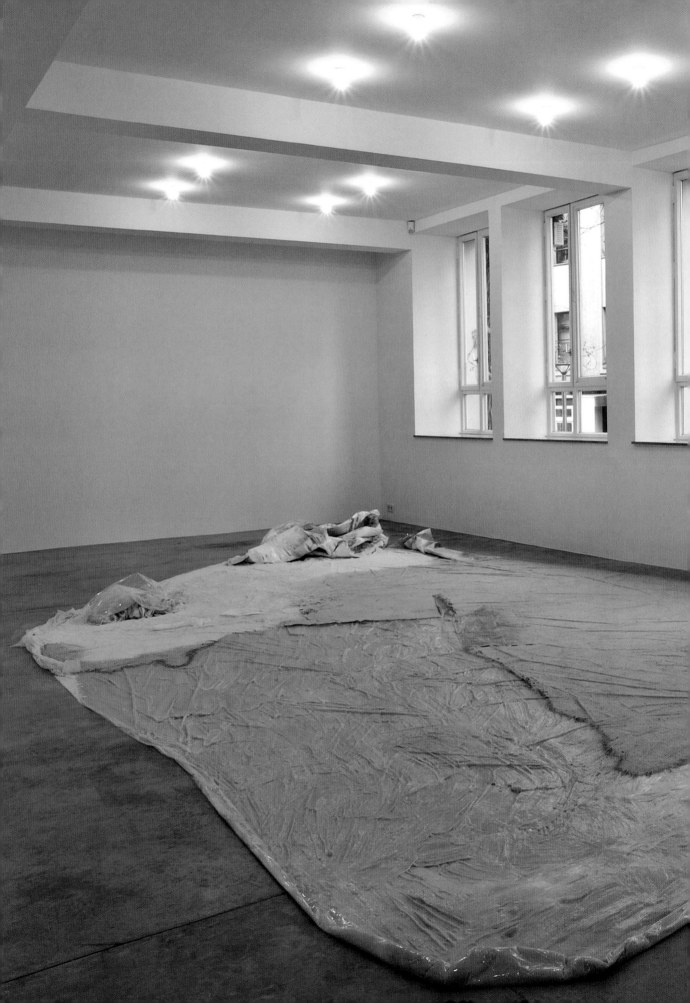

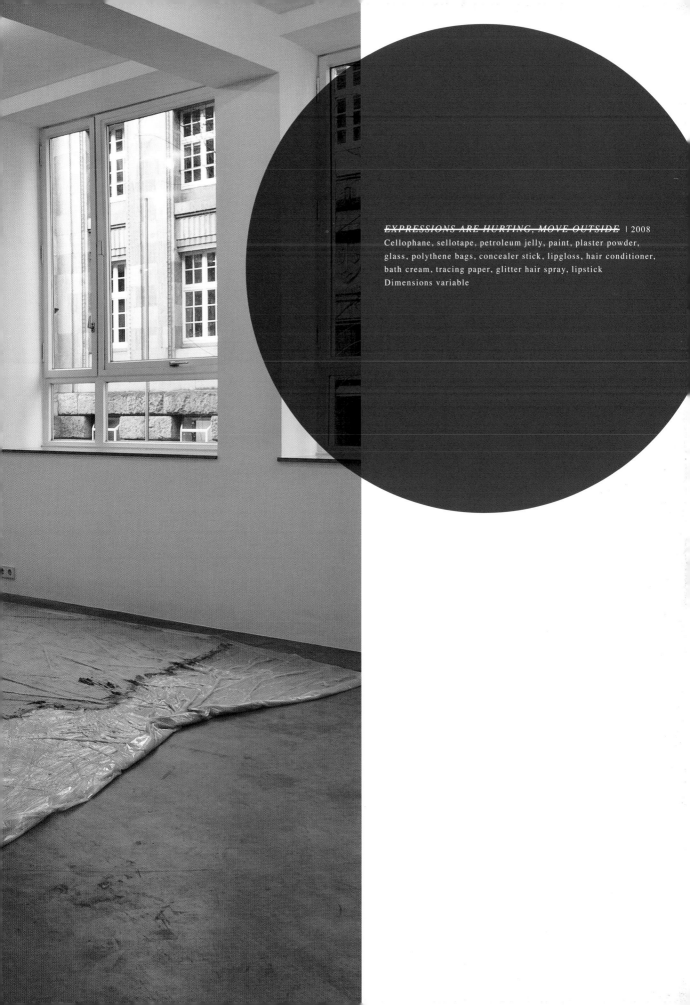

EXPRESSIONS ARE HURTING, MOVE OUTSIDE | 2008
Cellophane, sellotape, petroleum jelly, paint, plaster powder,
glass, polythene bags, concealer stick, lipgloss, hair conditioner,
bath cream, tracing paper, glitter hair spray, lipstick
Dimensions variable

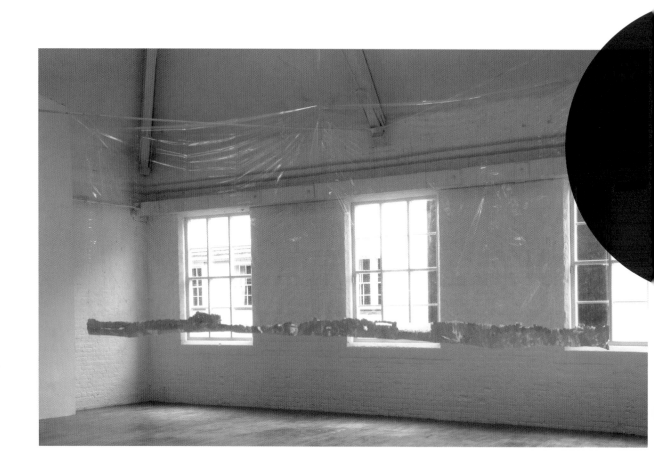

MADE TO WAIT | 2009
Cellophane, sellotape, paint, toothpaste,
hair gel, nail varnish, moisturising cream
304 × 748 × 3 см

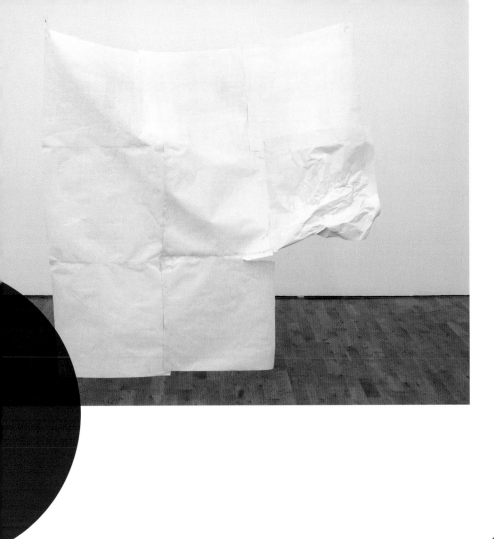

PREVENTABLE WITHIN | 2009
Sugar paper, chalk, thread
149 × 144 × 25 см

UNPREVENTABLE WITHIN | 2009
Cling film, baby oil, paint
59 × 824 × 303 см

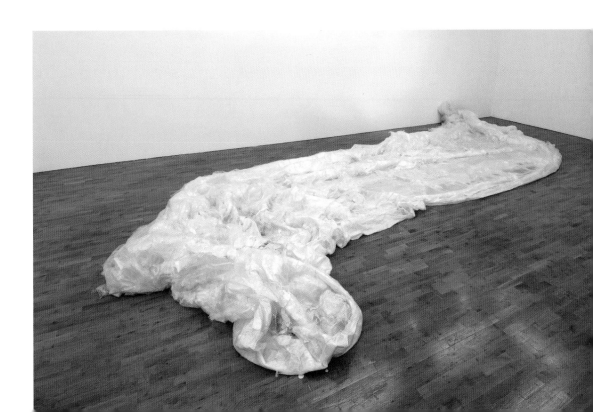

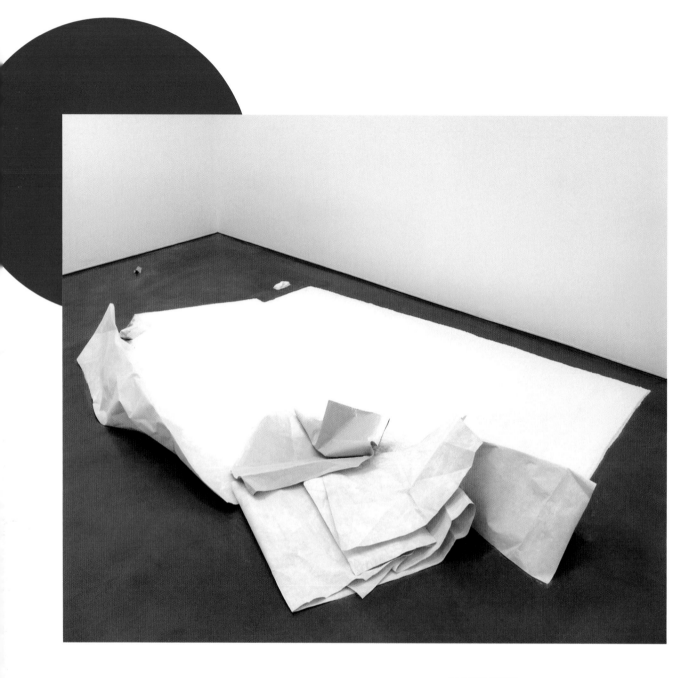

CAUSES BEND | 2007
Plaster, sugar paper, chalk, fabric dye, towel
34 × 330 × 210 см

FOR USE | 2008
Cellophane, sellotape, petroleum jelly, paint
15 × 356 × 300 см

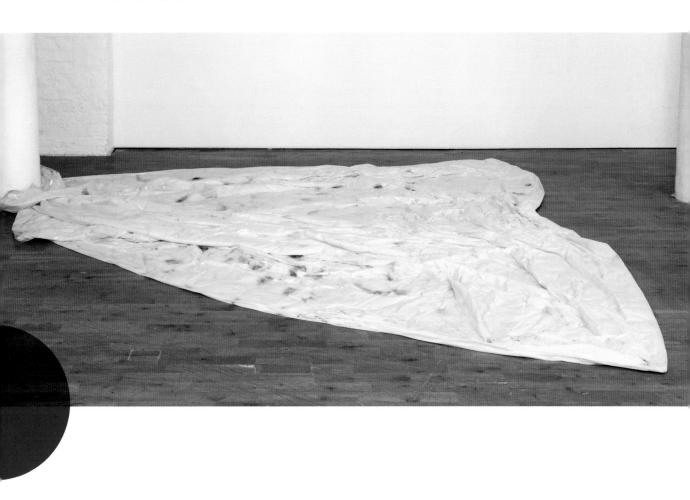

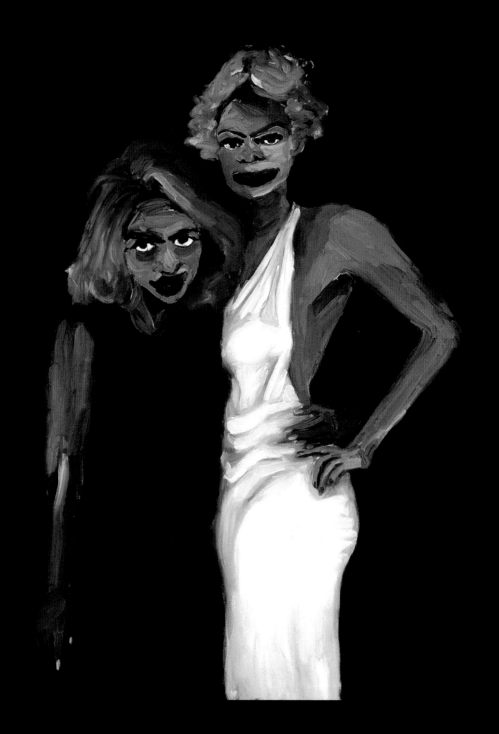

POLITICS | 2005
Oil on canvas
183 × 168 см

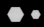

AMBASSADOR | 2003
Oil on canvas
213 × 162 см

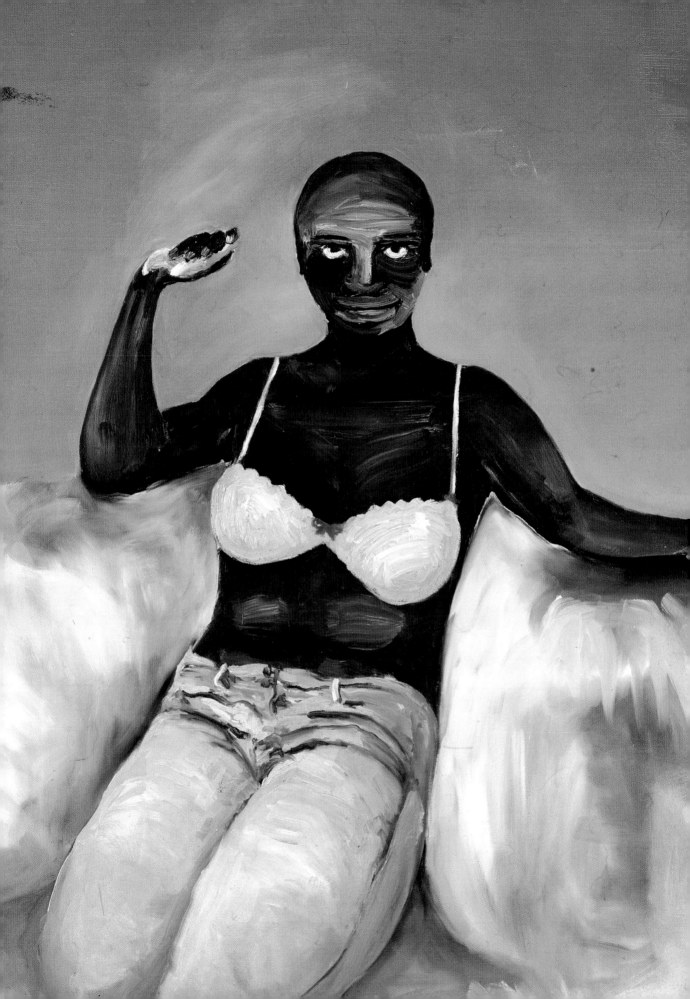

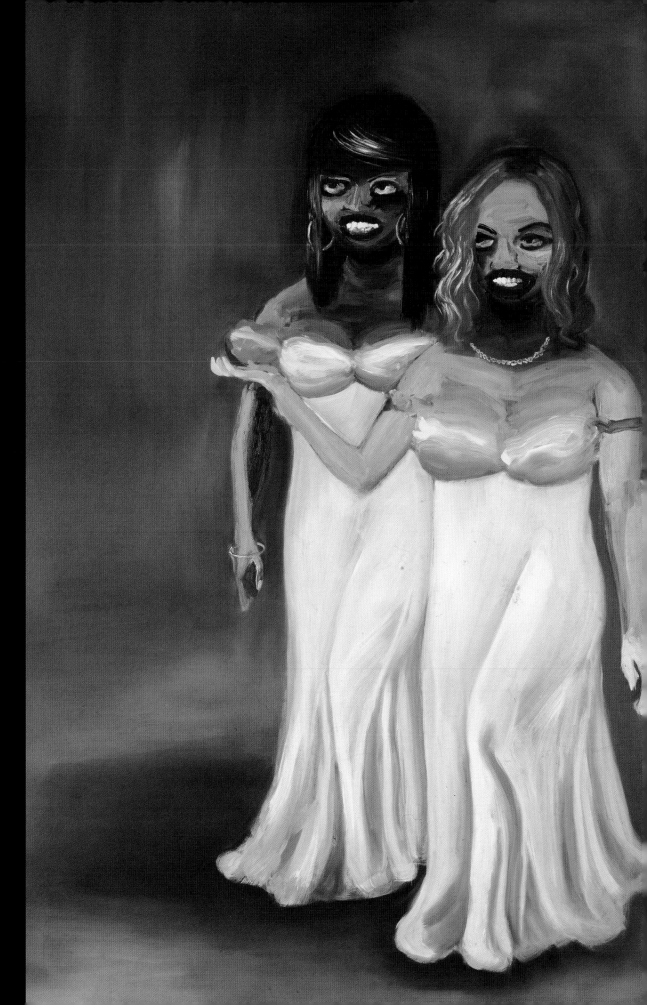

DIPLOMACY II | 2009
Oil on Linen
190 × 250 см

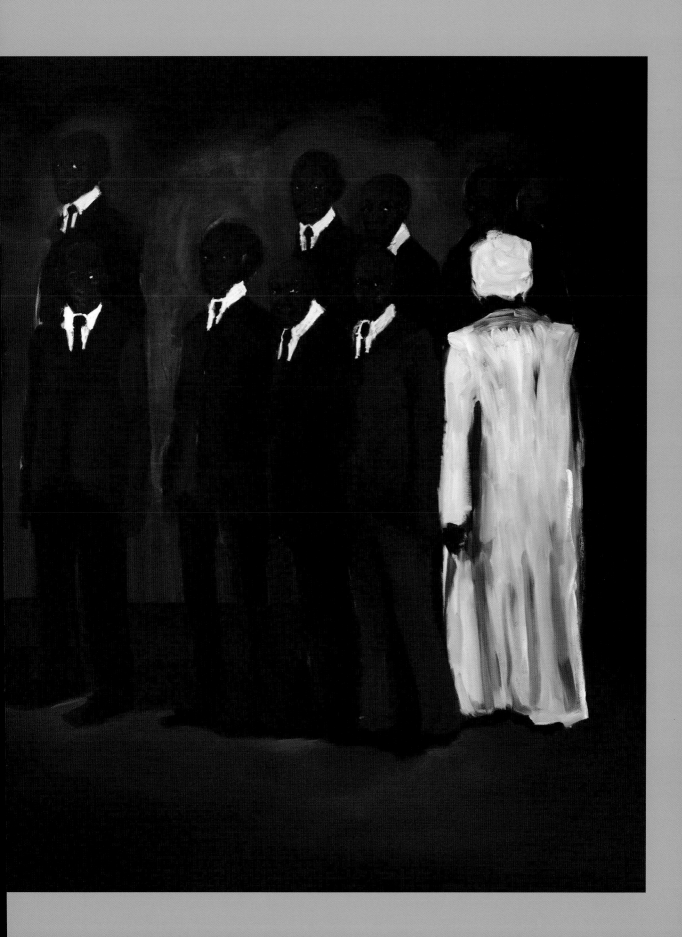

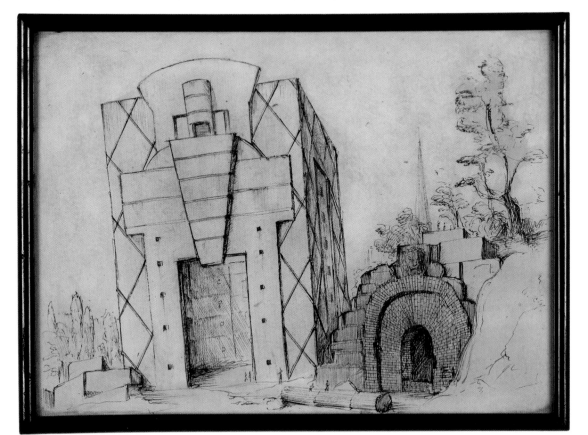

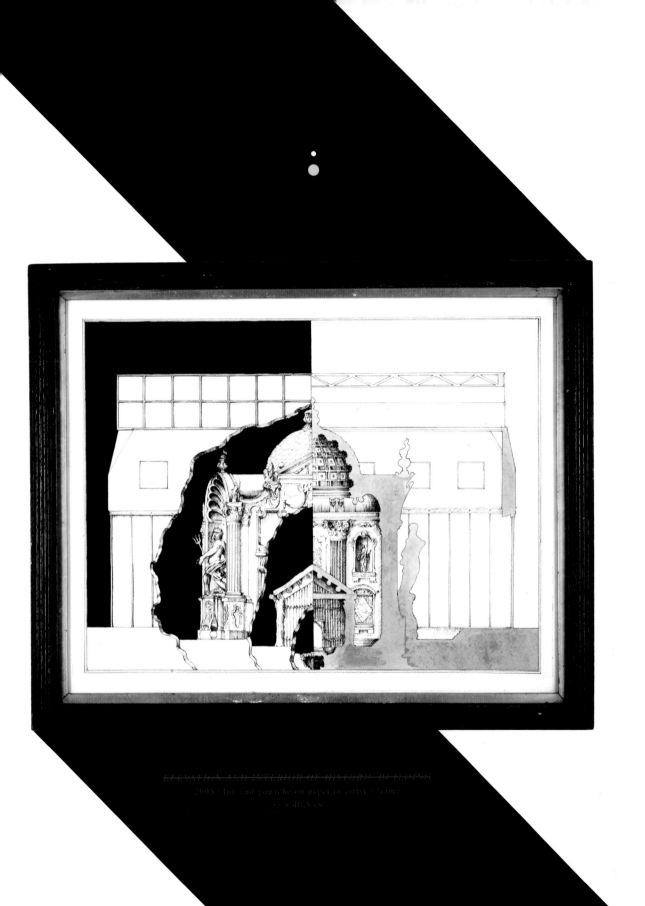

ELEVATION AND INTERIOR OF HISTORIC BUILDING
2005 | Ink and gouache on paper in artist's frame
33 × 40.5 cm

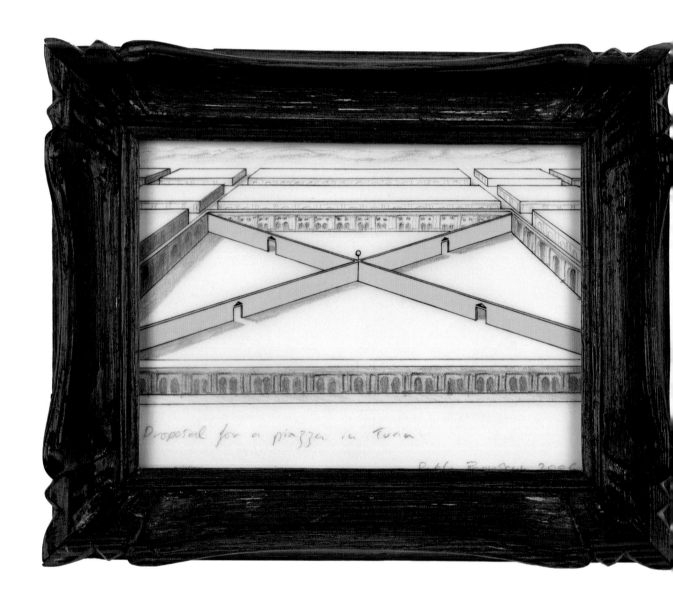

Proposal for a piazza in Turin

PROPOSAL FOR A PIAZZA IN TURIN | 2006
Ink, pencil & gouache on tracing paper in artist's frame
19.5 × 24 см

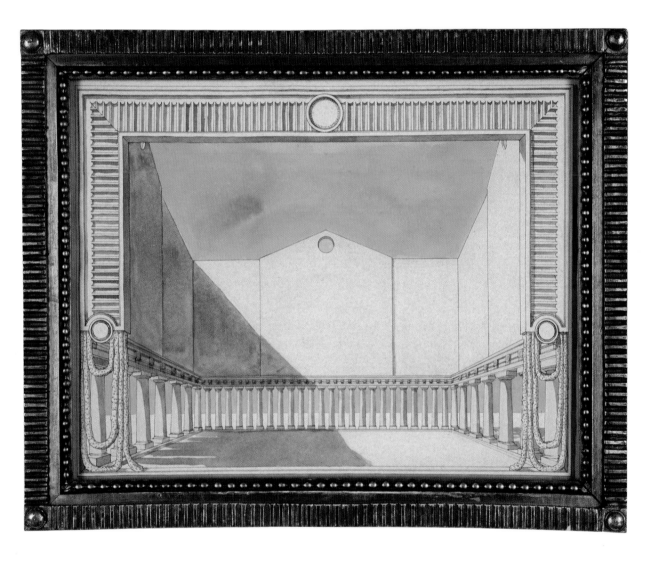

PLAZA MONUMENT | 2006
Ink, gouache & coloured pencil on paper in artist's frame
33 × 41 см

GRAND HALL REDECORATED
IN THE EARLY 19TH CENTURY | 2007
Ink & gouache on paper in artist's frame
94 × 122 cm

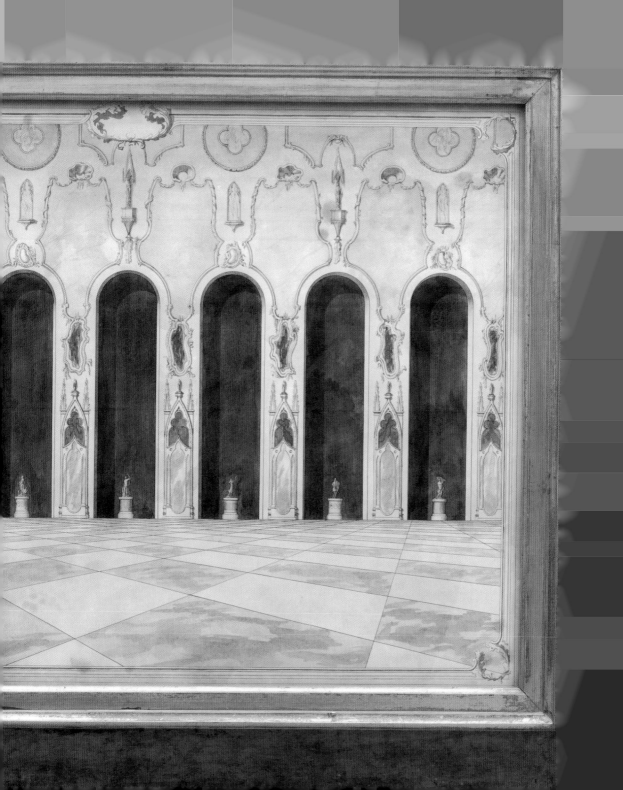

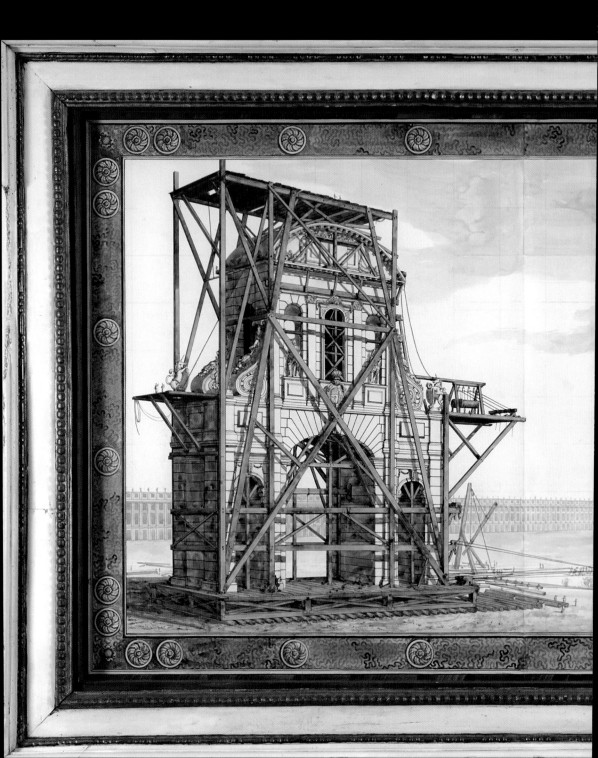

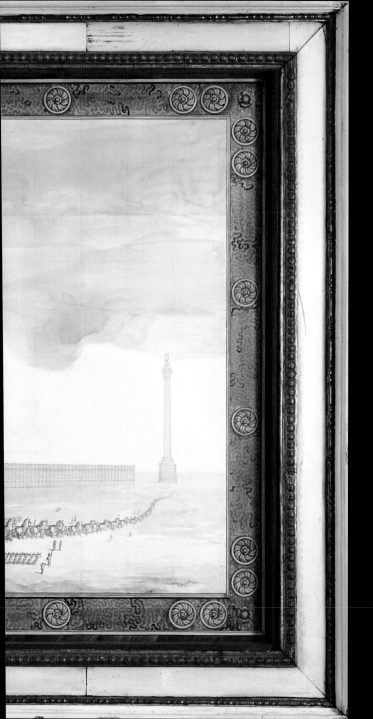

RELOCATION OF TEMPLE BAR | 2009
Ink, ink wash, gouache & pencil on paper in artist's frame
148 x 168.5 cm, framed 149 x 222.5 cm

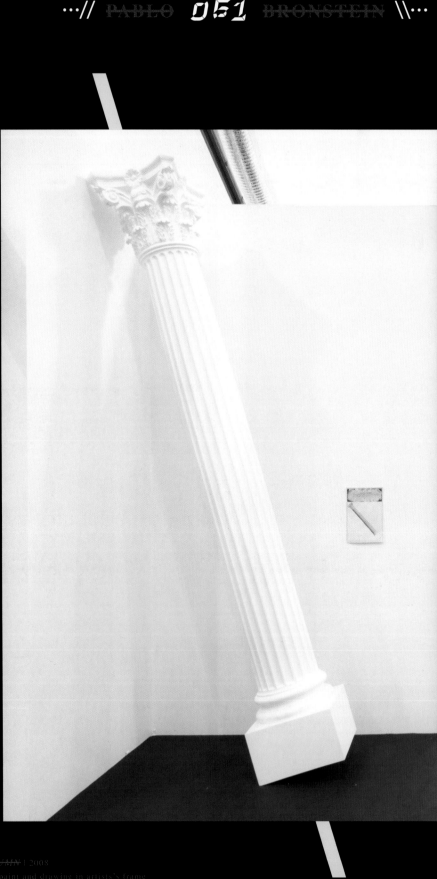

...AIN | 2008
point and drawing in artist's frame

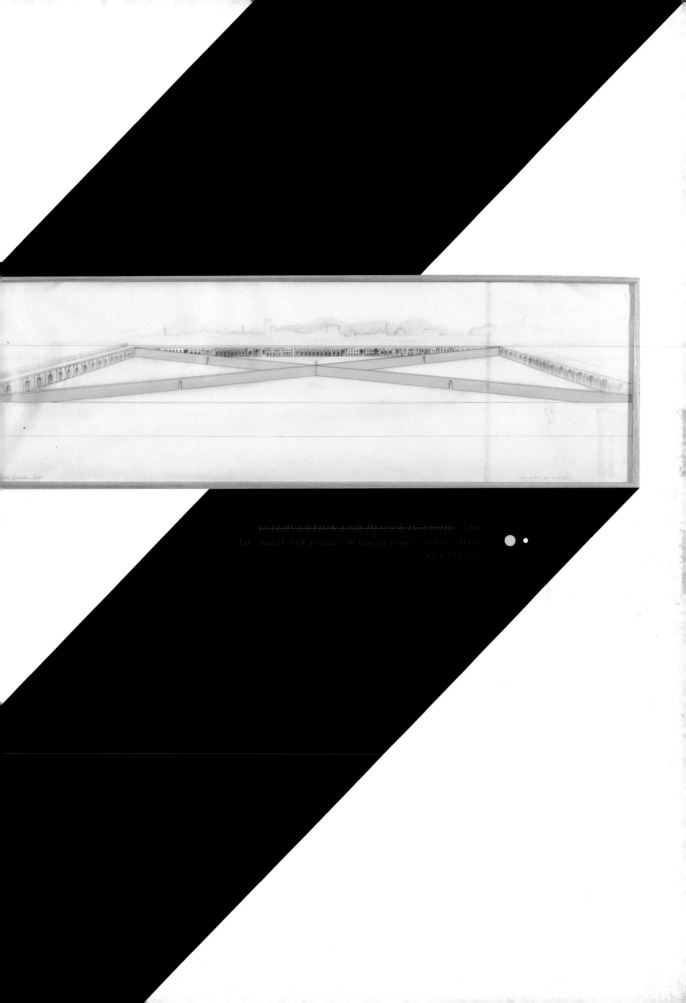

MR. SHOWERHEAD | 2008
Oil on canvas
100 × 100 см

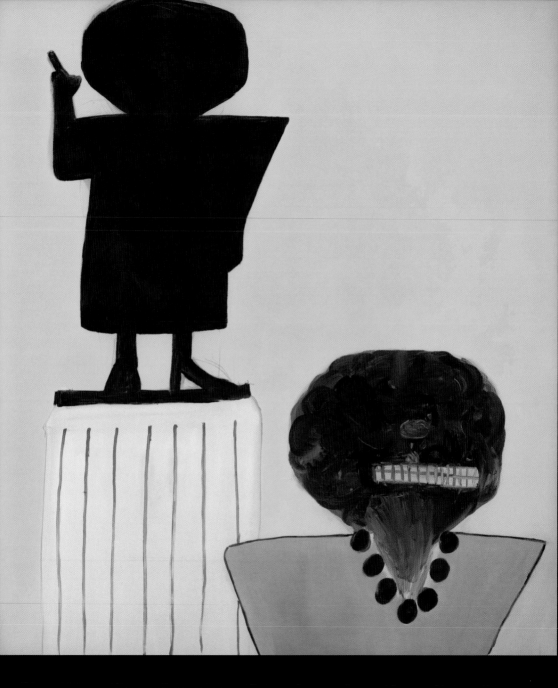

GREAT BRITISH SMILE | 2008

Oil on canvas

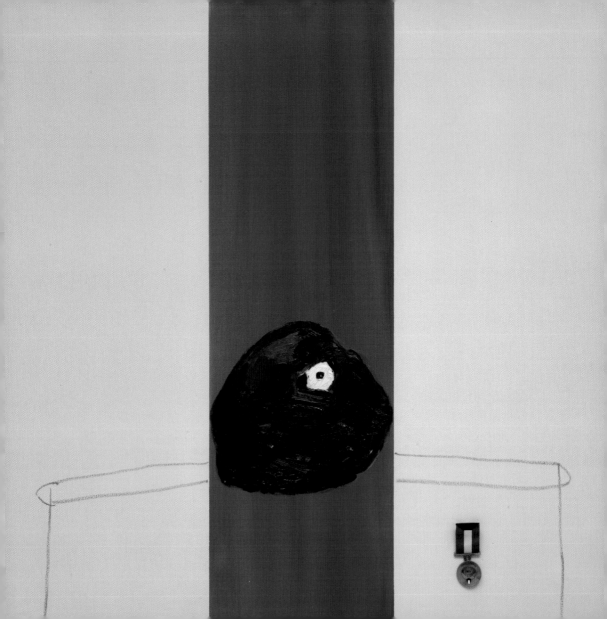

THE AIR IS FILLED WITH CHILDREN | 2008
Oil on canvas
150 × 150 см

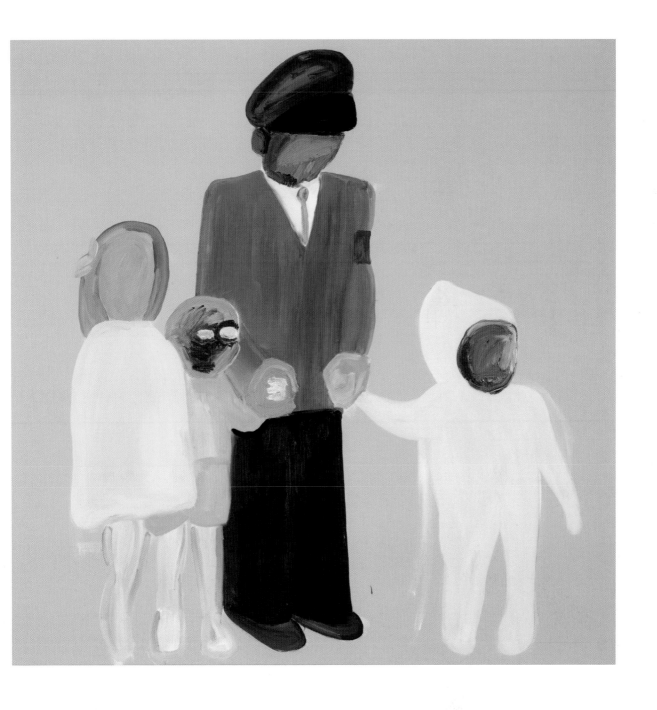

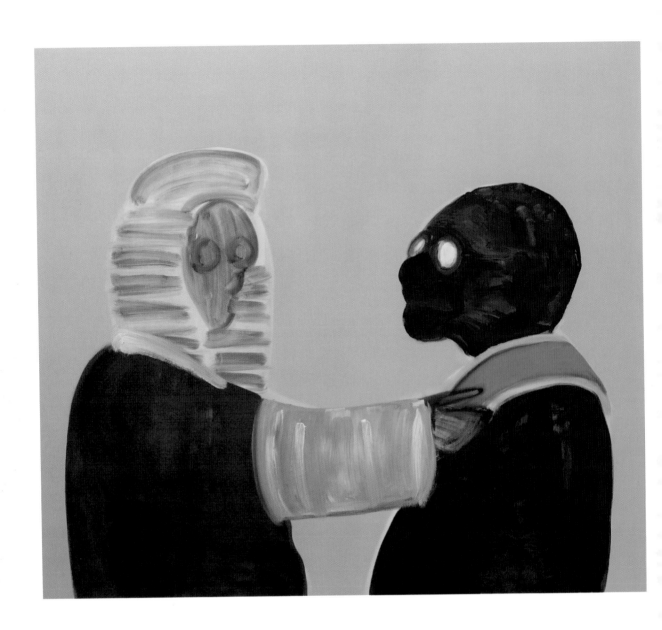

DON'T TELL MARLEY | 2008
Oil on canvas
160 × 150 см

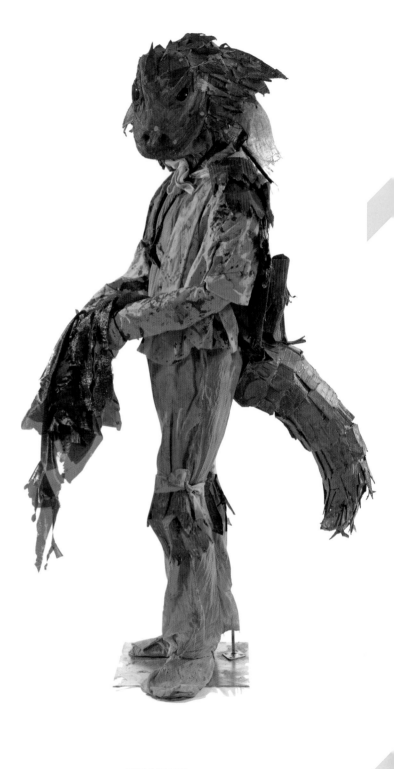

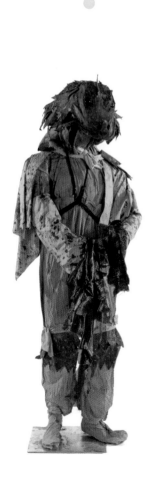

THE LIZARD | 2004
Fabric, latex, cardboard, paint, plastic and hessian
170 × 100 × 60 см

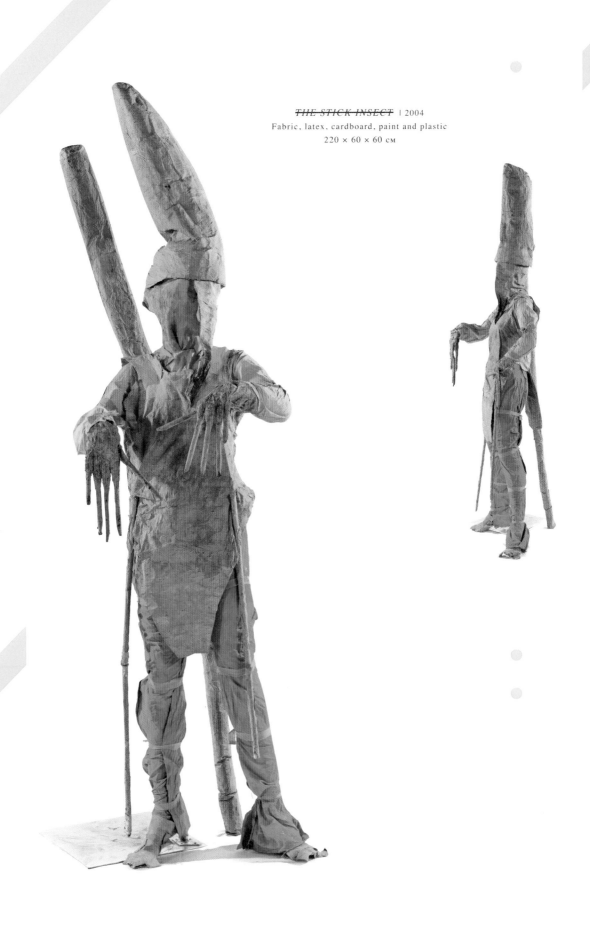

THE STICK INSECT | 2004
Fabric, latex, cardboard, paint and plastic
220 × 60 × 60 см

THE FAIRY FELLER | 2003
Paper, paint, paper-mâché, glue and dutch metal
200 × 150 × 20 см

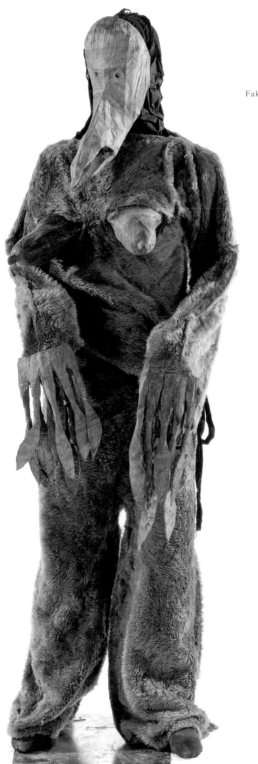

THE MOLE | 2005
Fake fur, latex, paper-mâché, paint and plastic
170 × 60 × 60 см

THE AUTHOR OF MISHAP (THEM) | 2005
Copper powder in resin and peacock feather
36 × 21.5 × 23.5 см

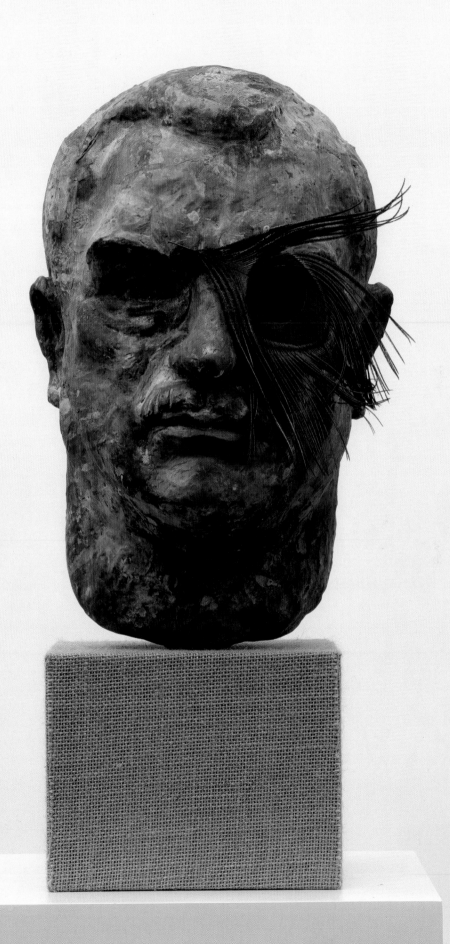

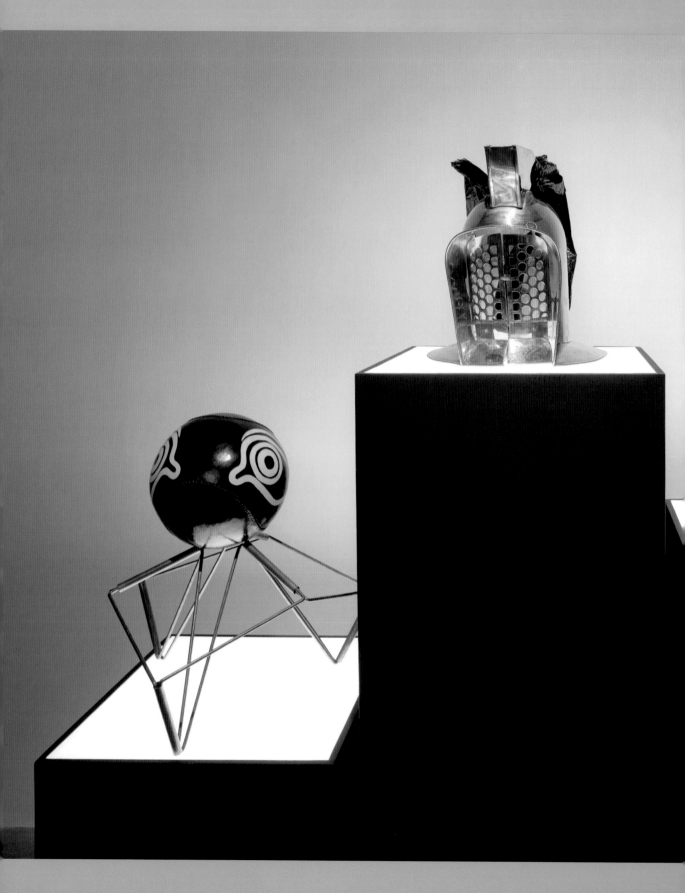

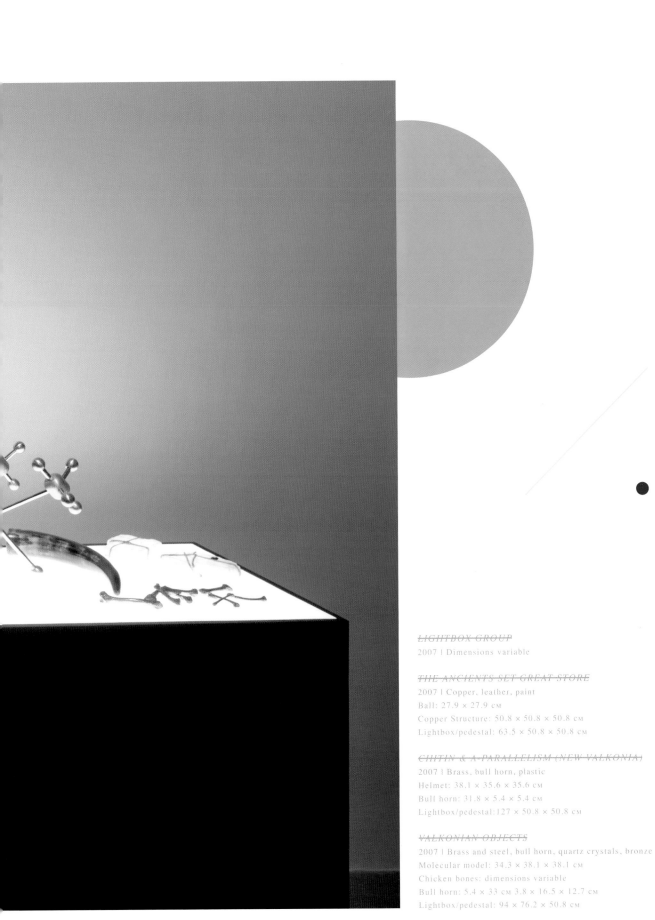

LIGHTBOX GROUP
2007 l Dimensions variable

THE ANCIENTS SET GREAT STORE
2007 l Copper, leather, paint
Ball: 27.9 × 27.9 см
Copper Structure: 50.8 × 50.8 × 50.8 см
Lightbox/pedestal: 63.5 × 50.8 × 50.8 см

CHITIN & A-PARALLELISM (NEW VALKONIA)
2007 l Brass, bull horn, plastic
Helmet: 38.1 × 35.6 × 35.6 см
Bull horn: 31.8 × 5.4 × 5.4 см
Lightbox/pedestal: 127 × 50.8 × 50.8 см

VALKONIAN OBJECTS
2007 l Brass and steel, bull horn, quartz crystals, bronze
Molecular model: 34.3 × 38.1 × 38.1 см
Chicken bones: dimensions variable
Bull horn: 5.4 × 33 см 3.8 × 16.5 × 12.7 см
Lightbox/pedestal: 94 × 76.2 × 50.8 см

THE THINGLINESS OF THINGS I (POTATOES IN THE CELLAR) | 2007
Acrylic, oil, steel, hessian, paper and wood, four parts mounted on plinth
157 × 300 × 150 см

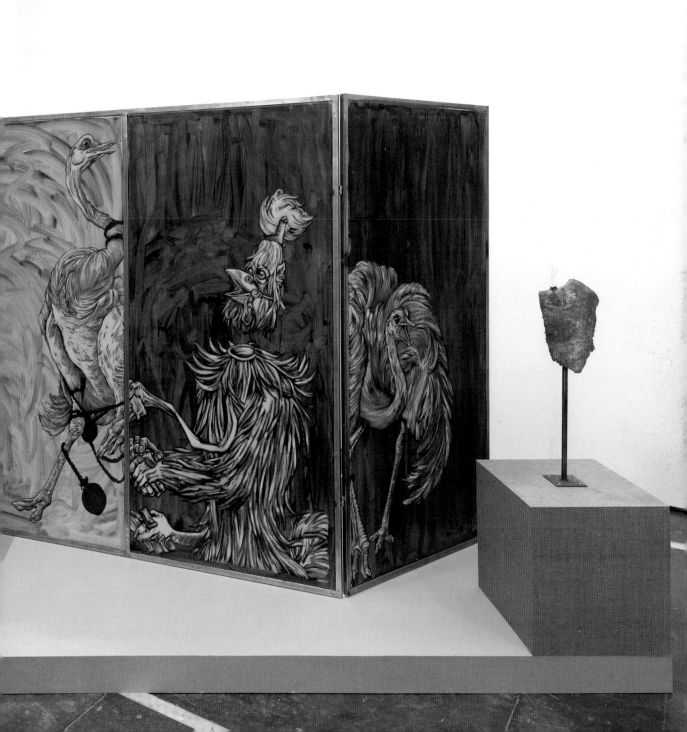

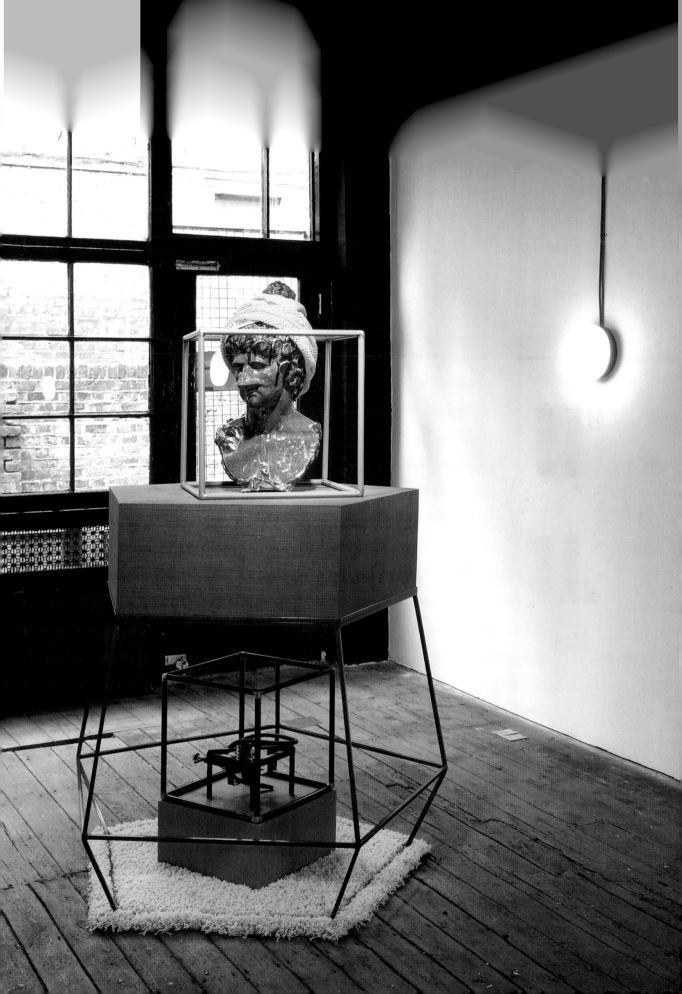

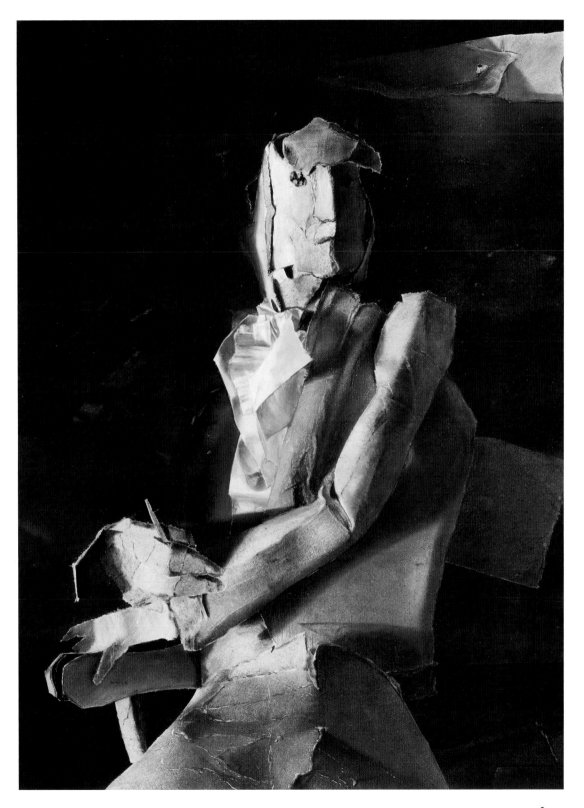

WILLIAM BLAKE H I 2006
Oil on board I 33.3 × 26 см

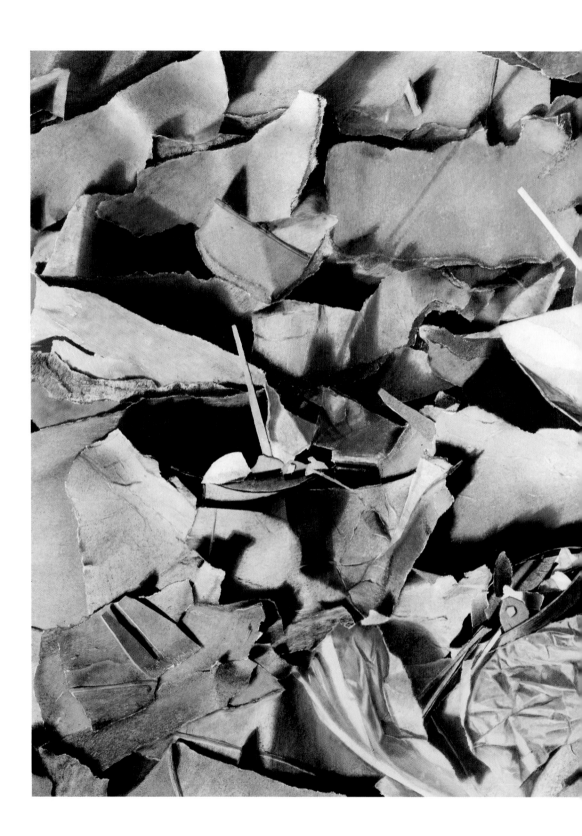

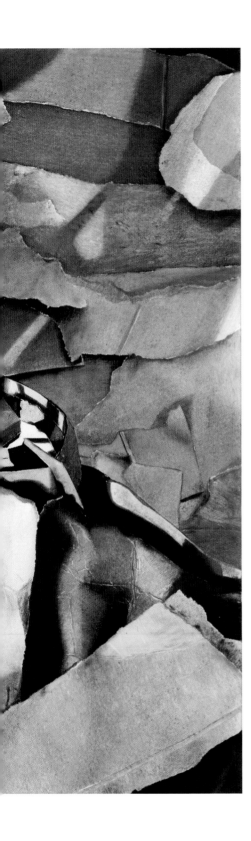

THE SHIPWRECK | 2005
Oil on board | 30 × 40 см

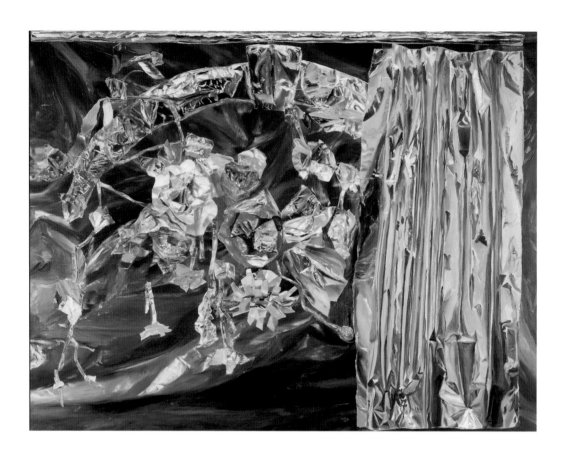

STILL LIFE WITH FLOWERS AND CURTAINS | 2007
Oil on board | 42 × 55 см

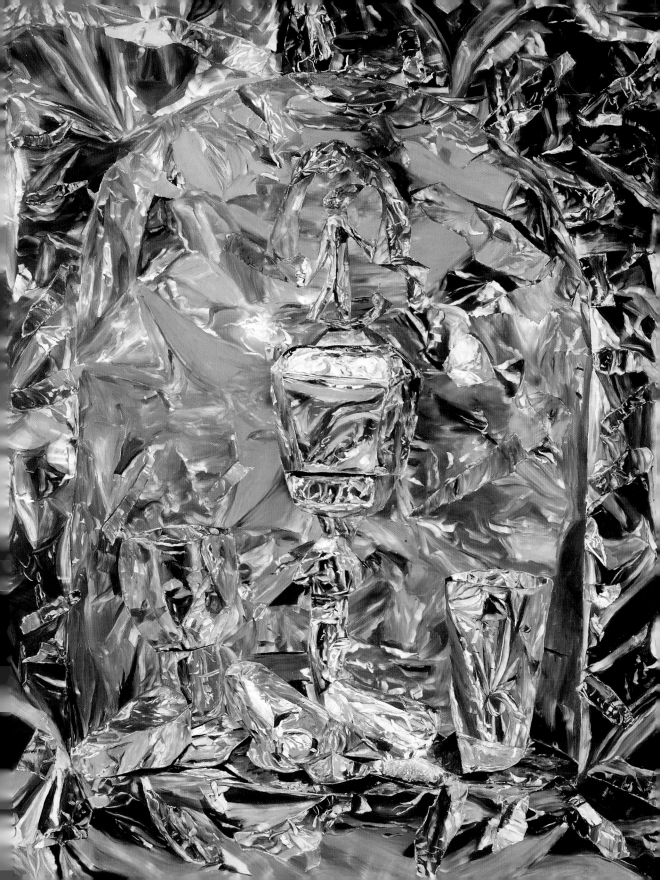

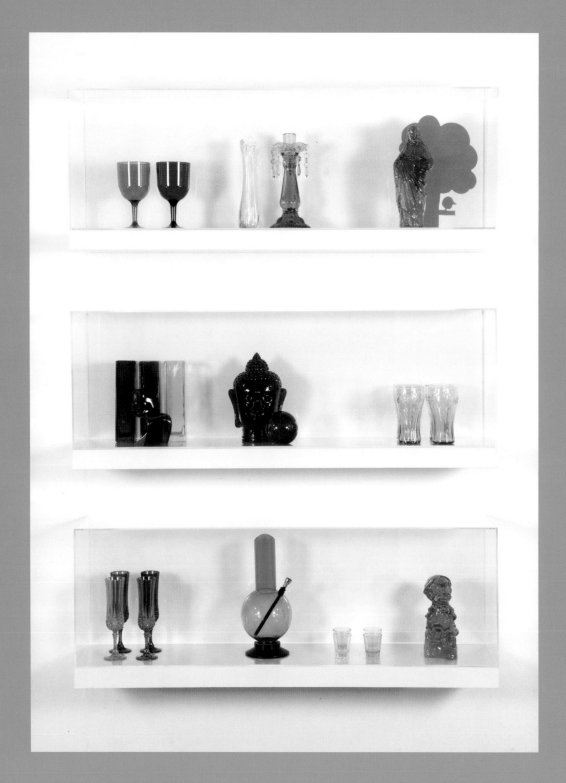

UNTITLED: SHELVES NO.5 | 2008
Various glass and plastic components
110 × 140 × 30 см

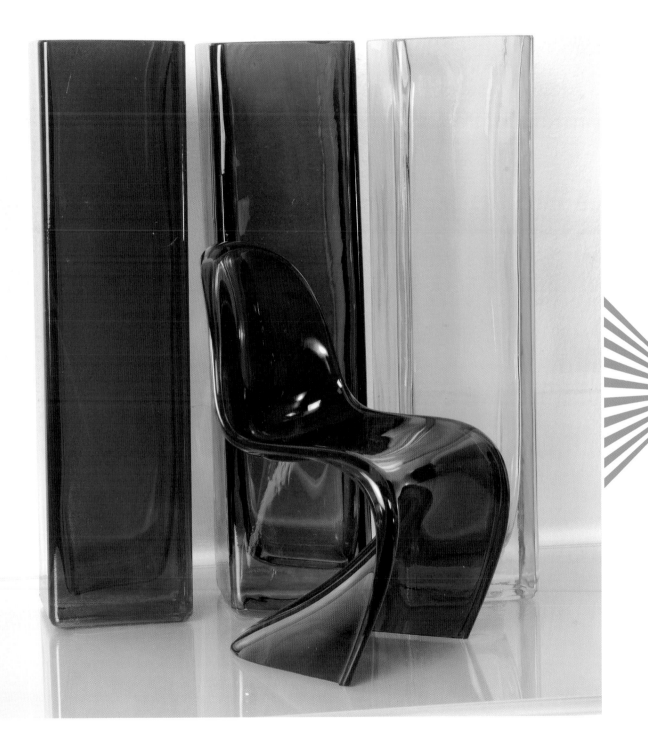

UNTITLED: SHELVES NO.5 (DETAIL) | 2008
Various glass and plastic components
110 × 140 × 30 см

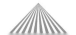

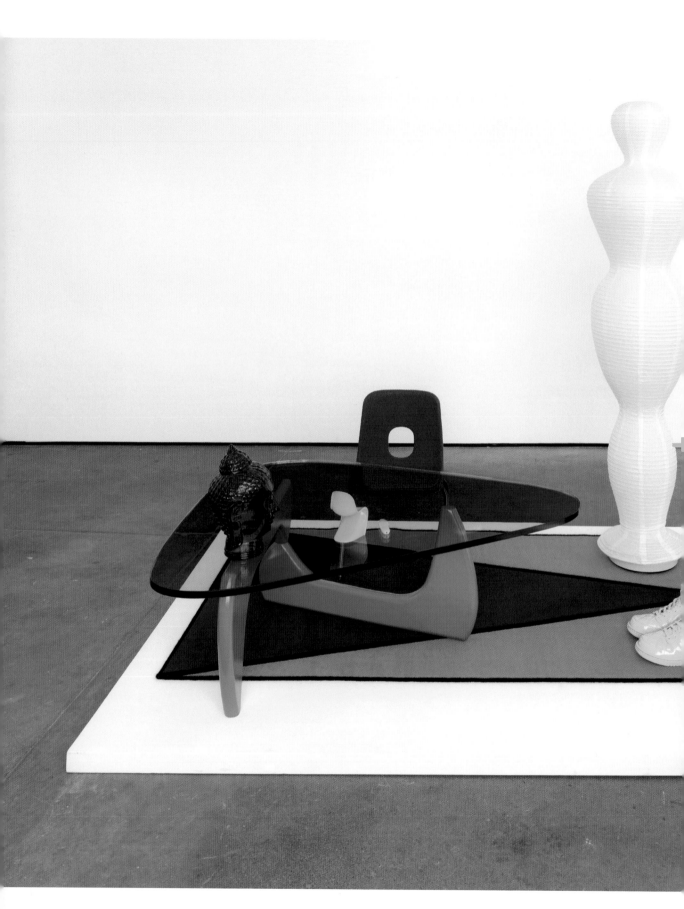

UNTITLED: FURNITURE ISLAND NO. 2 | 2008
Abacus rug, Ikea torim lamp, Noguchi replica table, Robin Day chair,
Nike dunk supremes, Buddha head, Panton miniature, Rashid lighter
190 × 180 × 140 см

UNTITLED | 2008
Mixed media
300 × 466 см

UNTITLED | 2008
Wood and paint
65 × 220 × 200 см

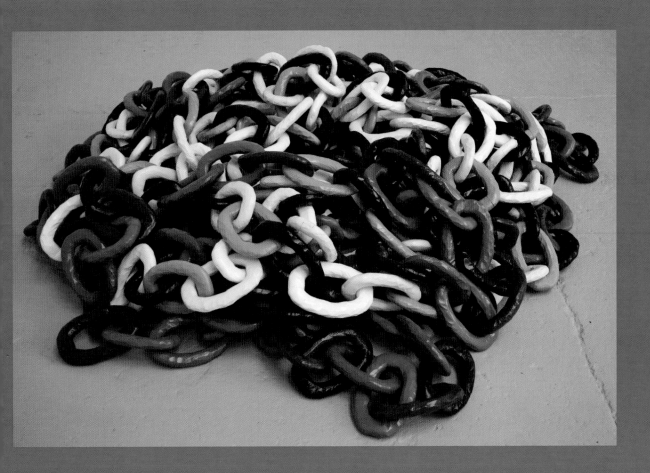

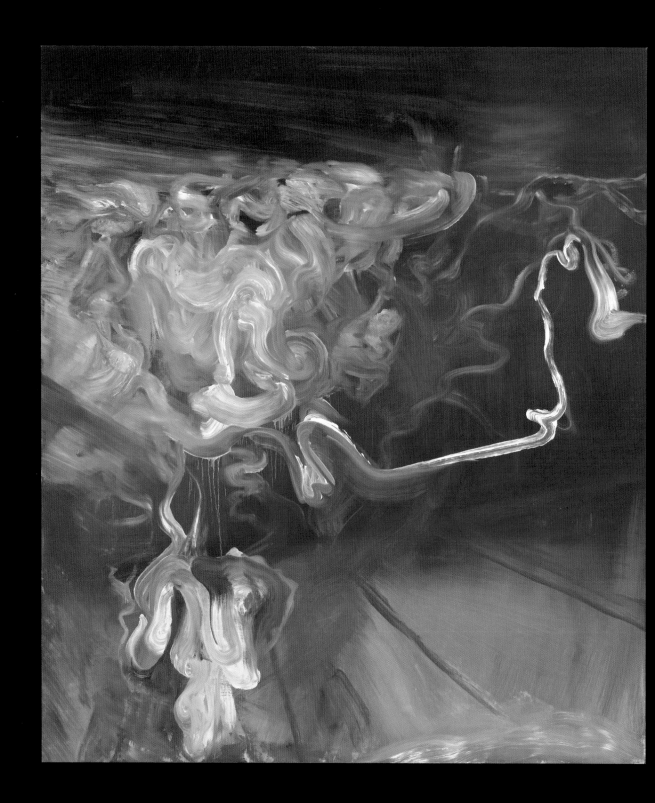

~~UNTITLED~~ | 2007
Oil on linen
121.9 × 106.7 см

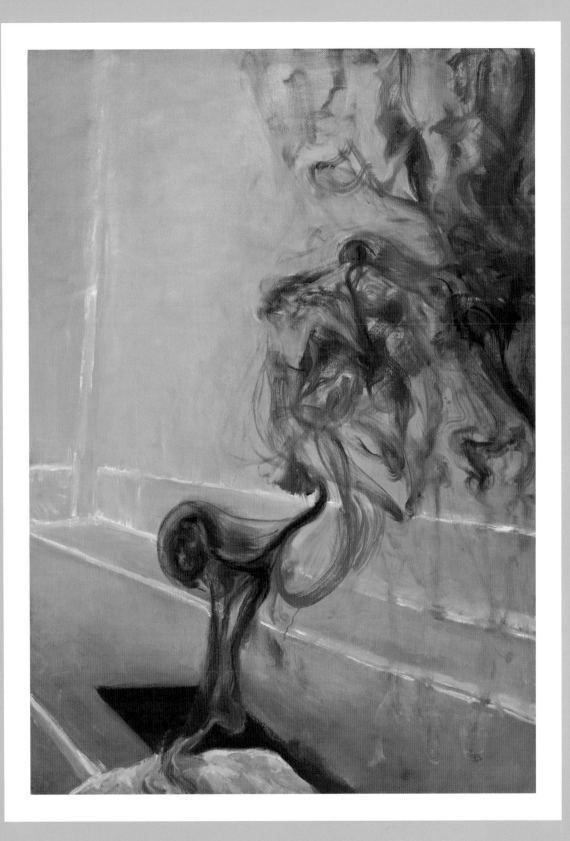

UNTITLED | 2007
Oil on linen
152.4 × 106.7 см

UNTITLED | 2007
Oil on linen
86.4 × 61 см

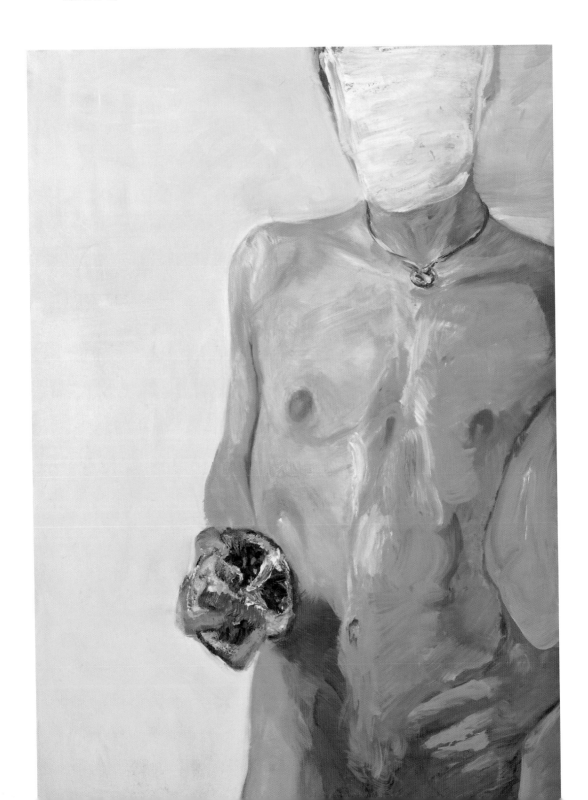

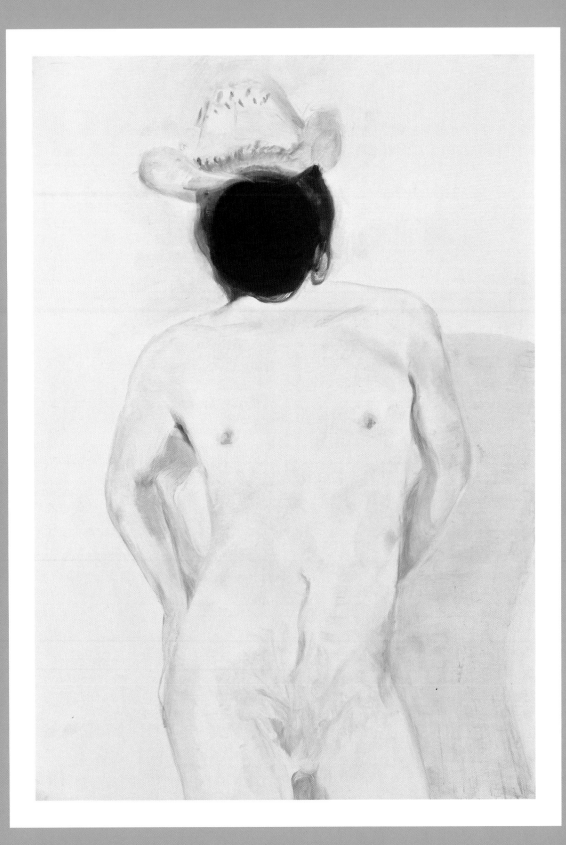

HOTMAIL I 2006
Oil on linen
81.3 × 63.5 см

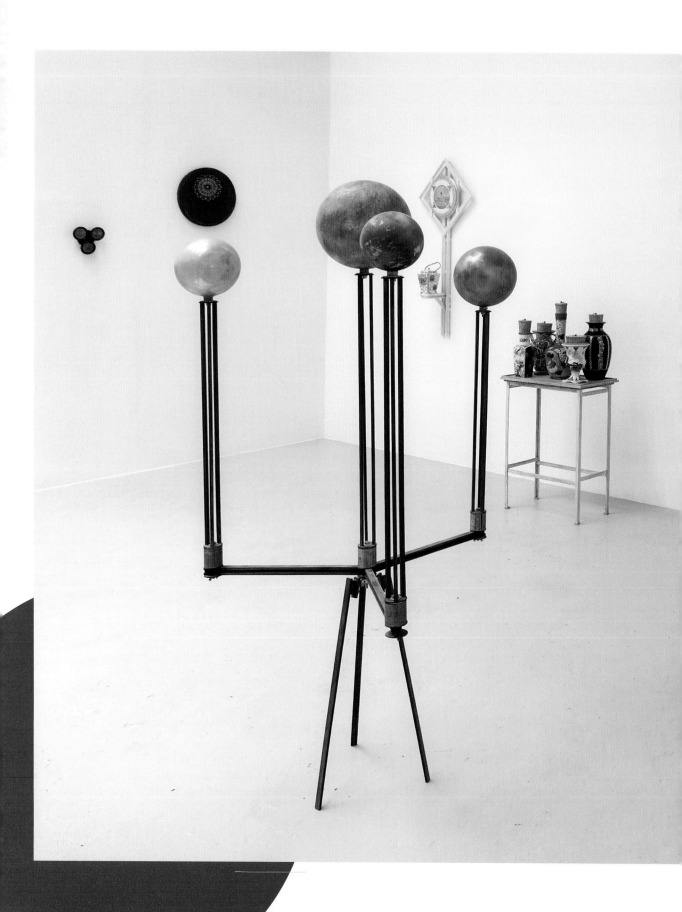

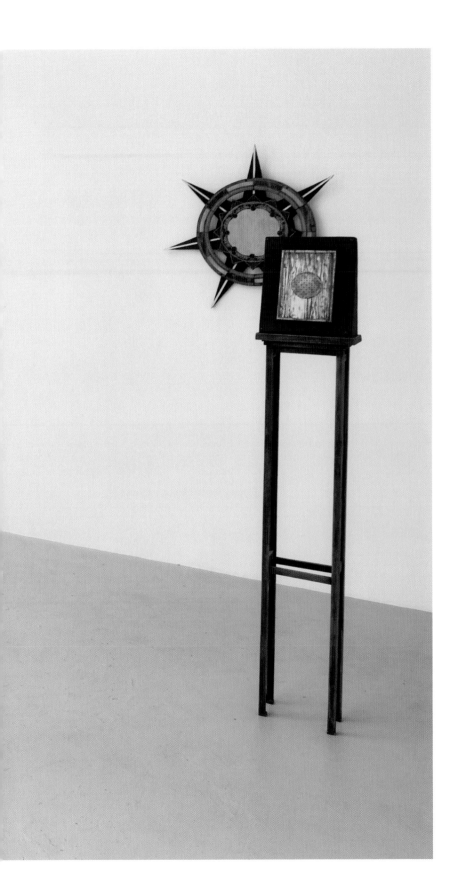

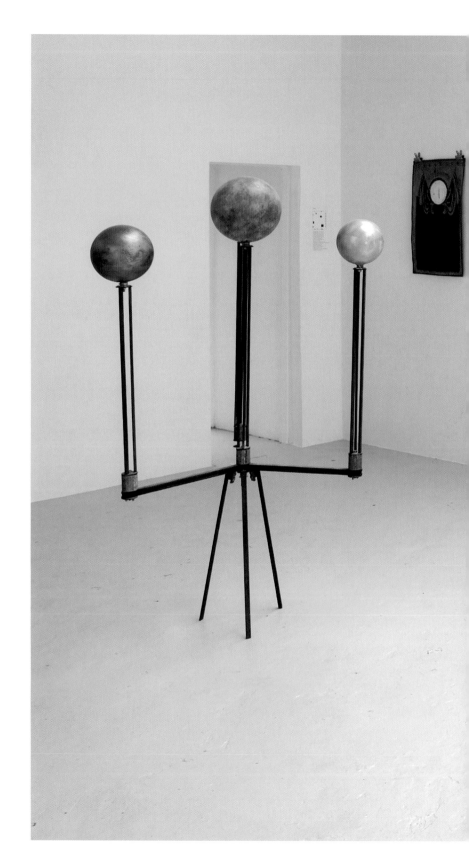

VARIOUS WORKS INSTALLED

IN A BEGINNING LIES AN END
2009 | Acrylic, wood stain, plastic, metal
fixings and wood | 168 × 85 × 85 см

UNITED IN DIFFERENT GUISES I
2009 | Acrylic and varnish on cotton
74 × 46 см

UNITED IN DIFFERENT GUISES II
2009 | Acrylic and varnish on cotton
73 × 46 см

UNITED IN DIFFERENT GUISES III
2009 | Acrylic and varnish on cotton
74 × 47 см

UNITED IN DIFFERENT GUISES IV
2009 | Acrylic and varnish on cotton
76 × 48 см

UNITED IN DIFFERENT GUISES V
2009 | Acrylic and varnish on cotton
74 × 48 см

UNITED IN DIFFERENT GUISES VI
2009 | Acrylic and varnish on cotton
77 × 48 см

FOUR QUARTERS
2009 | Acrylic, varnish, plaster and wood
160 × 76 × 76 см

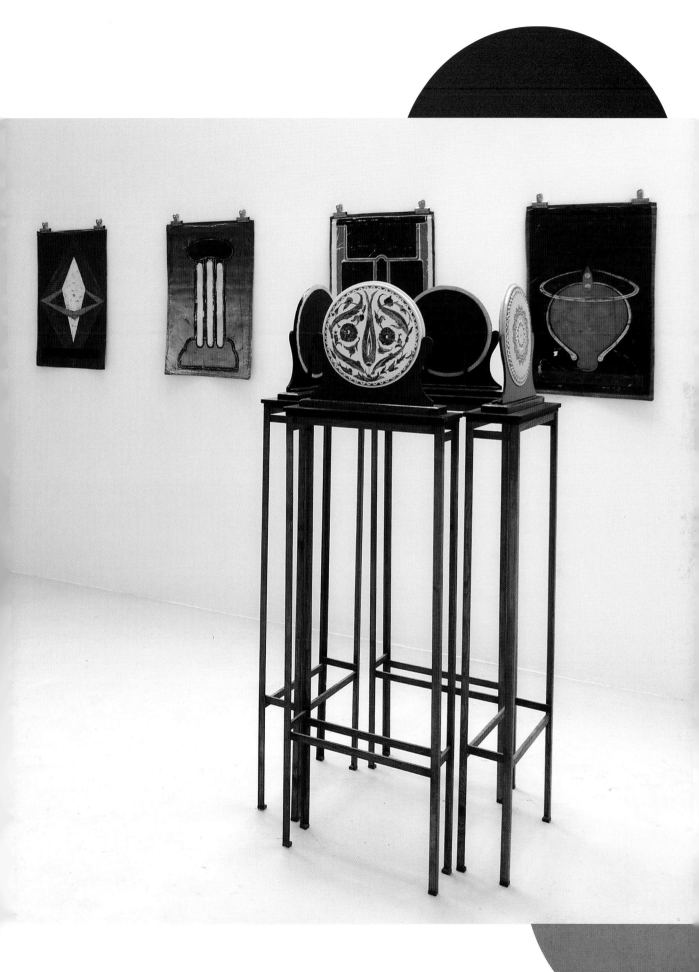

BLACK GRAPE | 2006
Silicon carbide, paint, artex, polystyrene, can, cigarette butts
222 × 165 × 200 см

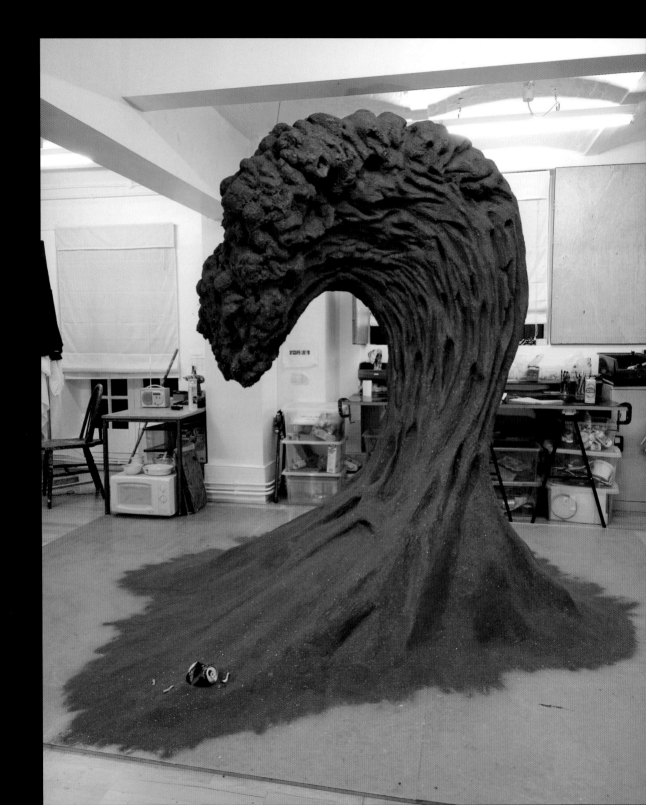

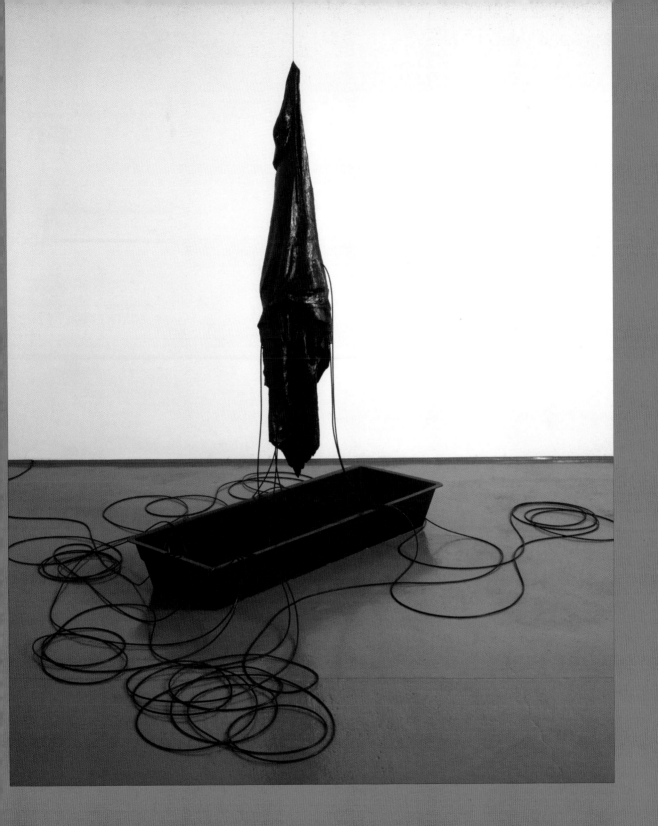

 HOODIE | 2006
Hydroponics, wax, aluminum, steel
205 × 51 × 153.5 см

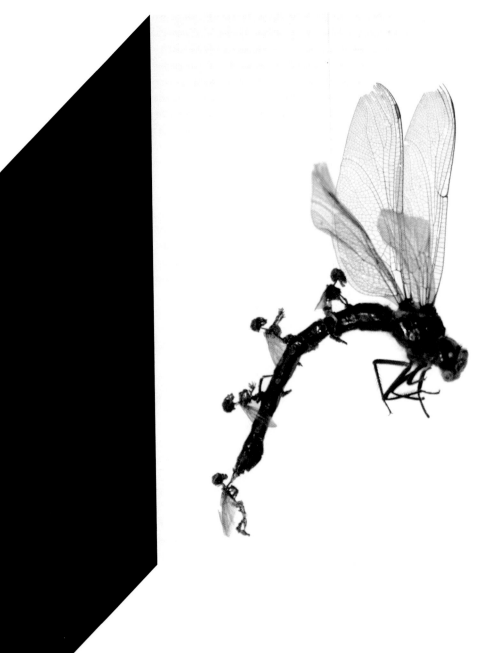

SWARM (Detail)
2004 | Mixed media
Dimensions Variable

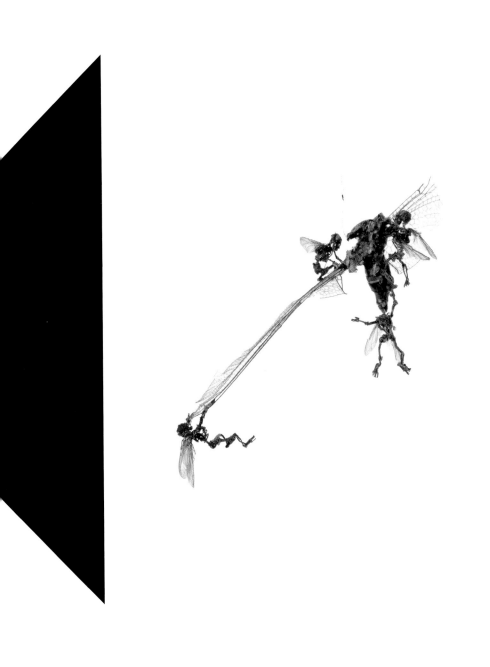

 (Detail)
2004 I Mixed media
Dimensions Variable

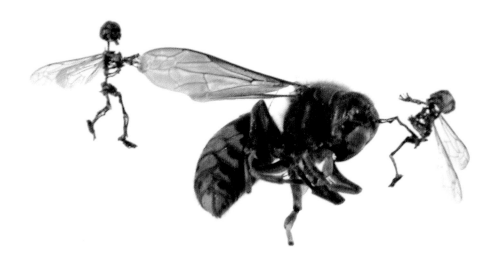

SWARM (Detail)
2004 | Mixed media
Dimensions Variable

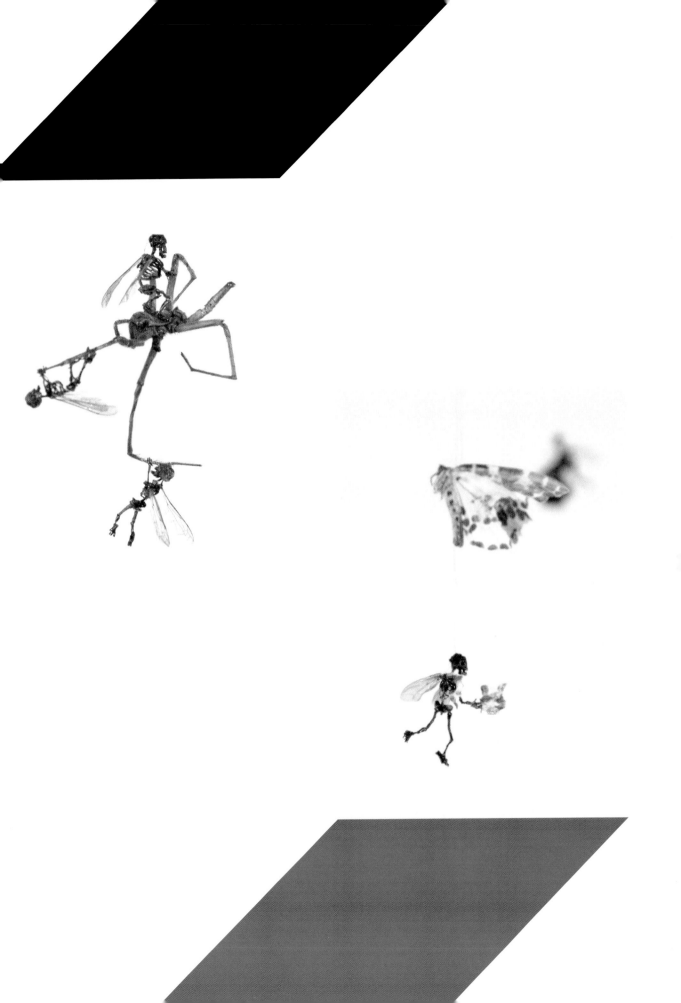

DRAWING ROOM STUDY 4 | 2008
Acrylic, oil and marker pen on canvas
198 × 163 см

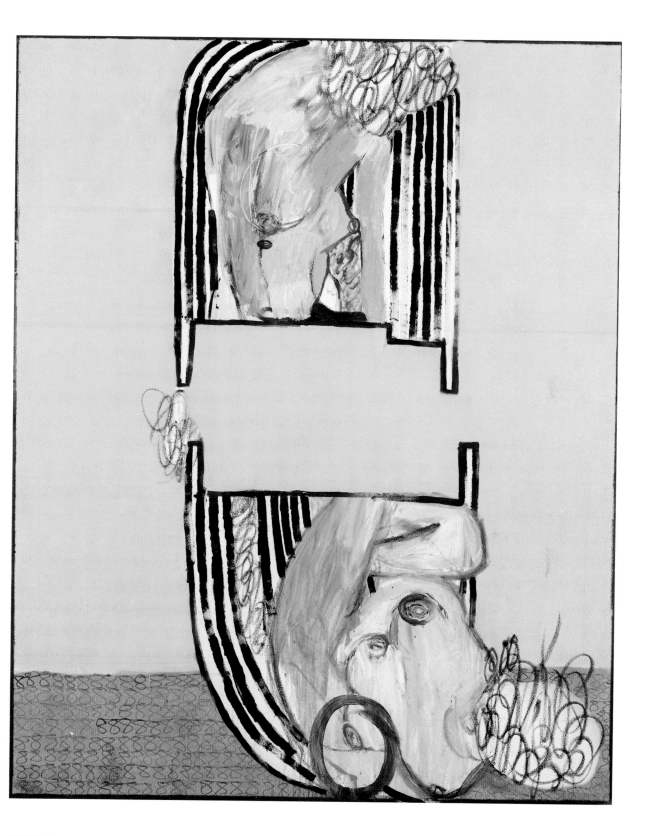

DRAWING ROOM STUDY 5
2008 | Acrylic, oil, enamel
and marker pen on canvas
198 × 163 см

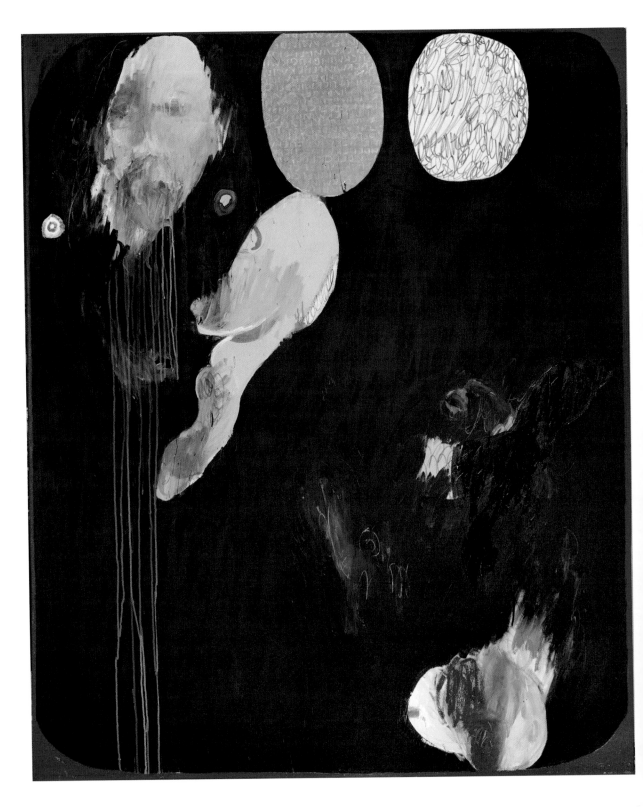

PURPLE STUDY 5 | 2009
Acrylic, oil, enamel, gloss paint
and marker pen on canvas
198 × 163 см

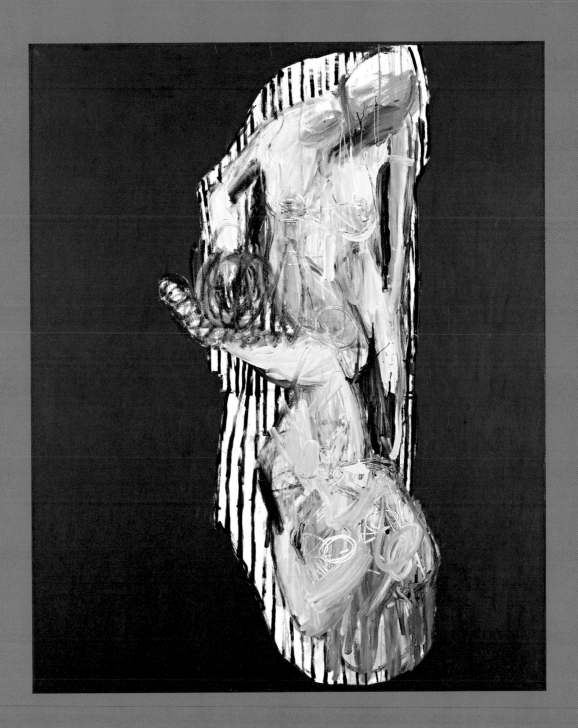

DRAWING ROOM STUDY 7 | 2008
Acrylic and oil on canvas
198 × 163 см

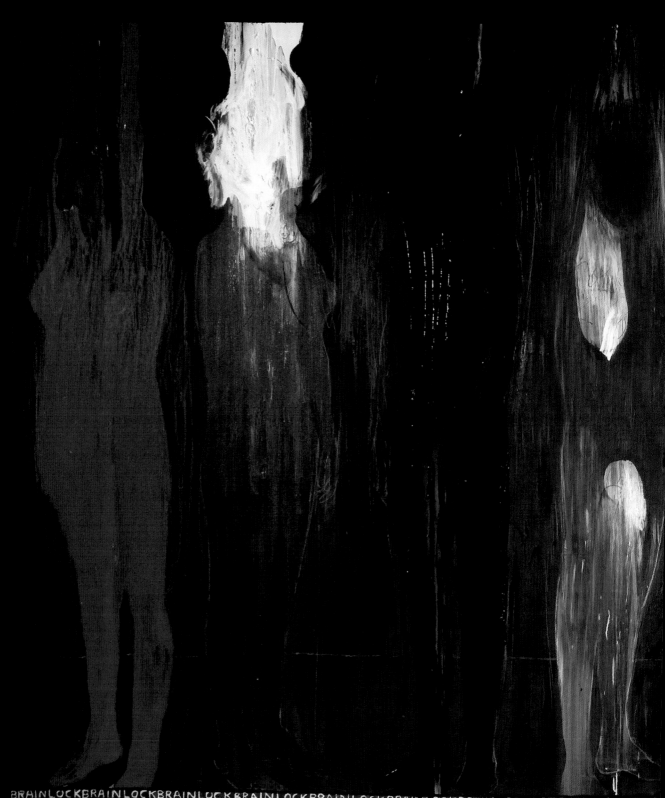

BRAINLOCKBRAINLOCKBRAINLOCKBRAINLOCKBRAINLOCKBRAINLOCKBRAINLOCKBRAINLOCKBRAINLO

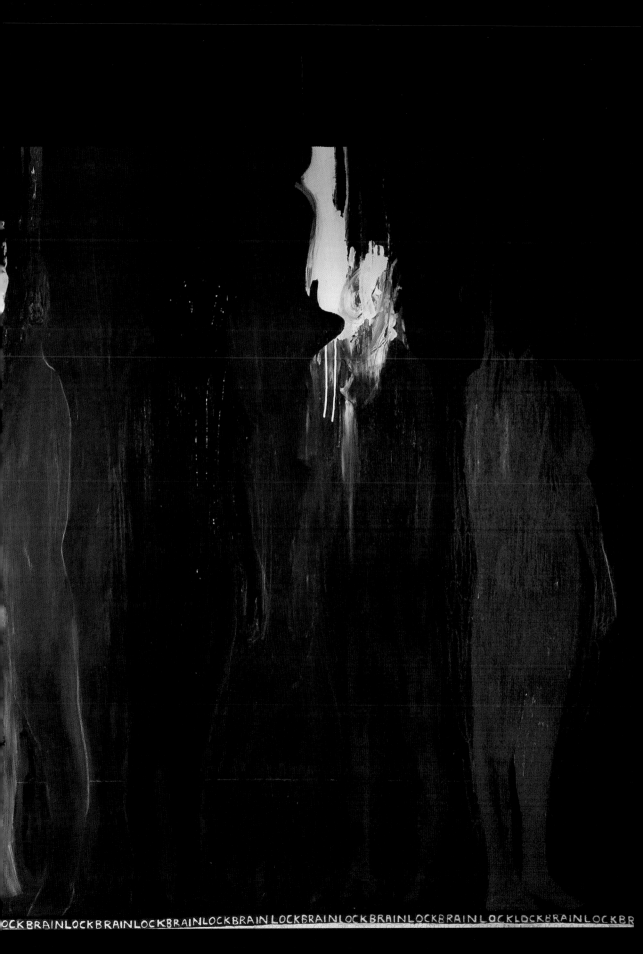

OCKBRAINLOCKBRAINLOCKBRAINLOCKBRAINLOCKBRAINLOCKBRAINLOCKBRAINLOCKLOCKBRAINLOCKBR

RED I | 2009 | Mixed media on canvas | 198 × 360cm

OCHOA | 2006 | Acrylic on canvas | 268 × 230 см

TRIKALINOU | 2007
Oil on linen
235 × 122 см

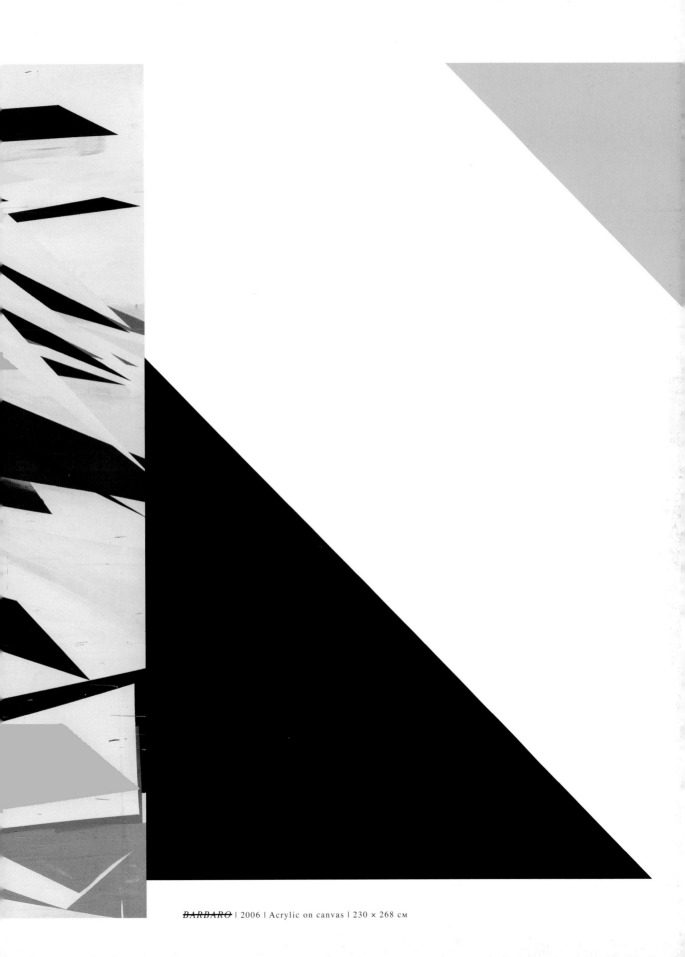

BARBARO | 2006 | Acrylic on canvas | 230 × 268 см

THE PIANO LESSON | 2007
Mixed media | approx. 200 × 500 × 400 см

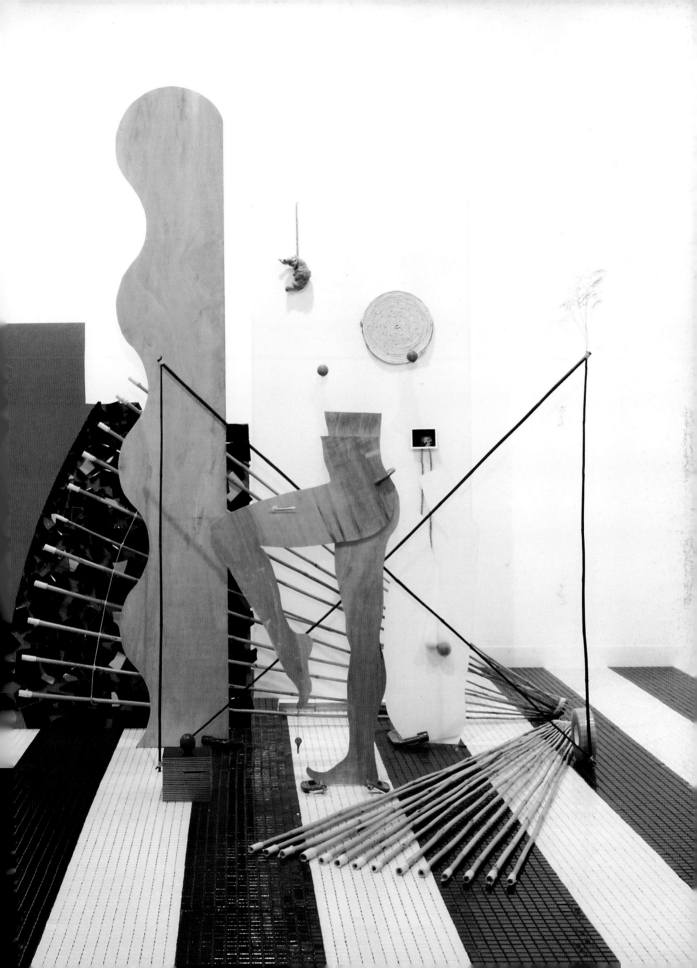

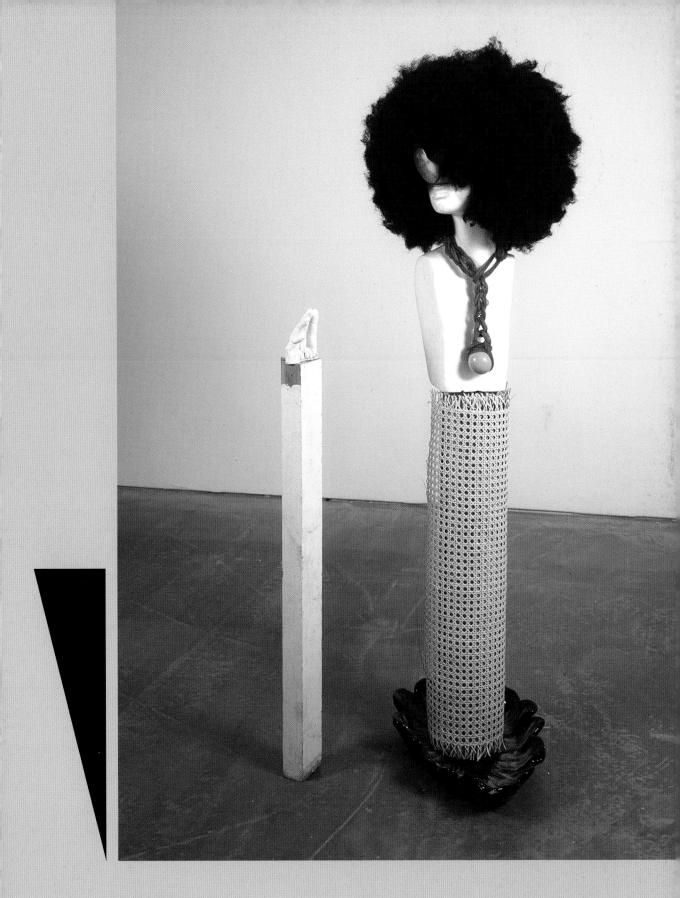

DAS BUSCHOMAN | 2007
Mixed media | 134.6 × 48.3 × 53.3 см

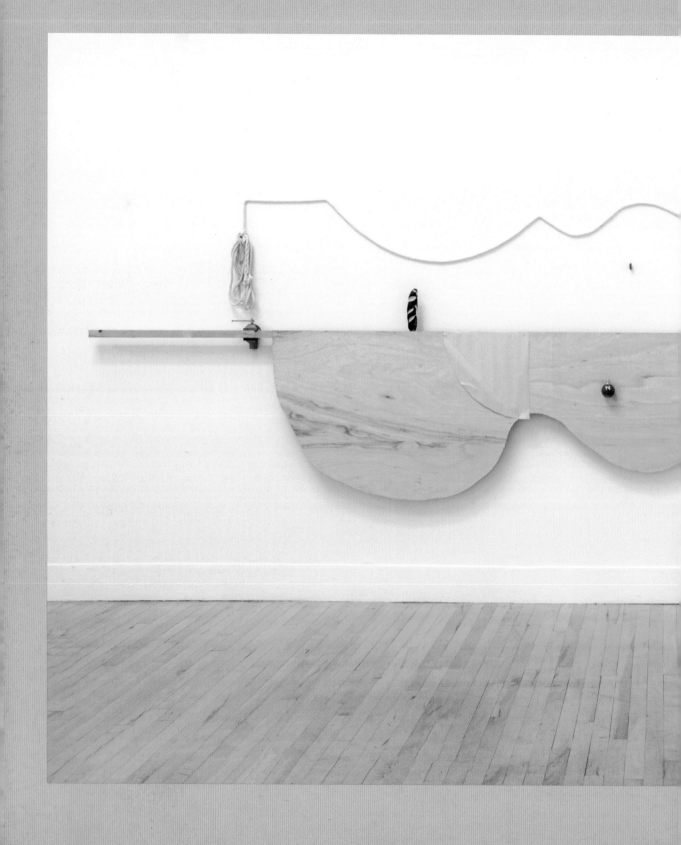

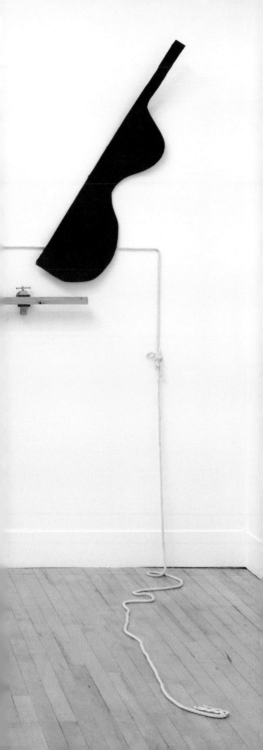

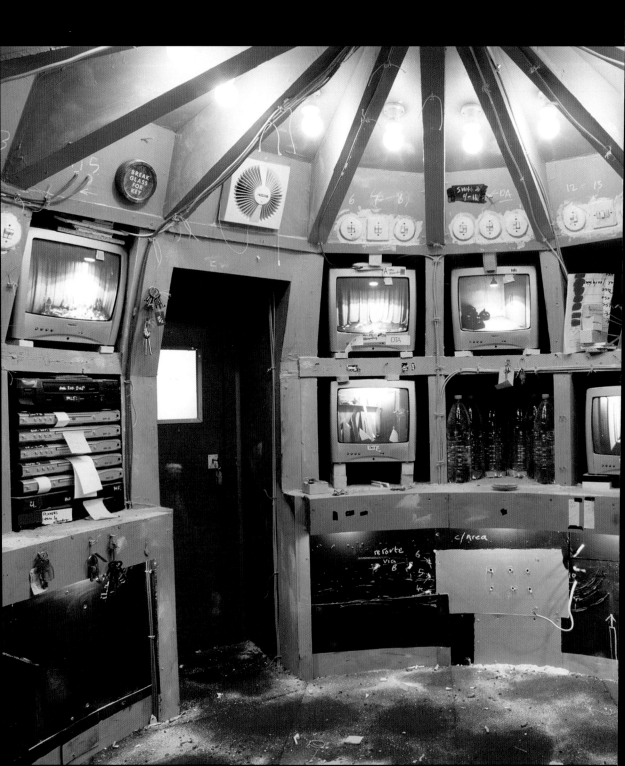

BUILDING | 2006
Diasec mounted c-type print
120 × 150 см

DRIFT | 2006
Diasec mounted c-type print
120 × 150 см

CELL | 2004
Diasec mounted c-type print
120 × 150 см

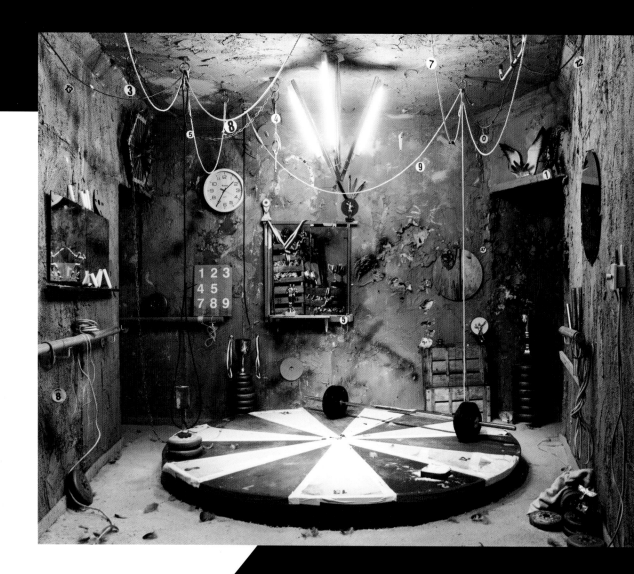

CIPHER | 200
Diasec mounted c-type pri
144 × 174 c

NTITLED VI | 2005
asec mounted c-type print
) × 150 см

MELONEBIDONE (FORNO BY THE
2009 | Oil and acrylic and Froot Loops on c
250 × 1

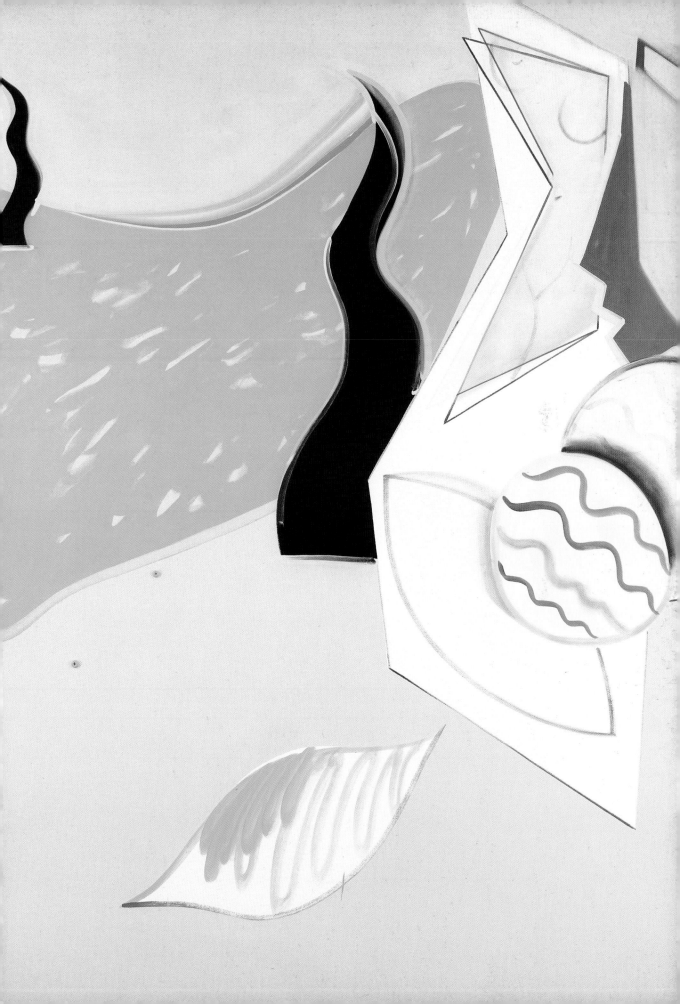

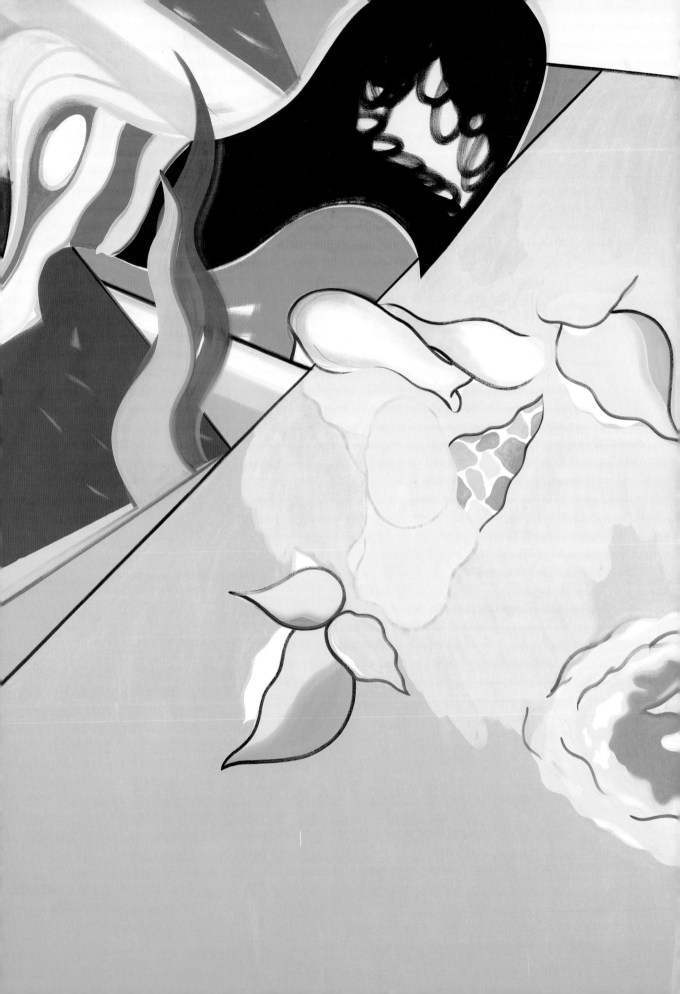

NUTRITION HIGHLIGHTS (DIFFERENT TOUCAN)

2009 | Oil and acrylic on canvas | 250 × 190 см

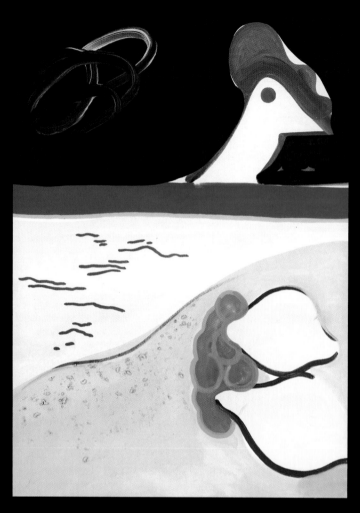

LIKE CARRA SINGS | 2009
Acrylic, gouache and crushed Froot Loops on paper
69 × 50 см

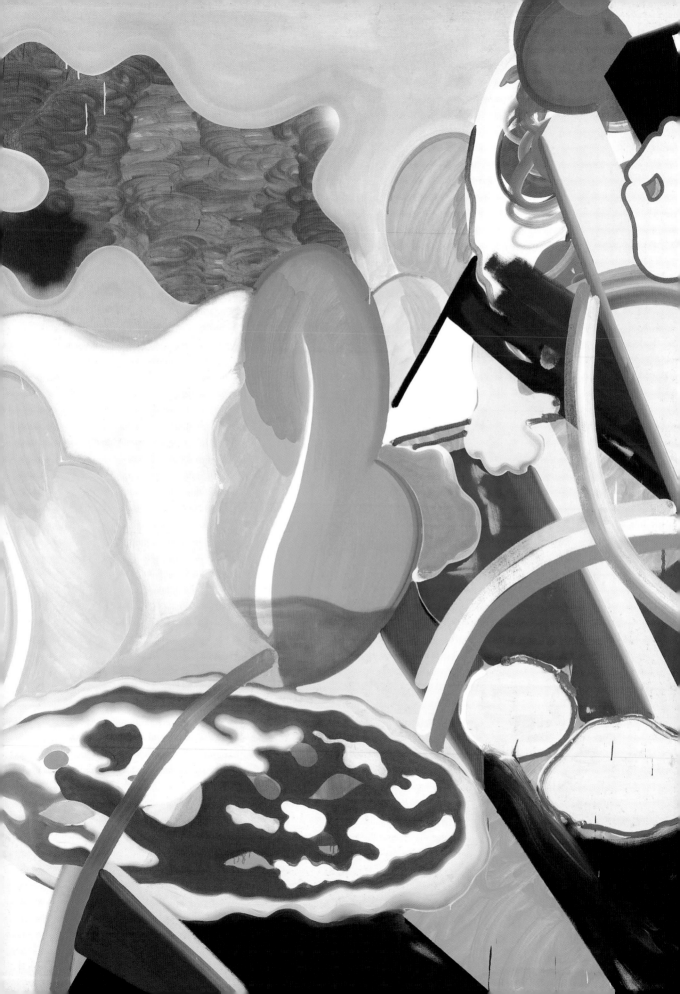

DIVERSIFIED CULTURAL WORKE

2008 | Oil on canvas | 81 × 71 ×

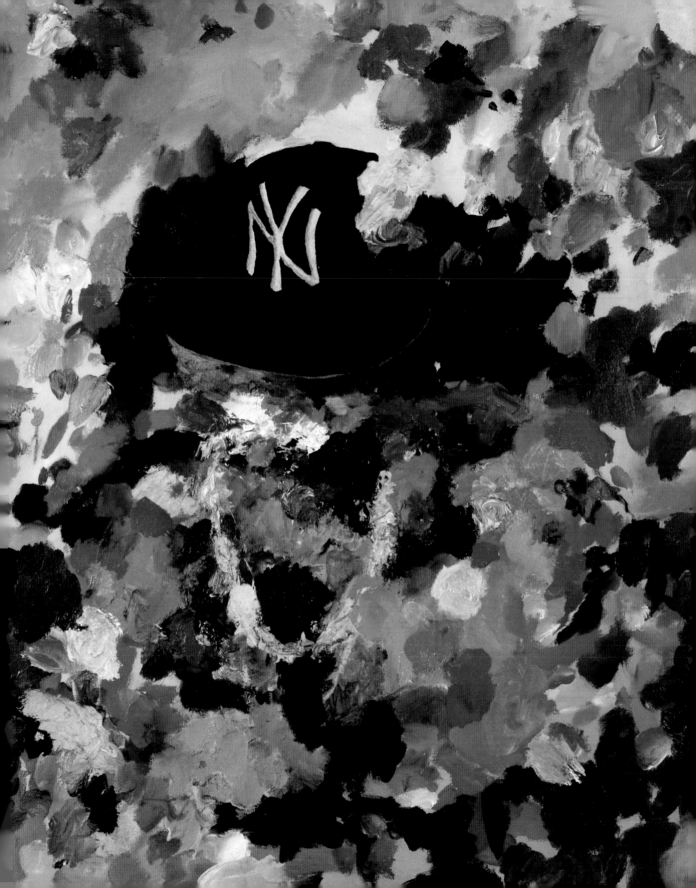

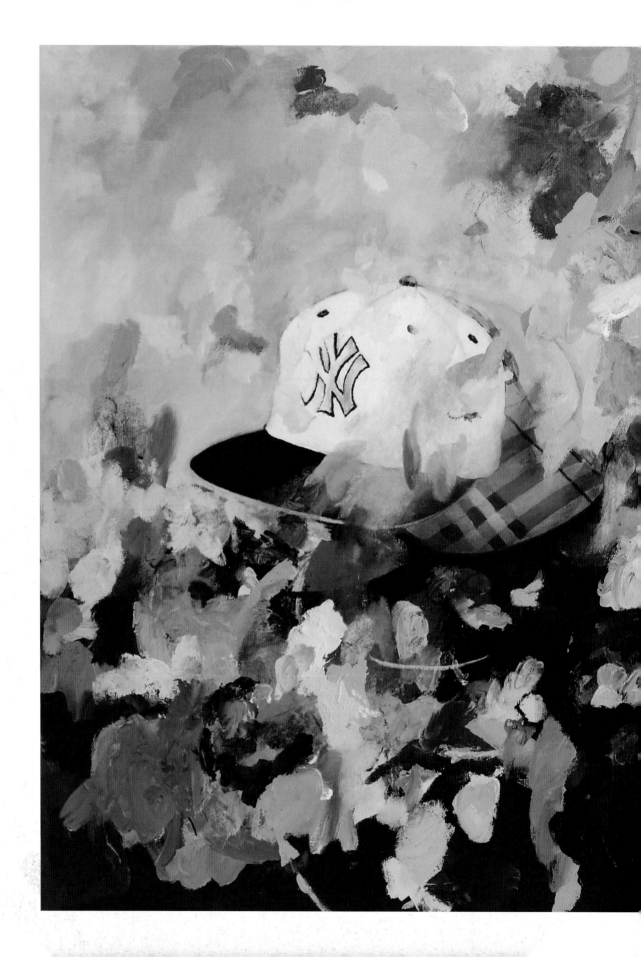

COMPOSITE PICTURE 1 (DIVERSIFIED CULTURAL WORKER)
2008 | Oil on canvas | 76.2 × 71.1 cm

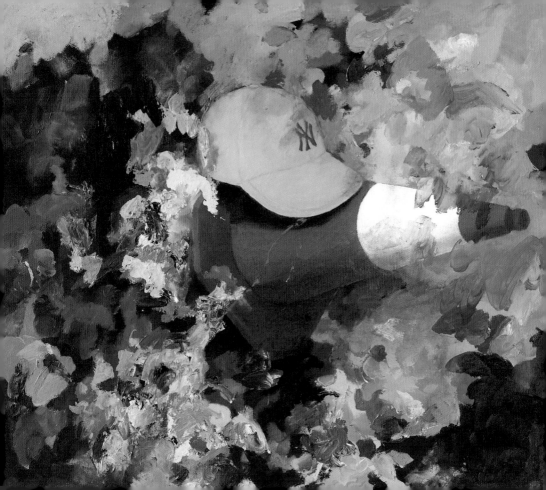

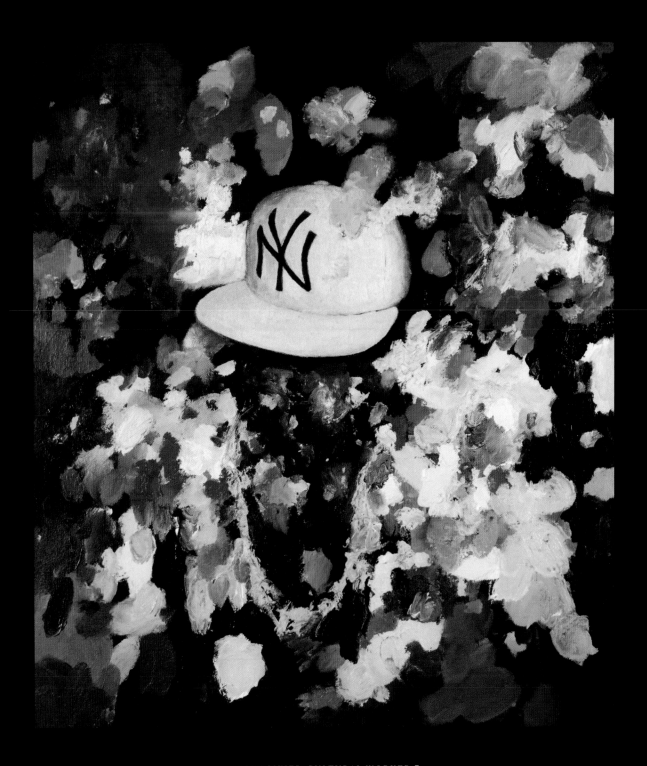

DIVERSIFIED CULTURAL WORKER 7
2008 | Oil on canvas | 81 × 71 × 2 см

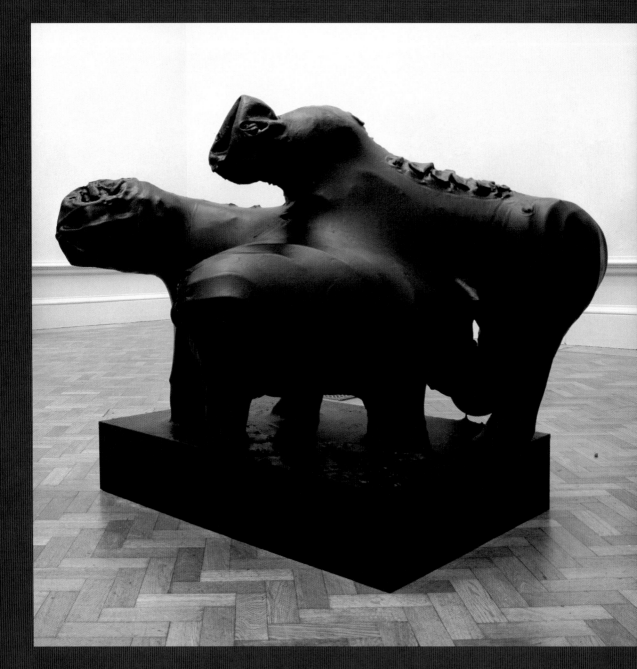

SADDLEBACK | 2007
Foam, paper, wire, rubber
145 × 120 × 125 см

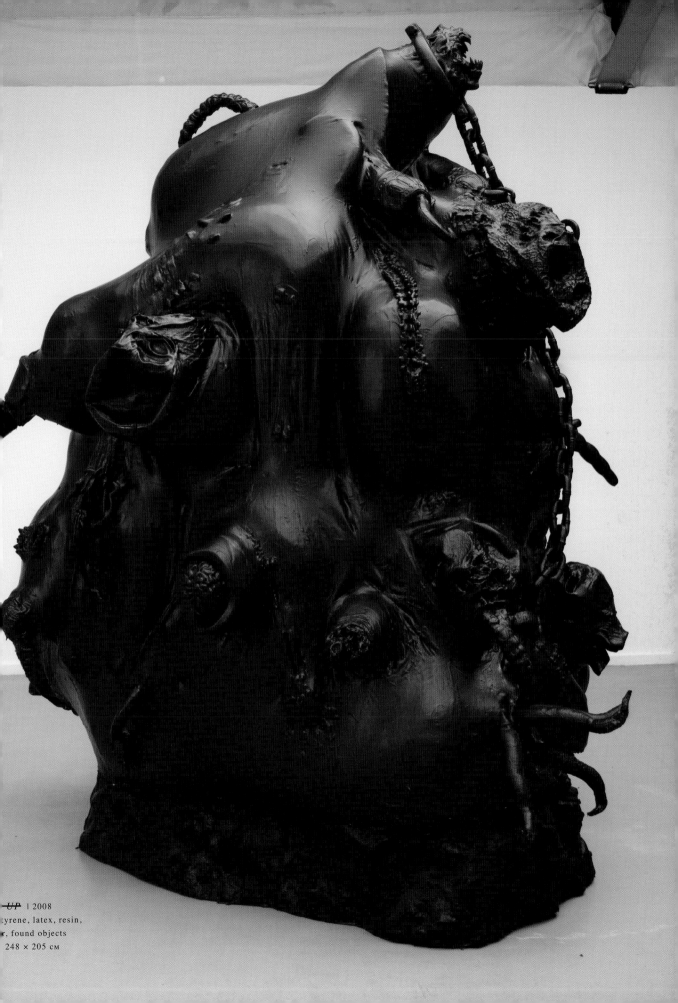

UP | 2008
tyrene, latex, resin,
, found objects
248 × 205 см

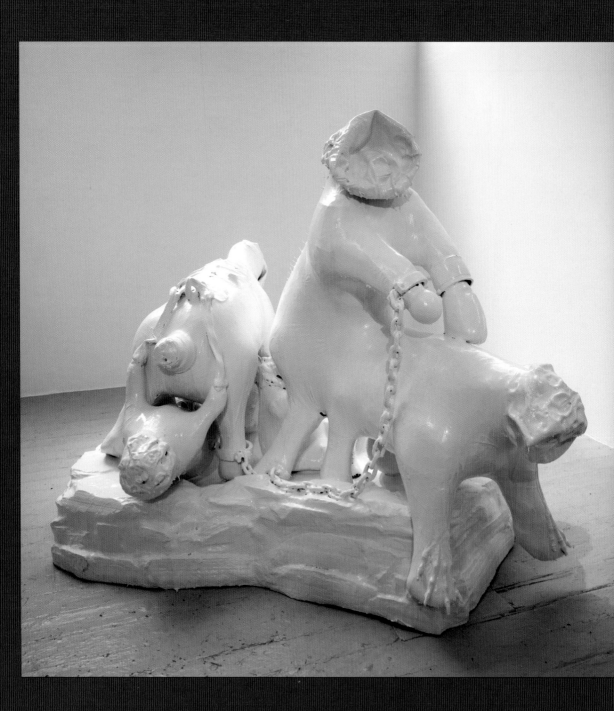

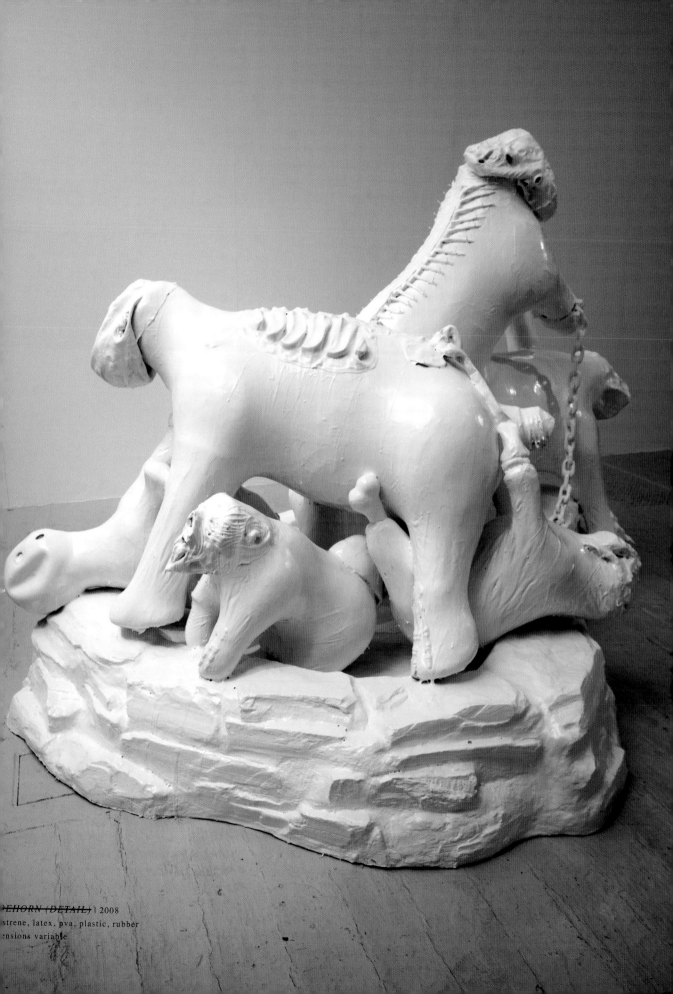

...EHORN (DETAIL) | 2008
...strene, latex, pva, plastic, rubber
...ensions variable

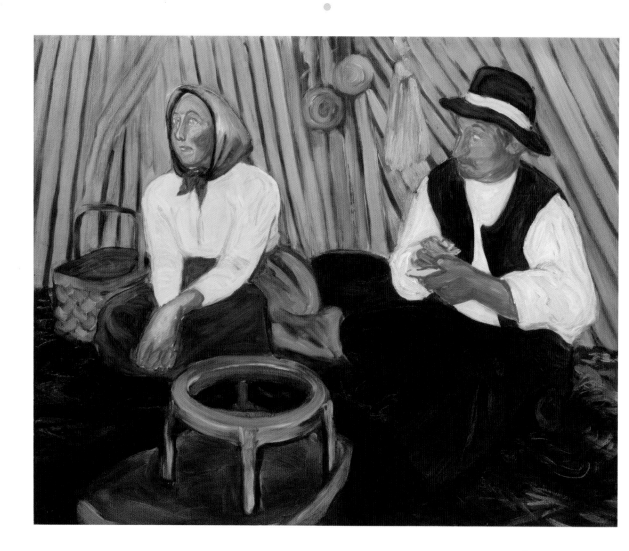

SÁMI COUPLE | 2007

Fluroescent yellow orange, fluroescent flame red egg tempera,
chrome yellow, lead white, cochineal, madder, french ultramarine,
prussian blue, lead antimonate, viridian in oils on board

61 × 75 см

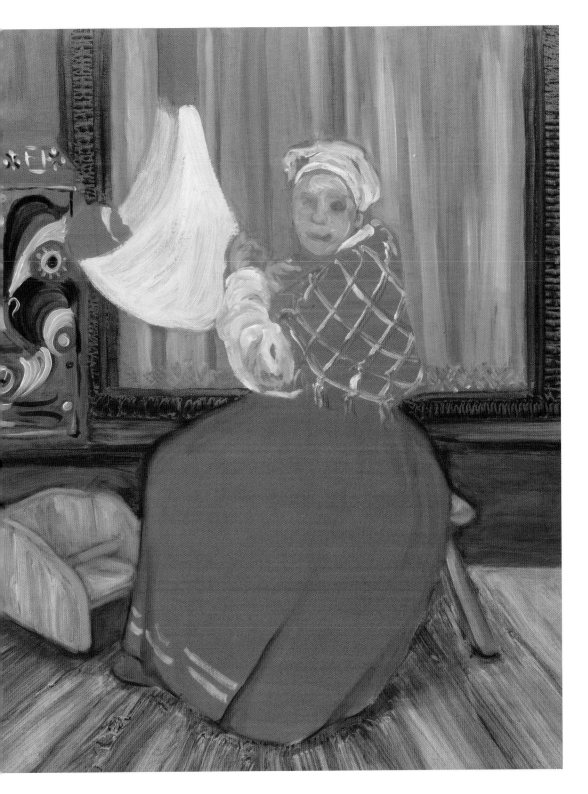

MOTHER AND CHILD | 2007
Fluorescent brick red egg tempera, Cobalt turquoise,
lead antimonate, red lead, lead white, Prussian blue in oils,
iron oxide in soured milk on board
91 × 74 см

*THE LAST PEASANT-PAINTERS PEELING
POTATOES (OLD WOMAN MILL)* | 2007
Fluorescent orange egg tempera, lead white, Prussian blue,
Chrome yellow light, lead antimonate, Bohemian green earth,
Spanish glazing ochre, iron oxide in soured milk,
birch leaf lake in pine resin on board
122 × 142 см

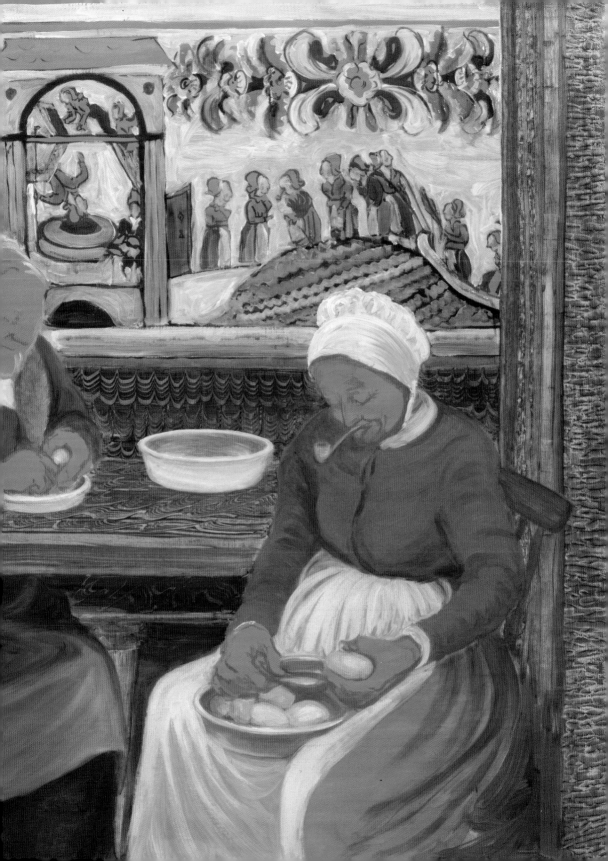

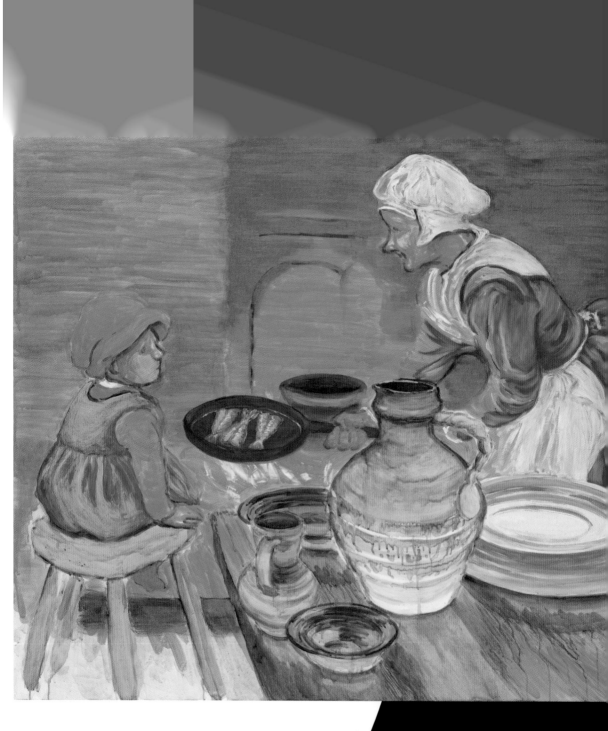

FRYING FISH

Fluorescent egg tempera, Bohemian green earth egg ter
verdigris, cochineal, lead white, lead antimonate, raw u
Bohemian green earth, Spanish red ochre in oils on

110 ×

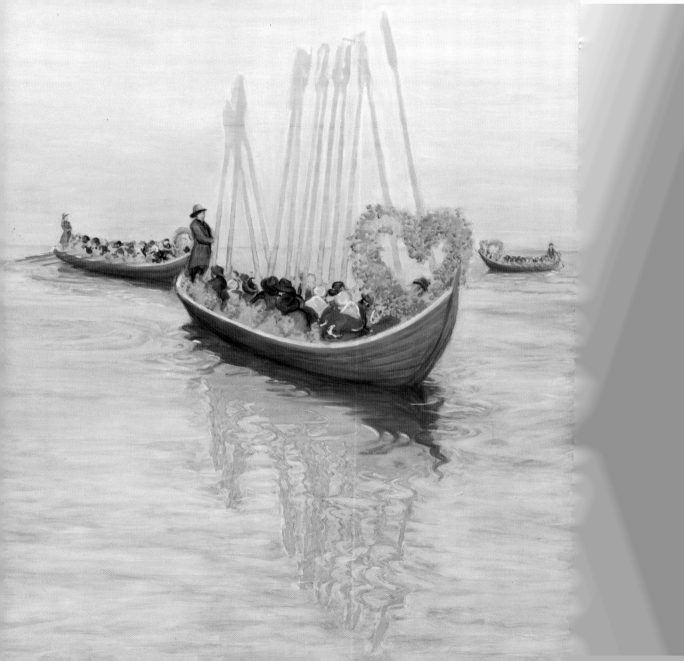

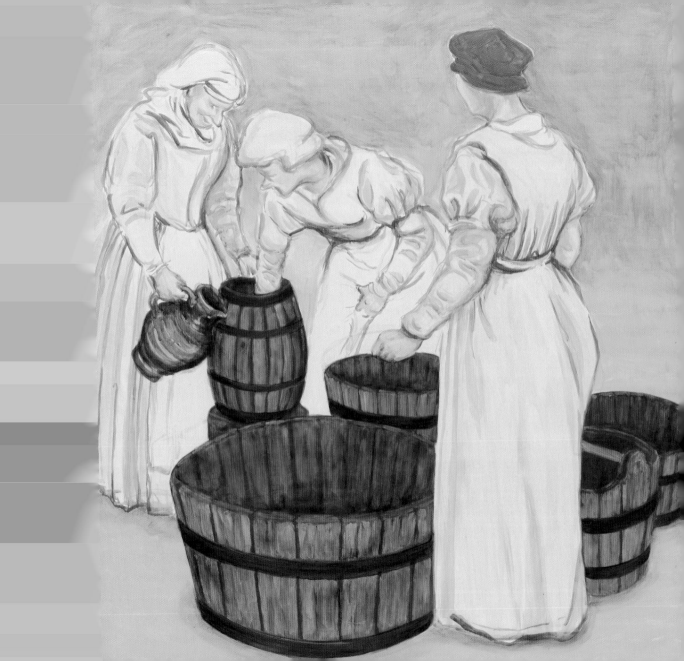

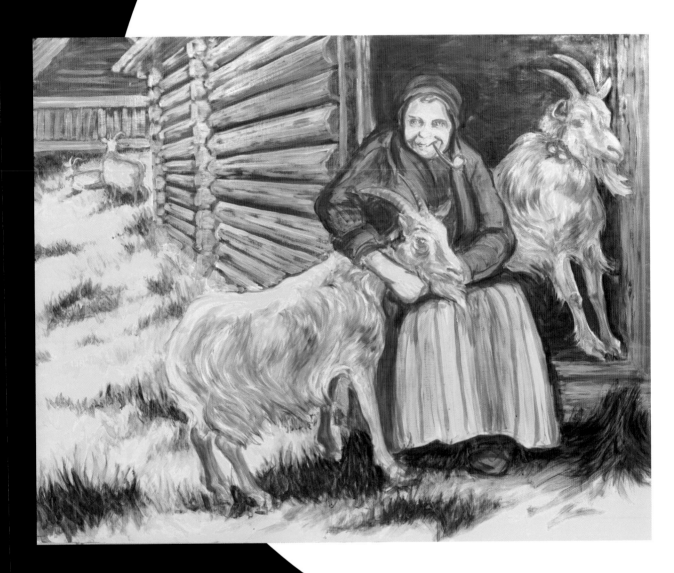

OLD WOMAN HUGGING A GOAT | 2008
Fluorescent lemon yellow, fluorescent flame red,
lead white, cochineal, ultramarine, green earth,
Spanish red ochre in egg tempera and oils on board
122 × 153 см

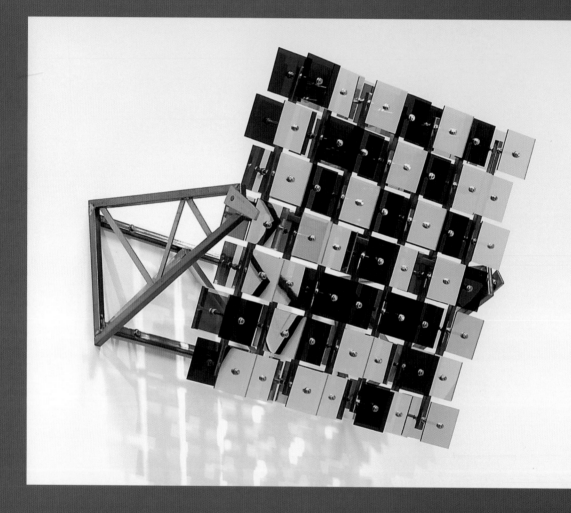

SINGLE SCREEN WALL MOUNTED CONSTRUCTION I
2006 I Two-way security mirror, steel, brass I 60 × 73 × 60 см

RADIAL CONSTRUCTION IN SPACE II I
Perspex (red, black and 2 way mirror), steel &
210 × 80 ×

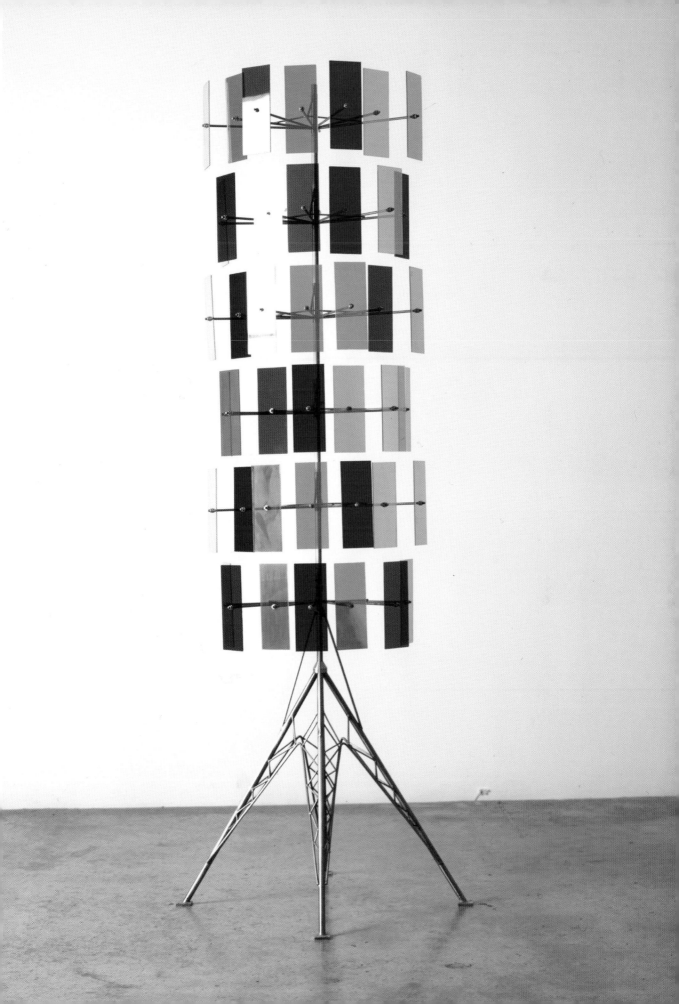

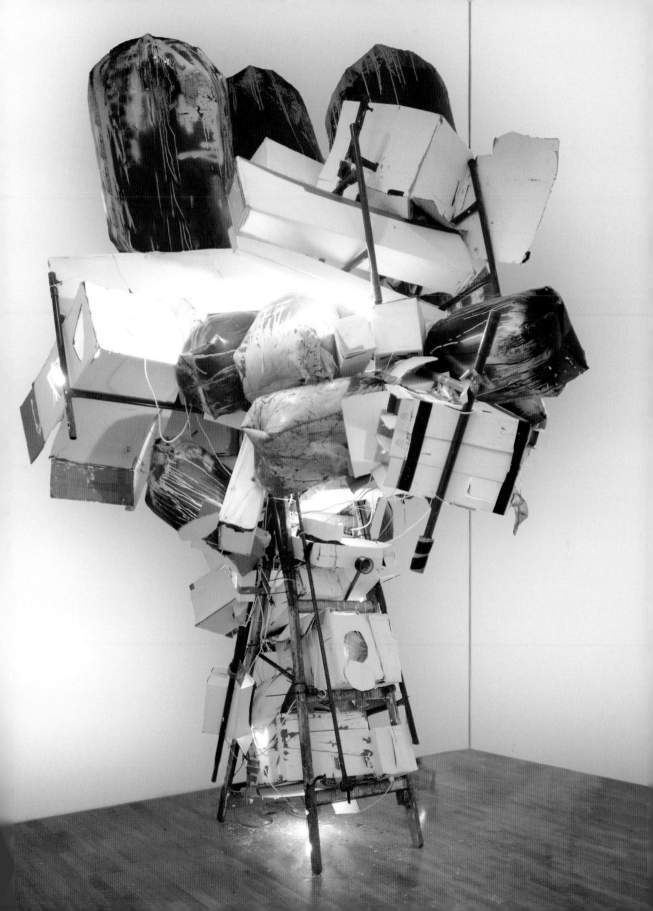

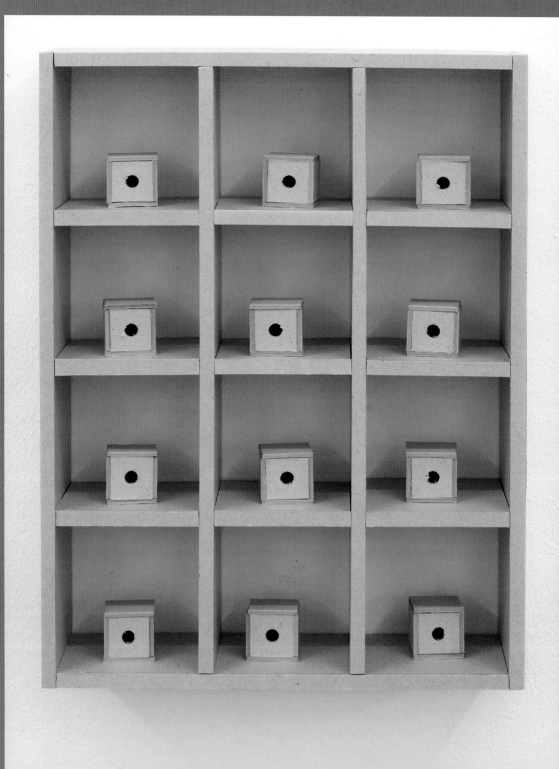

BOXES | 2008
Backing card | 30 × 22.4 × 6.3 см

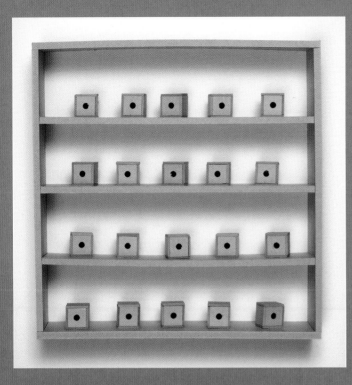

SHELVES (I) | 2008
Backing card | 30 × 30 × 6.3 см

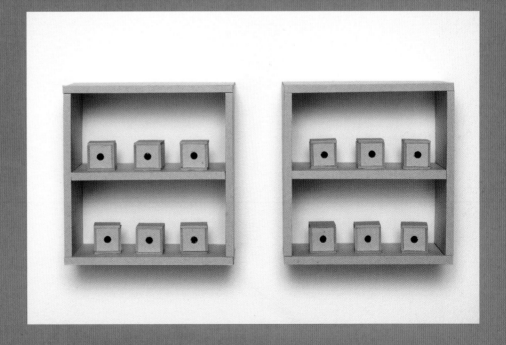

TWIN SHELVES | 2008
Backing card | 15.3 × 34.2 × 6.3 см

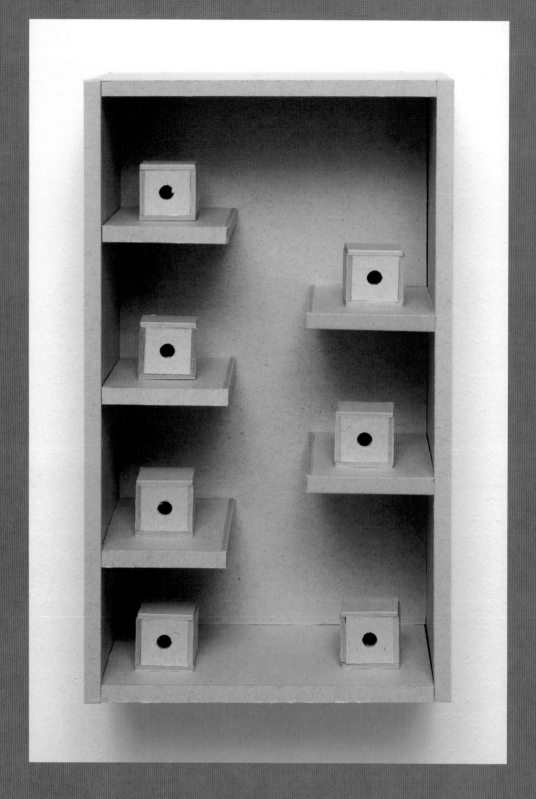

SHELVES (IV) | 2008
Backing card | 30 × 21 × 6.3 см

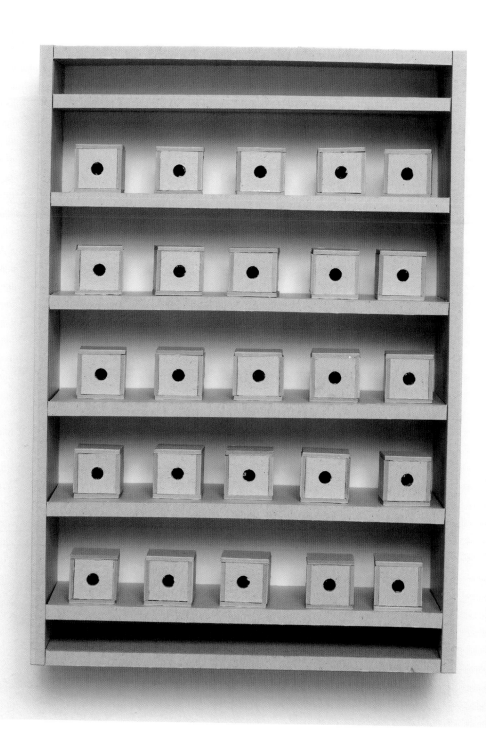

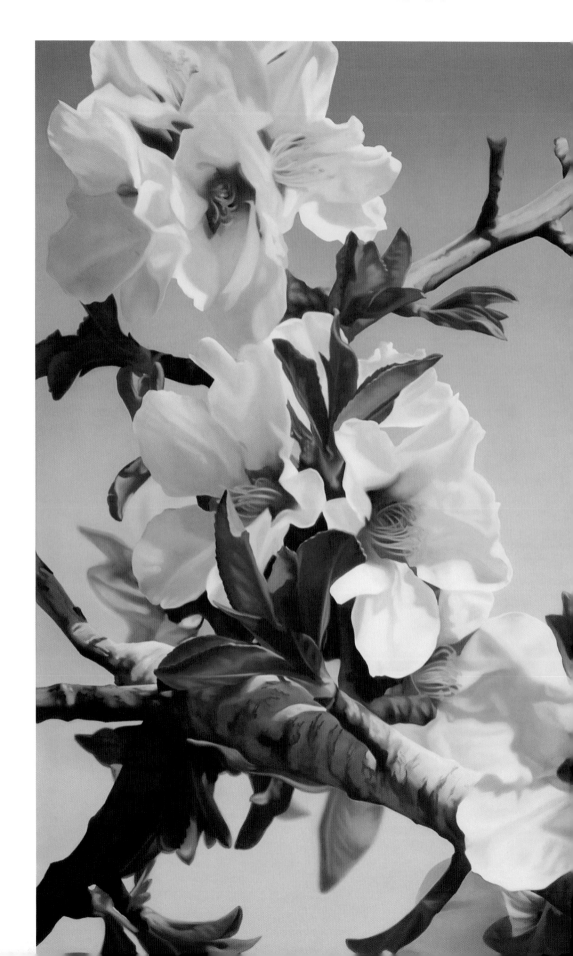

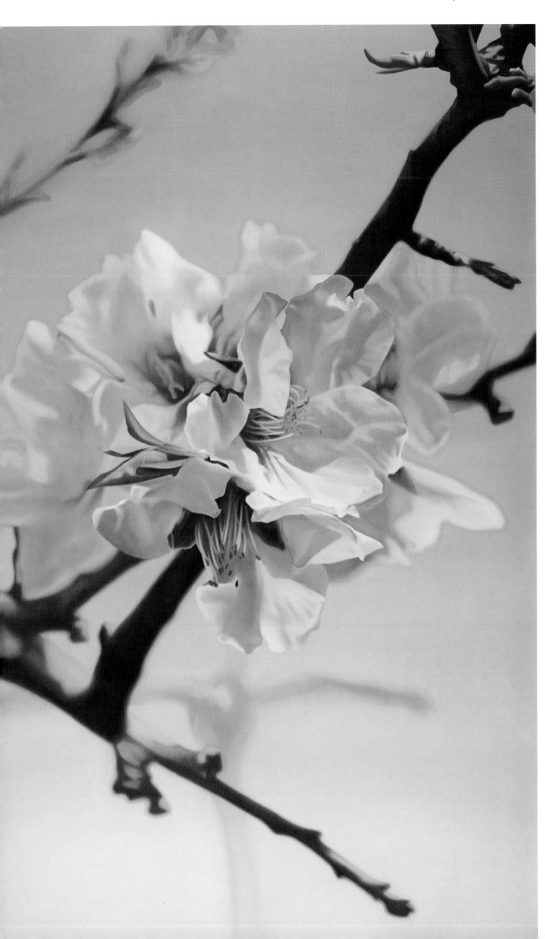

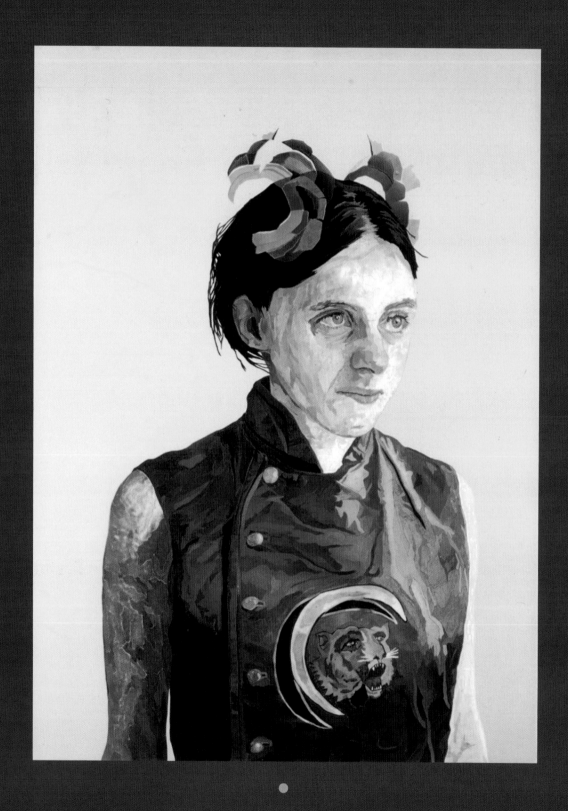

SISTER | 2006
Hand coloured paper collaged on board
72 × 55 см

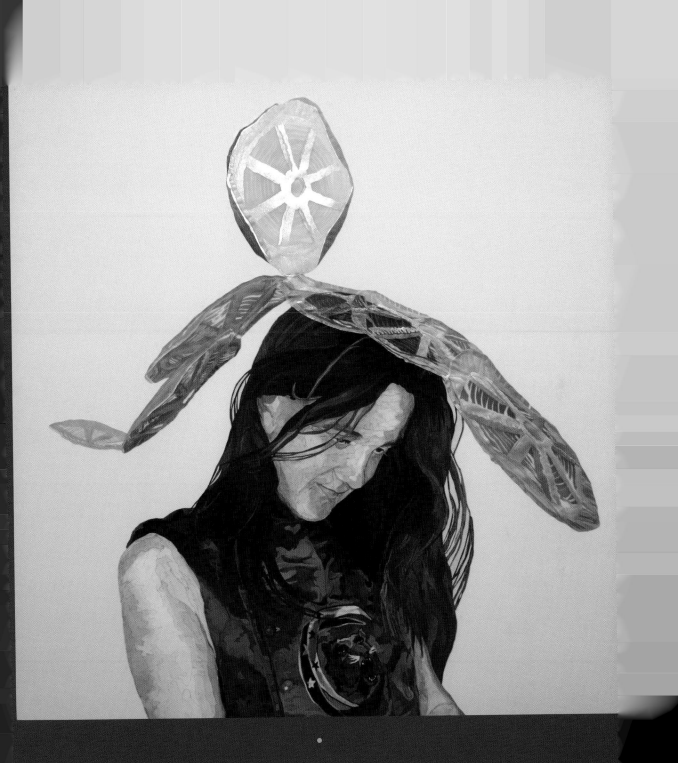

GUIDE | 2007
Hand coloured paper collaged on board
70 × 70 см

BROTHER BENEDICT |
Hand coloured paper on board | 72 ×

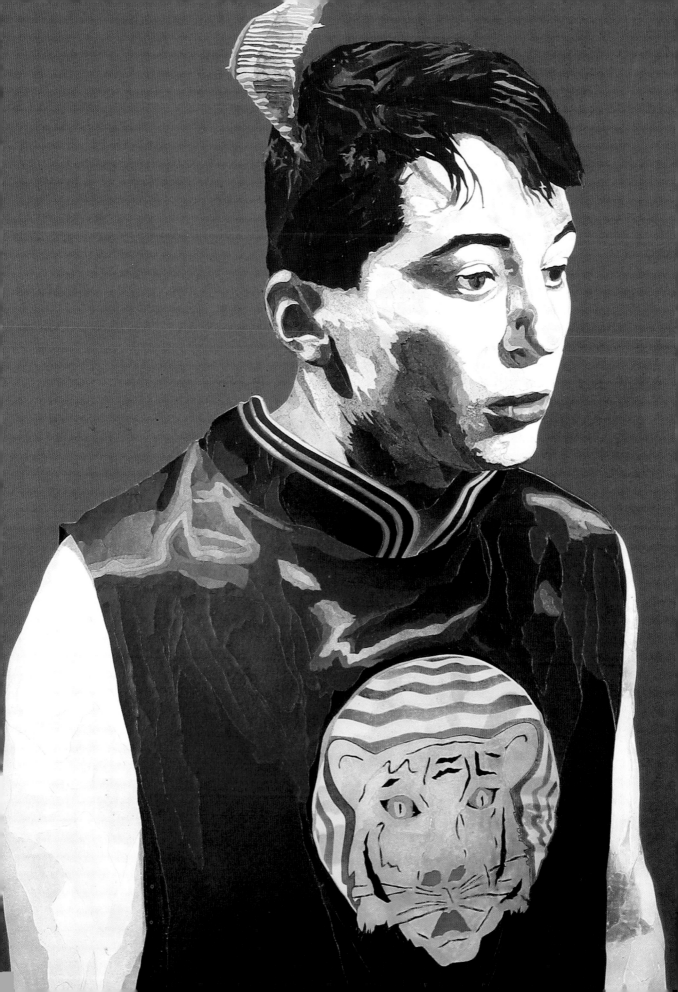

THE BON VIVEUR (II) | 2008
Oil on canvas | 70 × 60 см

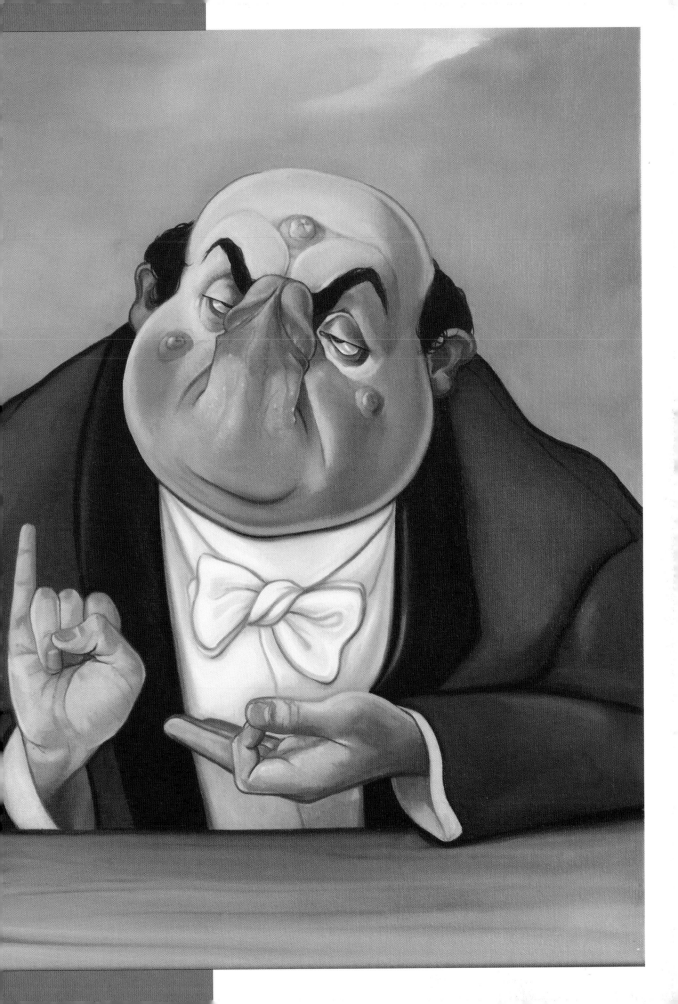

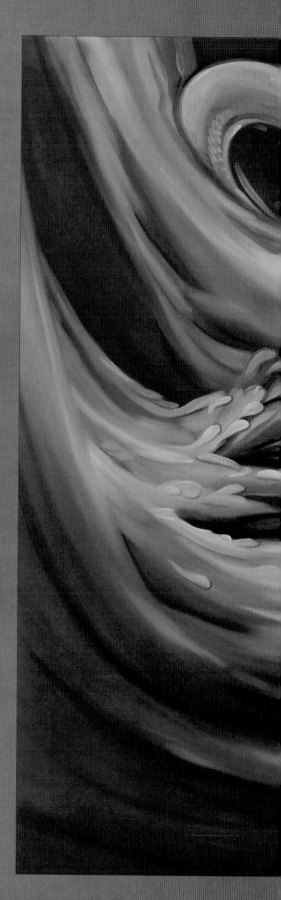

THE LOSERS | 2008
Oil on canvas on panel
110 × 140 см

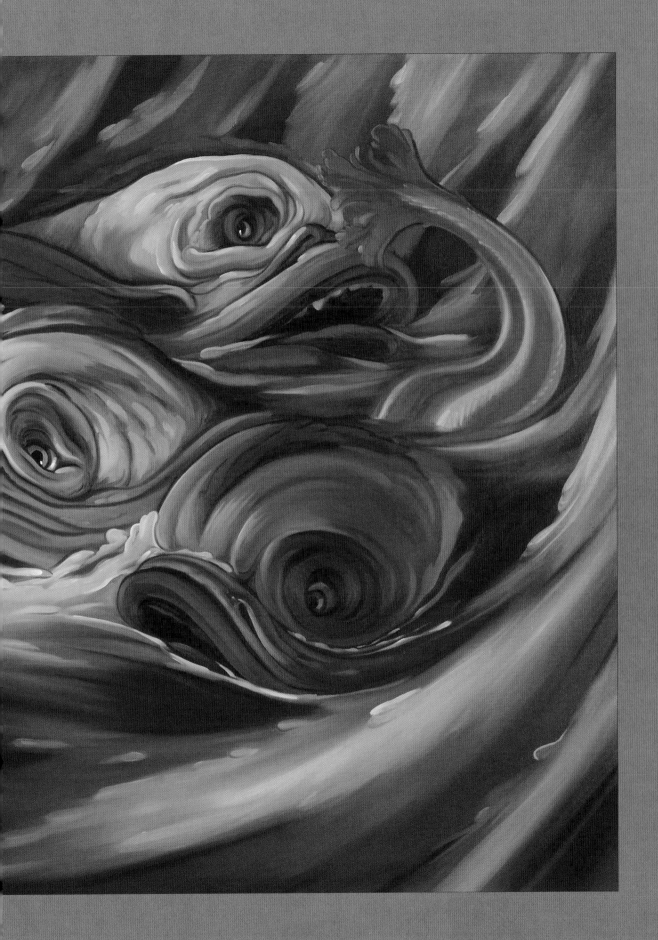

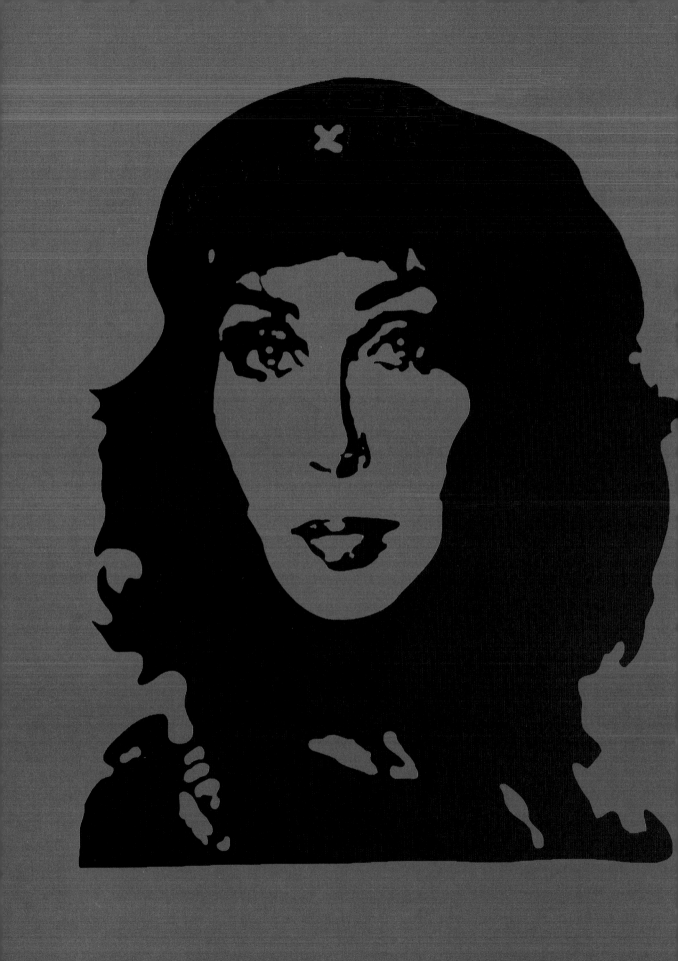

PINK CHER | 2008
Screenprint and paint on canvas
300 × 200 см

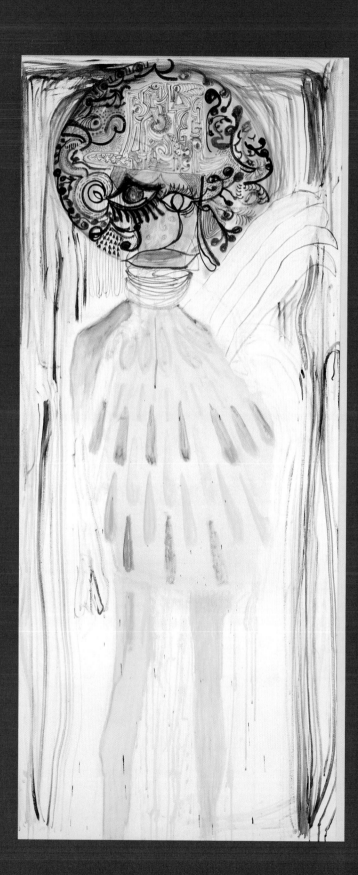

▼

MAN DRESSED AS GOD | 2009
Acrylics, crayons and colour pencil on linen
178 × 76 см

▲

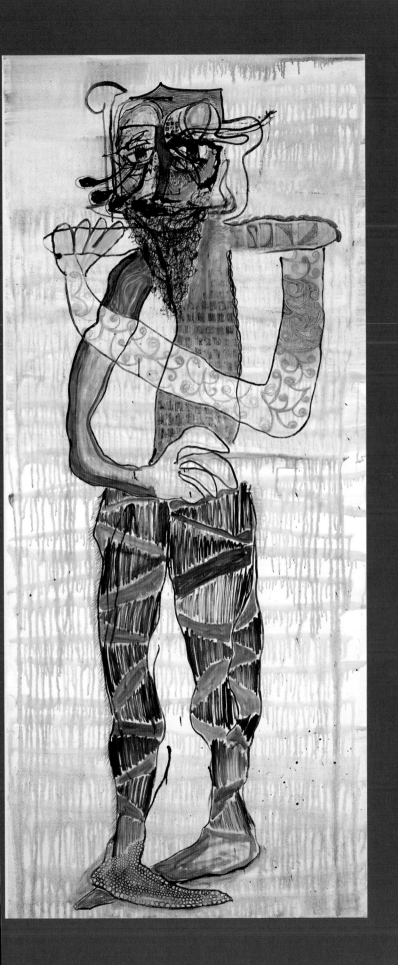

GREAT PERFECTED BEING | 2009
Acrylics on linen
124 × 78 см

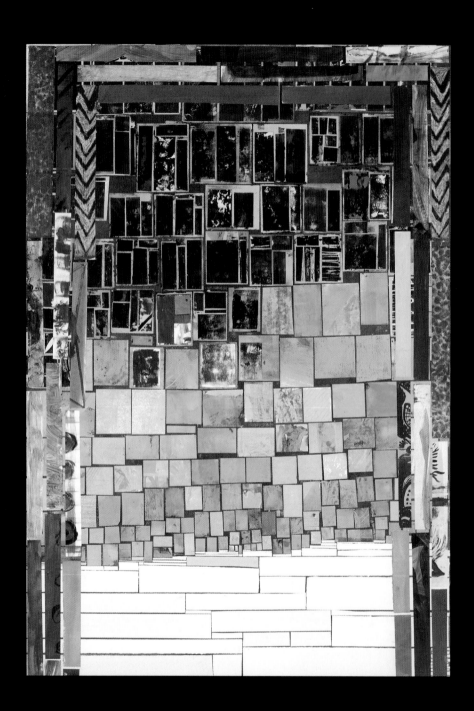

THERE IS NO EASY WAY DOWN | 2009
Mixed media collage on linen on MDF wood panel
130 × 90 см

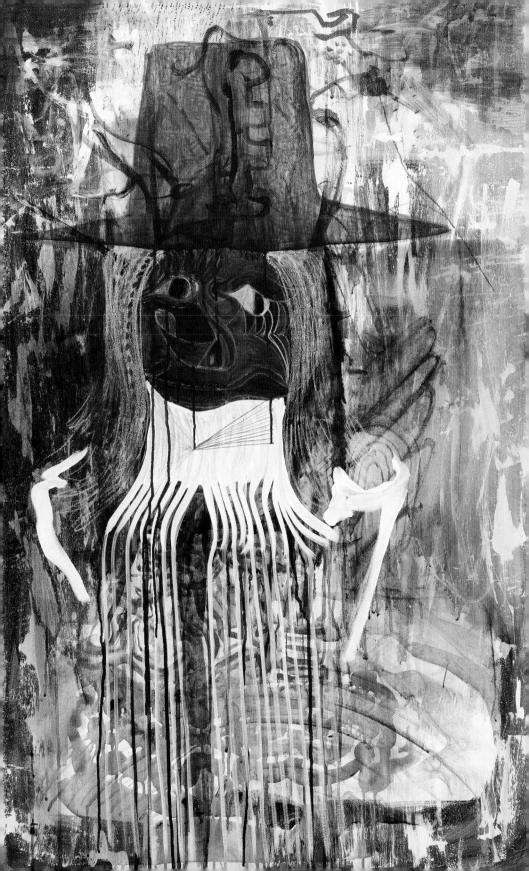

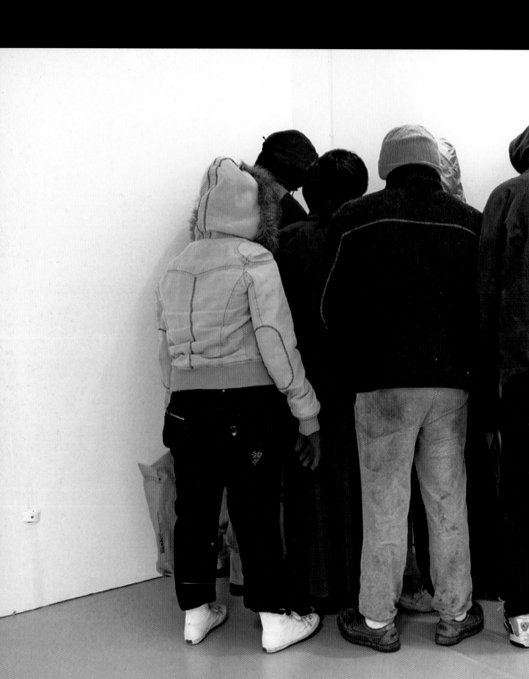

IT HAPPENED IN THE CORNER... | 2007
Plaster, wax, foam, hair, clothes
180 × 200 × 150 см

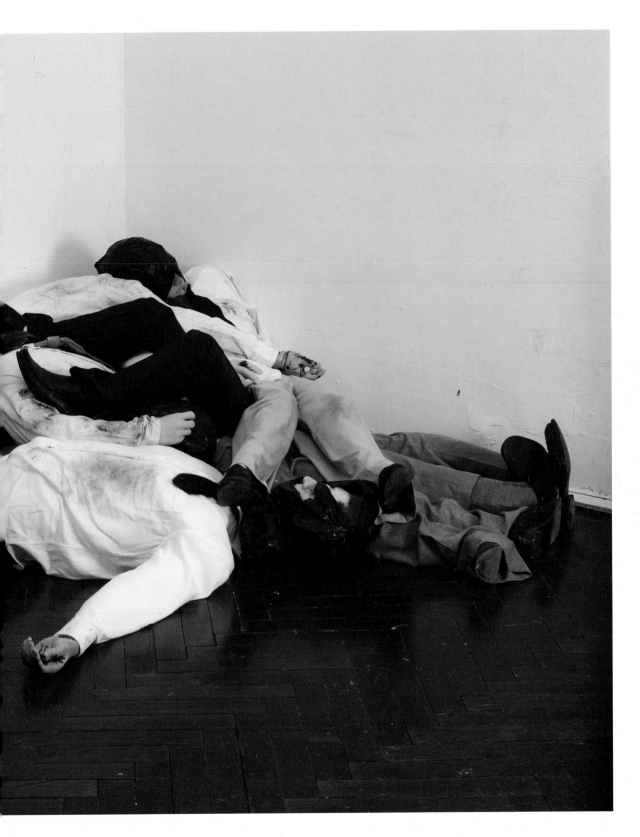

IT ALL DEPENDS ON ONE'S FANTASIES AS A CHILD | 2008
Plaster, wax, foam, hair, clothes, binbags, rubbish
90 × 220 × 200 см

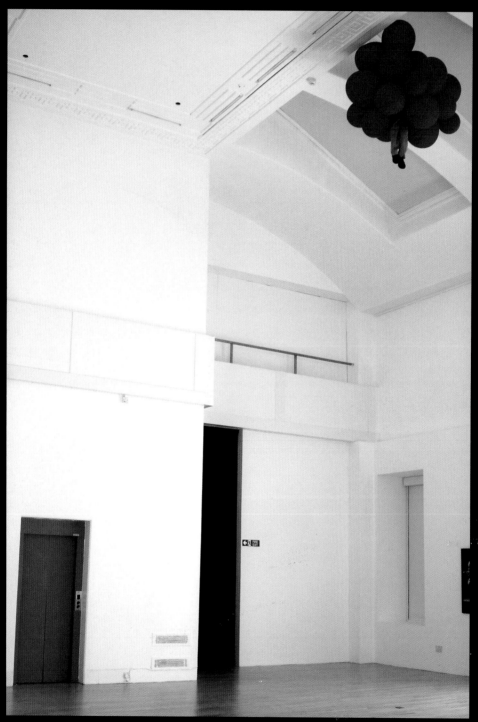

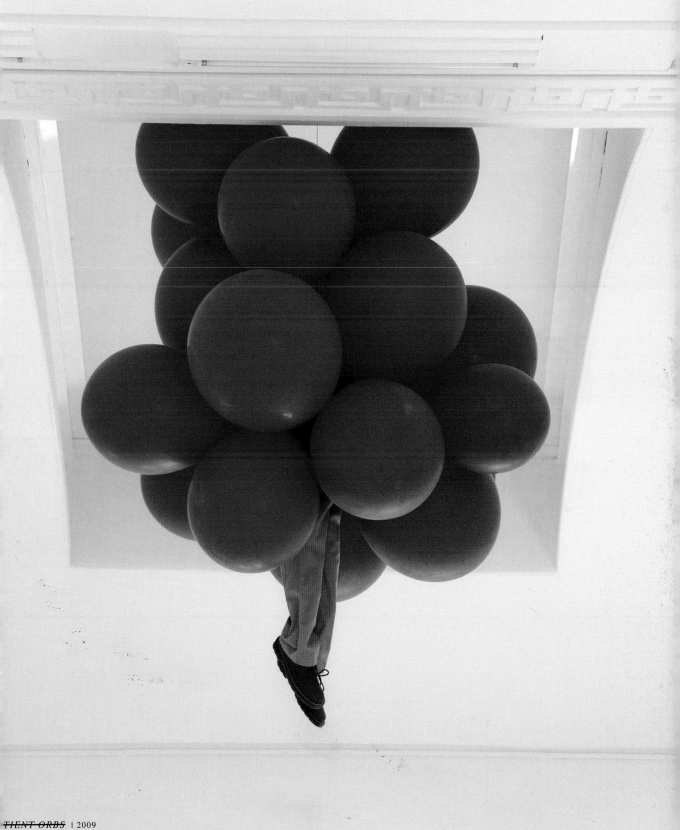

TIENT ORBS | 2009
s, chinos, sweater, balloons, wire, stuffing
× 200 × 200 см

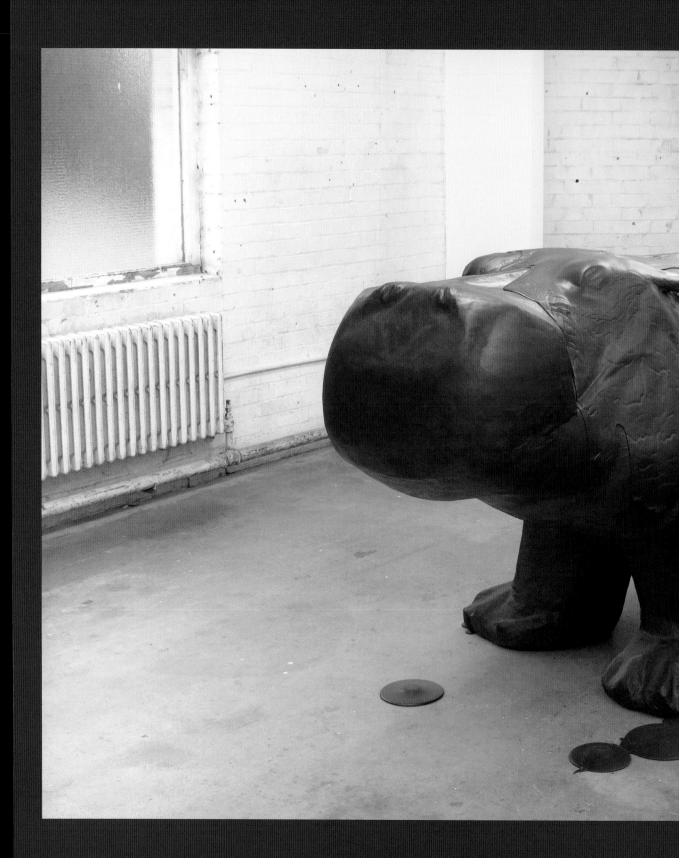

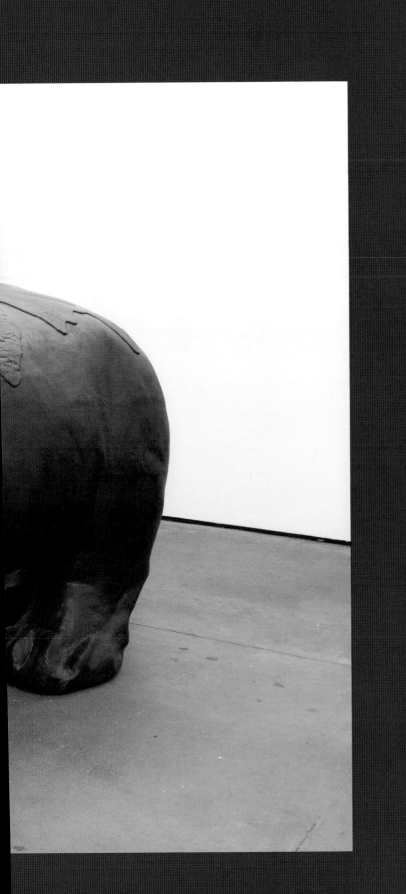

FIGURE 1 | 2007
Jesmonite with fibreglass matting
125 × 250 × 122 см

EXCELLENT (WITH A FLOURISH OF ADJECTIVES ABOUT THE ZEITGEIST)
2008 | Oil on canvas | 200 × 176 см

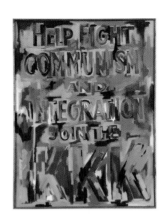

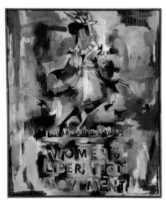

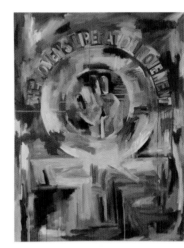

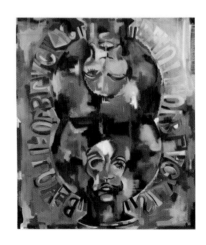

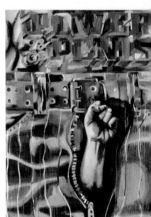

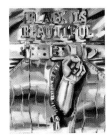

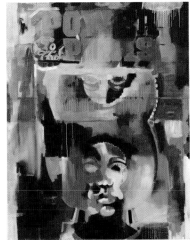

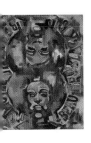

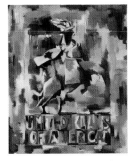

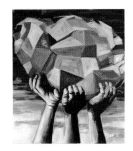

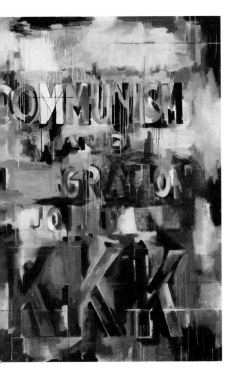

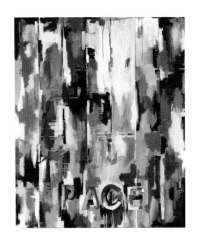

JERKING OFF THE DOG TO FEED THE CAT | 2008
Installation of 16 oil on canvas paintings
Dimensions variable

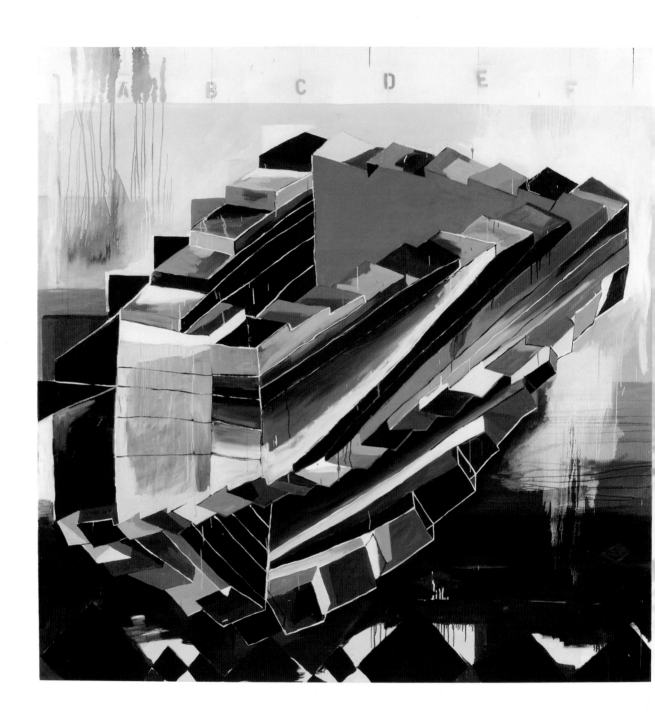

ET SICK IN INFINITUM [SIC] | 2
Oil on canvas | 210 × 21

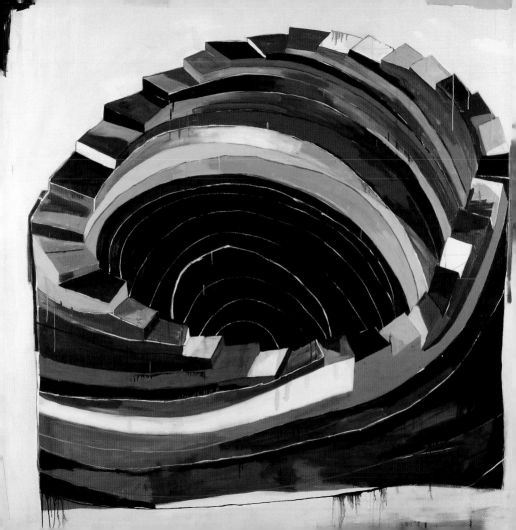

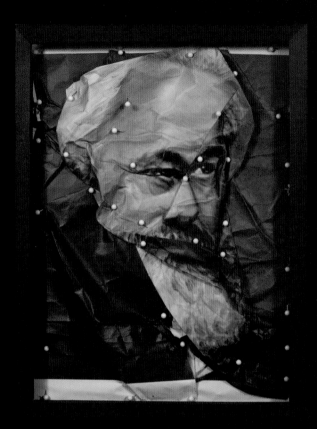

PORTRAIT OF THOMAS JEFFERSON AS KARL MARX
2009 | Collage, folded posters | 43 × 35 см

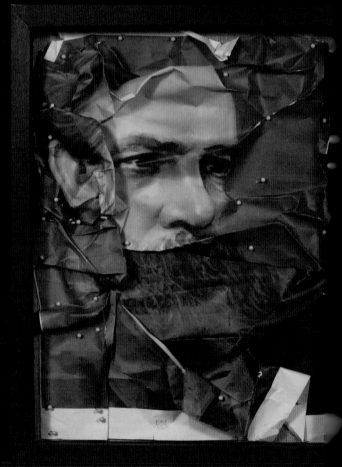

PORTRAIT OF THOMAS JEFFERSON AS FRIEDRICH ENGELS
2009 | Collage, folded posters | 43 × 35 см

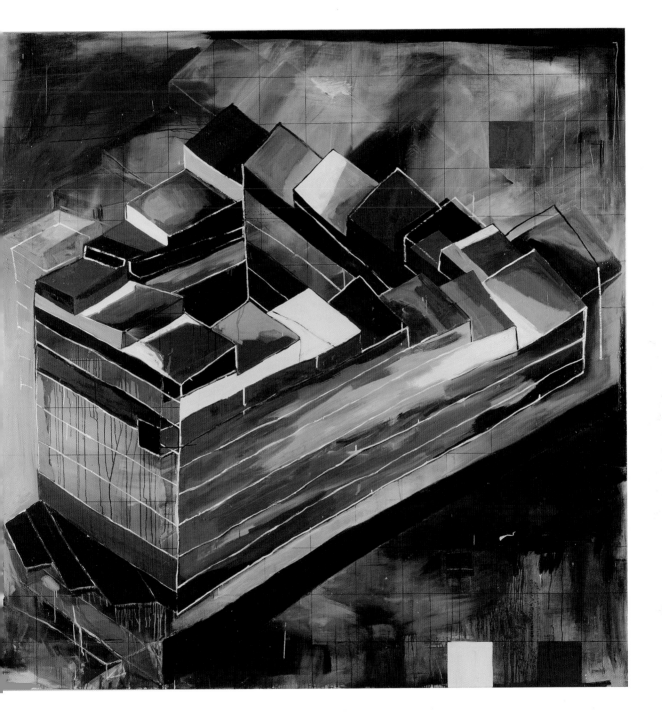

ET SIC IN INFINITUM | 2008
Oil on canvas | 210 × 210 см

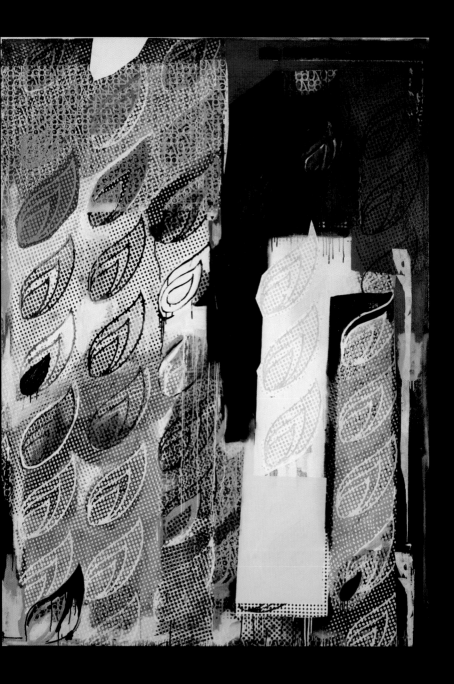

SOUTH OF HEAVEN | 2009
Screeprint and oil on canvas
220 × 160 см

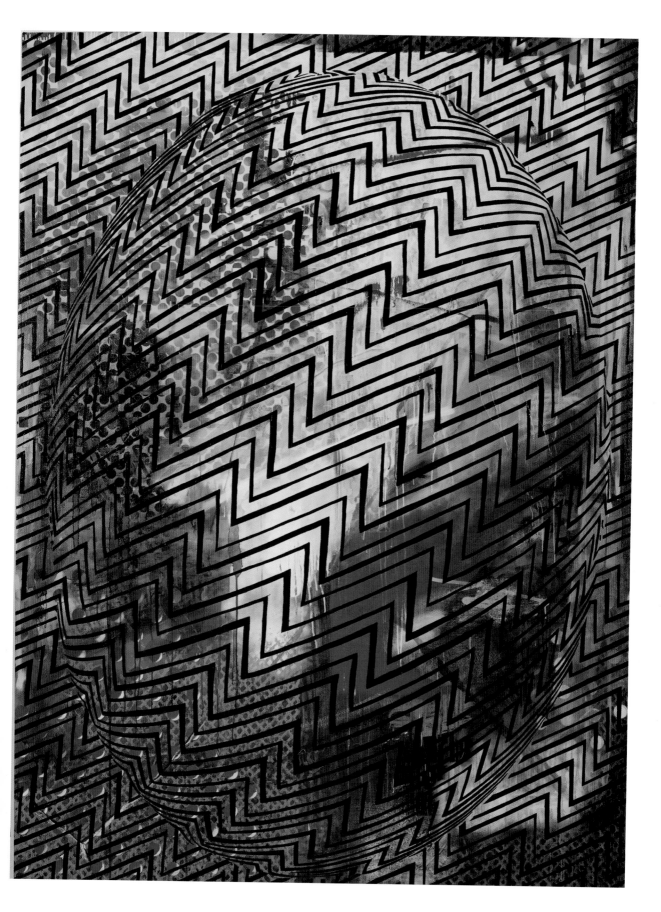

POP WAS THE SOUND OF THE BUBBLE BURSTING

2009 | Screeprint and oil on canvas | 220 × 160 cm

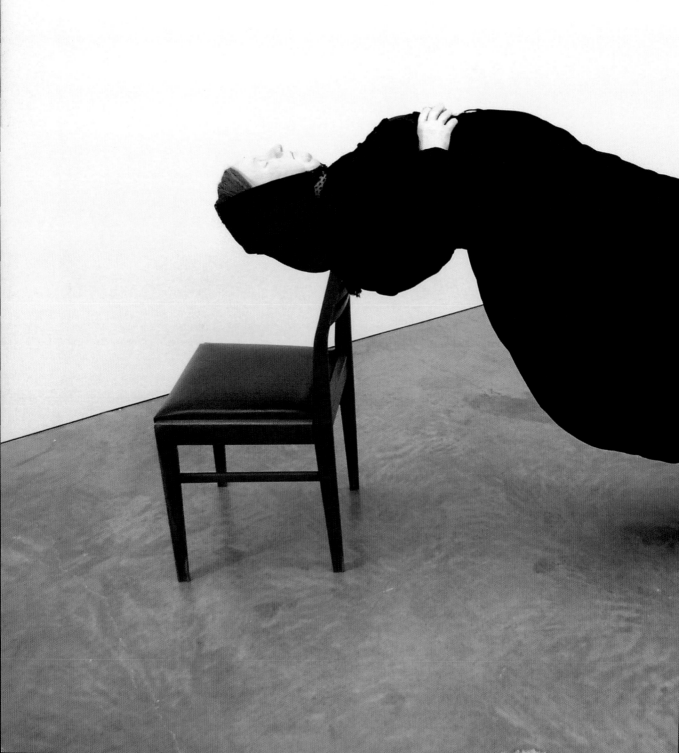

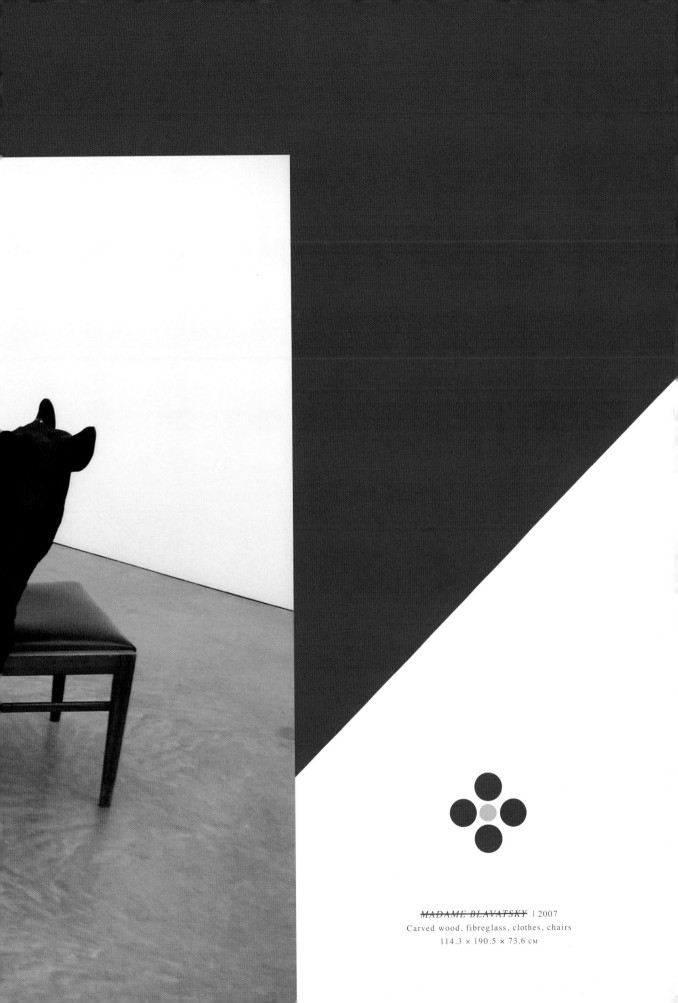

MADAME BLAVATSKY | 2007
Carved wood, fibreglass, clothes, chairs
114.3 × 190.5 × 73.6 см

LIBRARY TABLE | 2005
Oak table, leather bound books, customised lamps
140 × 206 см

UNTITLED (SHOES) | 2005 | Oil on canvas | 164 × 113 см

APOLOGIA PRO VITA POSITIVIA | 2005
Oil on canvas | 101.5 × 76 × 1.8 см

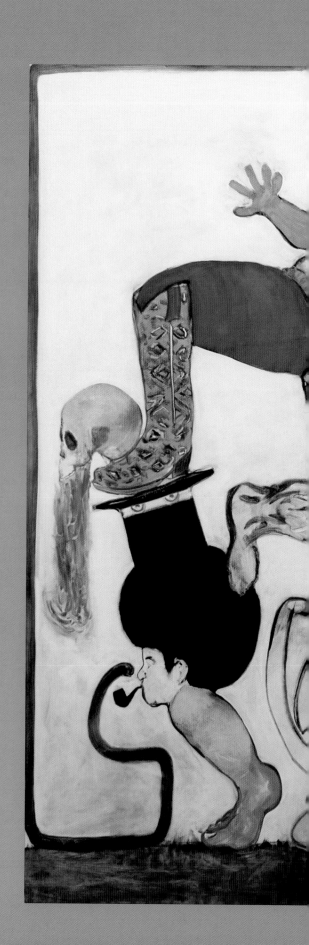

TAG TEAM | 2008
Oil on canvas | 215 × 275 см

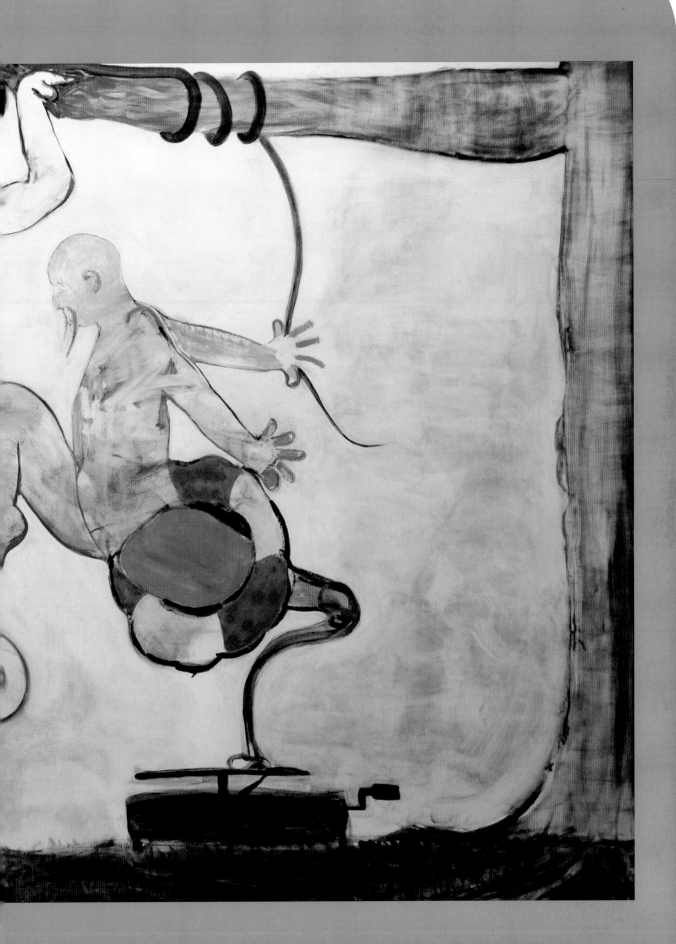

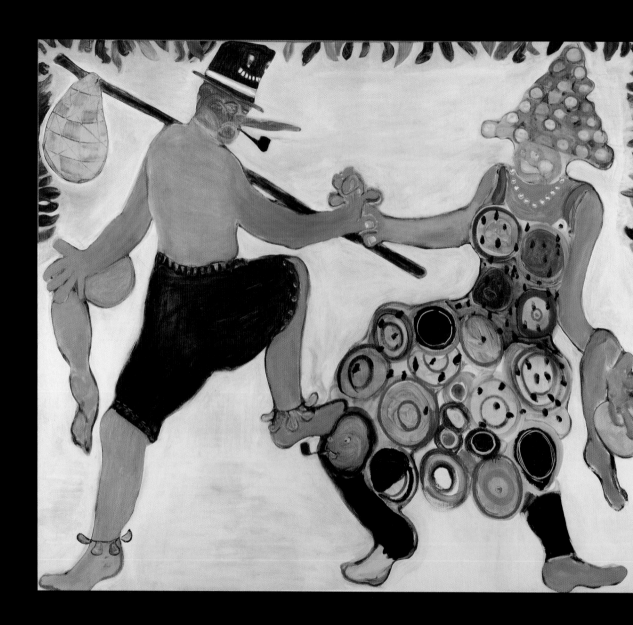

LIMB DANCE | 2008
Oil on canvas | 160 × 180 см

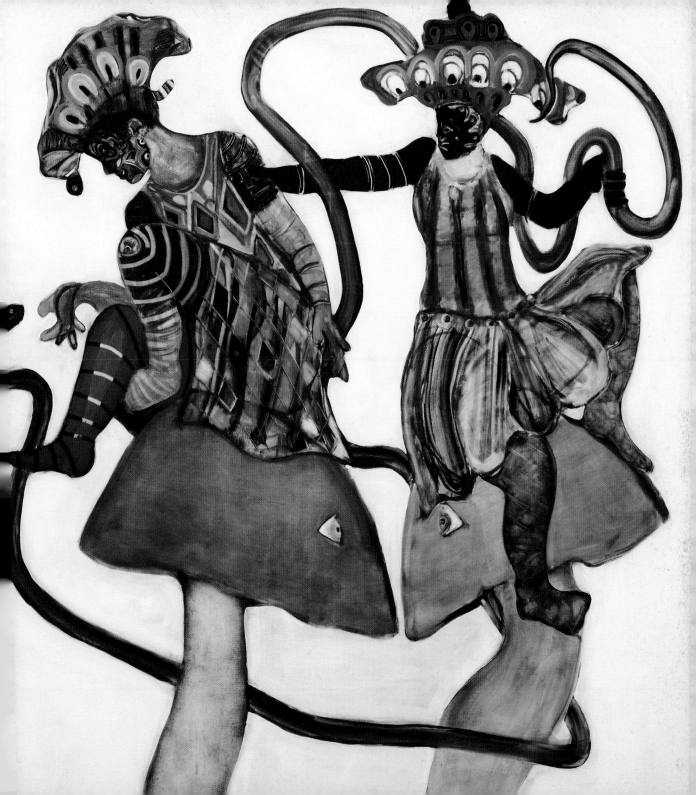

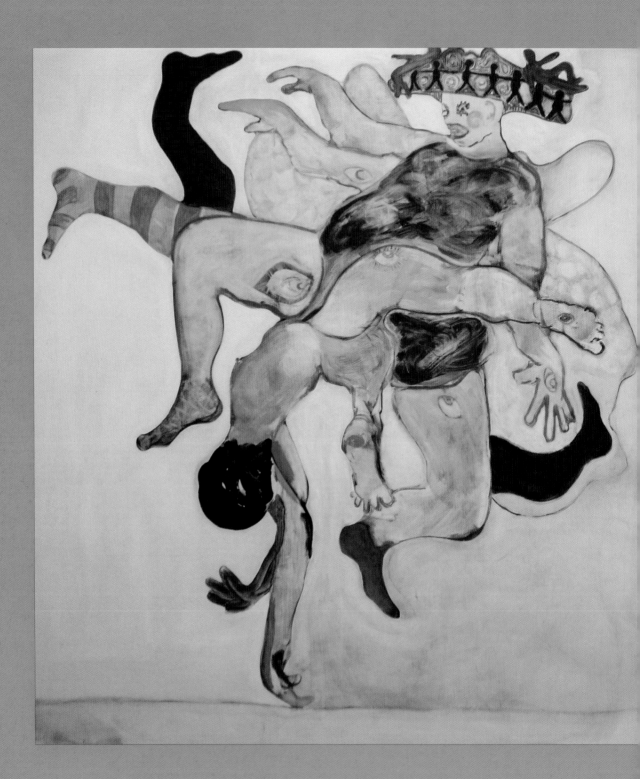

EMPRESS BUTTERFLY | 2007
Oil on linen | 200 × 180 см

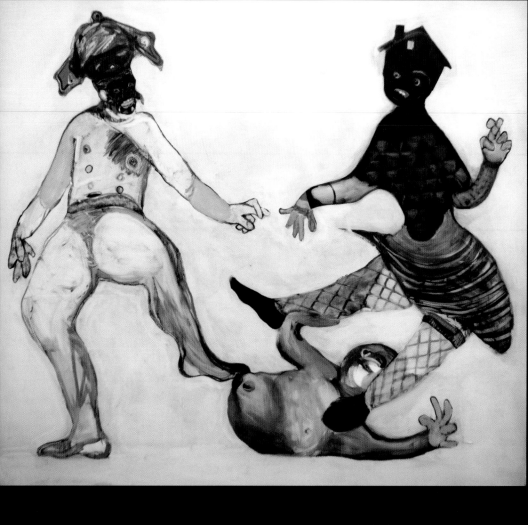

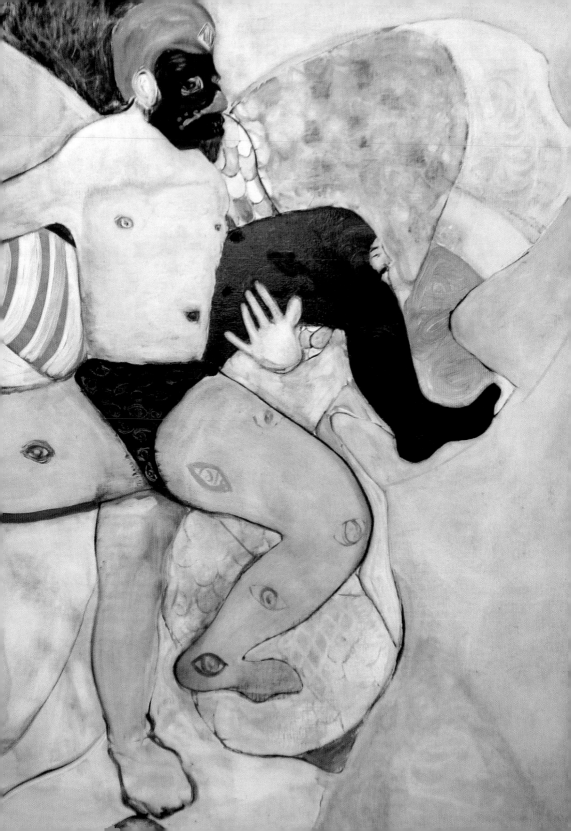

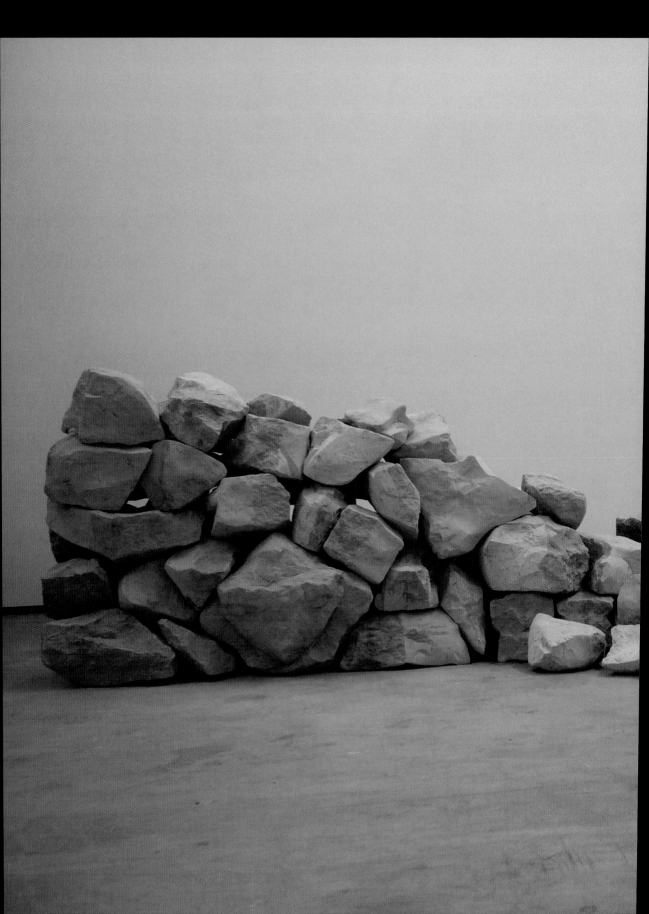

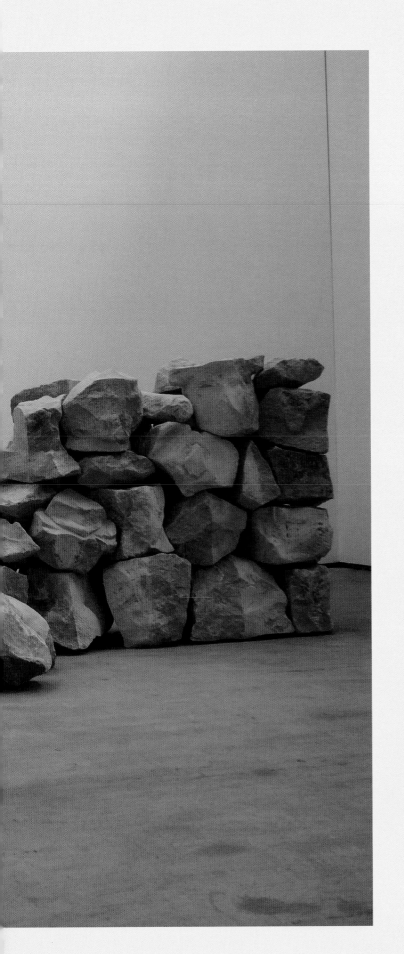

WALL

2006 | 125 carved limestone rocks | Dimensions variable

One side of each stone is hand carved to be symmetrical
to its other naturally formed side

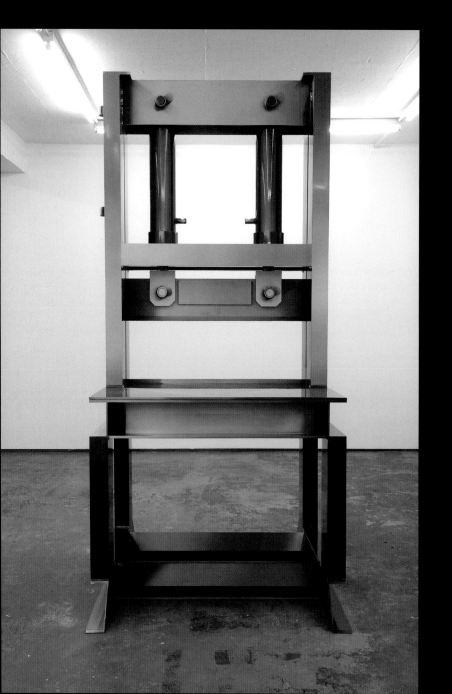

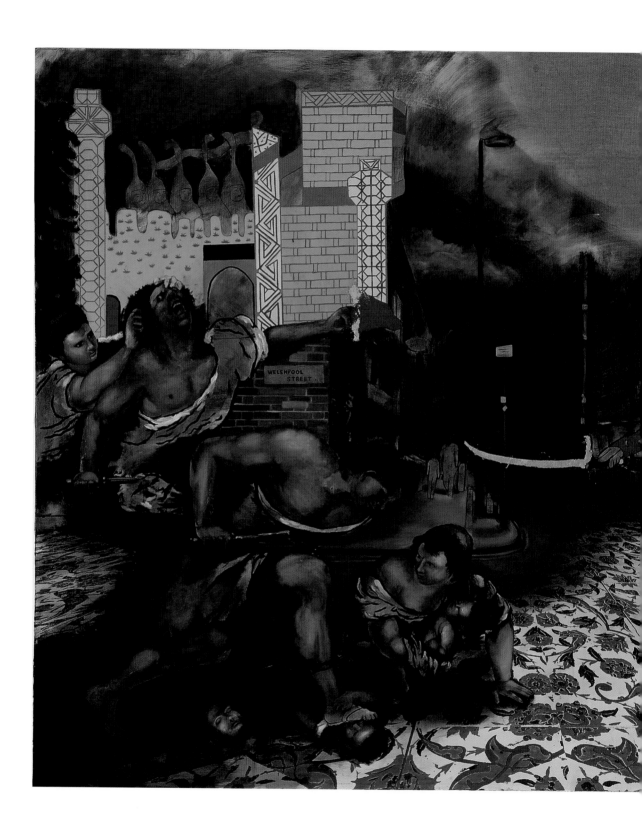

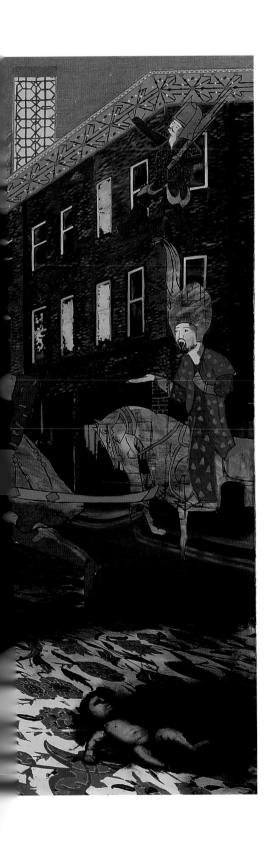

UNTITLED | 2007
Oil paint, gold leaf and screen
print on linen
181 x 244 см

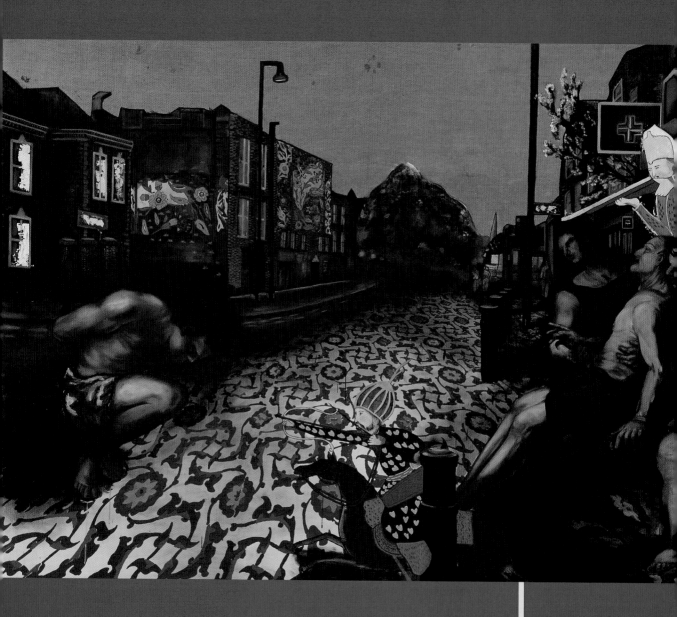

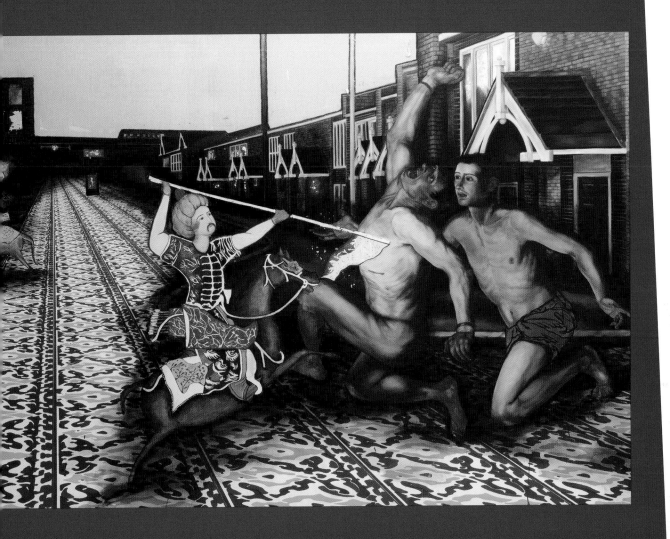

UNTITLED | 2008
Oil paint, tempera, gold leaf
and screen print on linen
173 × 244 см

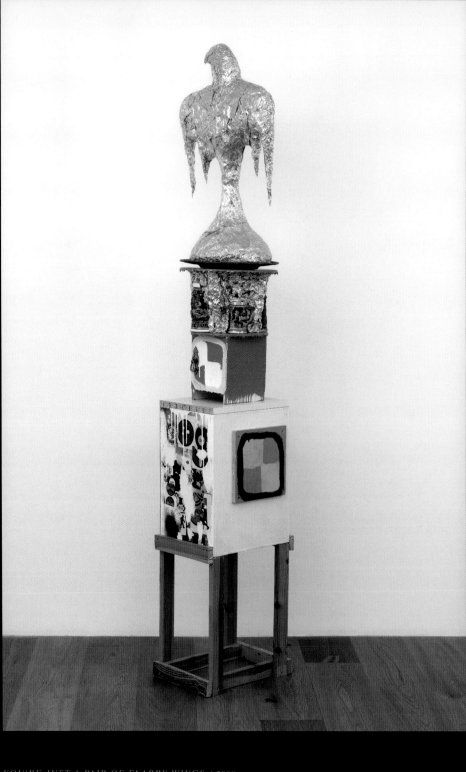

YOU'RE JUST A PAIR OF FLABBY WINGS | 2008
Aluminium foil, timber gloss paint.
German beer mugs, brass, customised plinth

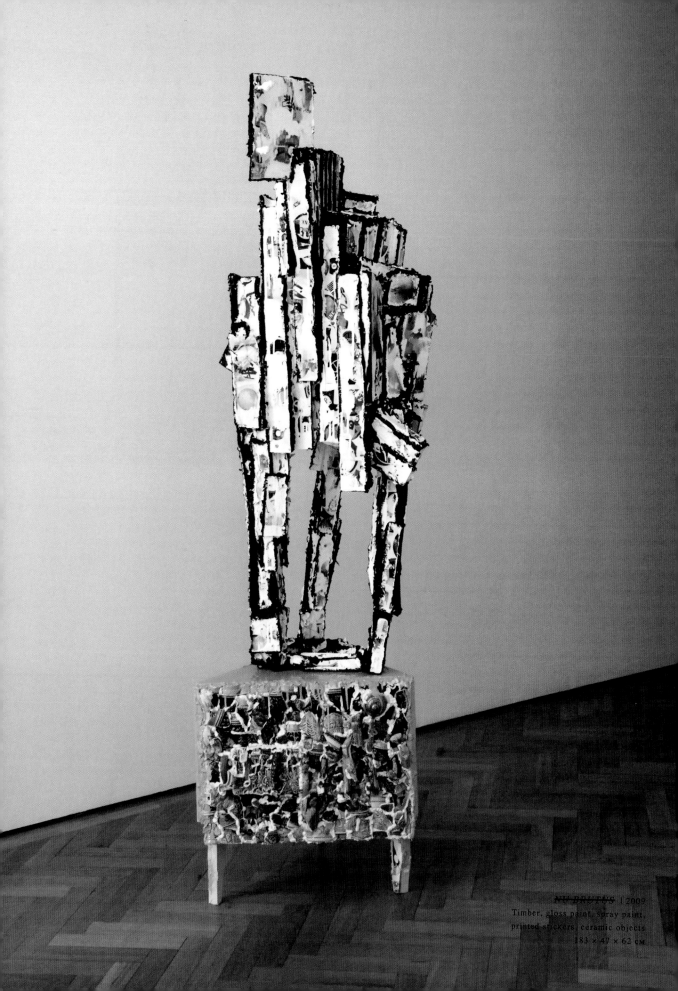

NU BRUTUS | 2009
Timber, gloss paint, spray paint,
printed stickers, ceramic objects
183 × 47 × 62 cm

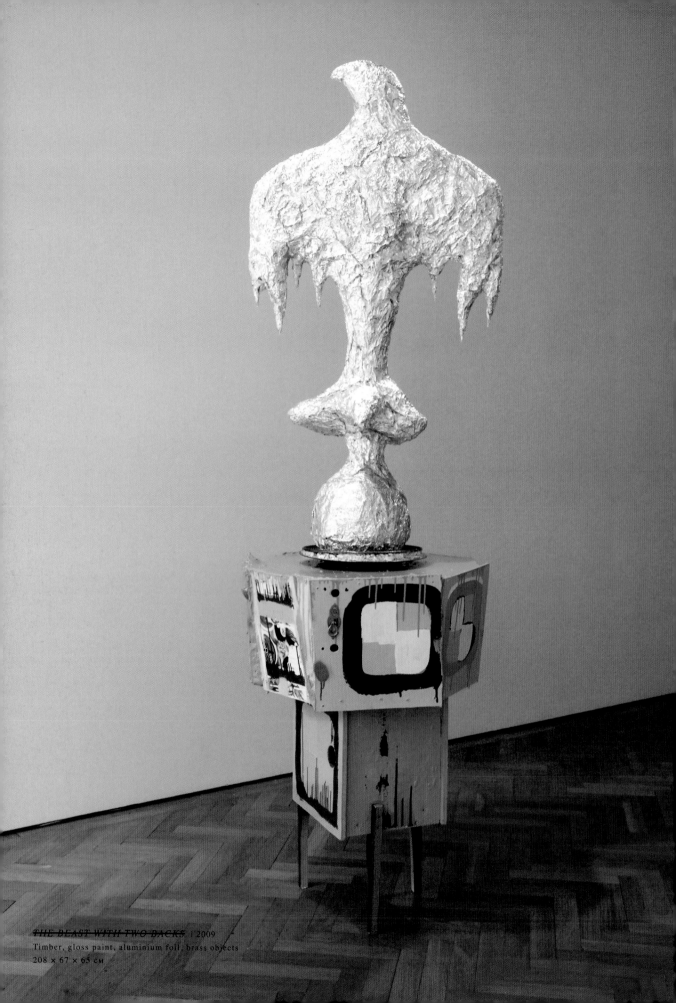

THE BEAST WITH TWO BACKS I 2009
Timber, gloss paint, aluminium foil, brass objects
208 × 67 × 65 см

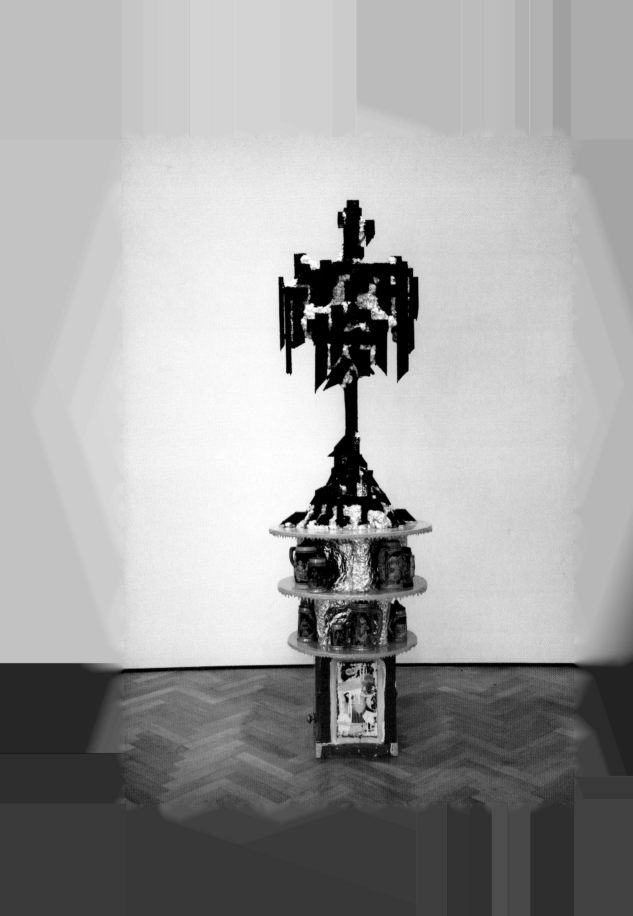

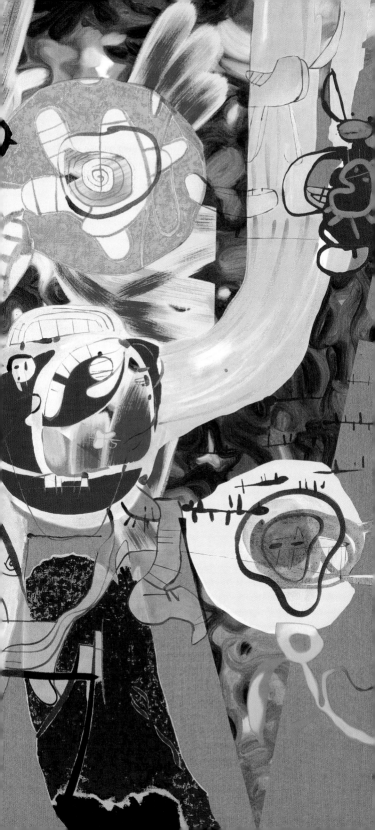

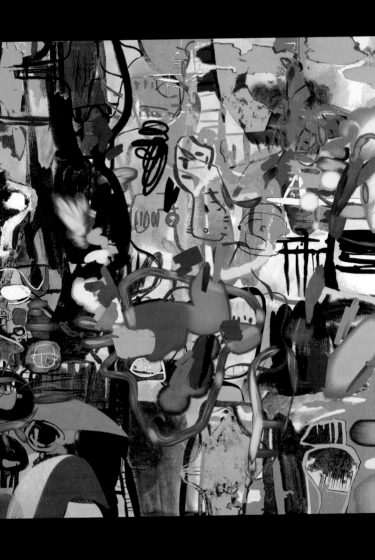

APPARITION | 2007
Oil and acrylic on linen
183 × 257 см

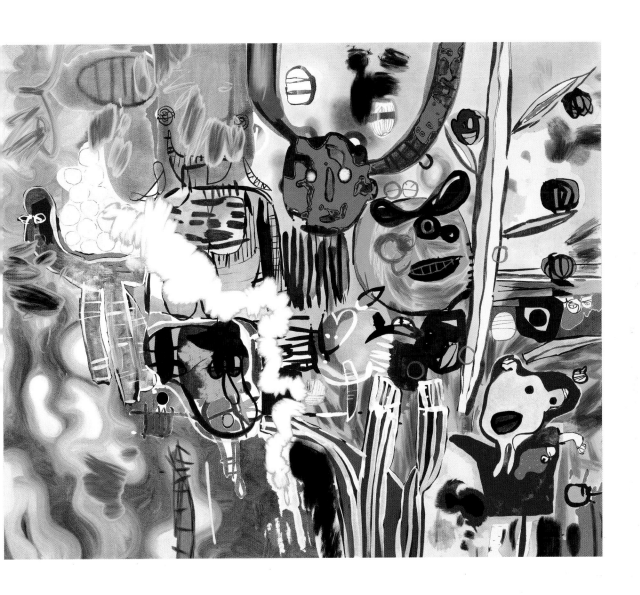

HUNG OUT | 2005
Oil and acrylic on linen
183 × 213 см

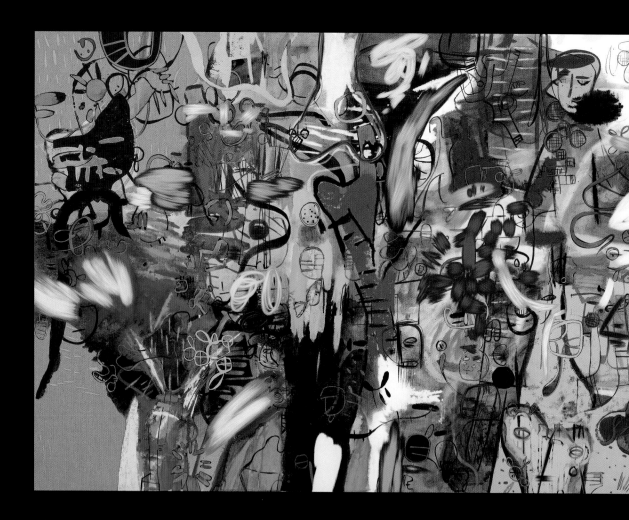

UPROAR | 2007
Oil and acrylic on linen
183 × 257 см

VILLAGE | 2007
Oil and acrylic on linen
183 × 257 см

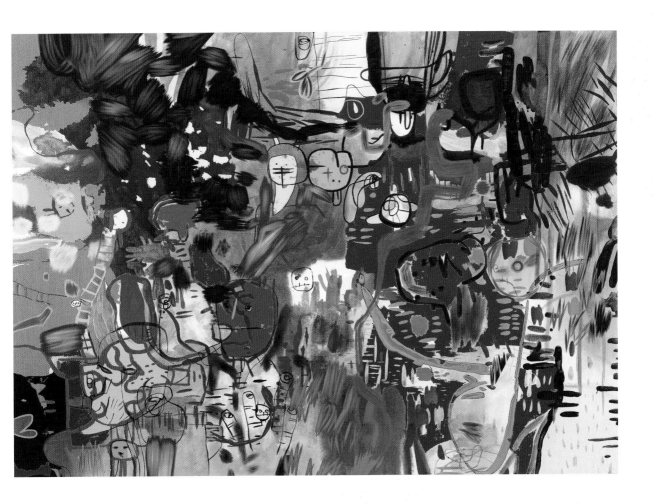

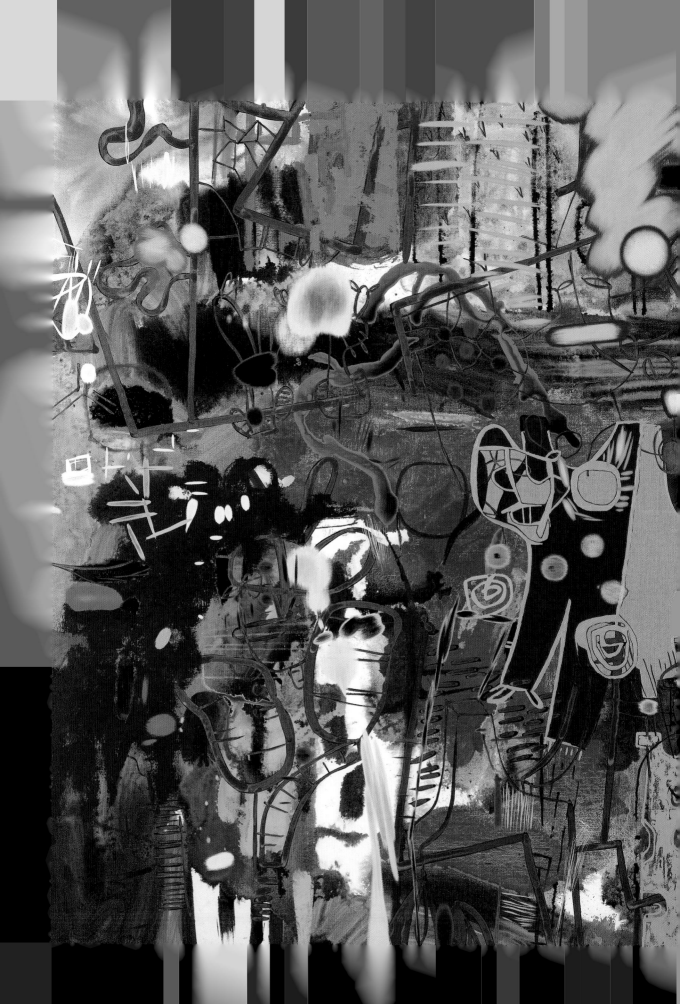

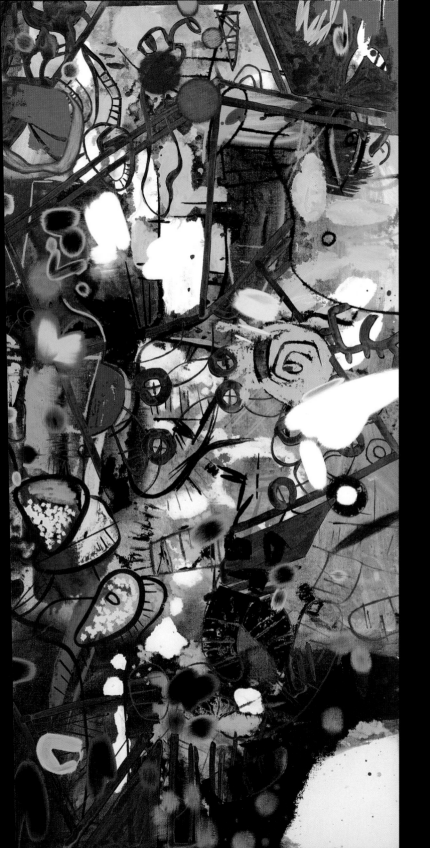

ALE
Oil a
183 x

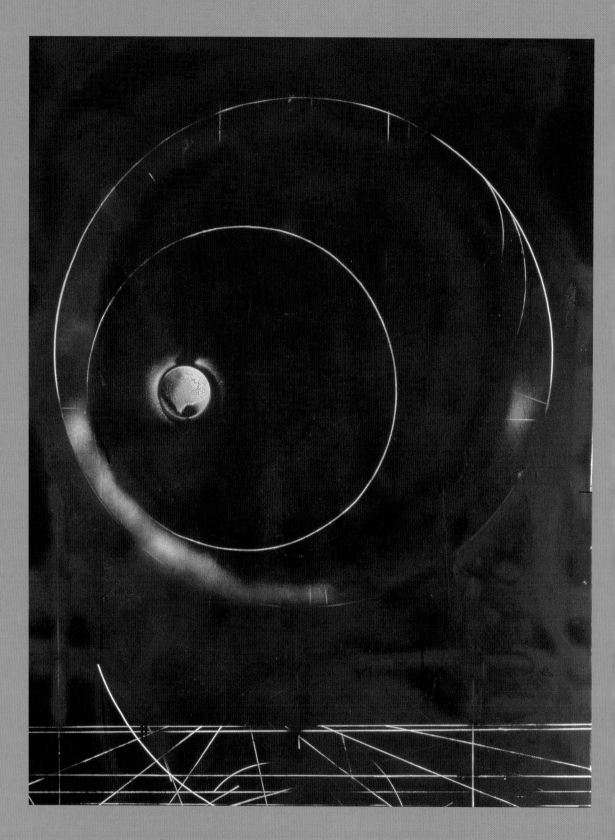

THE CALL | 2005
Mixed media on canvas | 122 × 92 см

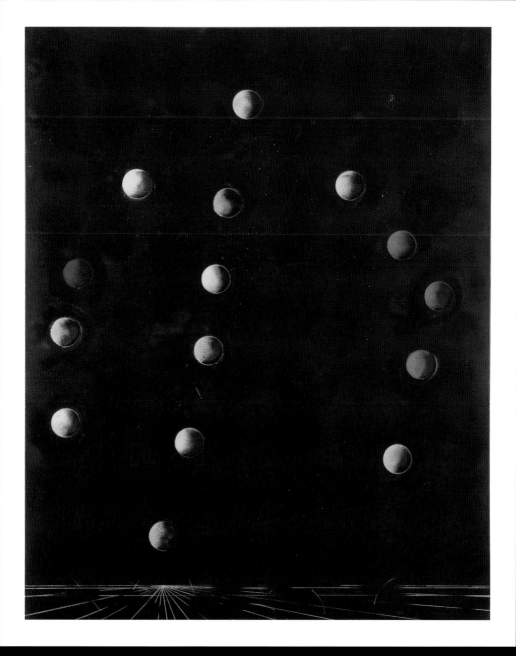

SLAB BLOCK | 2005
Mixed media on canvas
122 × 91 см

OD SUCKER | 2005
d media on canvas | 76 × 61 см

TUNNEL | 2005
Mixed media on canvas
76 × 76 см

VILLAGE HOUSE | 2005
mixed media on canvas
102 × 127 см

THE HEARING FOREST AND THE SEEING FIELD | 2006
mixed media on canvas
180 × 150 см

NO-INI I 2009
Acrylic and varnish on board
99 x 123 cm

NO.163 | 2009
Acrylic and varnish on wood
25 × 24 см

NO.224 | 2009
Acrylic and varnish on board
121 × 122 см

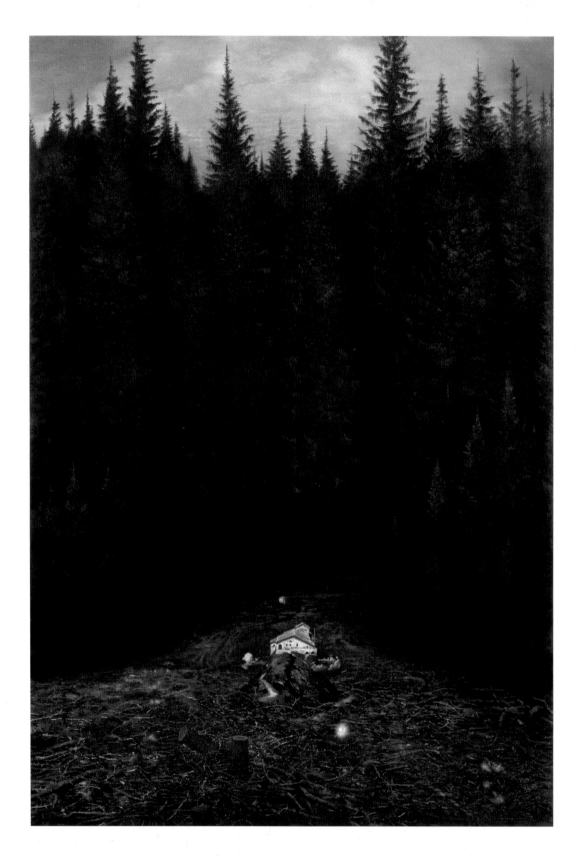

THE GHOST OF A MOUNTAIN | 2005
Oil on linen | 267 × 183 см

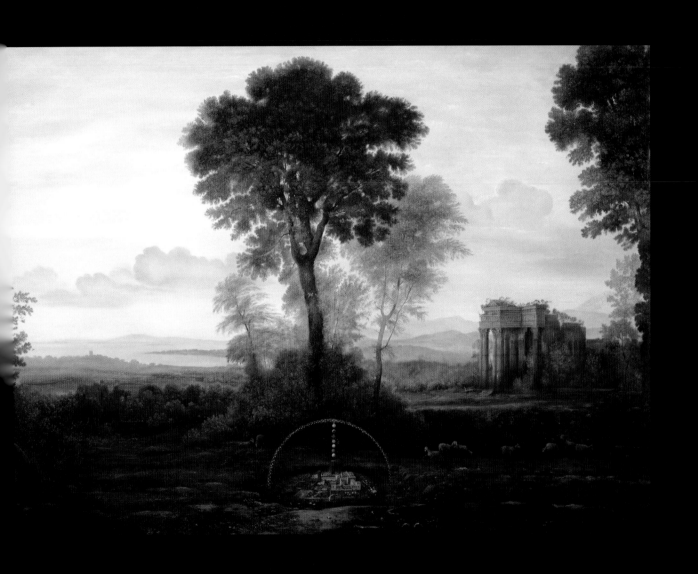

TRUE PEACE WILL PREVAIL UNDER THE RULE | 2004
Oil on linen | 183 × 250 см

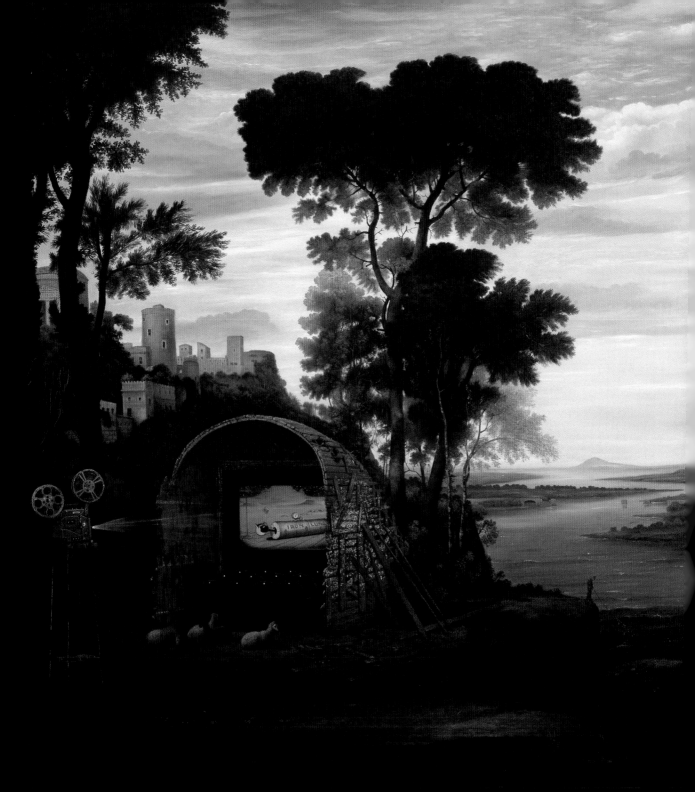

DREAMS OF PEACE AND LOVE GRADUALLY GIVING WAY
2006 | Oil on linen | 183 × 235 см

CAKE IN THE WILDERNESS | 2005
Oil on linen | 36 × 46 см

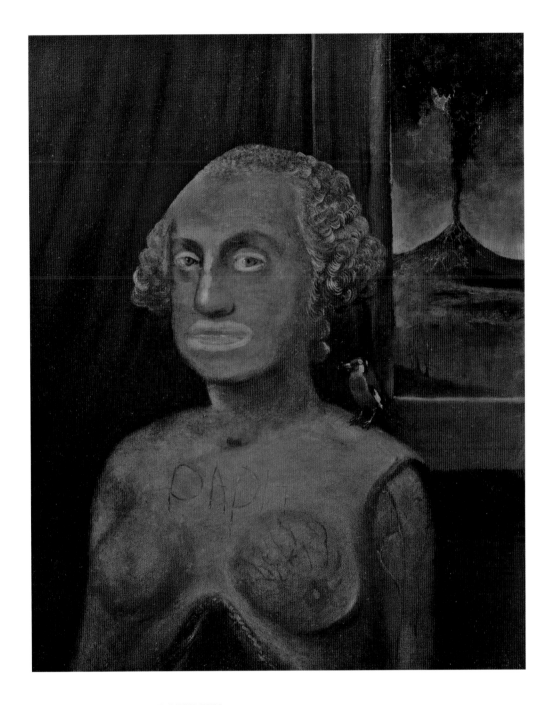

DAD WITH TITS | 2007
Oil on canvas | 60.5 × 48 см

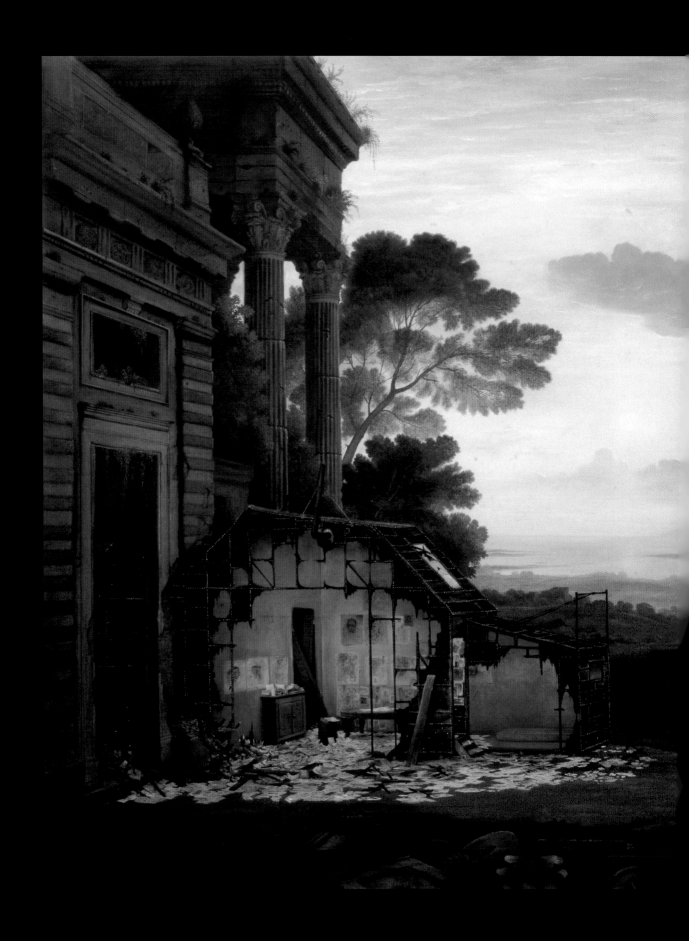

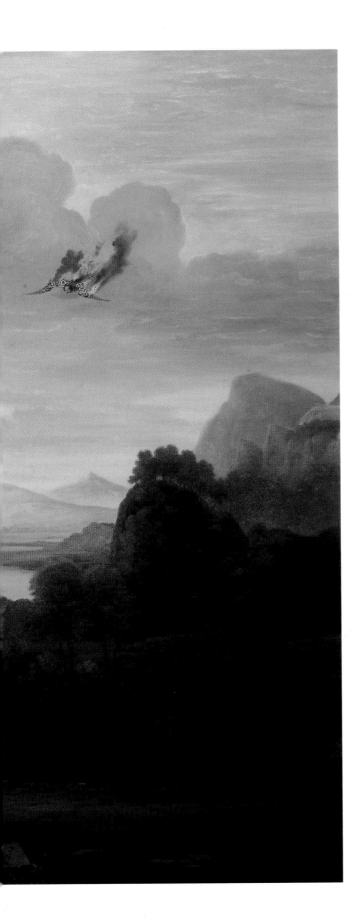

THE FALL | 2006
Oil on linen | 183 × 250 см

WINDOW, SMOKE, SQUARE | 2007
Marker pen and stickers on c-type print
34.7 × 29 см

PETE | 2007
Marker pen on C-type print
34.7 × 29 см

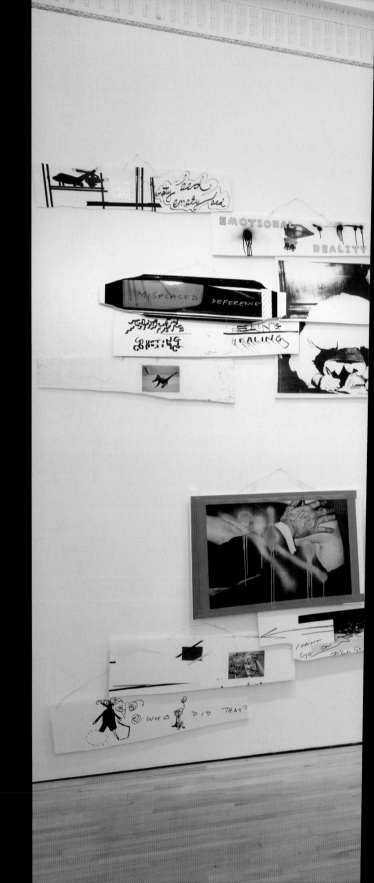

HE GETS EVEN HAPPIER | 2008
Mixed media | Dimensions variable
(63 components)

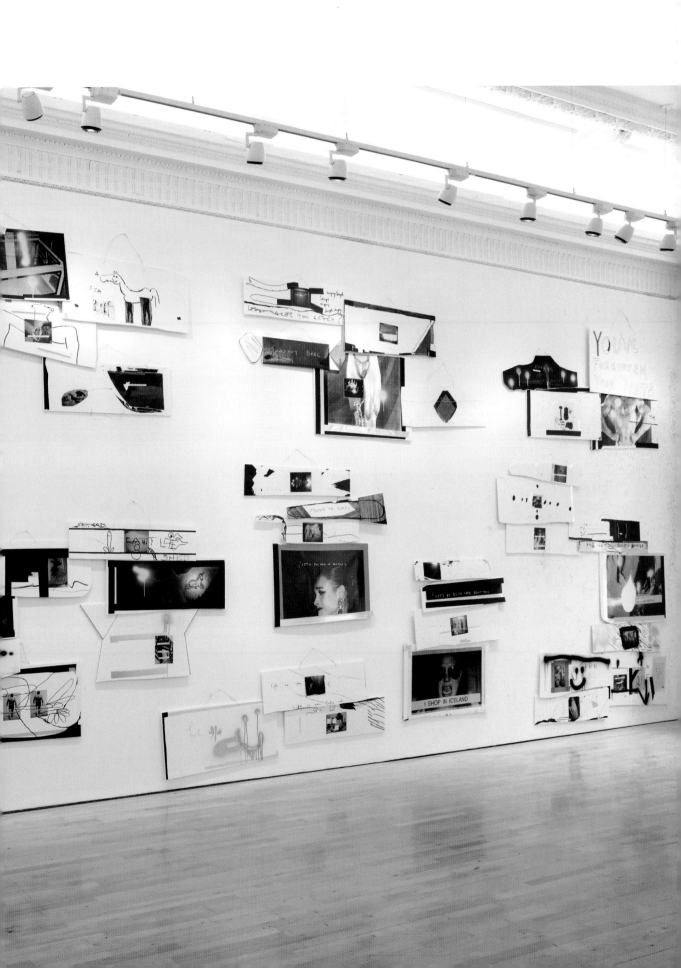

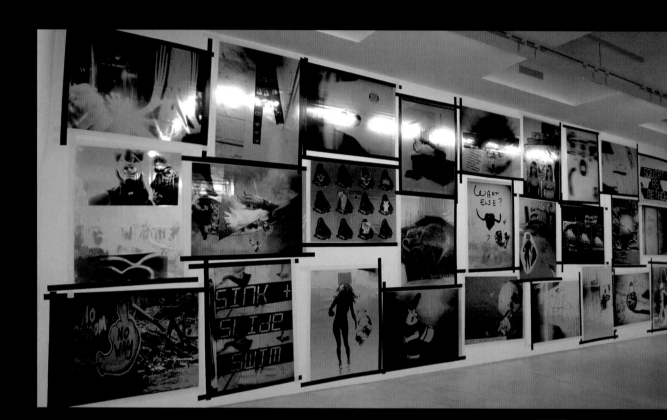

TAKE NO PHOTOGRAPHS, LEAVE ONLY RIPPLES
2009 | 27 Silver inkjet prints | each 84 × 120 см or 120 × 84 см

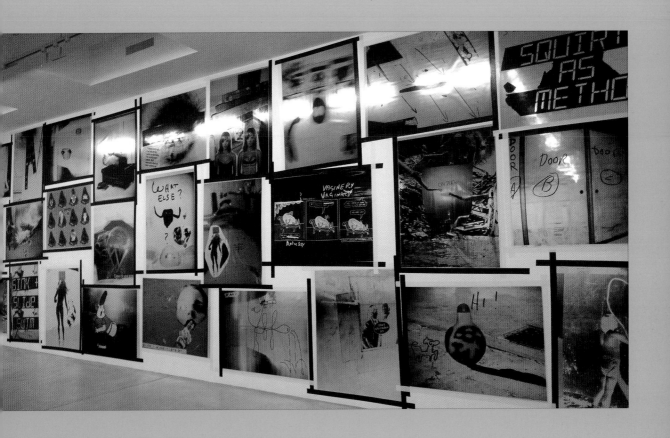

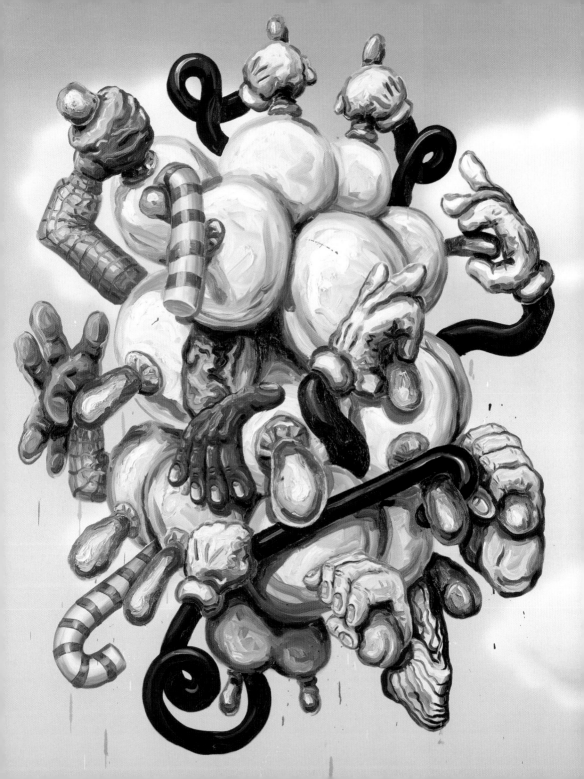

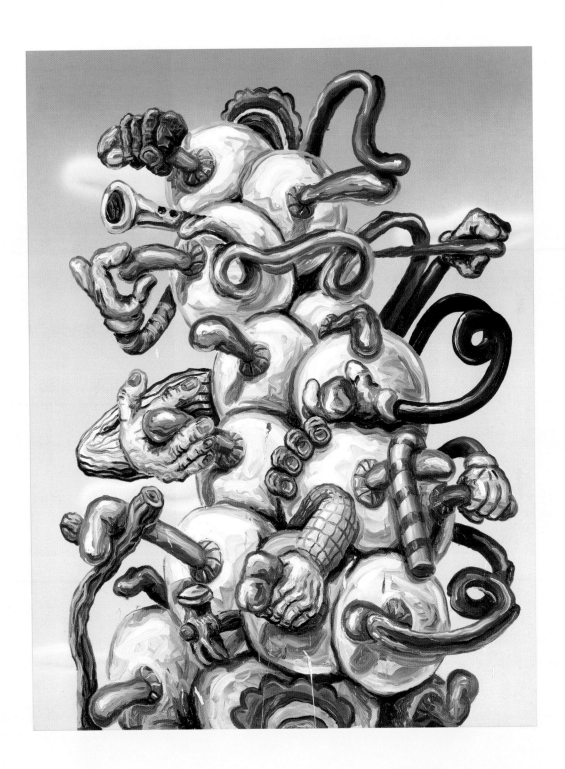

GREAT EXPECTATIONS | 2005
Oil and acrylic on canvas
198 × 152 см

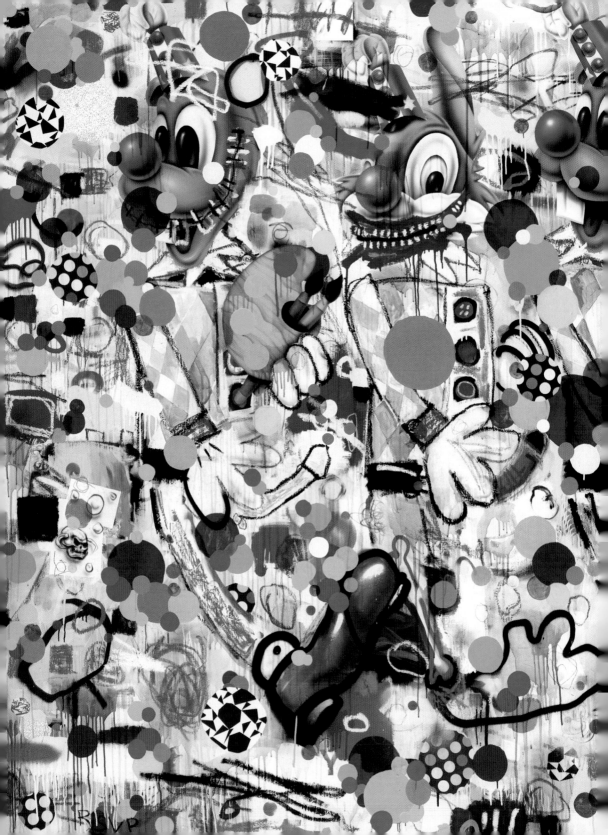

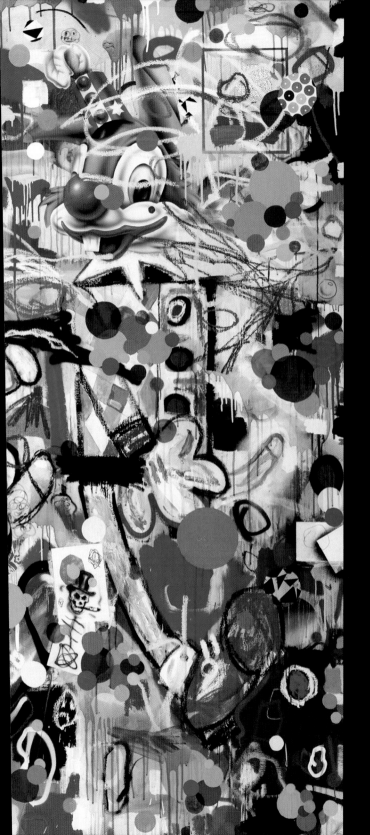

~~REAL SPECIAL~~
~~VERY PAINTING~~ | 2009
Acrylic, oils, oil pastel, pencil,
crayon, collage, wrapping paper,
spray paint, varnish, gloss paint,
wax, charcoal, gloss paint,
marker pen on canvas
235 × 306 см

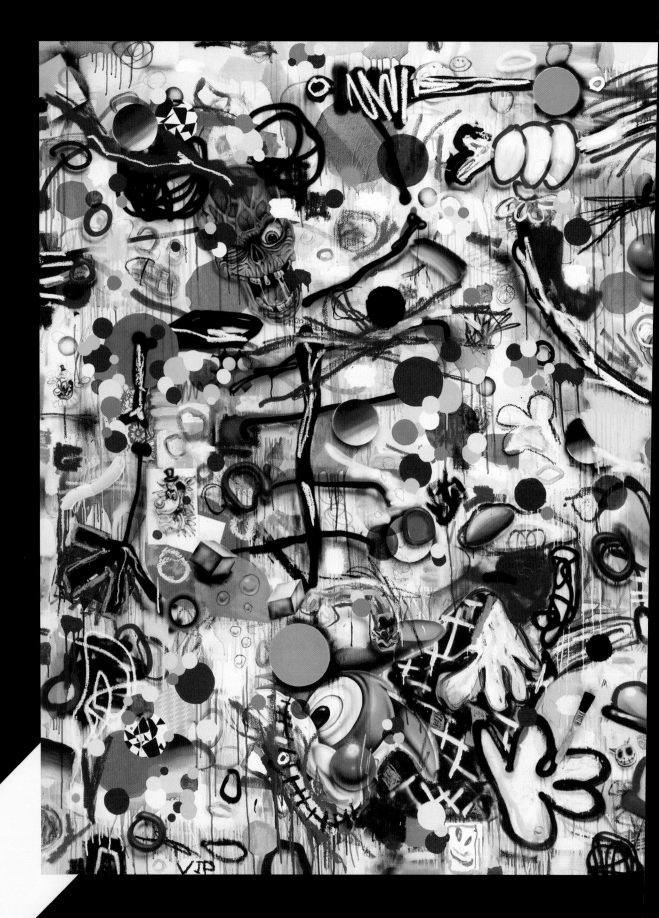

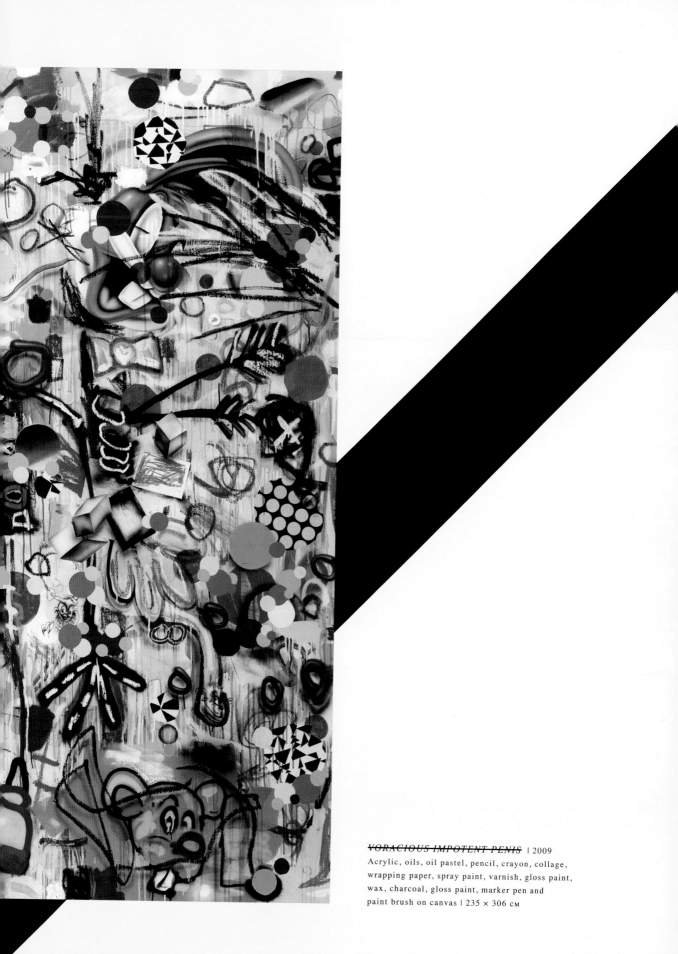

VORACIOUS IMPOTENT PENIS | 2009
Acrylic, oils, oil pastel, pencil, crayon, collage,
wrapping paper, spray paint, varnish, gloss paint,
wax, charcoal, gloss paint, marker pen and
paint brush on canvas | 235 × 306 см

TRIUMPH IN THE FACE OF ADVERSITY
2008 | Neon stick strip light, jesmonite,
ply and gloss paint | 159 × 214 см

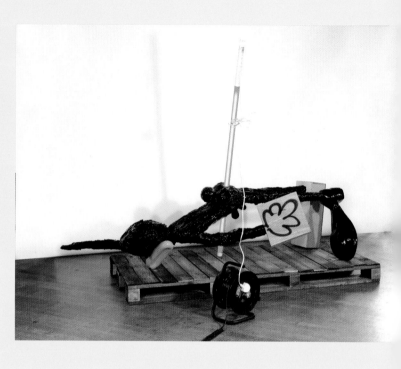

I'M A LEADER NOT A FOLLOWER | 2008
Neon stick strip light, jesmonite, ply and gloss paint
165 × 207 см

SNATCHING DEFEAT FR
THE JAWS OF VICTORY |
Neon stick strip light, jesmo
ply and gloss paint | 181 × 14

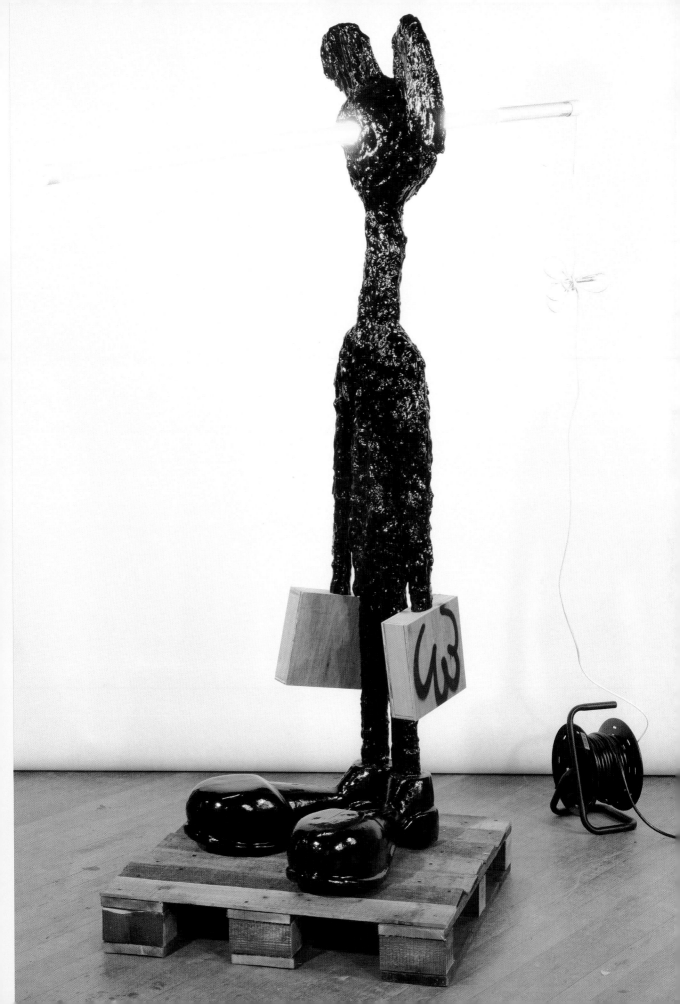

THE VISIT | 2005

Oil on canvas | 164

HOLIDAY | 2004
Oil on canvas
156.5 × 215 см

THE CRUISE
2004 | Oil on canvas

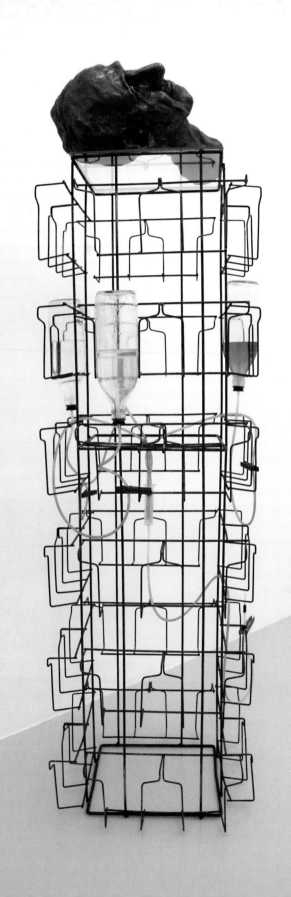

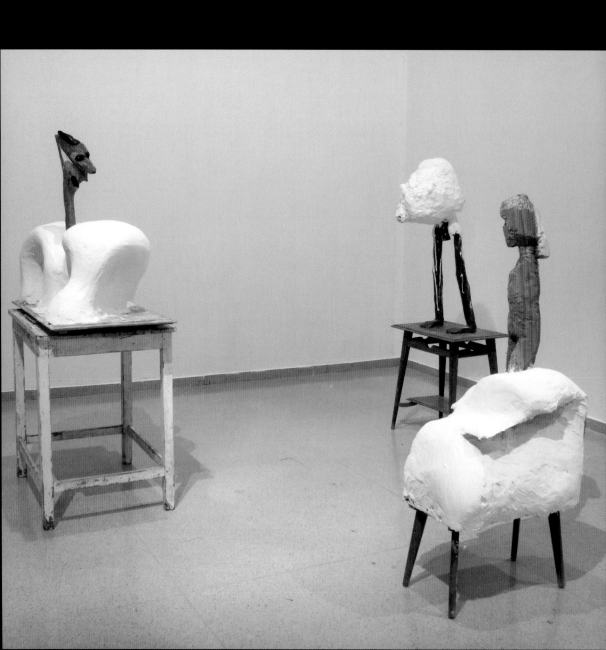

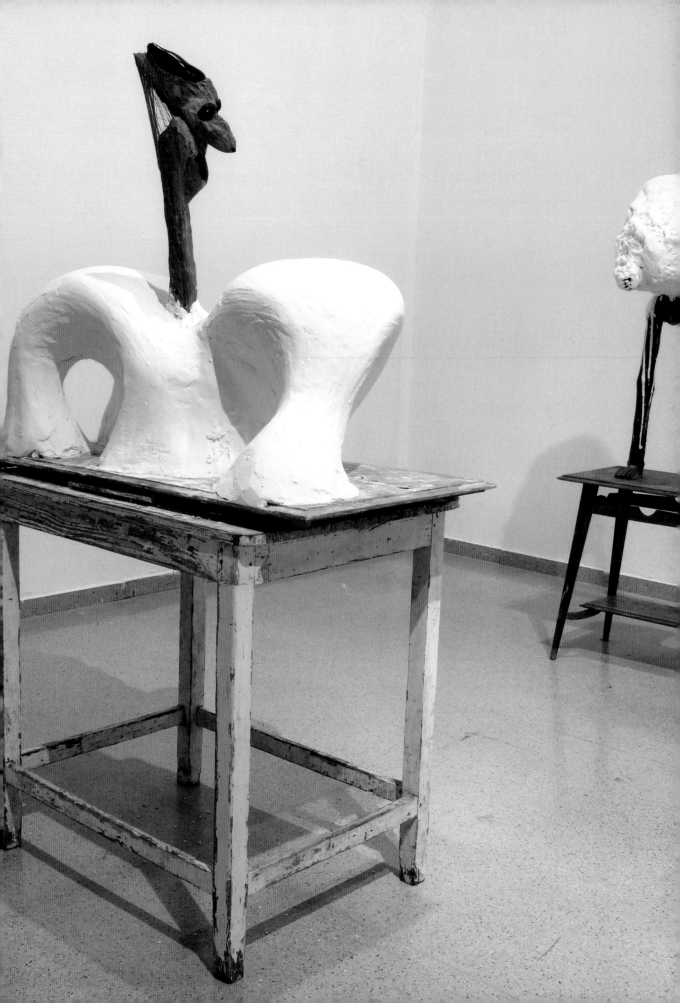

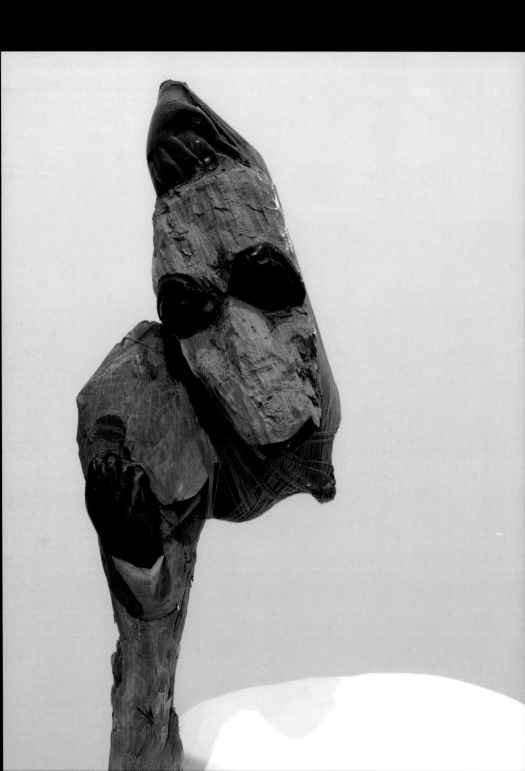

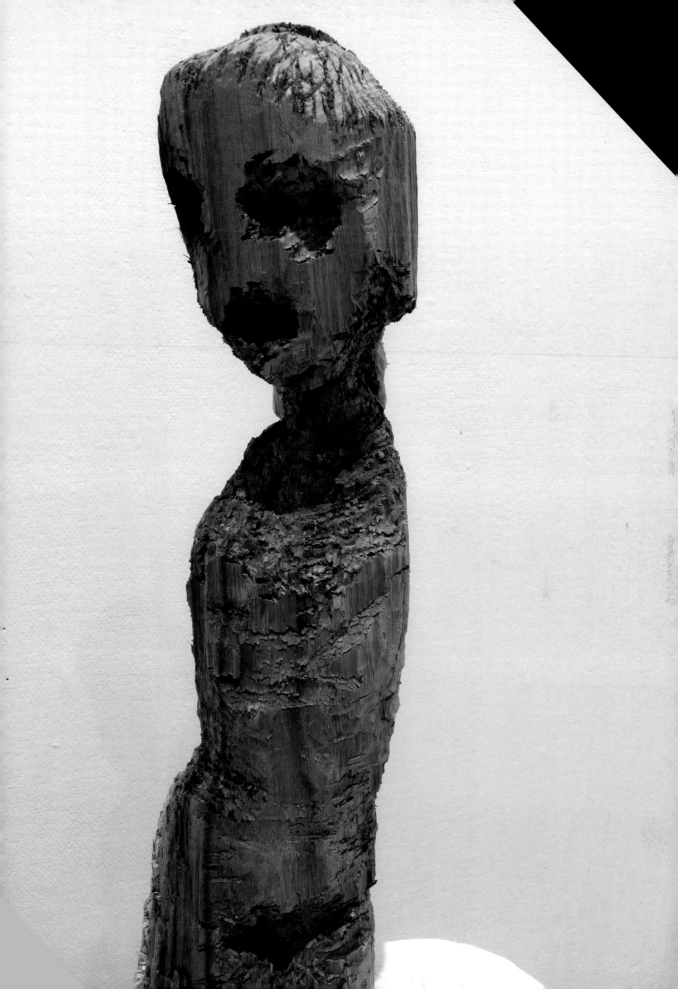

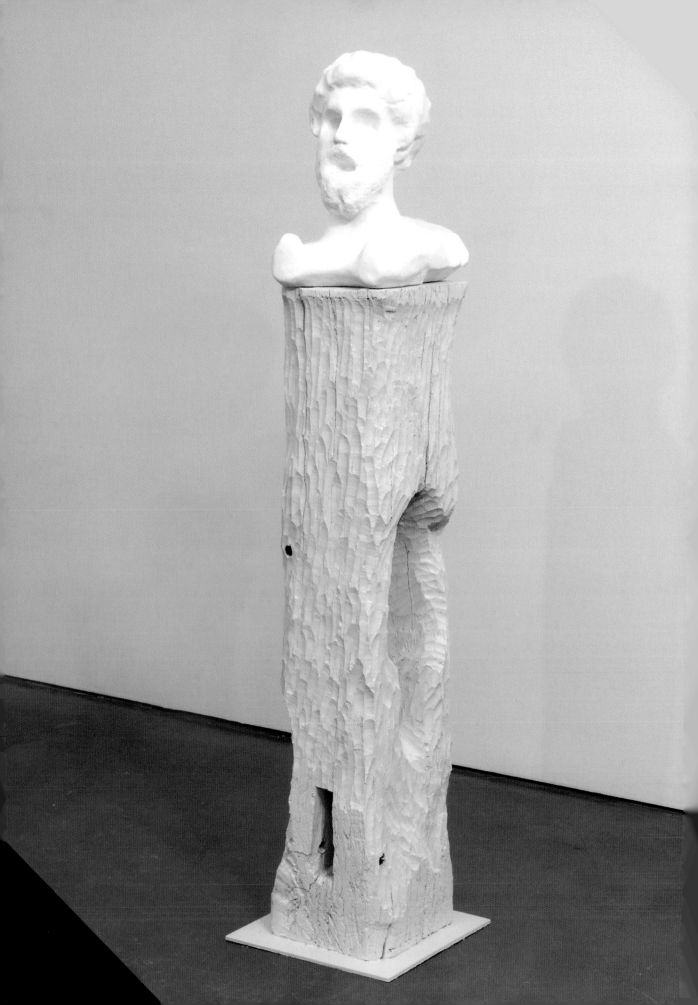

UNTITLED | 2008 | Wood, paint, steel base | 193 × 26 × 26 см

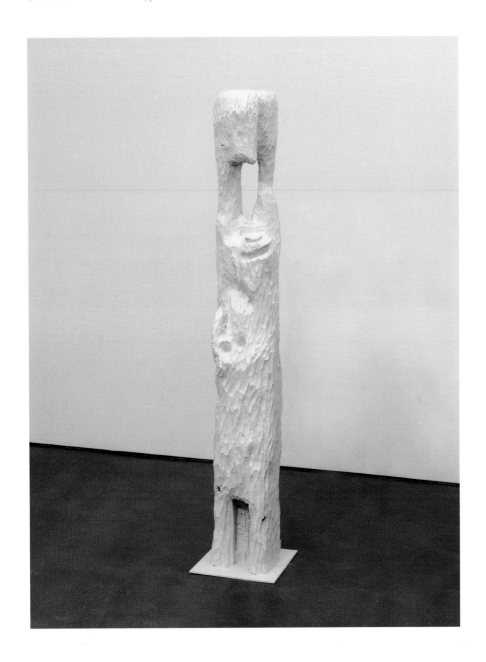

~TITLED | 2008 | Marble, wood, paint | 166 × 27 × 33 см

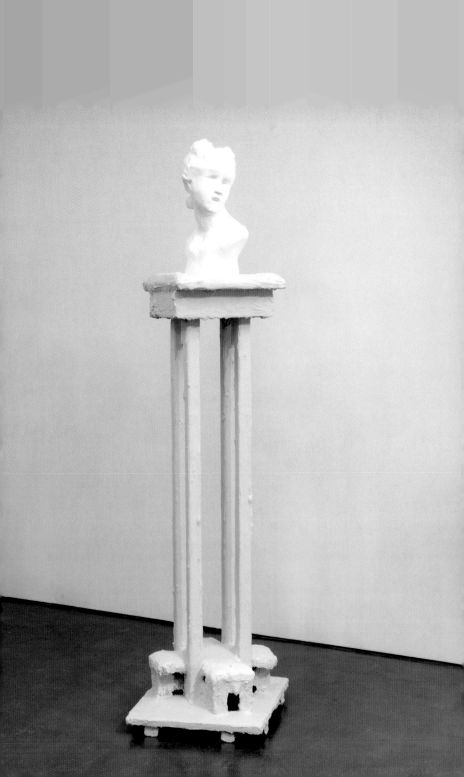

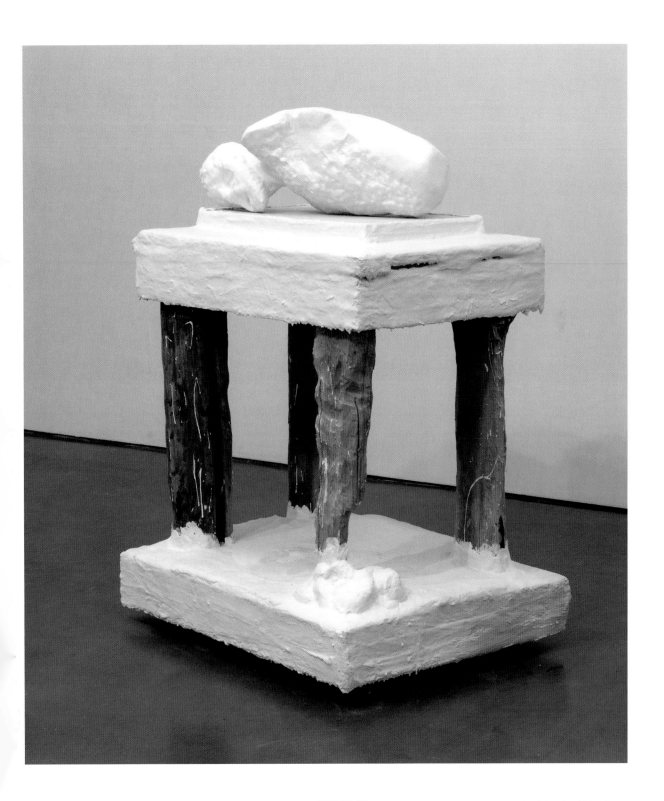

UNTITLED | 2008 | Marble, wood, plaster on wheels | 144 × 101 × 81 см

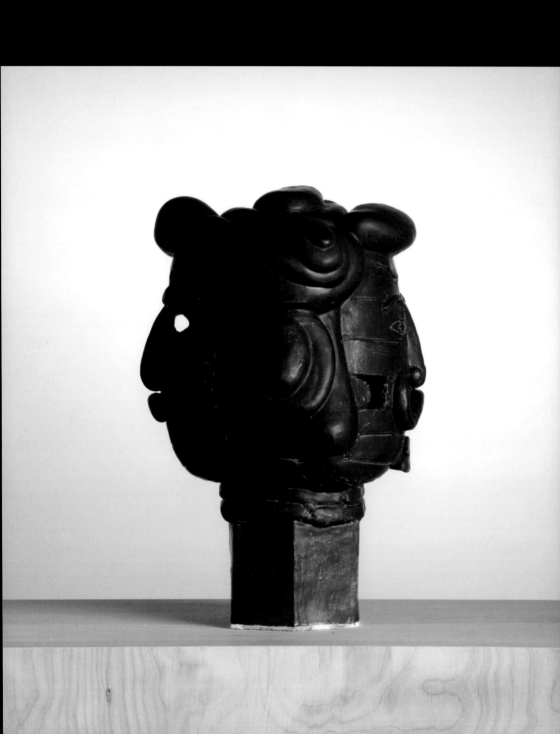

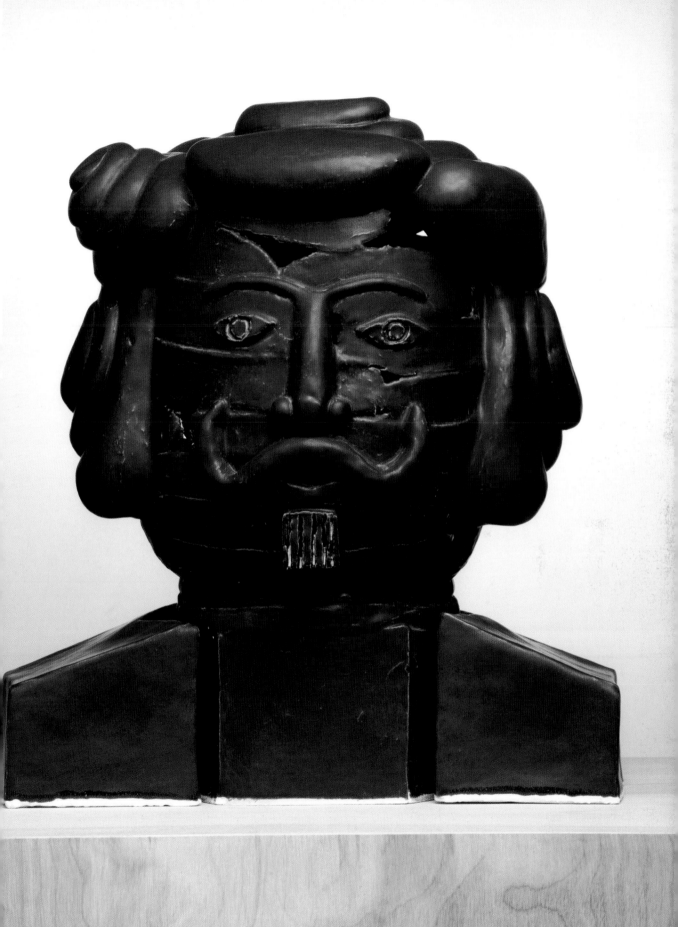

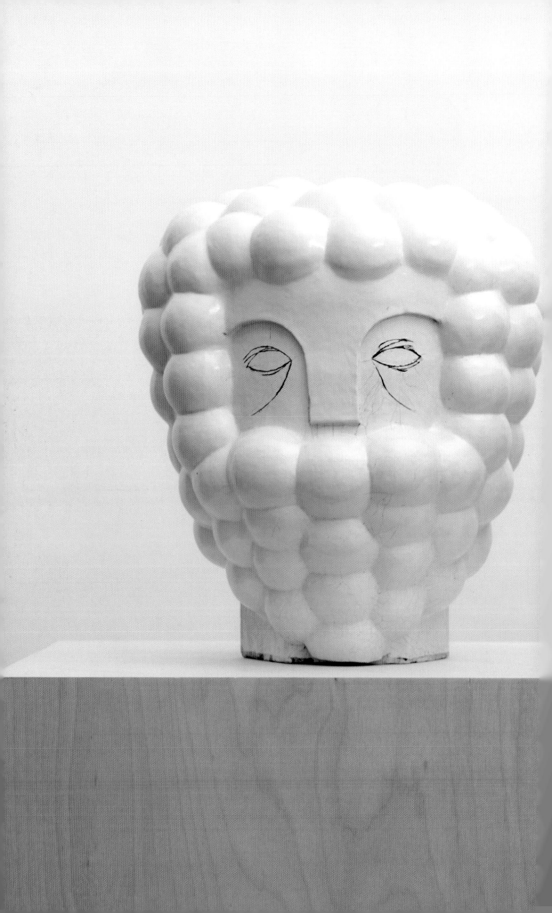

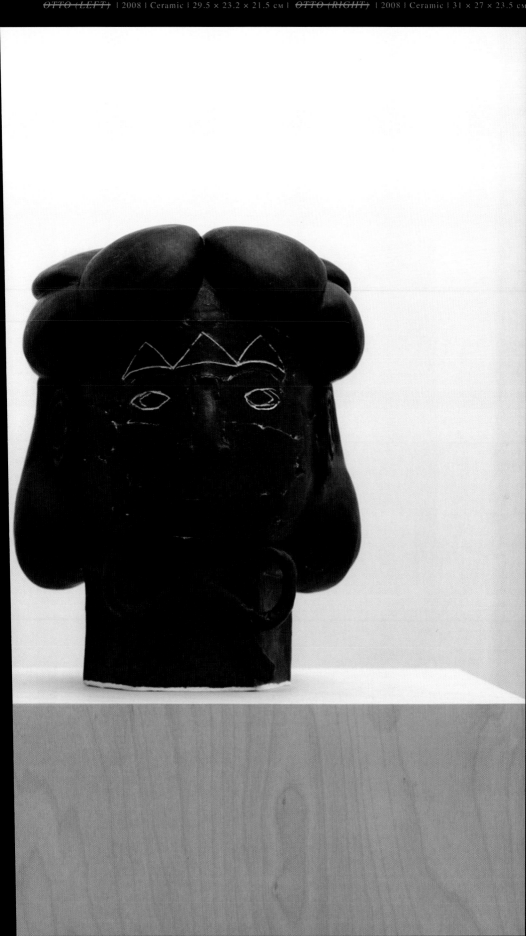

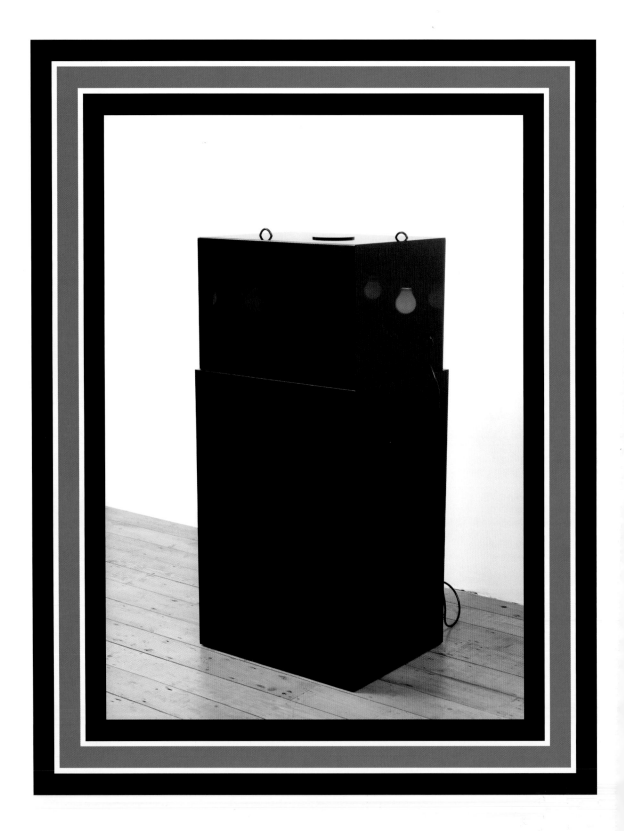

AND A DOOR OPENED..3. | 2007
Black perspex, electrical fittings, red lightbulbs,
polystyrene, concrete hardcore, wood cabling
130 × 66 × 54 см

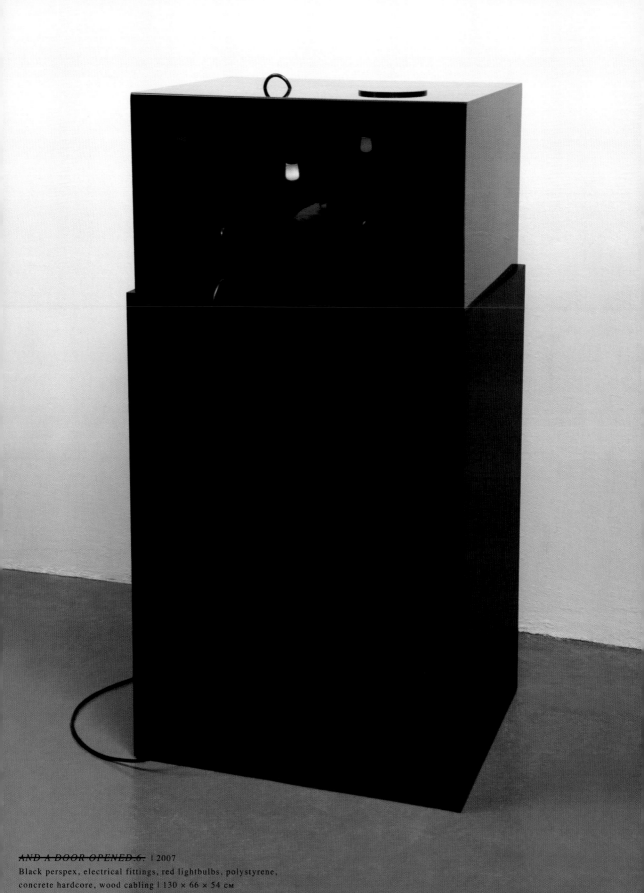

AND A DOOR OPENED.6. | 2007
Black perspex, electrical fittings, red lightbulbs, polystyrene,
concrete hardcore, wood cabling | 130 × 66 × 54 см

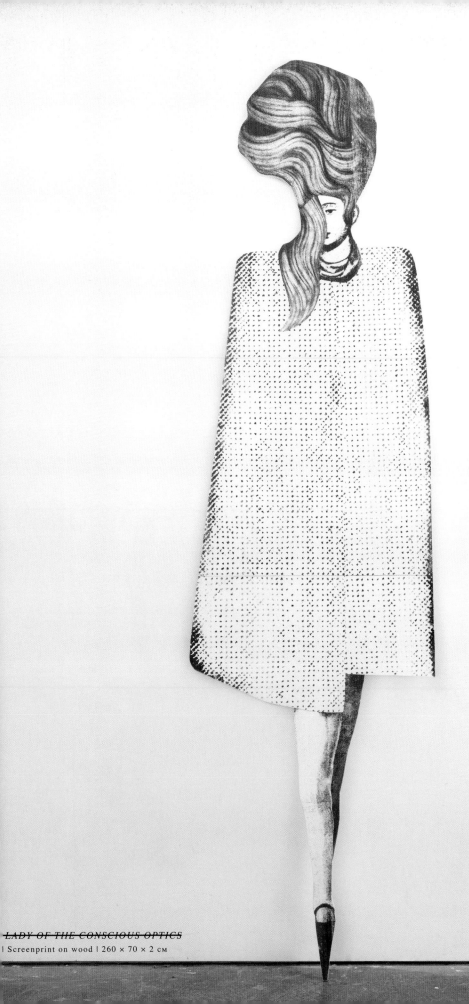

LADY OF THE CONSCIOUS OPTICS
| Screenprint on wood | 260 × 70 × 2 см

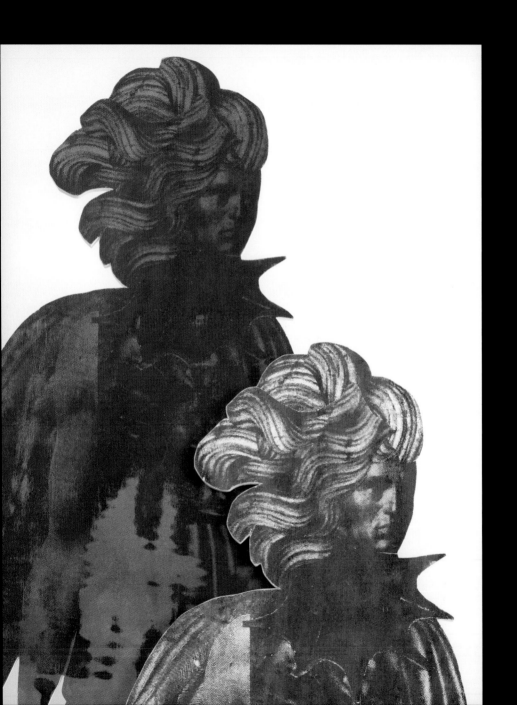

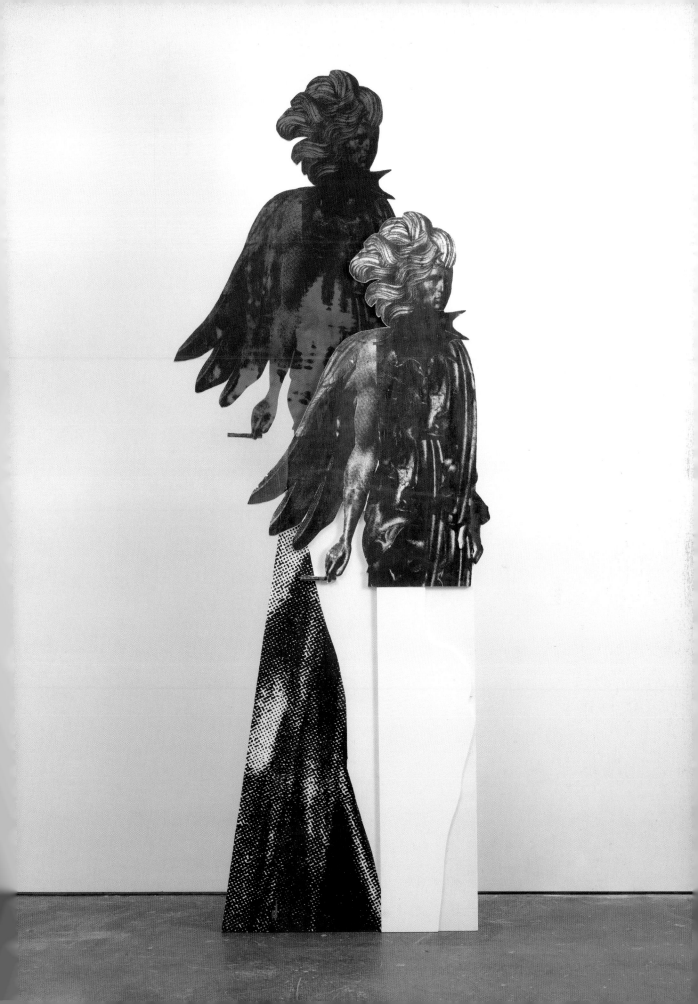

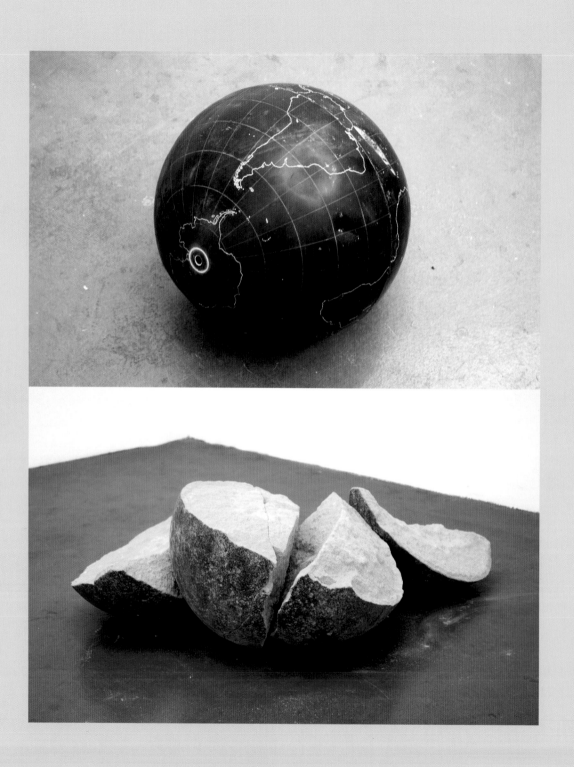

UNTITLED (INSTALLATION PART OF THE THANATOSIS OF OBJECTS SERIES)
2009 | Screen print suction plate, aluminium globe, concrete | Dimensions variable

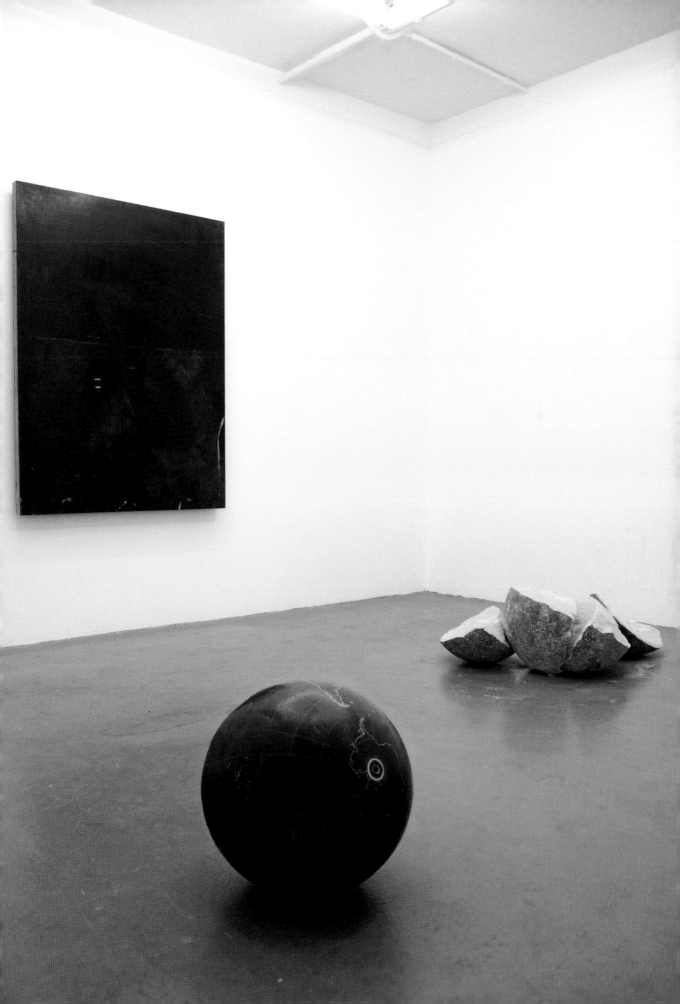

MAEGHT I | 2007 | Oil on linen | 122 × 183 см

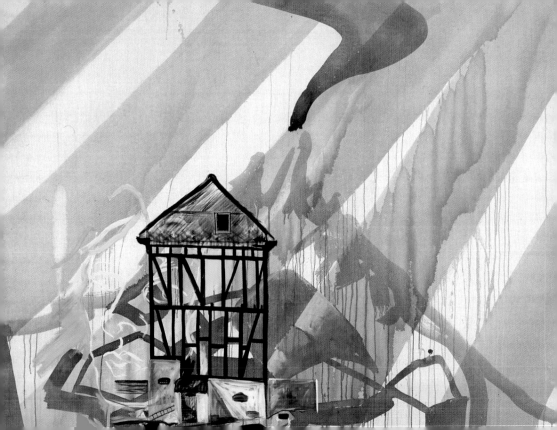

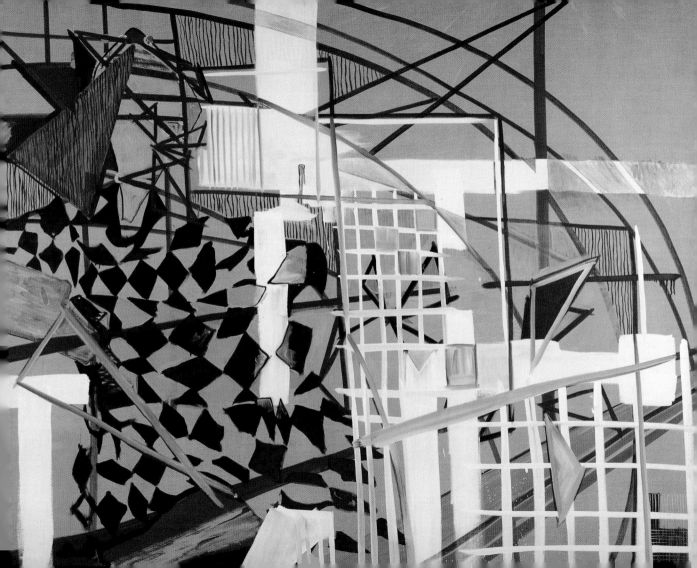

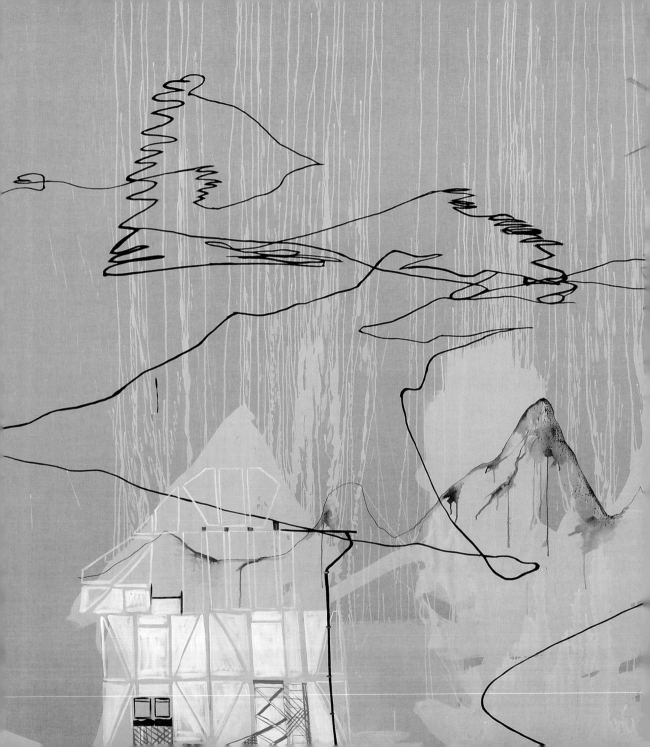

409 | 2008
Oil and gesso and ink on linen
244 × 335 см

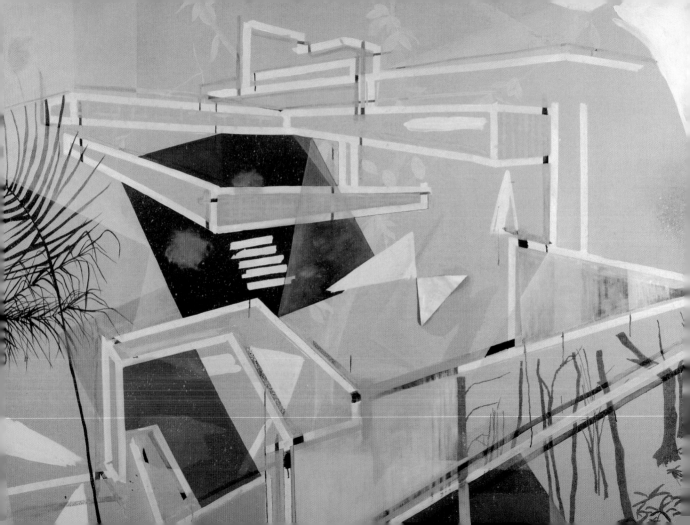

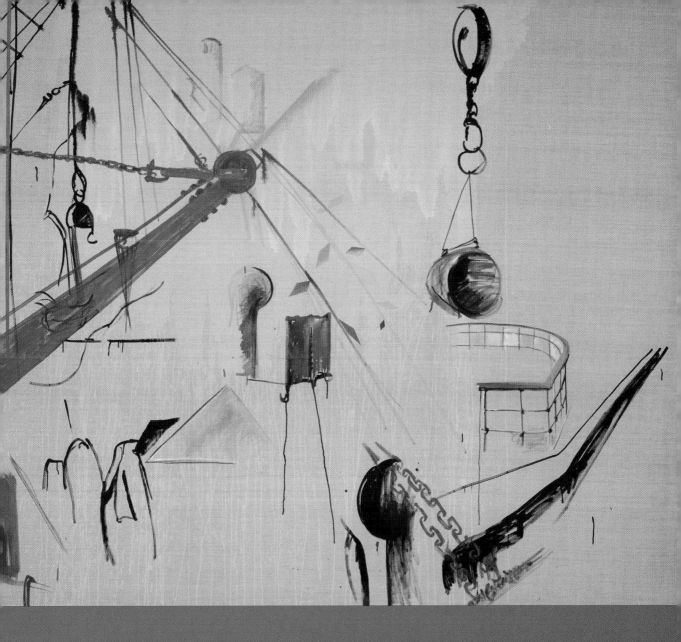

ERAL SCENES OF UNLOADING
Oil on linen | 199 × 250 см

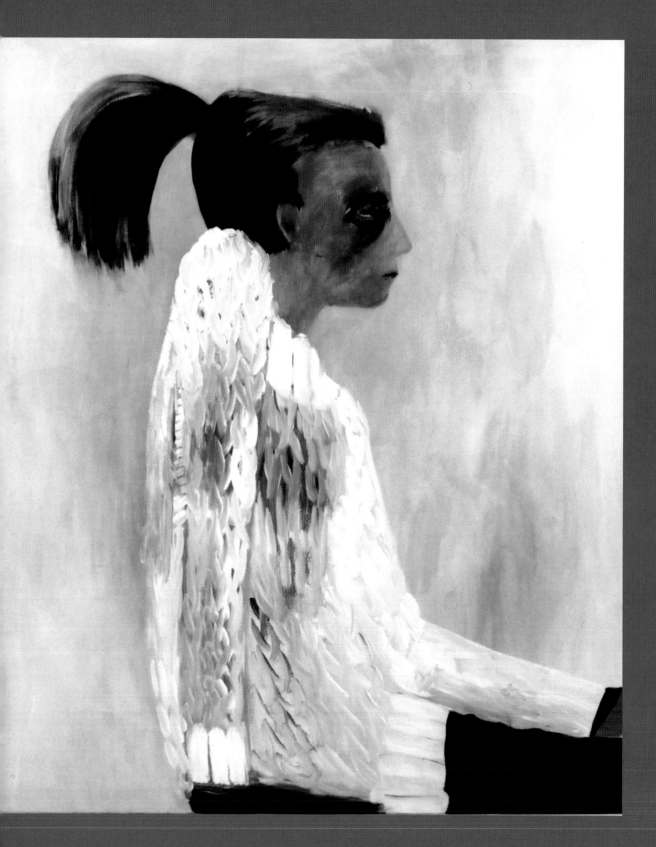

GIRL | 2005 | Oil on canvas | 147.5 × 122 см

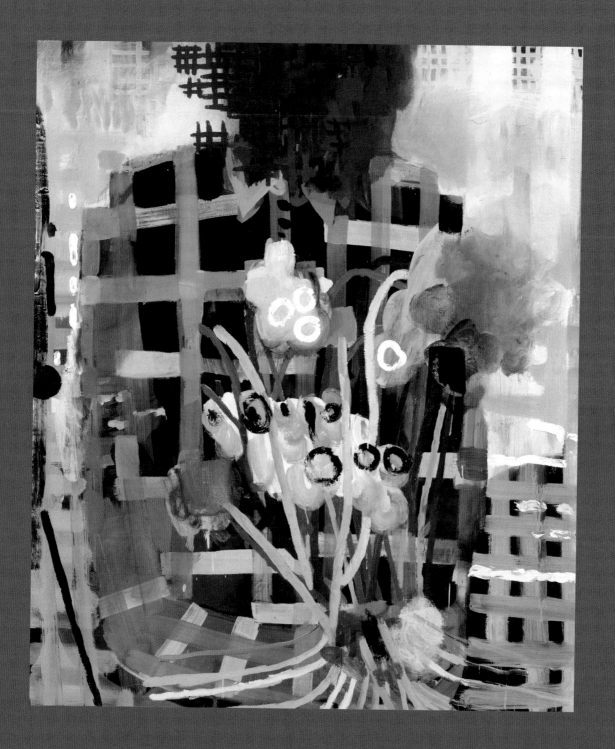

MAN WITH FLOWERS | 2007 | Oil on linen | 138 × 118 см

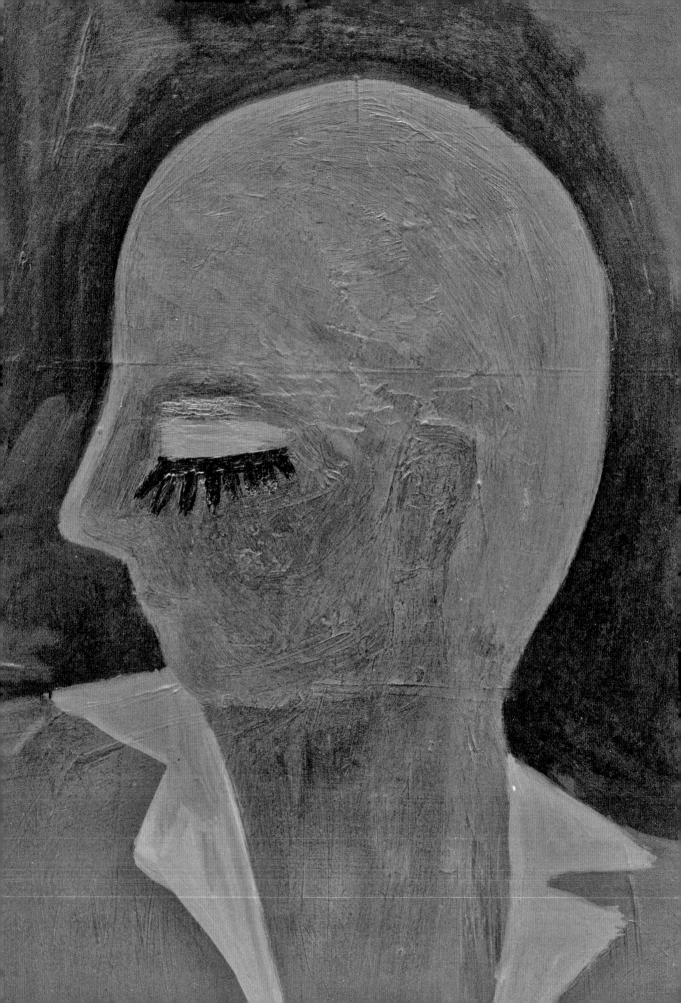

SOFT PERSON | 2008 | Gold leaf and acrylic on canvas | 220 × 185 см

DESK | 2008
Oil, aluminium leaf and spray paint on linen
183 × 153 см

DESK | 2008
Oil, aluminium leaf and spray paint on linen
183 × 153 см

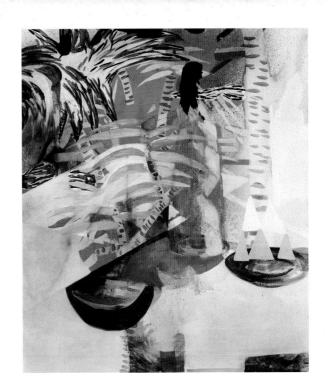

DAY | 2007
Acrylic on canvas
145 × 125 см

VIEW | 2006
Acrylic and oil on linen
122 × 97 см

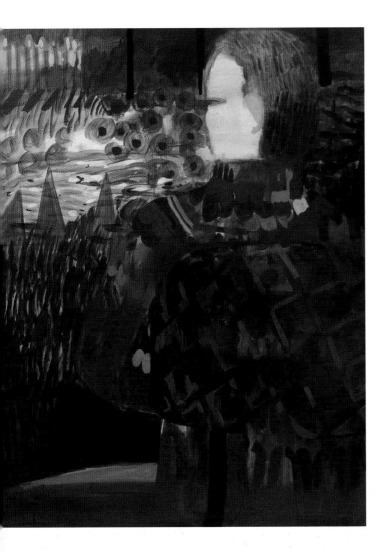

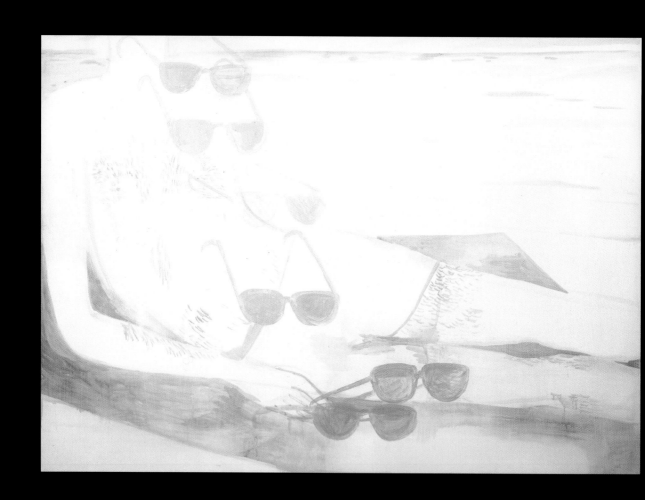

FALLING SUNGLASSES | 2007 | Oil on canvas | 120 × 170 см

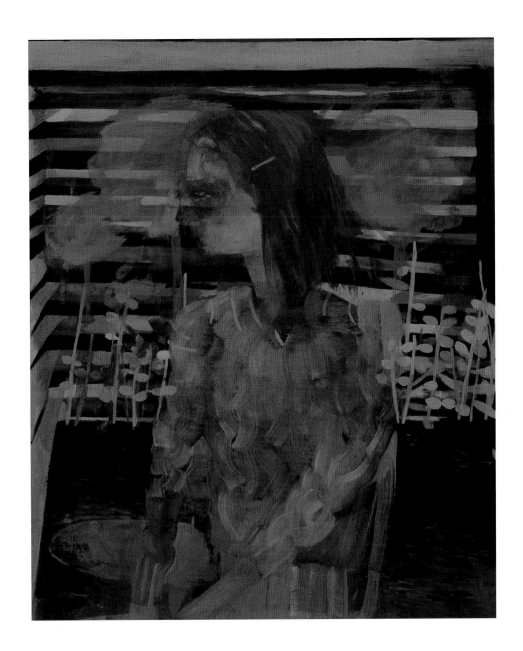

UNTITLED | 2006 | Oil, acrylic and graphite on canvas | 147.5 × 122 см

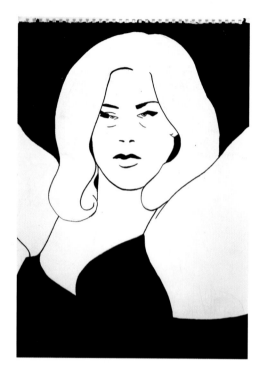

DORS | 2000 | Ink on paper | 46 × 34 см

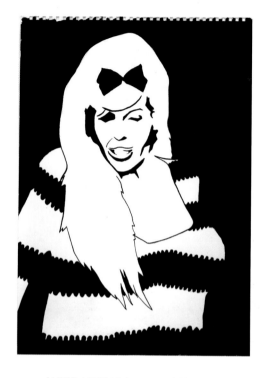

JAYNE | 2000 | Ink on paper | 46 × 34 см

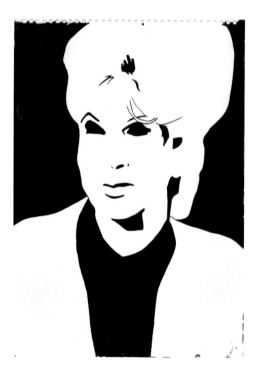

DUSTY | 2000 | Ink on paper | 46 × 34 см

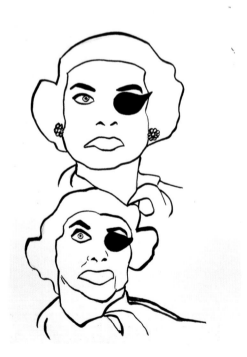

DAVID SCOWL | 2000 | Ink on paper | 46 × 34 см

KIMONO DRAGON I 2000 I Ink on paper I 46 × 34 cm

A JOAN CRAWFORD ALPHABET
2007 | Arcylic on canvas
215 × 300 см

A IS FOR ACCIDENT

B IS FOR BAD NEWS

C IS FOR CONTRETEMPS

D IS FOR DEAD MAGPIE

J IS FOR JUDGEMENT DAY

K IS FOR KLU KLUX KLAN

L IS FOR L'AMOUR

M IS FOR METEOR

N IS FOR NEV ON TH

T IS FOR TWISTER

U IS FOR UMBRELLA UP INDOORS

V IS F VAMP

IS FOR

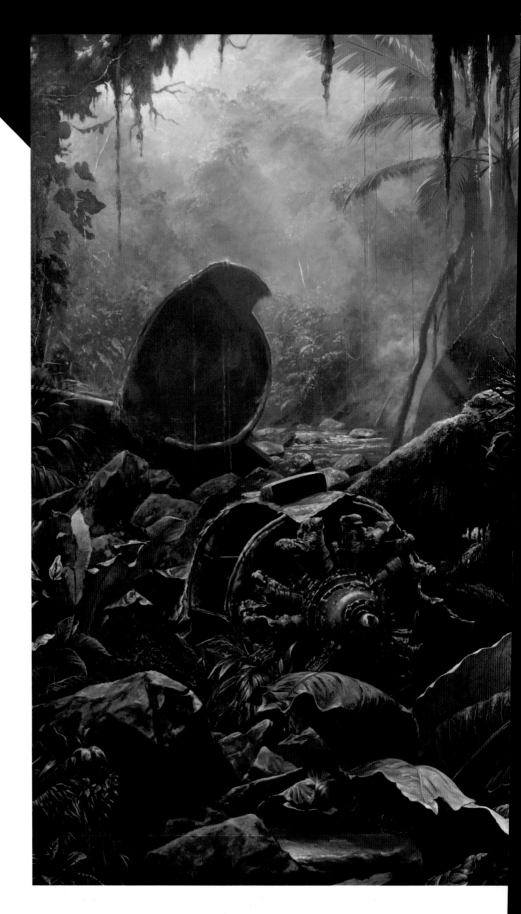

*JUNGLE SCENE WITH
PLANE WRECK* | 2007
Oil on canvas
272 × 400 см

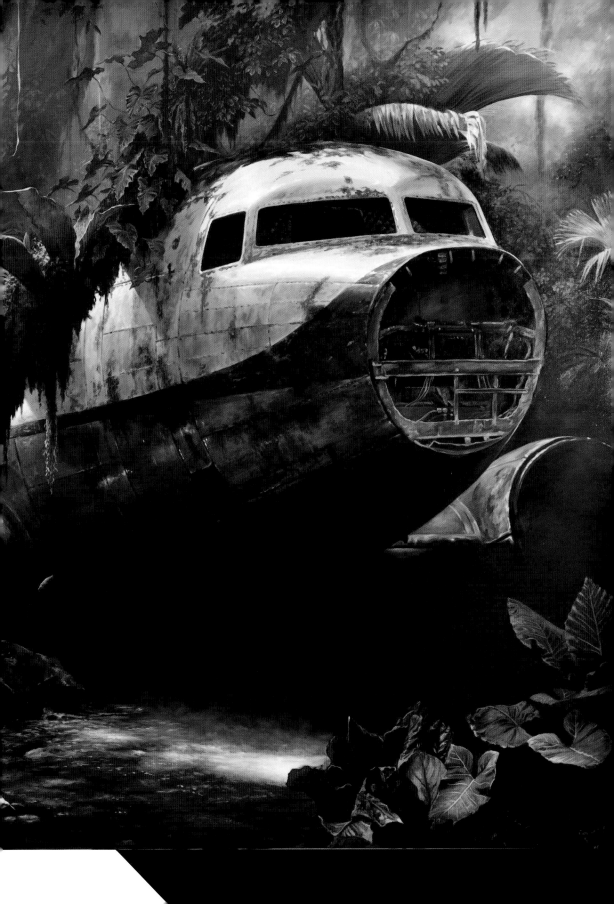

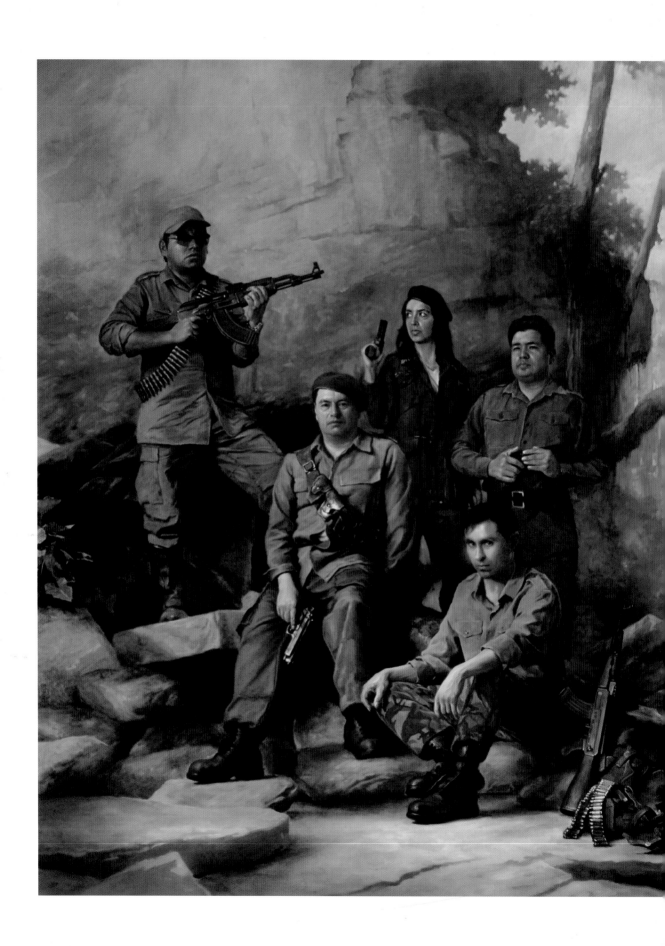

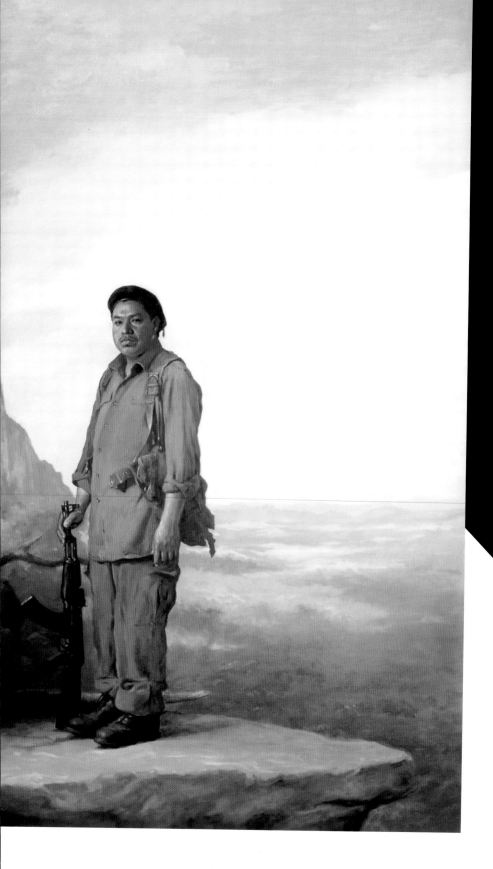

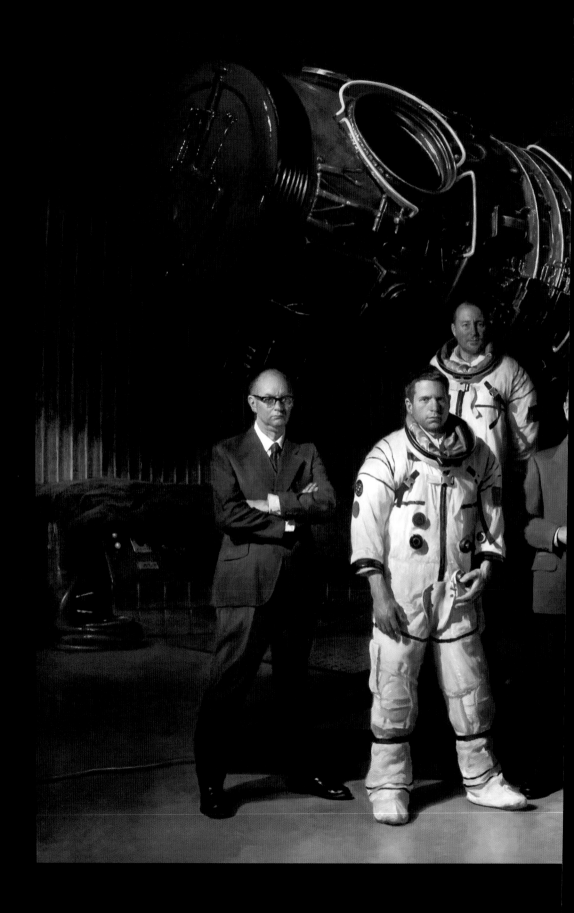

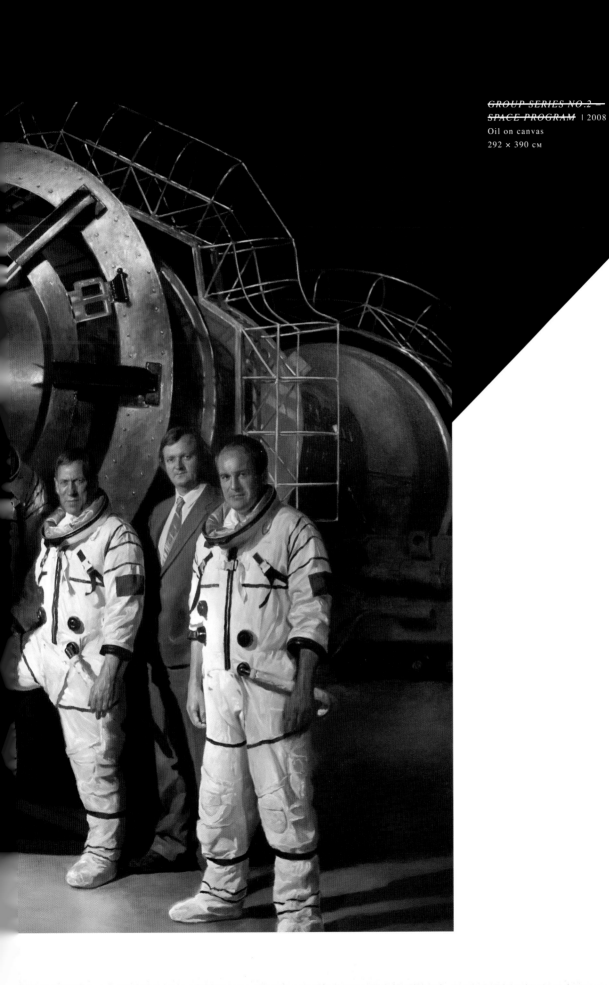

GROUP SERIES NO.2
SPACE PROGRAM | 2008
Oil on canvas
292 × 390 см

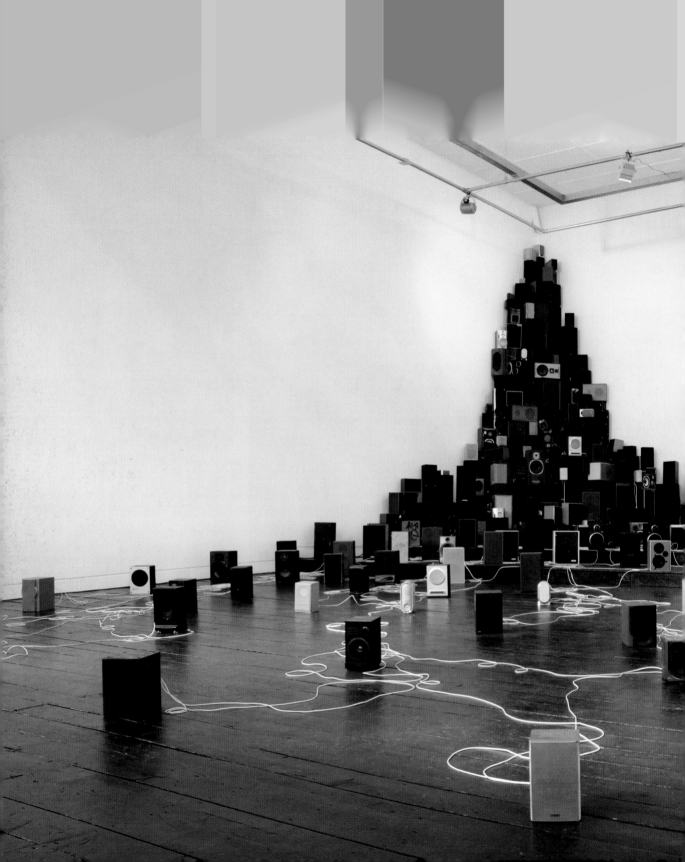

UNTITLED | 2009
300 speakers, Pianola, vacuum cleaner, audio
amplifiers, hard disc recorder, speaker wire,
suction hose, piano roll | Dimensions variable

THE GRAND CAUSE | 2006
Oil, pencil and gold leaf on canvas
210 × 242.5 см

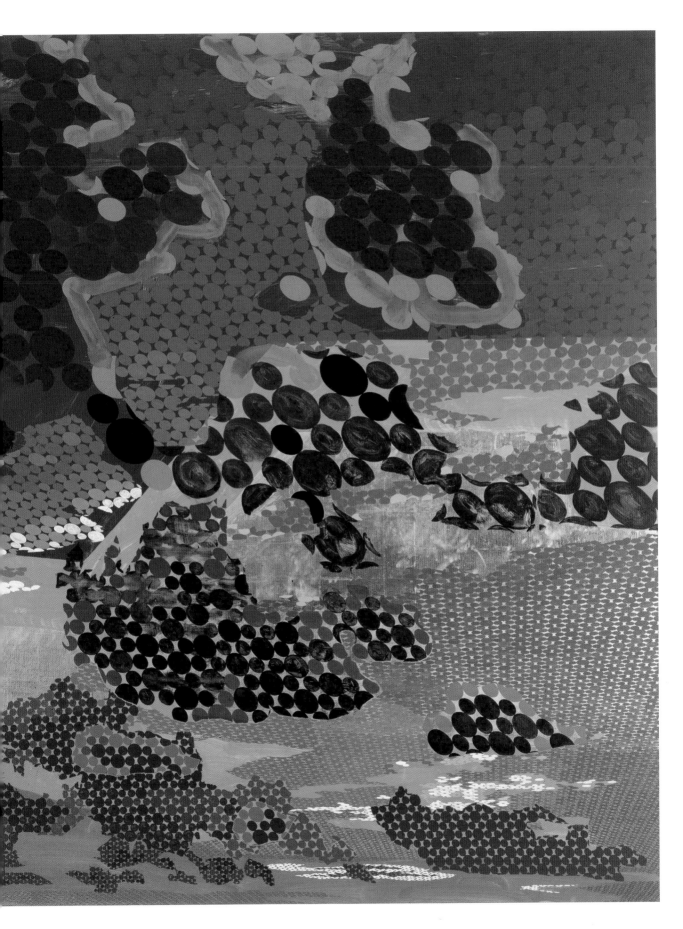

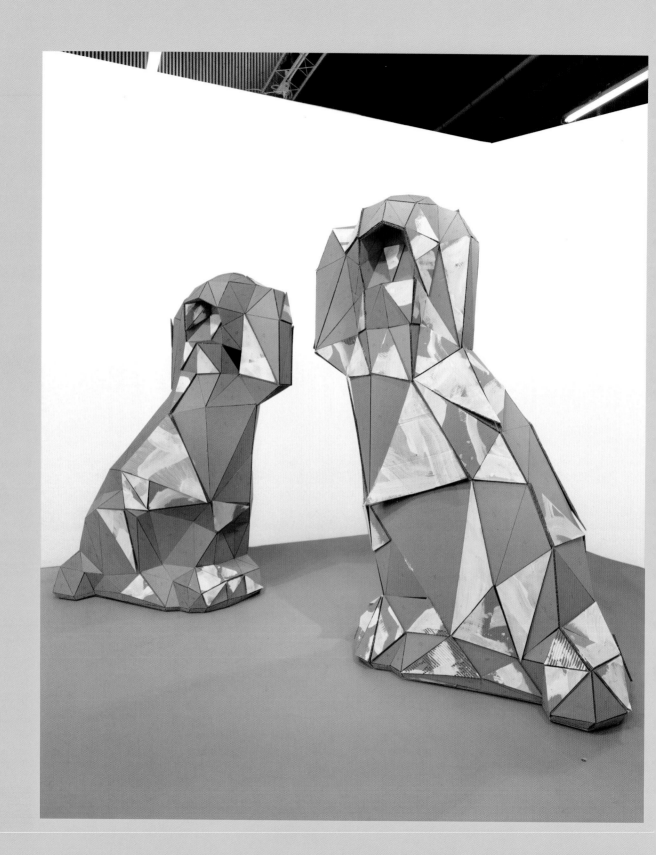

THE LIBERALS (3RD VERSION) | 2008 | Cardboard, gesso and pins
2 parts: part 1: 323 × 220 × 120 см / part 2: 279 × 220 × 105 см

TASHA AMINI Born in London, UK in 1970 // Lives and works in London, UK **Education** BA (Hons), Painting, Central St. Martins, 1992-95 **Selected Solo Exhibitions** 2009 Worry Beads, Tanja Pol Galerie, Munich // 2008 D'Amelio Terras, New York // Tasha Amini - Excellent Women, Kate MacGarry, London // 2005 Jack Hanley Gallery, Los Angeles // Tasha Amini - Dying Back, Kate MacGarry, London **Selected Group Exhibitions** 2007 East International, selected by Matthew Higgs & Marc Camille Chaimowicz, Norwich School of Art, Norwich // 2006 Sunset in Athens II, Vamiali's, Athens // 2004 Painting, Kate MacGarry, London. **HURVIN ANDERSON** Born in Birmingham, UK in 1965 // Lives and works in London, UK **Education** MA Painting, Royal College of Art, 1996-98 // BA Art; Painting, Wimbledon College of Art, 1991-94 **Selected Solo Exhbitions** 2009 Art Now, Tate Britain, London // Hurvin Ander Peter's Series 2007-09 Studio Museum, Harlem // 2008 Thomas Dane Gallery // Anthony Meier Fine Arts, San Francisco // 2007 M Gallery, University of Warwick, Coventry // 2006 Art Basel, Miami // 'A View on the River Cobre', Dulwich Picture Gallery, Lon **Selected Group Exhibitions** 2007 *Very Abstract and Hyper Figurative*, Thomas Dane Gallery, London // 2006 *Crivelli's Nail*, Cha Gallery, Cardiff // *Archipeinture, artists build architecture*, Le Plateau, Fonds regional d'art contemporain d'ille-de-France, Par Camden Arts Centre, London // *EastInternational*, Norwich Gallery, Norwich // 2004 *Back to Paint*, C & M Arts, New York // 2003 W in Room. Lewisham Art House London. **MAURIZIO ANZERI** Born in Loano, Italy, 1969 // Lives and works in London, **Education** MA Fine Art and Sculpture, Slade School of Fine Art , 2002-2005 // BA (Hons) Sculpture and Graphic Design, Camberw College of Arts, 1996-99 **Selected Solo Exhibitions** 2009 *I will buy the flowers myself*, Riflemaker Gallery - London //*Family I* Galleria IMAGE Furini, Arezzo – Italy // 2006 *Places*, Galleria Palladio, Lugano - Svizzera **Selected Group Exhibitions** 2009 * *Night in Paris*, The Photographer's Gallery PARISPHOTO 2009 // *Starting with a photograph*, Michael Hoppen Contemporary – Lon // *The Photographic Object*, The Photographer's Gallery – London // *VOODOO*, Riflemaker – London // 2008 *CONCRETE and GL* Saatchi Online at Beach Blanket Babylon – London // *The Beautiful Children*, The Wharf Road Project – London // *Whisper Immortality*, Natalia Goldin Gallery – Stockholm, Sweden // *The Sovereign European ArtPrize*, Somerset House - London // *L'Angelo Sigillato,Museo Icone Russe - Peccioli*, Italy curated by Rita Selvaggio // *Falling from an apple tree by mistake*, WILDE gallery – Berlin, Germany // *3am eternal*, Alexandre POLLAZZON Gallery - London // *ARTE FIERA* Bologna, Italy // 2007 *Drifting Clouds*, Galleria IMAGEFurini - Arezzo, Italy, curated by Rita Selvaggio // 2006 *Museo CAMEC*, Biennale Europea Arti Visive - LaSpezia, Italy. Curated by Bruno Cora // *Kunsthalle?-* Locarno Film Festival – Locarno, Svizzera // 2005 *Slade*, MA Show - London. **JONATHAN BALDOCK** Born in Pembury, UK in 1980 // Lives and works in London, UK **Education** MA Painting, Royal College of Art, 2003 – 2005 // BA Fine Art Painting, Winchester School of Art, 2000 – 2003 **Selected Solo Exhibitions** 2008 *Ennui*, Backlit Studios, Nottingham // *H.E*, FAS London // 2006 *No 2*, Meals and SUVs, London **Selected Group Exhibitions** 2009 British Art Now, hermitage Museum, St Petersburg // Memories and Encounters, Viafarini, Milan // *O / A Stiff Bandeau*, Tricycle Arts Centre, Kilburn, London // *Straylight Cavern*, Cell Project Space, London // *Group Show*, Turner Contemporary, Margate // *Stranger Things are Happening,* Aspex Gallery, Portsmouth // 2008 *Straylight Cavern*, Cooper Gallery, Duncan & Jordanstone School of Art, Dundee // *From Panic to Power* Angstrom Gallery, Los Angeles // *The Brotherhood of Subterranea*, Kunstbunker Nuremberg // *Wassail*, Cell Project Space, London // 2007 *Lady Holic*, Rod Barton Invites, London // *Group*, W.S. Bartletts, London // *Frou Frou Foxes in Midsummer Fires*, Colony Gallery, Birmingham // 2006 *First, Last and Always*, Axis Arts Centre Dublin // *Through The Large Glass*, Three Colts Gallery, London // *World Cup*, 39, London // *Baroque My World*, Transition Gallery, London // *Milk Before Tea*, Tara Bryan Gallery, London // *Hollow Salon*, Hollow Contemporary, London. **ANNA BARRIBALL** Born in Plymouth, UK, 1972 Lives and works in London, UK **Education** MA Fine Art, Chelsea College of Art and Design, 1999-2000 // BA ((Hons)) Fine Art ,Winchester School of Art, 1992-1995 **Selected Solo Exhibitions** 2009 Frith Street Gallery, London // 2008 Projection, Institut im Glaspavillon, Berlin // Live Art Performan *More and More – Performance of Reduction*, Artist Studio Residency, Camden Arts Centre, London // 2007Galleri Bo Bjergga Copenhagen // 2006 Ingleby Gallery, Edinburgh // The New Art Gallery, Walsall // 2005 Newlyn Art Gallery, Cornwall // Gaswor London **Selected Group Exhibitions** 2009 *Timewarp*, CRAC Alsace, Altkirch // *Second Hand*, Engholm Engelhorn Galleries, Vienn 2008 Park Avenue, Southampton City Art Gallery, Southampton // *Interiors and Prospects*, Henry Moore Institute/Leeds City Art Gal // *Out Riding Feet*, Harris Liebermann, NYC // *Scary Movie*, Contemporary Art Centre of SA1011 // 2007 *Echo Room*, Alcala 3, Mac // *Scary Movie*, Contemporary Art Centre of SA // 2006 *Resonance*, Frith Street Gallery, London // *How to Improve the World: 60 Ye of British Art*, Hayward Gallery, London // *I Walk the Lines*, Barbara Thumm, Berlin // *You'll Never Know*, Hayward Gallery Natio (touring exhibition). **STEVE BISHOP** Born in Toronto, Canada, 1983 // Lives and works in London, UK **Education** MA Sculpt ,Royal College Of Art, 2006 - 2008 // BA (Hons) Fine Art , Kingston University, 2003 - 2006 **Selected Solo Exhibitions** 2009 // *Inst Distance / Distant Instance* – Outpost Gallery, Norwich, UK // *Some Thing To Believe In* – Pianissimo, Milan, Italy // 2008 *Simply Re* Supplement Gallery, London **Selected Group Exhibitions** 2009 *Removed from the Eyes of Strangers* – Galeri Andersson/Sandstr

Umeå, Sweden // *Aurora/Outpost* – Norwich Arts Centre, Norwich, UK (screening) // *Works from the Franks-Suss Collection* – London, UK // *Jupiter and Beyond the Infinite* – Synchronicity Space, Los Angeles, USA // *Grey Matter* – Talbot Rice Gallery, Edinburgh, UK // *Ventriloquist* – Timothy Taylor Gallery, London, UK // *Meanwhile…* – Twenty by Thirty Gallery, Melbourne, Australia // *Mirror Site* – MWMN, New York, USA (screening) // *Short Artist's Films* – Christopher Crescent, London, UK (screening) // *Unheimlich* – The Nunnery, Bow Arts Trust, London, UK // 2008 *Bloomberg New Contemporaries* – A-Foundation, Liverpool, UK, Club Row, London, UK // *V22 Presents: The Wharf Road Project* – V22 Project Space, London, UK // *The Culture Clash* – The Working Rooms, London, UK // *An Evening of 3 Short Films* – Parasol Unit, London, UK (screening) // *The Enigma of William Tell and Other Tales* – The Agency, London, UK // *Soul Stripper* – Projet Midi, Brussels, Belgium. **KARLA BLACK** Born in Alexandria, Scotland, 1972 // Lives and works in Glasgow, Scotland **Education** Masters Degree in Fine Art, Glasgow School of Art, 2002-04 // Master of Philosophy in Organisational Contexts), Glasgow School of Art, 1999-2000 // BA ((Hons)) Fine Art, Sculpture, Glasgow School of Art, 1995-99 ...cted **Solo Exhibitions** 2009 Migros Museum, Zurich // Mary Mary, Glasgow // Modern Art Oxford, Oxford (Sept) // *Karla Black: ...tures with paintings by Bet Low* (1924-2007), Inverleith House, Edinburgh (Nov) // 2008 West London Projects, London // *Catch ...: New Works from the Arts Council Collection*, Longside Gallery, Yorkshire Sculpture Park // Galerie Gisela Capitain, Cologne // 2007 ... Projects, London // 2006 Galerie Sandra Bürgel, Berlin // *Mary Mary*, Glasgow Outpost, Norwich Have Him Be Her, Broadway ..., New York **Selected Group Exhibitions** 2009 *Reduction & Suspense*, Magazin 4, Bregenz, Austria // Nothing to say and I am saying ...unstverein Freiburg // *Dont Expect Anything*, Galleria Francesca Minini, Milan // *Contemporary Scottish Art: New Acquistitions & ...s*, Scottish National Gallery of Modern Art, Edinburgh // 2008 *Stuart Shave/Modern Art*, London Strange Solution, Art Now, Tate ...in, London // 2007*Ultramoderne*, Hall Paul Wurth, Luxembourg; La Passerelle, BrestWhat remains. Quello che resta, Lambretto Art ...ect, Milan // *Poor Thing*, Kunsthalle Basel (curated by Simone Neuenschwander). **████████████████** Born in ...on, UK 1977 // Lives and works in London, UK **Education** Ma Fine Art, Royal Academy Schools ,2000-03 // BA Fine Art, Falmouth ...ege of Art, 1997-2000 **Selected Solo Exhibitions** 2009 Faye Fleming & Partner, Geneva // 2007 Gasworks, London // *Series*, ...QUEBUSE (now Faye Fleming & Partner), Geneva // 2004 *How To Live*, Prowler Project Space, London **Selected Group Exhibitions** 2009 *Convoi Exceptionnel*, Triangle France, Marseille // *Living Together: Towards a Contemporary Concept of Community*, curated by Xabier Arakistain and Emma Dexter, Centro Cultural Montehermoso Kulturanea, Vittoria-Gasteiz, Spain. Travelling to MARCO, Museu de Arte Contempornea, Vigo, Spain // 2008 *M25. Around London*, curated by by Barry Schwabsky, Andratx, Mallorca, Spain // *7th Gwangju Biennial*, curated by Okwui Enwezor, Gwangju, Korea // *Flow*, The Studio Museum in Harlem, New York // 2007*100 Years Kunsthalle*, Kunsthalle Mannheim, Mannheim // 2006-2007 *The Unhomely: Phantom Scenes in Global Society*, 2nd International Biennal of Contemporary Art of Seville, curated by Okwui Enwezor, Centro Andaluz de Arte Contemporareo Reale Ataronanas, Seville // 2006 *Personne ne veut mourir*, ARQUEBUSE, Geneva // Liquid, Lynette Boakye and Gary Hume, New Paintings, Royal Academy Schools Gallery, Hornsey // 2005 *Direkte Malerei – Unmittelbare Bildwelten zwischen Abstraktion und Figuration*, Mannheimer Kunsthalle, Mannheim, Germany. **PABLO BRONSTEIN** Born in Buenos Aires, Argentina in 1977 // Lives and works in London, UK **Education** MA Visual Arts; Goldsmiths College, 2004 // BA Slade School of Fine Art, 1998–01 **Selected Solo Exhibitions** 2009 *Permanent Commission*, Nottingham Contemporary // *Pablo Bronstein at the Met*, The Metropolitan Museum of Art, New York // 2008 *Palaces of Turin*, Solo Show, Franco Noero, Turin, Italy // *Paternoster Square,* Herald St, London // 2007*Franco Noero*, Turin // Städtische Galerie im Lenbachhaus und Kunstbau, Munich **Selected Group Exhibitions** 2009 *Blinding the Ears:Action*, Behaviour, Performance, Instant Theatre in Turin, Italy // *Farm Building (permanent commission)*, Grizedale Arts, Cumbria Monument for Study // *Characters, Figures and Signs: Choreography as "Doing" and "Saying"*, Tate Modern, London // 2008 *La Petite Histoire*, Kunstraum Niederoesterreich, ...na // *Publish and be Damned*, London // *That Beautiful Pale Face is my Fate (for Lord Byron)*, Nottingham Contemporary in partnership with ...stead Abbey, Nottingham // *Parallel Voices*, Siobhan Davies Studios, London // 2007 *Performa 07*, New York // *The 53rd International Kurzfilmtage ...hausen*, Germany // *The Present Order is the Disorder of the Future*, Die Hallen, The Netherlands // *New Work Uk, You and Me*, screening, ...techapel gallery in association with Lux Luisenstraße // *Prague Biennale,* Prague // 2006 *Tate Triennale*, Tate Britain, London. **████ BUSUCH** Born in Johannesburg, South Africa in 1982 // Lives and works in Berlin, Germany **Education** Postgraduate ...oma, Royal Academy Schools, London 2005-08 // BA (Hons) Fine Art, University of Witwatersrand, Johannesburg 2001-04 **Selected ...** **Exhibitions** 2009 *Tuxed Fucks – And other curious outfits* (forthcoming) // Gimpel Fils, London **Selected Group Exhibitions** 2009 ...een my Finger and my Thumb*, Curated by Kobetsvasey Schwartz Gallery, London // *Daily Miracles* Josh Lilley Gallery, London // ...wood Contemporary Painters Prize* Jerwood Space, London // 2008 *Pulse Art Fair* Miami // *The World's Most Dangerous Ideas,* Dray ...k Gallery Truman Brewery, London // *Concrete and Glass Festival* – Saatchi Online Beach Blanket Babylon, London // *Scope Art Fair ...don* // *Yellow Freight* Fold Gallery, London // *Royal Academy Schools Summer Show* Royal Academy of Arts, London // *Form Art Fair,* ...npia, London // *MA Show* Atkinson Gallery, Somerset // 2007 *Neck to Nuts,* La Viande Gallery, London // *Painting Music* – Performance ...ge Festival, Edinburgh // *Group Exhibition* Chelsea Arts Club, London // *Influx, Group Show* Nolias Gallery, London // *Premiums ...ibition* Royal Academy of Arts London // 2006 Group Show, La Viande Gallery, London // *Lynn Painter-Stainers Prize Exhibition ...ters' Hall*, London // *Royal Academy of Arts Summer Exhibition*, London. **SPARTACUS CHETWYND** Born in London, UK

in 1973 // Lives and works in London, UK **Education** MA Painting, Royal College of Art, 2002-04 // BA Fine Art, Slade School of Art, 1996-00 **Selected Solo Exhibitions** 2008 Galerie Giti Nourbakhsch with Esther Teichmann, Phantasie Fotostudio, Berlin // S, *Chaffinche's Film Festival*, Studio Voltaire, London // *Help! I'm trapped ina Muzuzah Factory*, Le Consortium, Dijon, France // Mass de Carlo, Milan // 2007 Migros Museum, Zurich // Galerie Giti Nourbakhsch, Berlin // *A Comedy of Errors (g/p)*, Artspace, Sydney // *Sp Chatroom's Film Club*, Studio Voltaire, London **Selected Group Exhibitions** 2009 *Tate Triennale*, Tate Britain, London // 2008 *A sho many parts, each part more spectacular and elaborate than the last*, The City Gallery, Leicester // Galerie Giti Nourbakhsch with E Teichmann, *Phantasie Fotostudio*, Berlin // Spany Chaffinche's Film Festival, Studio Voltaire, London // *Collection 1978 – 2008*, Mi Museum, Zurich // *Help! I'm trapped in a Muzuzah Factory*, Le Consortium, Dijon // *Martian Museum of terrestrial Art*, Barbican Gallery, London // *Don't Play with Dead Things*, The National Contemporary Art Center of Villa Arson // *The Skat Players*, Vilma C London // 2007 *The Call of the Wild*, Collective Gallery, Edinburgh // *Plumbing Pipe...1...2...3*, Creative Time, New York // *Stay For and Ever*, South London Gallery, London. **STEVEN CLAYDON** Born in London, UK in 1969 // Lives and works in London, **Education** MA Fine Art, Central Saint Martins, 1997 // BA Fine Art, Painting, Chelsea School of Art & Design, 1991 **Selected : Exhibitions** 2009 *The Ground id Good*, Galarie Rüdiger Schöttle, Munich // *The Fifth Dimension*, Artissima, Turin // *Two Times New Horizon*, Galleria Massimi de Carlo, Milan // 2008 *Osram and Omar*, HOTEL, London // Independent Project Space, Bourneville, Birmingham // Galerie Dennis Kimmerich, Düsseldorf // 2007 *New Valkonia*, David Kordansky, Los Angeles // 2006 *Courtesy Of The Neighbourhood Watch*, White Columns, New York // *The Glidded Baum*, Art Statement, Art Basel 37, Switzerland // 2005 *All Across the Thready Eye*, Galerie Dennis Kimmerich, Düsseldorf // *Fear of a Planet*, HOTEL, London **Selected Group Exhibitions** 2009 *The Dark Monarch*, Tate St.Ives, Cornwall // *Dune*, The Drawing Room, London // *Le Sang d'un Poète*, Frac des Pays de la Loire // *Remote Memories*, Kai10, Düsseldorf // 2008 *The Ancient Set*, Serpentine Gallery Pavilion, London // *Busan Biennial*, Busan, South Korea // *In Geneva No One Can Hear You Scream*, Blondeau Fine Art Services, Geneva // 2007 *Strange Events Permit Themselves the Luxury of Occurring*, curated by Steven Claydon, Camden Arts Centre, London // *Pale Carnage*, Arnolfini, Bristol. **WILLIAM DANIELS** Born in Brighton, UK in 1976 // Lives and works in London, UK **Education** MA, Royal College of Art, 2001-03 // BA, Edinburgh Art College, 1996-99 **Selected Solo Exhibitions** 2007 Vilma Gold, London // Marc Foxx, Los Angeles **Selected Group Exhibitions** 2008 *Perverted by Theater*, Apex Art // *M25 Around London*, CCA Andratx, Mallorca // *Precious Things*, Highlanes Gallery, Drogheda // Summer show, Marc Foxx, Los Angeles // *Zuordnungsprobleme*, Johann Konig, Berlin // *Legend*, Domaine Departemental de Chamarande, Chamarande // Dadadandy Boutique, Artprojx Space, London // 2007 *Painted Objects*, Harris Lieberman, New York // At Home at the Yvon Lambert Gallery, New York // *Size Matters*, Hudson Centre for Contemporary Art, New York // *Counterfacture*, Luhring Augustine, New York (cat) // 2006 Jerwood Contemporary Painters, Jerwood Space, London // *April is the Cruelest Month*, Transmission Gallery, Glasgow. **MATTHEW DARBYSHIRE** Born in Cambridge, UK in 1977 // Lives and works in London, UK **Education** Post-Graduate Diploma, Royal Academy Schools, 2005 // BA ((Hons)) Fine Art, Slade School of Fine Art, 2000 // Foundation Course, Ipswich Art School, 1996 **Selected Solo Exhibitions** 2 *Funhouse*, Hayward Project Space, London, UK Curated by Tom Morton // *Furniture Islands*, Outpost, Norwich, UK // 2008 *Nougl Sixty*, Institute of Contemporary Arts, London, UK // Presented as part of the programme *Blades House*, Gasworks, London, UK // 2 *Recreate* (with Richard Wilson), Pumphouse Gallery, London, UK // 2004 Urban Pastoral, Relais De La Baie, France **Selected Gr Exhibitions** 2009 *Tate Triennial 2009*, Tate Britain, London. Curated by Nicholas Bourriaud // *OTHER WORLDS: THE HAYW GALLERY PROJECT SPACE IN SOUTH KOREA*, Platform 2009, Seoul, Korea. Curated by Tom Morton // *Eat Me – Drink Me*, The G Michael Foundation, Dallas, USA // 2008 *White Columns*, New York, USA (screening) * // *Le Chant du Rossignol*, Matthew Darbyshire Sam Gunn, July // *Screenings*, Herald St, London, UK // *Matthew Darbyshire, Jess Flood–Paddock*, William Hunt, Sadlers Wells, Lon UK. Curated by Sasha Cradock // 2007 *Matthew Darbyshire*, Djordje Ozbolt and Alexander Tucker, Parade Gallery, London, **ROBERT DOWLING** Born in London, UK in 1979 // Lives and works in London, UK **Education** BA ((Hons)) Fine Art, S School of Fine Art, 2000-04 // MA Sculpture, Royal College of Art, 2006-08 **Selected Solo Exhibitions** 2009 Robert Dowling, Ele Howland Ltd, London // 2005 Stellasphere, Andrews Road, London **Selected Group exhibitions** 2009 *Early Dawning*, Engholm Engelk Galerie, Vienna // *Adventure Beyond the Edge of Time*, Eleven Howland Ltd, London // *Maximal Minimal*, Andreas Grimm, Munich // 2 *Alexandre Pollazzon Presents*, Alexandre Pollazzon Ltd, London // *Degree Show*, Royal College of Art, London // 2007 *New Build*, Terrace, London // *Interim Show*, Royal College of Art, London // 2006 *George Polke Invites*, George Polke, London // *Tannoy*, Terrace, London // 2005 *Line Rodeo*, Kingly Court, London // *Parlour*, House Gallery, London. **GRAHAM DURWARD** Born Aberdeen, UK in 1966 // Lives and works in New York, USA **Education** BA Fine Art, Edinburgh College of Art 1977 // MA Fine Art ,Edinburgh College of Art, Postgraduate 1978 // Whitney Museum Independent Study Program 1986 **Selected Solo Exhibitions** 2009 Maureen Paley, London // 2007 *White Room*, White Columns, New York // *2001 AC PROJECTS*, New York // 1997 Marianne Boesky Gallery, New York **Selected Group Exhibitions** 2008 *The Hidden*, Maureen Paley, London // 2006 *Looking Back*, White Columns, New York // 2003 *20th Aniversary Show*, Gavin Brown's Enterprise, New York // 2001 *A painting*, Trans Hudson Gallery, New York // *Snakes, Snails and Puppydogs Tails*, Nicolai Fine Art, New York // 2000 *Under Pressure*, Swiss Institute, New York // *New Videos*, AD HOC, New York // 1998 *I LOVE NY*, Video Show curated by Graham Durward for The Edinburgh International Festival // 1996 Boesky Callery, New York // John Michael Kohler

'enter, Sheboygan, Wisconsin // Gender Affects, Kinsey Institute, Indiana University. ████████ Born in Chester, UK in 1981 // Lives and
's in London, UK **Education** MA Fine Art, Royal Academy Schools 2006-09 // BA ((Hons)) Fine Art, Liverpool School of Art 2000-03 **Selected**
ıp Exhibitions 2009 *New Sensations*, The Rochele School London // 2008 *Alexandre Pollazzon Presents*, Alexandre Pollazzon London
e Future Can Wait, Charlie Smith London // Group Show, The Wilde Gallery Berlin // *Premiums*, Royal Academy of Arts London //
Interceptor, The Peles Empire, London // Ritual Abuse The Boys Hall Dalston, London // 2006 *Half cut for confidence Independents*,
*pool Biennial // The Last Gang in Town, Arena Gallery, Liverpool // 2005 *The Jerwood Drawing Prize*, The Jerwood Space - London,
*lle Gallery - Cheltenham, Rennie Mackintosh Gallery - Glasgow, Bayart - Cardiff, The Gallery - Dorset // 2004 *Bracket This*,
endents, Liverpool Bienniel, Hayvend Laboratories, Manchester Cornerhouse, Baltic Centre for Contemporary Art, Newcastle upon
, Arnolfini Gallery, Bristol, ICA (Institute of Contemporary Arts), London, Hayward Gallery, London, Whitechapel Gallery, London //
Northern Graduates, The Curwen and New Academy gallery London. █DICK EVANS█ Born in Stratford-Upon-Avon, UK in 1976
*es and works in London, UK **Education** MA, Chelsea College of Art, 2000 – 01 // BA, Wimbledon College of Art, 1996 – 99 **Selected**
Exhibitions 2009 Solo project, U.R.A., Istanbul // Solo project, Boyschool, London.// Solo project, The Black Mariah, Ireland // 2008
Solo project, *The Hidden*, Maureen Paley, London // 2006 Maureen Paley, London // Solo project, Dior Homme, Hong Kong //
Selected Group Exhibitions 2009 *Newspeak*, Saatchi Gallery at The Hermitage, St.Petersberg // *CrASH*, 110 Warner Road,
London // 2008 *The V22 Collection*, The Wenlock Building, London // *Nul*, Foxy Production, New York // *The Hidden*, Maureen
Paley, London // *Mask*, James Cohan Gallery, New York // 2007 *Nueva Dimension*, Hats-Plus, London // 2005 *Conquests and
Techniques: a Synthesis*, 12-27 February 2005, The Ship Projects // 2004 *The Black Album*, Maureen Paley, London // *Leptin
Constellation*, Floating I.P., Manchester // *Motes in all eyes*, 31 October - 5 December 2004, The Ship Projects // *One Bright Day, People Get
Together*, 19 June - 18 July 2004, The Ship Projects // *Concert In The Egg*, 10 April - 9 May 2004, The Ship Projects // *Tongs ya Bass*, 6
March - 3 April 2004, The Ship Projects. █TESSA FARMER█ Born in Birmingham, UK in 1978 // Lives and works in London, UK
Education MFA, Ruskin School of Drawing and Fine Art, 2002-03 // BFA (First Class), Ruskin School of Drawing and Fine Art, 1997-2000
Selected Solo Exhibitions 2008 Spencer Brownstone Gallery, New York // 2007 *Little Savages*, Natural History Museum, London //
Infestation, Chapter Arts Centre, Cardiff // 2006 *The Terror*, Firstsite, Colchester // 2004 New Work, Museum of Oxford, Oxford // **Selected**
Group Exhibitions 2009 *Breaking New*, Five Hundred Dollars, London // Slump City, Space Studios, London // 2008 *Riddle Me*, Danielle
Arnaud Gallery, London // *Wrap Your Troubles in a Dream*, Lautom Gallery, Oslo // *In Transit*, Ladbroke Grove, London // *Animal Magic*,
Eleven, London // *Tatton Park Biennial*, Knutsford VOLTA 4, with Spencer Brownstone Gallery, Basel // *LOCKED IN: The Visible*, Casino
Luxembourg, Luxembourg // *Gothic*, Fieldgate Gallery, London // 2007 *The Future Can Wait*, Atlantis Gallery, London // *Les Fleurs du Mal*,
Primo Alonso, curated by John Stark London // *Art Basel Miami*, with Spencer Brownstone Gallery, Miami Beach // *Growing Wild*,
*eiana Mihail Gallery, Bucharest, Romania // *Growing Wild*, Kontainer Gallery, Los Angeles // *VOLTA 3*, with Spencer Brownstone
*ery, Basel, Switzerland // *Am Schlimmsten: nicht im Sommer sterben*, Nassauische Kunstverein, Wiesbaden,Germany. █ROBERT█
Born in London, UK in 1980 // Lives and works in London, UK **Education** BA Fine Art, Oxford Brookes University, 2002 **Selected**
Exhibitions 2009 Atelier 2, Moscow, Russia // Alexia Goethe Gallery, London // **Selected Group Exhibitions** 2009 *Newspeak –
sh Art Now, The State Hermitage Museum, St.Petersberg, Russia // Minnie Weisz Studios, London // 2008 Alexia Goethe Gallery,
*lon // *'Make Believe'*, Concrete and Glass Festival, London // *Macmillan Contemporary Art Auction and Exhibition*, London // Scope
*ni, Miami. █JAIME GILI█ Born in Caracas, Venezuela in 1972 // Lives and works in London, UK **Education** PhD, University of
*elona, 2001 // MA, Royal College of Art, 1996 - 98 **Selected Solo Exhibitions** 2009 Solo show, Kunsthalle Winterthur, Winterthur,
) // COMMA04, BloombergSPACE, London // 2008 *Superestrellas*, Riflemaker LONDON // 2007 *Jaime Gili - Superstars*, Buia Gallery
*V YORK // 2006 *Jaime Gili makes things triangular at riflemaker* – LONDON **Selected Group Exhibitions** 2009 *Coalesce
enstance, Smart AMSTERDAM (NL) // *Everything is Borrowed*, Alejandra von Hartz Gallery. Miami (US) // 2008 *John Moores 25'
pool Biennial. Walker Art Gallery. LIVERPOOL (UK) // *Coda*, Oficina #1. Periférico Caracas. CARACAS // *The expanded painting
, (Curated by Paco Barragán). Space Other, BOSTON (US) // *Holiday!*, Buia Gallery NEW YORK (US) // 2007 *6a bienal do mercosul
s fronteiras, (Curated by Gabriel Pérez-Barreiro and Ticio Escobar) Porto Alegre (BR)(catalogue) // *jump cuts - coleccion banco
mercantil*, Cifo MIAMI (US) (catalogue) // *The expanded painting show*, (Curated by Paco Barragán), Mash, MIAMI (US) // *Bogotá Tipos
Móviles*, (Curated by JG and Luis Romero) Universidad de Los Andes. BOGOTÁ (CO) // *Indica*, Nyehaus Gallery NEW YORK (catalogue)
// 2006 *don't trust*, (Curated by Luis Romero and Suwon Lee) University of California. LOS ANGELES (US)(catalogue) // Riflemaker
becomes INDICA, riflemaker, LONDON (catalogue). █ANTHEA HAMILTON█ Born in London, UK in 1978 // Lives and works in
London, UK **Education** MA Painting, Royal College of Art, London, 2005 // BA Fine Art,Leeds Metropolitan University, 2000 **Selected**
Solo Exhibitions 2009 *Anthea Hamilton*, IBID Projects, London UK // *Calypsos: collaboration with Nicholas Byrne*, Studio Voltaire,
London UK // *Spaghetti Hoops La Salle de bains*, Lyon, France // Turnhalle Kunstverein Freiburg Freiburg Germany // 2008 *Gymnasium*,
Chisenhale Gallery, London, UK // 2007 *Art Statements*, Art Basel 38, Basel, Switzerland // *CutOuts*, Galerie Fons Welters, Amsterdam, The
Netherlands // *Anthea Hamilton and Thomas Kratz*, Mary Mary, Glasgow, UK // 2006 *Solo Presentation Liste 06: The Young Art Fair*, Basel,
Switzerland // *Athens*, IBID Projects, London, UK **Selected Group Exhibitions** 2009 *Small Collections*, Nottingham Contemporary,

Nottingham, UK // *Verite Tropicale*, Circuit, Lausanne, Switzerland. Curated by Jill Gasparina and Caroline Soyez-Petithomme // *O / A Bandeau*, Tricycle Gallery, London, UK // 2008 *Art Now: Strange Solution*, Tate Britain, London, UK // *Martian Museum of Terrestria* Barbican Art Gallery, London, UK // *IBID PROJECTS*, Hoxton Square, London, UK // *M25 Sobre Londres*, CCA Andratx, Mallorca, S Curated by Barry Schwabsky // *Anthea Hamilton and Thomas Kratz*, Parkhaus Düsseldorf, Germany // 2007 *Blackberrying*, G Christina, Wilson Copenhagen, Denmark // *Charlotte Thrane & Anthea Hamilton*, The Hex, London, UK. **ANNE HARDY** Born Albans, UK in 1970 // Lives and works in London, UK **Education** MA Photography, Royal College of Art, 2000 **Selected Solo Exhibit** 2009 Maureen Paley, London, UK // 2008 Bellweather Gallery, New York // 2005 ArtSway, Sway, UK // 2004 Laing Solo, Laing Gal Newcastle Interior Landscapes, Quicksilver Galerie, Berlin, Germany **Selected Group Exhibitions** 2008 *Untitled (Vicarious): Photograp the Constructed Object*, Gagosian, New York, US // *Martian Museum of Terrestrial Art*, Barbican Art Gallery, London, UK (c) // *Gree from Thingland*, Friends of Helsinki Biennale, Helsinki Biennale, Helsinki Design Museum, Finland // *New Photography in Britain*, Gal Civica di Modena, Italy // *A Stain Upon The Silence*, Central Saint Martins, London, UK // *The Brotherhood of Subterranea*, Kunstbu Nuremberg, Germany // 2007 *07/08*, Bellwether, New York, USA // *52nd International Art Exhibition: La Biennale di Venezia*, New F Pavilion, Venice, Italy (c) // *New Forest Pavilion Local*, ArtSway, UK (c) // *STILL LIFE*, STILL: contemporary variations, T 1+2 Gallery, London, UK // *The Juddykes*, The Old Art Shop at John Jones, London, UK // *The Lucifer Effect*, Primo Alonso, London, UK // 2006 *MERZ*, Magazin4, Bregenzer Kunstverein, Austria, curated by Peter Lewis, (c) // 2005 to be continued.../jaatku... Kunsthalle Helsinki, Finland, curated by Brett Rodgers and Mika Elo (c). **NICHOLAS HATFULL** Born in Tokyo, Japan in 1984 // Lives and works in London, UK **Education** BA Fine Art, Ruskin School of Drawing and Fine Art 2003–06 // MA Painting, Royal Academy Schools, 2007–10 **Selected Solo Exhibitions** 2009 Ignorant With the Suncream (Seafroot Delivery), Karsten Schubert, London // 2007 Supercafone's Autoberryblues, the Wallis Gallery, London **Selected Group Exhibitions** 2009 *Royal Academy Summer Exhibition*, London // *Wallis Dies and goes to Paradise*, Paradise Row, London // 2008 *20eventi 2008*, Sabina, Italy // 2006 *Tournament*, Spital Square, London // *Montana Butch*, Great Eastern Hotel, London. **IAIN HETHERINGTON** Born in Glasgow, Scotland in 1978 // Lives and works in Glasgow, Scotland **Education** Masters Degree in Fine Art, Glasgow School of Art // 2002-04 BA ((Hons)) Fine Art, Painting, Glasgow School of Art 1996-2000 **Selected Solo Exhibitions** 2008 *Nought to Sixty*, ICA, London // *(August) - solo Diversified Cultural Workers*, Mary Mary, Glasgow // 2006 *Other Mixed Background*, Whitechapel Project Space, London // *Eyes in the Heat*, Glasgow Project Room, Glasgow // 2005 *Who We Want*, 656 Alexandra Parade, Glasgow // 2001 *Knowlij Enclave*, Collective Gallery, Edinburgh // *Interstitial Campsite*, Glasgow Project Room, Glasgow **Selected Group Exhibitions** 2009 *Group show*, Monica de Cardenas Gallery, Milan // 2007 *La Commune*, Serpentine Gallery, London* // *Iain Hetherington/Lynn Hynd*, Studio 40, Glasgow School of Art, Glasgow // 2006 *126 Gallery*, Galway City, Ireland // *Survey Show of 126 Projects*, Galway Arts Centre, Ireland // 2005 *Slimvolume Poster Publication*, Fortescue Avenue/Jonathan Vyner, London* // *Campbell's S* Mackintosh Gallery, Glasgow // *The Last Chickens of Sainsbury*, The Chateau, Glasgow & W.A.S.P.S, Glasgow* // 2004 *Spacemaker.* Lothringer Dreizehn, Munich* // *Publish & Be Damned*, Cubitt, London* // *The Principle of Hope*, Three Colts Gallery, London* // *S Me To The Tradesman's Entrance*, Tramway, Glasgow // *Synth*, Kunstraum B/2, Leipzig // *Transmission*, Grazer Kunstverein, C **████████████** Born in Canterbury, UK in 1980 // Lives and works in London, UK **Education** Wimbledon College o 1999 – 2000 // Goldsmiths College 2000 – 2003 // Royal Academy Schools 2005 – 2008 **Selected Solo Exhibitions** 2009 *Pipedre* Dickinson Gallery New York (solo exhibition) // *Pileup*, curated by Ken Mcgegor, Metro 5 Gallery, Melbourne // 2008 *Alexander H* curated by Nick Aikens, University of the Arts, London **Selected Group Exhibitions** 2008 *Anticipation*, curated by Kay Saatchi Catriona Warren, Selfridges, London // *M25: Around London*, curated by Barry Schwabsky, CC Andratx, Mallorca // *The Future Can* Truman Brewery, London // 2007 *Who's On Second?*, curated by Michael Pettey, Pumphouse Gallery, London // 2006 // *Premiums*, R Academy Schools, London // 2004 *Material*, curated by Nick Aikens and Alexander Hoda, Next New Artists, London. **SIGI HOLMWOOD** Born in Hobart Australia in 1978 // Lives and works in London, UK **Education** MA Painting, Royal College of 2000-02 // BFA, Ruskin School of Drawing and Fine Art, 1997-2000 **Selected Solo Exhibitions** 2008 *1847 – Paintings*, Annely Juda Art, London // 2006 *Past-times and Re-creation*, Transition, London // *Self-sufficient*, Contemporary Arts Projects, London // 2004 *la Pi Sale sugli Alberi*, 42contemporaneo, Modena **Selected Group Exhibitions** 2007 *Artificial Glory*, Standpoint Gallery, London // *Cur Chapters,* The British Library, London // 2006 *The Spiral of Time*, APT, London // *Responding to Rome*, Estorick Collection, London // 2005 *The Jerwood Drawing Prize 2005*, Jerwood Space, London (touring) // *Spiral of Time*, OHOA, Reading // *Hand in Hand we walk alone*, Clapham Art Gallery, London // *Pocket-Scopic*, Sartorial Contemporary Art, London // 2004 *If you go down to the woods today...*, Rockwell Gallery, London // *Spazi Aperti*, Romanian Academy, Rome // *Extra-Natura: Konst! Scopriamo la Svezia*, 42contemporaneo, Modena // *Compass*, Sala 1, Rome, ITALY. **████████████** Born in Kent, UK in 1974 // Lives and works in London, UK **Education** MA Fine Art, Goldsmiths College, 2004 - 06 // BA Fine Art , Nottingham Trent University, 1994 - 97 **Selected Solo Exhibitions** 2009 *Sculpture Roof*, Crisp London Los Angeles, London, UK // *Martin Fletcher Systems House*, Gallery 333, Exeter, UK // 2008 *Martin Fletcher Systems House*, Galleri S.E, Bergen, Norway // 2007 *Martin Fletcher Systems House*, Galerie Michael Janssen, Berlin // 2003 *Air Cushioned Sculpture Division*, Commercial Too Gallery, London // 2001 *Weightmaster*, Kingsgate Gallery, London // 1998 The Commercial Gallery, London **Selected Group Exhibitions** 2009 *Pattern Recognition*, The City Gallery, Leicester, UK // 2008 *The Show will be Titled after its*

Form Content, London, UK // 2007 *FOREIGN BODY(ies)*, Cottelston Advisors at White Box, New York // *Absent Without Leave*, Victoria Miro ery, London // *SNAP*, Cell Projects, London // Distinction, Galerie Michael Janssen, Cologne, Germany // 2006 *News From Nowhere – Visions of ia*, William Morris Gallery, London // 2005 *Worn Out Wash Monkeys*, Riley Kenny Projects, London. **GRAHAM HUDSON** a in Kent, UK in 1977 // Lives and work in London and LA **Education** MA Fine Art Sculpture, Royal College of Art, London 2000-02 A Fine Art Sculpture, Chelsea College of Art and Design, London 1997-2000 **Selected Solo Exhibitions** 2009 Monitor, Rome // 2008 Cunen Museum, Oss, Netherlands // Locust Projects, Miami // 2007 Rokeby, London // *Monitor*, Rome // 2006 Zinger Presents, terdam, Netherlands // 2005 VTO, London // 2004 Jerwood Artist's Platform, Jerwood Space London **Selected Group Exhibitions** *Strange days and some flowers*, Storey Gallery, Lancaster // Notes on a return, Laing gallery, Newcastle // *Space Revised #3 What if was a piece of Art*, Halle fur Kunst Leuneburg, Germany // *Canal Street Sculpture Park*, LMCC, New York // *Ctl Alt Shift*, Baltic Centre ontemporary Art, Gateshead/Newcastle // 2008 *Material presence*, 176/Zabludowicz collection, London // *6 of 1: Live art Performance*, iden Arts Centre, London // *All my favorite singers couldn't sing*, Workplace, Gateshead/Newcastle // *We would like to thank the curators wish to remain annoymous*, Seventeen, London // *Better is something you build*, Kevin Kavanagh Gallery, Dublin // *Eyesore*, V1, Copenhagen // 2007 *From a distance*, Wallspace, New York // *Says the junk in the yard*, Flowers East, London // *I was a sculptor (but then again no)*, BearSpace, London // *It was the best of Time Outs*, it was the worst of Time Outs, Seventeen, London // *Those Quaint Moments of distress*, MontanaBerlin, Berlin. **DEAN HUGHES** Born in Salford, UK in 1974 // Lives and works in Edinburgh, UK **Education** 1993 - 1996 BA ((Hons)) Fine Art, Chelsea College of Art and Design, London **Selected Solo Exhibitions** 2008 Dicksmith Gallery, London // 2003 Jack Hanley Gallery, San Francisco, USA // 2002 38 Langham st. London // Turnpike Gallery, Leigh // 2001 Jack Hanley Gallery, San Francisco, USA // 2000 International 3, Manchester // Laure Genillard Gallery, London // 1998 Gian Carla Zanutti Arte Contemporanea, Milan **Selected Group Exhibitions** 2009 *Boneless Box*, Embassy, Edinburgh // 7, Recent British Drawings, Trinity Contemporary, London // 2008 *Library*, UOVO open office, Berlin, curated by Adam Carr 'Eskimo', Polarcap, East Lothian/Scotland, UK // *Neau Alte Brucke*,'Schwarz weiss ausstellung', Frankfurt/DE // The Arts Gallery, University of the Arts, *...the same as it ever was ? painting at Chelsea 1990 - 2007* Curated by Clyde Hopkins London/UK* // 2007 Galerie Praxis Hagen, *To the centre of the city*, Berlin/DE // Laure Genillard Gallery, *Presque Rein*, London/UK // 2006 Doggerfisher, *Karla Black/Dean Hughes/ Duncan Marquiss/Jonathan Owen Hanneline Visnes*, Edinburgh // 2005 Bury Museum and Art Gallery, *The Text*, Lancashire Grundy Art Gallery,- Social Club-, Blackpool. **MUSTAFA HULUSI** Born in London, UK in 1971 // Lives and works in London, UK **Education** MA Photography, Royal College of Art, 2002-04 // BA, Fine Art, Goldsmiths College, 1992-95 **Selected Solo Exhibitions** 2009 *Mustafa Hulusi : Obliteration and Memory,* Patrick Painter, Los Angeles // 2008 *Iznik-Kibris-Londra*, Galerist, Istanbul // *Exstacy*, Max Wigram ery, London // 2007 *The Cyprus Pavilion*, Venice Biennale, Venice // *Cennet Bahçesi*, A-Foundation, Liverpool // *preBuild (a Field of Flowers)*, Wigram Gallery, London // 2006 *Mustafa Hulusi Too*, Rachmaninoff's, London **Selected Group Exhibitions** 2009 *RANK. Picturing ocial order 1516-2009*, Northern Gallery for Contemporary Art,Sunderland // 2008 *Landscapes: Contemporary Aspects of Orientalism*, ng Gardens, London // *Imaginary Realities*, Max Wigram Gallery Temporary Exhibition Space, London // *Beyond Paradise*, Stedelijk eum Bureau, Amsterdam // 2007 *Salon 2007: New British Painting and Works on Paper* 319 Portobello Road, London // *Abstraction tracting from the World* (curated by David Thorp), Millennium Galleries, Sheffield // *The Zabludowicz Collection: When We Build, Let hink That We Build Forever*, BALTIC Centre for Contemporary Art, Gateshead // RODEO gallery, Istanbul // *Yama*, The Marmara Pera el, Istanbul // 2006 *Into Me Out of Me*, P.S.1, New York, USA (touring to Kunst-Werke, Berlin and Museo d'arte Contemporanea Roma) *Here*, Bloomberg SPACE, London, UK. **PAUL JOHNSON** Born in London, UK in 1972 // Lives and works in London, UK cation MA Fine Art, Royal Academy Schools, London 2000-03 // BA (Hons) Fine Art, Painting, Glasgow School of Art 1990-94 cted Solo Exhibitions 2009 *Ascension into Unselfishness*, Ancient & Modern, London // *When Were Gone Destroy Everything*, One in Other, London // 2008 *Sensitive Chaos*, Mizuma Gallery, Tokyo // 2005 *The Glass Family*, One in the Other, London // 2003 *Paul nson Studio darte Cannaviello*, Milan // *Second Seed One in the Other*, London **Selected Group Exhibitions** 2009 Collider, Margini Contemporanea, Massa, Italy // 2008 *Living London*, Zabludowicz Collection, 176, London // *Brotherhoods of Subterreria*, KunstBunker, nberg, Germany // 2006 *The Souvenir Mine*, Mizuma Gallery, Tokyo // *Black Moon Island One in the Other*, London // 2005 *The Future Lasts a Long Time*, Le Consortium, Dijon // *Future Primitive* (curated by Paul Johnson) One in the Other, London // *Faux Realism part 2* Rockwell, London // 2004 *The Future Lasts a Long Time Tal Esther*, Tel Aviv // *World.B*, Flaca Gallery, London // 2003 *Arrivals*, Pump house gallery, London. **EDWARD KAY** Born in Chester, UK in 1980 // Lives and works in London, UK **Education** MA Painting, Royal Academy Schools, London 2002-05 // BA (Hons) Fine Art, Ruskin School of Drawing & Fine Art, Oxford 1999- 2002 **Selected Solo Exhibitions** 2008 *The Hidden Network*, Solo Exhibition, Dicksmith Gallery, London // *Surfaced*, two person show with Nayland Blake, Royal Academy Schools Gallery // *005 Solo show*, Dicksmith Gallery, London **Selected Group Exhibitions** 2009 *Being and Nothingness*, Light & Sie Gallery, Dallas // 2007 *Group show*, Engholm Engelhorn Galerie, Vienna // 2006 *Icons*, Chung King Project, Los Angeles Celeste Art Prize, Old Truman Brewery, London // 2005 *Zoo Art Fair*, Dicksmith Gallery MABA, Art Fortnight London // 2004 *Final Exhibition*, Royal Academy Schools, London // *Zoo Art Fair*, Dicksmith Gallery, London // AT Carney, London // Lexmark Prize, Air Gallery, London // *Premiums*, Royal Academy of Arts, London // *Art School*, Bloomberg Space, London // 2003 *Pastoral*, Dicksmith Gallery, London

- // Group vs Show, Dicksmith Gallery, London // *The Woods*, Ruskin Schools, Oxford // 2002 *Royal Society of Portrait Painters,*
- Galleries, London // 2001 *The Drawing Show*, Mary Ogilvy Gallery, Oxford. ▮▮▮▮▮▮▮ Born in Goole, UK in 1969 // Lives
- works in London, UK **Education** BA Graphic Design, Hull College of Art, 1989 - 92 **Selected Solo Exhibitions** 2008 *The Penulti*
- *Straw,* Herald St, London // *The Trial Continues,* Bortolami, New York // *Temporary Eyesore,* Artists' commission, Bankside, Lond
- 2006 *And the Pylons Stretched for Miles*, Herald St, London // *Scott King,* Frac Nord-Pas de Calais, Dunkirk // *Information*, Borto
- Dayan, New York // *Oh! Pylon Heaven*, Sonia Rosso, Turin **Selected Group Exhibitions** 2008 *All That is Solid Melts into Air / Wins.*
- *Children*, Jeremy Deller and Scott King, Palais de Tokyo, Paris // *100 Years, 100 Artists, 100 Works of Art*, Rochelle School, London //
- *Was Then…This Is Now*, PS1 Contemporary Art Centre, New York // *Martian Museum of Terrestrial Art*, Barbican Art Gallery, Lond
- *Pop Goes The Weasel!*, Kunstverein Karlsruhe // *Publish & Be Damned*, Ludlow 38, New York // 2007 *Left Pop*, Moscow Museum
- Modern Art (2nd Moscow Biennale) // *Scott King / Graphic Semantics*, Il Ju Art Space, Seoul // *Sympathy for the Devil: The Converge*
- *of Art and Popular Music,* Museum of Contemporary Art, Chicago/ Montreal/ Miami // *Multiplex: Directions in Art, 1970 to Now*, Mus
- of Modern Art, New York. ▮▮▮▮▮▮▮▮ Born in Copenhagen Denmark in 1974 // Lives and works in London,

Education 2006-9 Postgraduate Diploma in Fine Art, Royal Academy Schools, London // 2008- Gasthoererschaft zum Studium fur Freie Kunst, w. professor Peter Doig, Kunstakademie Duesseldorf, Duesseldorf // 2004 BA in Fine Art (exchange stay), Hunter College of Art, New York **Selected Solo exhibitions** 2008 *And all I ever wanted was everything*, Art Copenhagen (solo presentation with Galleri Christina Wilson), Forum, Copenhagen // 2007 Ancient and Modern, London // 2006 *Come at the King, You Best Not Miss*, Galleri Christina Wilson, Copenhagen // *BA Degree show*, Slade School of Fine Art, London // 2002 *So Far, so Good, so What*, Dronningens Tværgade, Copenhagen **Selected Group exhibitions** 2009 *Royal Academy Schools Show 2009*, Royal Academy of Arts, London // Daily Miracles, Josh Lilley Gallery, London // *The Long Dark*, International 3, Manchester // 2008 *Premiums Show*, Royal Academy of Arts, London // 2007 *Accrochage*, Galleri Christina Wilson, Copenhagen Aquarium, C4RD (Centre for Recent Drawing), London // *5 years anniversary show*, Galleri Christina Wilson, Copenhagen // *Strange Weight*, Martos Gallery, New York // *The Late Notice show*, London // 2006 *Club Lobby præsenterer*, Møstings Hus, Copenhagen // 2005 *Copenhagen Art Fair* - Galleri Christina Wilson, Copenhagen // *Bulky Luggage*, Seven Seven Gallery, London. ▮▮LITTLEWHITEHEAD▮▮ littlewhitehead (b 2005) is the artistic persona of Craig Little and Blake Whitehead. They began working collaboratively after studying together at Glasgow School of Art. They both live and work in Glasgow // **Craig Little** Born in Glasgow, Scotland in 1980 // College of Commerce 1999-2002 // BA (Hons), Visual Communication, Glasgow School of Art, 2003- 07 // **Blake Whitehead** Born in Lanark, Scotland in 1985 // BA (Hons), Visual Communication, Glasgow School of Art, 2003-07 // **Selected Solo Exhibitions** 2009 *The Black Smoke Machine Gun Club*, The Royal Standard, Liverpool // *The Fourth Wall*, Bloc, Sheffield // *Playing Dog*, Gimpel Fils, London // *So many fellows find themselves*, K Gallery, Milan // *So this is romance*, Bun House Bandits, London // 2008

- *Nothing Ever Happens Here*, SWG3, Glasgow **Selected Group Exhibitions** 2009 *Newspeak: British Art Now*, The Hermitage, St Petersb
- Russia // *Tales That Witness Madness*, Elevator Gallery, London // *Alternative States*, Gimpel Fils, London // *Adventure beyond the edg*
- *time*, Eleven Howland, London // *Field of Sets Part II: Disjunction*, Field Project Space, London // *Grey Matter*, Talbot Rice Gal.
- Edinburgh // *Wild is the Wind*, Wall Gallery, London // 2008 *Conjunction 08*, Stoke-on-Trent // *Bloomberg's New Contemporarie*
- Foundation, Liverpool and London. ▮▮CHRISTINA MACKIE▮▮ Born, Oxford, UK in 1956 // Lives and works in London, UK **Educa**
- B A (Hons), Central St. Martins, 1976-79 **Selected Solo exhibitions** 2008 *Steal*, In the Silent, Sonia Rosso, Turin, Italy // 2007 *This th*
- *the other*, Herald St, London // *Art Now Sculpture Court*, Tate Britain, London (cat) // 2006 *How to Begin*, I-Cabin, London // *Ga*
- Project, Gadani, Pakistan // *Five 06*, VM Gallery, Karachi // 2005 *I Can't Help You*, Herald St, London // 2003 *Magnani*, London, U
- 2002 *The Interzone*, Henry Moore Institute, Leeds // 2001 *AC Project Room*, (with Katrin Asbury), New York // 2000 *Meanwhile, C*
- Kitakyushu, Japan // *Forcing It*, Magnani, London **Selected Group exhibitions** 2008 Busan Biennale, Korea, curated by Tom Mor
- Roger Hiorns, Christina Mackie, Maaike Schoorel, Diana Stigter, Amsterdam // 2007 *It starts From Here*, De La Warr Pavillion, Bexhi
- Sea // *Love Me Tender*, Tate Britain // 2006 *Flutter*, curated by Michael Readecker, The Approach, London // *British Art Show 6*, Ba
- Newcastle, UK (touring) // *5five*, VM Gallery, Karachi Pakistan // 2005 *5 Sculptors*, Westfälischer Kunstverein, Münster, Germany Be
- Futures, ICA, London, UK & CCA, Glasgow. ▮▮ALASTAIR MACKINVEN▮▮ Born in Clatterbridge, UK in 1971 // Lives and work

London, UK **Education** MFA, Goldsmiths College, 1994-96 // BFA, Alberta Collage of Art 1992-94 // University of Calgary, Fine Arts Department, 1990-92 **Selected Solo Exhibitions** 2009 *Performances 2006 to 2009*, Focal Point Gallery, Southend-on-sea // *Abaract* Capitalist Realism (part 1: Dark Side of the Wall), Galerie Rüdiger Schöttle, Munich, Germany // 2008 *0-60*, ET SIC IN INFINITUM AGAIN, ICA, London // 2007 *Solo Project*, Liste 07, Basel // 2006 *Jerking Off The Dog To Feed The Cat*, HOTEL Gallery, London **Selected Group Exhibitions** 2008 *That's Not How I Remember It*, Anna Helwing Gallery, Los Angeles // *Strange Events Permit Themselves The Luxury Of Occuring*, Camden Arts Centre, London // *Horsebit Cocktail*, Galerie Dennis Kimmerich, Dusseldorf // *The Nang Gallery Frieze Soup Kitchen*, Nang Gallery, London // *0-60 Performace Weekend*, ICA, London // *Novel*, Bibliothekswohnung Anna-Catherina Gebbers, Berlin // *Congratulations You Are Represented By Nang Gallery*, Nang Gallery, London // Zodiac 3000, The Reach of Tomorrow, the JG Ballard Centre of Psycopathological Research, International Project Space Birmingham // 2007 *The Death Of Affect*, Parade, London // *Gallery Swap*, Hotel at Guido Baudach, Berlin // 2005 *Islands of Glory in Streets Caked With the Faeces of Decadence:* NANG Gallery,

...don // 2004 Group show: Opposite the Play Ground, London // *I Love Music: Creative Growth*, Oakland, California. **GOSHKA MACUGA**

...n in Poland in 1967 // Lives and works in London, UK **Education** MA Fine Art, Goldsmiths College, 1995-6 // BA (Hons) Fine Art, Central St. ...tins, 1991-5 **Selected Solo Exhibitions** 2009 *The Bloomberg Commission - Goshka Macuga*, Whitechapel Gallery, London, April 2009 ...pril 2010 // *Goshka Macuga – I Am Become Death*, Kunsthalle Basel // 2008 Goshka Macuga: Gottessegen, Galerie Rüdiger Schöttle, ...ich, May - June // 2007 *Objects in Relation*, Art Now, Tate Britain, London, June – October // *What's In a Name*, Andrew Kreps Gallery, ... York, February – March // 2006 *Mula sem Cabeça (Headless Mule)*, How to Live Together, 27th São Paulo Biennial, October - ...ember // *Sleep of Ulro*, The Furnace Commission, A Foundation, Liverpool, September - November **Selected Group Exhibitions** 2009 ...*Dark Monarch: Magic and Modernity in British Art*, Tate St Ives // *Textile Art and the Social Fabric*, MuHKA Museum of Contemporary ...// 53rd Venice Biennale: Fare Mondi/Making Worlds, Corderie dell'Arsenale, Venice // 2008 *Turner Prize 2008*, Tate Britain, London // ...* beautiful pale face is my fate (For Lord Byron)*, Newstead Abbey, Nottinghamshire // *The Great Transformation: Art and Tactical ...ic*, Frankfurter Kunstverein, travelling to MARCO, Museo de Arte Contemporanea de Vigo, Spain // *5th Berlin Biennial for Contemporary ...* Neue Nationalgalerie // *Martian Museum of Terrestrial Art*, Barbican Art Gallery. **KARLA BLACK** Born in Glasgow, Scotland ...in 1967 // Lives and Works in Glasgow, Scotland **Education** MA Fine Art, Glasgow School of Art, 1996 -98 // BA Fine Art, Duncan ...of Jordanstone College of Art, Dundee1992 -96 **Selected Solo Exhibitions** 2009 *In a Rotterdam Cell*, Galerie Micky Schubert, ...Berlin // 2008 *It's a British Sound*, Schurmann Berlin, Berlin // *Mood: Casual*, Tate Britain, London (at Art Now) // *Touch Void*, ...Talbot Rice Gallery, Edinburgh // 2007 *Decamp*, David Kordansky Gallery, Los Angeles // *Space to Squabble*, Galerie Micky ...Schubert, Berlin // 2005 *Solo*, Modern Art, London // The Invention of Birth Control, Sorcha Dallas, Glasgow **Selected Group ...Exhibitions** 2009 *Depression*, Marres Centre for Contemporary Culture, Maastricht // *The Associates*, Dundee Contemporary Arts, Dundee ...(Part of DCA's 10th Anniversary Exhibitions programme.) // 2008 *To bring forth and give*, Sorcha Dallas Artist's Print Project, Glasgow // ...*Print Studio*, Glasgow (curated by Sorcha Dallas) r e p'e . t' t i o n, Sorcha Dallas, Glasgow (closed 21 December to 5 January) // *Sphinxx*, ...Modern Art, London (curated by Alexis Vaillant) // *Frieze Art Fair*, London // Liste, Basel // *Legend*, Domain de Chamarande, nr Paris ...(Curated by Alexis Vaillant) // *Ritual In The Dark*, Hotel, London (with Stephen Sutcliffe. **RYAN MOSLEY** Born in Chesterfield, UK ...in 1980 // Lives and works in London, UK **Education** MA Painting, Royal College of Art, 2005-07 // BA Drawing and Painting, Huddersfield ...University, 2000-03 **Selected Solo Exhibitions** 2009 *A Gathering*, Regina Gallery, Moscow // *Project Room*, Alison Jacques Gallery, London ...// 2008 *Census*, Engholm Engelhorn, Vienna // *Art Basel*, Miami Beach, Engholm Engelhorn, Miami // 2004 *Eight Years Ago and Before*, ...Bloc Space, Sheffield **Selected Group Exhibitions** 2009 *Bolte&Lang*, Zurich // *Newspeak*, Saatchi Gallery at The Hermitage, St.Petersburg ...// *Jerwood Contemporary Painters Prize*, Jerwood Space, London (touring to PSL, Leeds, Norwich Gallery, Norwich and New Pitville ...Gallery, Cheltenham) // 2008 *Moravia*, Cell Project Space, London // *Make Believe*, Concrete & Glass, London // Cory Michael Project, ...don // The Painting Room, Transition Gallery, London // 2007 *Wassail*, Cell Project space, London // *Summer School*, Ibid Projects, ...don *The Great Exhibition*, Royal College Of Art, London // *Celeste Art Prize*, Old Truman Brewery, London // *Dropping's*, Blythe ...ery, Imperial College, London // 2006 *SAUDADE*, Highbury Studios, London // *Seeking Tacit Utopias*, Surface Gallery, Nottingham // ...*sure Yourself*, Howie Street London. **RUPERT NORFOLK** Born in Abergavenny, Wales in 1974 // Lives and works in London, ...// **Education** BA ((Hons)) Fine Art , Chelsea College of Art and Design, 1996 **Selected Solo Exhibitions** 2008 Stella Lohaus, Antwerp ...07 Dicksmith Gallery, London // 2006 Solo Presentation at Dicksmith Gallery, VOLTAshow 02, Basel, Switzerland // 2005 Dicksmith ...ery, London **Selected Group Exhibitions** 2009 May/June, Stella Lohaus, *Antwerp Drawing 2009* - Biennial Fundraiser, The Drawing ...m, London // 2008 *M25 Around London*, CCA Andratx, Mallorca Novel, Anne-Catharina Gebbers Bibliothekswonhning, Berlin // ...uring, Chez Valentin, ParisThe Walls in Three Places*, Charlton Art Centre, Dover // *Henry Coleman & Rupert Norfolk*, Balice Hertling, ...s // 2007 *Los Vinilos*, Buenos Aires // *Abstraction: Extracting from the World*, curated by David Thorp, Millennium Galleries, Sheffield ...nterfacture: William Daniels, David Musgrave, Rupert Norfolk, Alex Pollard, Luhring Augustine, New York // George Longly, Rupert ...folk, Galerie Chez Valentin, Paris // 2006 *Rockridge*, The Embassy Gallery, Edinburgh // Between a Rock and a Hard Place – The Stone ...rt, Kenny Schachter:Rove, London // *Crivelli's Nail*, curated by David Risley, Chapter Gallery, Cardiff // 2005 *Zoo Portfolio 2005*, ...ted by David Thorp, Zoo Art Fair, London // Les Merveilles du Monde, curated by Peter Fillingham, Musee des Beaux Arts de ...Dunkerque, France // Waste Material, curated by David Musgrave, The Drawing Room, London // Doubtful Works and Copies: Alasdair ...Gray, Rupert Norfolk, Jane Topping, Transmission, Glasgow. **ARIF OZAKCA** Born in London, UK in 1979 // Lives and works in ...London, UK **Education** MA, Chelsea School of Art, 2006-07 // BA Painting, Camberwell College of Arts, 2000 – 03 // Foundation ...Painting, Central St. Martins, 1999-2000 // **Selected Group Shows** 2009 *Newspeak: British Art Now*, The Hermitage, St.Petersberg, ...Russia // 2008 *Soul Stripper*, Projet Midi Brussels // Art Brussels, The Agency, Brussels // Every Body, Kunstlaboratorium Vestfossen, ...Norway (cat) // Re-aspora, w. Karen Tang, Camilla Akraka, Hassan D'Arsi, Johannes Phokela a/o, Casablanca // 2007 *Showoff Paris ...Re-aspora*, Showroom MAMA Rotterdam // The Agency, London // Art Brussels, Brussels // 2006 *Canon*, Group Show, The Agency, ...London // Hollyrood, Edinburgh. **MARK PEARSON** Born in Wakefield, UK in 1966 // Lives and works in London, UK **Education** ...MA Fine Arts, Goldsmiths College 1999–2000 // BA Fine Arts, Chelsea College of Art and Design 1988–91 // **Selected Solo Exhibitions** ...2009 *BAR VUG GUM*, Moot, Nottingham // Open Space Cologne, Solo Presentation with Galerie Reinhard Hauff // 2008 *Disco Mystic*,

Galerie Reinhard Hauff, Stuttgart, Germany **Selected Group Exhibitions** 2009 *Ventriloquist*, Timothy Taylor Gallery, London (curated Emma Dexter) // 2008 *Say Sorry for Not Making*, Moot, Nottingham United We Fall (Mark Pearson / Annie Whiles), Standpoint Gall London Event Horizon, GSK Contemporary Season, Royal Academy of Arts, London // 2007 *Circle of the Tyrants*, Southwell Artsp Nottinghamshire (curated by Moot) Drunken Boat, Colony, Birmingham, UK Intoposition, Bauernmarkt1, Vienna, Austria // 2006 *Metrop Rise: New Art from London*, CQL Design Center, Shanghai, DIAF // 2006, Beijing, China (curated by Anthony Gross and Jen Wu) // 2 *Old Money*, Intermedia, Glasgow, UK (curated by Cedar Lewisohn) // *Gifts to the City of Sheffield*, Art Sheffield 2005, *Site Gal* Sheffield (curated by Gavin Wade) // 2004 *Mind the Gap*, La Friche, Marseille, France (curated by Alicia Paz) // Tealeaf, Cell Project Sp London (curated by Richard Priestley) // *Wilkommen*, Metropole Art Galleries, Folkstone, UK (curated by Luke Oxley) // *Sculpture Gar* Old Street, London (curated by Jacob Dahl // Jurgensen) // *Tonight*, Studio Voltaire, London (curated by Paul O'Neill) // *Dusu Choi & M* Pearson, The Economist Building, London // *Multistorey*, Pump House Gallery, London // Blind Date, Temporary Contemporary, London. **DAN PERFECT** Born in London, UK in 1965 // Lives and works in London, UK **Education** BA (Hons) in Fine Art, Painting, St Martins School of Art ,1983 - 86 // DATEC in Art & Design, Chelsea School of Art ,1981–83 **Selected Solo Exhibitions** 2008 *Dan Perfect: Paintings & Drawings*, Road Agent, Dallas, USA // *Dan Perfect: Drawings*, One in the Other, London // *Dan Perfect: Paintings*, Chisenhale Gallery, London (Catalogue; texts by Simon Wallis and Martin Herbert) // 2006 *Dan Perfect, One in the Other*, London // 2003 *Perfect Drawings*, Karsten Schubert, London // 2001 *Floating Islands*, Habitat, London **Selected Group Exhibitions** 2006 Far From the Madding Crowd, Road Agent, Dallas, USA // 2006 *Black Moon Island*, One in the Other, London // 2005 *Recent Aquisitions*, Southampton City Art Gallery // 2003 *Exploring Landscape: Eight Views from Britain*, Andrea Rosen Gallery, New York 2002–2003 // *Beck's Future's*, ICA, London, travelled to CCA, Glasgow, and Mappin Art Gallery, Sheffield, UK (Catalogue; text by Simon Wallis) // 2001 Death to the Fascist Insect that Preys on the Life of the People, Anthony d'Offay Gallery, London (Catalogue; text by Martin Maloney). **PETER PERI** Born in London, UK in 1971 // Lives and works in London UK **Education** MA Fine Art, Chelsea College of Art, London // 2001-03 BA (Hons) Design, Central St Martins School of Art and Design, London 1991-94 // **Selected Solo Exhibitions** 2008 *Wave-Grain in the Wall*, Carl Freedman Gallery, London // 2007 *ART NOW*, Tate Britain, London Hole Here, Galerie Giti Nourbakhsch, Berlin // 2006 *Country 10*, Kunst Basel, Switzerland Overflow and Extinction, Counter Gallery, London, 2005 // *The Grey Point*, Counter Gallery, London, 2004 **Selected Gr Exhibitions** 2009 *Black Hole*, CCA Andratx // *Mallorca Classified: Contemporary British Art from the Tate Collection*, Tate Bri London // *Modern Modern*, Chelsea Art Museum, New York // 2008 *Space Now*, Space Studios, London // *Back to Black: Black in Cur Painting*, Kestner Hannover Beyond Measure: Conversations Across Art and Science, curated by Barry Phipps, Kettles Yard, Cambrid ...*same as it ever was*, Painting at Chelsea 1990 – 2007, curated by Clyde Hopkins, The Arts Gallery, London // 2006 *How to Improve World*, 60 years of British Art - Arts Council Collection, Hayward Gallery, London // *Motion on Paper*, Ben Brown Fine Art, Londe *TOUTES COMPOSITIONS FLORALES*, Counter Gallery, London // A Violet From Mother's Grave, curated by Matthew Weir. **AIGARS BIKSE** Born in Riva, Latvia in 1973 // Lives and works in London, UK // **Education** MA Scenography, Central Saint Martins, 200 Professional degree in Scenography, Art Academy of Latvia, 1998 // BA Scenography, Art Academy of Latvia, 1996 **Selected S Exhibitions** 2009 *The Third Degree*, Sesame Art Gallery, London // 2007 *Icon Resistance*, Sesame Art Gallery, London // 2005 *Sesame Gallery*, London // Istaba Gallery, Riga, Latvia // 2004 *Salon des Arts*, London // 1998 Pfefferbank Gallery, Berlin // 1997 Galerie-Werks Berlin **Selected Group Exhibitions** 2009 *Innerer Klang*, Rod Barton Gallery, London // East End Accademy, Whitechapel Gallery, Lon // *Salon*, Whitecross gallery, London // 2008 *Summer exhibition*, Royal Academy of Arts, London // *Scope Art Fair*, Represented by Ses Art Gallery, London // *Group*, lois Lambert Gallery, Los Angeles // *Salon*, Whitecross gallery, London // 2007 Bridge Art Fair-Represen by Sesame Art Gallery, *London Building a Legacy: Paintings 1985-2007*, Bemis Center For Contemporary Arts, Omaha, Ne, US // 2006 *Visual AIDS*, Postcards From the Edge, Sikkema Jenkins & Co, New York // Regroup Sesame Art Gallery, London // *Summer show*, Edgarmodern Gallery, Bath // 2005 *Sense & Sensuality*, BlindArt, RCA, London. **GED QUINN** Born in Liverpool, England in 1963 // Lives and works in London, UK **Education** Ruskin School of Drawing Oxford 1982-85 // Slade School of Fine Art 1985-87 // Kunstakademie Dusseldorf 1988-1990 // Rijksakademie1993-1994 **Selected Solo Exhibitions** 2010 Wilkinson Gallery, London // 2007 *My Great Unhappiness Gives me a Right to your Benevolence*, Wilkinson Gallery // 2005 *Wilkinson Gallery*, London // The Heavenly Machine, Spike Island, Bristol // 2004 *Utopia Dystopia*, Tate St Ives **Selected Group Exhibitions** 2009 *Newspeak: British Art Now*, State Hermitage Museum, St Petersburg // *Kunskog*, Five Hundred Dollars, London // *Kings*, Gods and Mortals, Hamish Morrision Galerie, Berlin // 2008 *John Moores 25*, Walker Art Gallery, Liverpool // *Liverpool Biennale 2008*, 'Made Up', Tate Liverpool // *Jekyll Island*, Honor Fraser, Los Angeles // *DoktorsTraum*, Olbricht Collection – New Aspects, Neues Museum Weserburg Bremen // *Monochrome: Drawing & Prints*, Rabley Drawing Centre, Wiltshire // 2007*Stranger than Paradise*, Galerie Charlotte Moser, Genève // *Rockers Island*, Olbricht Collection, Museum Folkwang, Essen // *Salon Nouveau*, Rabley Drawing Centre, Wiltshire // 2006 *Collezionami*, 2nd Biennale of Southern Italy, Bari Puglia, Italy // 2005 *The Real Ideal*, With Damien Hirst Gregory Crewdson Pippolotti Rist, Millenium Galleries, Sheffield // *Wonderings...* with Peter Macdonald, Judith Goddard & Sean Dower, Waugh & Thistleton, London // *ShowCASe*, City Art Gallery, Edinburgh // *MOSTYN 2005*, Oriel Mostyn, Llandudno. **CLUNIE REID** Born in Pembury, UK in 1971 // Lives and works in London, UK **Education** MA Painting, Royal College of Art, 1995 // Winter term exchange, School of the Art Institute of Chicago, USA. 1994 // BA (Hons) Painting,

bledon College of Art, 1993 **Selected Solo Exhibitions** 2009 *Zoo 2009 John Jones Prize Winner Exhibition*, London // *Clunie Reid*, Mot rnational, London // *Out There, Not Us*, Focal Point Gallery, Southend-On-Sea // *Peek A De Boom*, Galerie Reinhard Hauff, Stuttgart // 2007 *Life You Like It*, Mot International, London // 2006 *Trousers Too Tight*, Heels Too High Keith Talent Gallery, London **Selected Group ibitions** 2009 *Karaoke - Photographic Quotes*, Fotomuseum Winterthur, Zurich // *We Came Here To Get Laid*, Not To Critique Dutch ure With Tom Ellis And Richard Parry, Wilfried Lentz, Rotterdam // 2008 *Nought To Sixty*, Institute For Contemporary Arts, London // *As You Like It*, Camden Arts Centre, London // 2007 *East International Norwich Selected By Matthew Higgs & Marc Caamille imowicz*, Propaganda Machine Local Operations, Serpentine Gallery, London // Transmission Gallery, *Glasgow One In The Other*, don // *Aspen 11 Neue Alte Brucke*, Frankfurt // 2006 *A Tree You Can't See*, Flaca Gallery, London // *Launch Project "Falkeandcharlotte ject Space"/Dolores*, Ellen De Bruijne Gallery, Amsterdam Needle Drops Parade, London. **BARRY REIGATE** Born in London, in 1971 // Lives and works in London, UK **Education** MA Fine Art, Goldsmiths College,1995 -97 // BA Graphic Design and Fine Art, berwell College of Arts, 1990 -93 **Selected Solo Exhibitions** 2009 *Almost*, Nang Gallery, London // 2008 *Happiness*, Paradise Row, don // 2006 *The end of communism*, Trolley Gallery, London // 2004 *UnHolyVoid*, Private warehouse space, London // **Selected Group Exhibitions** 2009 *Natural Wonders: New Art From London*, Baibakov Art Projects, Moscow // *Paradise Row at Art Rotterdam*, Netherlands // 2008 *LA BETE OR OBJECT OF DESIRE*, T1+2 Gallery Annex Projects, London // 2007 *Zelda Rubinstein*, Paradise Row at Princlet St., London // 2006 *Only when the excoriated ruins of human endeavour litter the scorched horizon shall the meek inherit the earth…* Chapman Fine Arts, London // *Canon*, The Agency gallery, London // *Cannibal Ferox*, Paradise Row, London // 2005 *Flies around the fury flotsam*, CuratorSpace, London. **MAAIKE SCHOOREL** Born in Santpoort, The Netherlands in 1973 // Lives and works in London, UK **Education** MA, Royal College of Art, 2001 // BA, Gerrit Rietveld Academy, Amsterdam, 1998 // Michaelis School of Fine Art, Cape Town, 1997 **Selected Solo Exhibitions** 2008 *Museum de Hallen*, Haarlem // Maureen Paley, London // 2007 *Stilleven*, Portret, Schutterstuk, Marc Foxx: West Gallery, Los Angeles // 2006 *Bathing dining garden father beach bed*, Maureen Paley, London // 2004 Galerie Diana Stigter, Rheinschau, Cologne Twilight, Galerie Diana Stigter, Amsterdam **Selected Group Exhibitions** 2008 *Hiromi Yoshii*, curated by Maxine Kopsa, Tokyo, Japan // *Eyes Wide Open – New to the Collection*, Stedelijk Museum, Amsterdam // 2007 *Prix de Rome 2007*, de Apple, Amsterdam The Triumph of Painting, The Saatchi Gallery, London // *How to Endure*, curated by Tom Morton, Athens Biennial, Athens // *Very Abstract and Hyper Figurative*, curated by Jens Hoffmann, Thomas Dane Gallery, London // *Zes*, Marc Foxx, LA, & Harris Lieberman, New York, curated by Marc Foxx Double A-Side, Artis,'s-Hertogenbosch // 2006 *Just in time*, Stedelijk Museum, Amsterdam // *Le Nouveau ciècle*, Museum van Loon, Amsterdam // Van Gogh Museum, Amsterdam // 2005 *Group Show*, Maureen Paley, London // *Slow Art*, Museum Kunst Palast, Düsseldorf // *Prague Biennale 2*, presentation for Flash Art, Prague // *IBID Projects*, nius, London // 2004 *Must I paint you a Picture?*, Haunch of Venison, London // Concert in the Egg, The Ship, London. **WILLIAM CARTER** n in Canada in 1972 // Lives and works in London, UK **Education** MA, Combined Media, Chelsea College of Art and Design, 2000 –01 iploma, Department of Sculpture, The Alberta College of Art and Design, Calgary, Canada,1992 –96 // **Selected Solo Exhibitions** 2009 *e me*, Carter Presents, London // 2008 Carter Presents, London // 2007 The Pump House Gallery, London // 2004 Dead Cowboys Gibo, don // 2000 *Video Spin*, The Photographers Gallery project space, London // 1998 *Punch*, Harcourt House Gallery, London // *Prospectus* , Truck Gallery, Calgary // 1997 *Time For Pause The Little Gallery*, Calgary // *Punish*, Stride Gallery, Calgary Jack Pack, The New lery, Calgary **Selected Group Exhibitions** 2009 *The Social lives of Objects*, Dallas Seitz, Lisa Penny, Hilary Jack, Castlefield Gallery nchester // *Laboratory Polymorphic*, Tou Scene Stavangar Norway 2009 // V22 Sculpture show London 2009 // 2008 The Wharf Road ject, London // 2007 *Yee Haw*, Vegas Gallery London // 2006 *Mining*, Gallery West Germany, Berlin // *Everybody Comes to HollyRood*, ic Salt, Edinburgh // *Black Implication Flooding*, Colony, Birmingham // *Family Viewing*, Curators Space, London // *Pencil*, Carter sents, London. **DANIEL SILVER** Born in London, UK in 1972 // Lives and works in London, UK **Education** MA Fine Art ulpture, Royal College of Art, 2001 // BA Fine Art, Slade School of Fine Art, 1999 **Selected Solo Exhibitions** 2009 *Cabinets #4: Daniel er, SE8*, London // *Lionz in Zion*, Galleria Suzy Shammah, Milan // 2008 *Making Something Your Own*, IBID PROJECTS, London // *The Monks*, Ancient & Modern, London // 2007 *Heads*, Camden Arts Centre, London // *Demos*, Northern Gallery for Contemporary Art, Sunderland // 2006 *Daniel Silver*, Galleria Suzy Shammah, Milan // 2005 *Daniel Silver*, Pescali & Sprovieri Gallery, London **Selected Group Exhibitions** 2009 *Newspeak: British Art Now*, State Hermitage Museum, St Petersburg, Russia // *Remap2*, Athens, Greece // Milestone, Edinburgh College of Art, Edinburgh, UK // 2008 *Group Show*, IBID PROJECTS (Hoxton Sq), London // *The Krautcho Club*, Forgotten Bar Project, Berlin // *In Silence*, Rothschild 69, Tel Aviv // *ART TLV*, Tel Aviv // *M25 Sobre Londres*, CCA Andratx, Mallorca // *Origins*, Hudson Valley Center for Contemporary Art, Peekskill, (cat.) // *A Colour Box*, Arcade, London, UK // *Sculpture Trail*, Grieder Contemporary, Küsnacht, Switzerland // *A Life of their Own*, Lismore Castle, Lismore, Ireland (cat.) // 2007 *Boys Craft*, Haifa Museum of Art, Haifa (cat.) // *Strange Weight*, Martos Gallery, New York // *Out, Still & Kicking*, Givon Art Gallery, Tel-Aviv. **RENEE SO** Born in Hong Kong in 1974 // Lives and works in London, UK **Education** BA Fine Art, Royal Melbourne Institute of Technology, Australia, 1993–1997 **Selected Solo exhibitions** 2009 *Renee So*, Kate MacGarry, London // 2008 Renee So, Uplands Gallery, Melbourne // 2003 *Close Knit*, Craft Victoria, Melbourne Close Knit II, Studio 12, Gertrude Contemporary Art Spaces, Melbourne // 2002 *Simple Pleasures*, Gallery 4A, Sydney // 2000 I*nspirational Contents of Living*, Gertrude Contemporary

Art Spaces, Melbourne // *Insects (in collaboration with Nathan Gray)*, TCB art inc., Melbourne **Selected Group Exhibitions** 2008 *Revol* *Doors: an exhibition in memory of Blair Trethowan*, Uplands Gallery, Melbourne // 2007 *SV07*, Studio Voltaire, London (selected by F Staple, Christabel Stewart, Stuart Comer) // *Neointegrity*, Derek Eller Gallery, New York // 2006 *Satellite* (curated by Richard Tho official Shanghai Biennale event) Family Resemblance, Centre for Contemporary Photography, Melbourne // The Schanck Show, Schanck, Melbourne Meeting Place, The Arts Centre, Melbourne (curated by Steven Tonkin) // 2005 *A Group Show*, Kaliman Gal Sydney // *A Re-Constructed World*, Linden – St Kilda Centre for Contemporary Arts, Melbourne (curated by Jan Duffy). ZERO STAPLETON Born in Ireland, UK in 1961 // Lives and works in London, UK **Education** MA, Goldsmiths College, 1993 **Selected Exhibitions** 2007 *And a Door Opened*, Carl Freedman Gallery, London // 2005 *Stapleton Grey*, Counter Gallery, London // 2003 *I S Arrive Soon*, Counter Gallery, London // 2002 *Crack Whore*, Five Years, London // 2001 *Bad Ape Report*, Neon gallery Billboard, Lor // 2000 *This*, Platform, London Rank Cheeseboard, Five Years, London // 1996 *Riutsu Centre*, Tokyo **Selected Group Exhibitions** 2009 *V22 Presents: The Sculpture Show*, Almond Building, London // 2008 *The Wharf Road Project*, V22, London // *Space Now*, Space Studios, London // 2006 *Toutes Compositions Florales*. Counter Gallery, London // 2003 *Picture Room*, Gasworks, London // *The Straight Or Crooked Way*, Royal College of Art, London Chockerfuckingblocked, Jeffrey Charles Gallery, London. CLARE STEPHENSON Born in Newcastle Upon Tyne, UK in 1972 // Lives and works in Glasgow, UK **Education** Ecole Regionale des Beaux-Arts, Nantes 1995 // BA (Hons) Fine Art , Sculpture, Duncan of Jordanstone College of Art & Design, University of Dundee1993-96 // **Selected Solo Exhibitions** 2009 She Who Presents, Spike Island, Bristol // 2008 *Parole Vaine*, Linn Luhn, Cologne // 2007 *Bandaged Heads*, Sorcha Dallas, Glasgow // 2006 *Solo*, Linn Luhn, Cologne // 2005 *Solo*, Dicksmith Gallery, London Solo, The Round Room, Talbot Rice Gallery, Edinburgh Solo, Sorcha Dallas, Glasgow // **Selected Group Exhibitions** 2009 *Dress to the left! No! Dress to the right!*, *Think Tank Project Space*, Curtin University Campus, Perth, Australia (Alex Pollard and Clare Stephenson) // *Ten Days in August in Münster* with…, Linn Luhn, Cologne (With Florian Baudrexel, William N. Copley, Alex Jasch, Sebastian Ludwig and Christoph Schellberg) The Fool, Northern Gallery for Contemporary Art, Sunderland (With Katia Bassanini, Natasha Caruana, Marcos Chaves, Moyna Flannigan, Michael Gardiner, Alexander Heim, Jim Hollands and Nick Osborn) // *Compass in Hand: Selections from The Judith Rothschild Foundation Contemporary Drawings Collection*, MOMA, New York // *Being and Nothingness*, Light and Sie Gallery, Dallas (curated by James Cope) The Dirty Hands, Centre for Contemporary Art, Glasgow (Alex Pollard and Clare Stephenson). JACK STRANGE Born in Brighton, UK in 1984 // Lives and works in London, UK **Education** BA, Fine Art, Slade School of Fine Art, 2007 **Selected Solo Exhibitions** 2009 *In the Pi* Limoncello, London, UK // Not Really, Galerie Maribel Lopez, Berlin, DE // 2008 *Wallowing*, Tanya Bonakdar Gallery, New York, US 2007 The Stupidest Thing Alive, MOOT, Nottingham // **Selected Group Exhibitions** 2009 *The Fair Show*, Limoncello, London, UK // *A and Repeat*, 176, London, UK // *Extraordinary Days*, Oriel Davies Gallery, Newtown, Wales, UK // *Retro Pulfer*, Alexandre Singh, J Strange. An Evening of Performances, The David Roberts Art Foundation, London, UK // *The little shop on Hoxton Street*, Limonce London, UK // *Ventriloquist*, Timothy Taylor Gallery, London, UK // *Its A Mess and Probably Irreversible*, Newburgh Quarter, London, (curated by Five Storey Projects) // *Make Your Own Kaleidoscope*, The Tricycle Gallery, London, UK // 2008 *Seeing The Light*, Ta Bonakdar Gallery, New York, USA // *Fuck you human*, Maribel Lopez Galerie, Berlin, Germany Downstairs, Flat B, 32 Newark Str London (curated by Omnifuss) // *The Krautcho Club / In and Out of Place*, Forgotten Bar Project, Berlin, Germany, and 176, London Forward, 176, London (curated by Vincent Honoré)*. ADAM THOMPSON Born in Ipswich, UK in 1980 Lives and works in Lond UK **Education** MFA Fine Art. Goldsmiths College. 2007-09 // BA (Hons) Fine Art - Studio Practice and Critical Theory. Goldsm College. London 1998-01 Art and Design, Ipswich School of Art. 1996-98 **Selected Solo Exhibitions** 2008 Galerie Bernhard Kn Frankfurt, Germany // 2007 Benign Neglect. Bernhard Knaus Fine Art. Mannheim. Germany // 2006 *UK06: Touring Japan*, Gallery Suz - Kyoto, Kaede - Osaka, AO - Kobe, Japan // 2005 Grieving Matter, Bernhard Knaus Fine Art, Mannheim. Germany // 2004 *As my fath have already died*, Firstsite Gallery, Colchester, UK // **Selected Group Exhibitions** 2009 *The Object of the Attack*, The David Roberts Art Foundati London // *R.I.P. 19 April 2009*, Peacock Projects, London // *A Work A Day*, MOT International, London // *Goldsmiths College MFA Show*, London // *Group/Grope*, Area 10 Project Space, Peckham, London // *Part One*, Nordisk Kunst Plattform, Brusand, Norway // *No End in Sight*, Vegas Gallery, London // 2008 *Terra Firma*, Fold Gallery, London // *(No) Fear*, Kunstverein Ludwigshafen, Germany // *Drawings*, Peacock Projects, London // *No End in Sight*, Galerie Polaris, Paris // 2007 *Statement*, Galerie Bernhard Knaus, Frankfurt, Germany // *Inter-View*, The Space Gallery, Seoul, Korea. CARAGH THURING Born in Brussels in 1972 // Lives and works in London, UK **Education** BA (Hons) Fine Art Nottingham Trent University 1991-1995 **Selected Solo Exhibitions** 2009 *Assembly*, Simon Preston Gallery, New York // *Caragh Thuring*, Thomas Dane Gallery, London **Selected Group Exhibitions** 2009 *Objects in the Forrest*, Visual Art at Sadler's Wells, London (curated by Sacha Craddock) // 2008 *Thuring Ziegler*, 10 Vyner Street, London // *Hypersurface Plus*, OVADA, Oxford // *In Pieces*, 39 Myddleton Square, London (curated by Philly Adams) // *Imaginary Realities: Constructed Worlds in Abstract and Figurative Painting*, Max Wigram, London // *Hypersurface*, Rod Barton Invites, London // 2007 *Doubleuse*, The Nunnery, London // *The Dog Projec'*, The Hospital, Covent Garden, London // 2006 *Caragh Thuring & Pat O'Connor*, Ashwin Street, London // 2004 *Bart Wells Institute*, Hamish McKay Gallery, Wellington, New Zealand // 2001 *Tattoo Show*, Modern Art, London // *Glory Hole*, Magri Walk, London. PHOEBE UNWIN Born in Cambridge, UK in 1979 // Lives and works in London, UK **Education** Newcastle University 1998 - 2002 // Slade School

ine Art 2003 - 2005 **Selected Solo Exhibitions** 2009 *Making An Outside Space Theirs*, Honor Fraser, Los Angeles, CA // 2008 *Feelings and Other ...ms*, Wilkinson Gallery, London, UK // 2007 *A Short Walk from a Shout to a Whisper*, Milton Keynes Gallery, UK // 2006 *The Grand and the ...monplace*, Wilkinson Gallery, London **Selected Group Exhibitions** 2009 *Jerwood Contemporary Painters*, Jerwood Space, London // *Voice and Nothing More*, curated by Sam Belinfante and Neil Luck, Slade Research Centre, London // 2008 *M25. Around London*, ...ated by Barry Schwabsky, CCA Andratx Art Centre, Mallorca Jekyll Island, curated by Erik Parker and Max Henry, Honor Fraser, Los ...geles // 2007 *The Sorcerer's Apprentice*, Galleri Faurschou, Copenhagen (curated by Max Henry with Andre Butzer, Bendix Harms, Sean ...ders, Bjarne Melgaard, Erik Parker, Pablo Picasso, Dana Schutz, and Nicola Tyson) // *Very Abstract and Hyper Figurative*, Thomas ...e, London (curated by Jens Hoffmann) // *Saturn Falling*, The Corridor, Iceland (curated by Gavin Morrison with Luke Fowler, Adam ...Ewen, Fraser Stables and Singrid Sandstrom). █████████████████ Born in Dumfries, Scotland, UK in 1963 // Lives and ...ks in London, UK **Selected Solo Exhibitions** 2009 Galleria S.A.L.E.S., Rome // 2008 *Plagues*, performance commission, Studio ...taire, London, Transmission Gallery, Glasgow // Jack Hanley Gallery, Los Angeles // Asia Song Society, New York // 2007 *52 Girls*, ...ureen Paley, London // *White Columns*, New York // 2006 *There's a wee girl at my school*, Herald St, London // *No Axe To Grind*, Jack ...ley Gallery, San Francisco // 2005 Another Drama, Schnittraum, Cologne **Selected Group Exhibitions** 2008 *50 Moons of Saturn*, The ...ond Turin Triennale, Turin. The Wizard of Oz, CCA Wattis Institute for Contemporary Arts, San Francisco // *Sack of Bones*, Asia Song ...iety, New York // *What Are You Like?*, Dulwich Picture Gallery, London // *In Drawing*, Purdy Hicks Gallery, London // *100 Years, 100 ...sts, 100 Works of Art*, Rochelle School, London // 2007 *Das Kapital: Blue Chips and Masterpieces*, Museum für Moderne Kunst, ...nkfurt am Main // 2006 *Le Retour De La Colonne Durutti*, Isabella Bortolozzi, Berlin // 2005 *l'Entr'acte*, Frieze Projects, Frieze Art Fair, ...don // *I still believe in miracles/Drawing Space (part I)*, Musée d'Art moderne de la Ville de Paris / ARC au Couvent des Cordeliers, Paris // ...ugural, Herald St, London Herald St & The Modern Institute present, GBE Modern, New York // *Becks Futures*, ICA, London // Other People's ...jects, Herald St, London // *White Columns*, New York // Consignia, Hiscox gallery, London. ██████████████████ Born in Zambia, 1972 // Lives and works in London **Education** Glasgow School of Art 1990 - 1992 **Selected Solo Exhibitions** 2010 *All Visual Arts presents Jonathan Wateridge* // 2006 On a Clear Day You Can See Forever, David Risley Gallery, London // 2005 The Glass Family, One in the Other, London // 2004 Fordham Gallery, London **Selected Group Exhibitions** 2009 *The Age of the Marvellous*, All Visual Arts, London // 2007 *A Song Turning Inwards*, Tatjana Peters/One Twenty, Ghent // 2006 *The Stone in Art*, curated by Danny Moynihan, Rove, London // Black Moon Island, One in the Other, London // 2005 *Accidental Death*, David Risley Gallery, London // *Introspective Men*, Madder 139, London // *The Future Lasts a Long Time*, Le Consortium, Dijon // *Future Primitive*, One in the Other, London // *Faux Realism Part 2*, Rockwell, London // 2004 // *The Future Lasts a Long Time*, Tal Esther, Tel Aviv // World B, Flaca Gallery, London. ████████████ Born in Zweibrücken, Germany in 1957 // Lives and works in London, UK **Education** PhD in Sound Art, Goldsmiths College, London // **Selected Solo Exhibitions** 2009 *Untitled installation for 300 speakers*, player piano and vacuum cleaner. Beaconsfield Soundtrap commission, London // *Wireframe*, Surrey Art Gallery, Vancouver, Canada // 2008 *Transplant*, Collaborative installation w Tim Wainwright, The Nunnery, London and Beldam Gallery, Brunel University, Uxbridge Hearts // *Lungs and Minds*, (half-hour radio piece) BBC Radio 3 // 2007 *Flow*, Collaborative installation w Tim Wainwright, Old Operating Theatre Museum, London // 2006 *230 Unwanted Speakers* (Walnut Grained Vinyl Veneered Particleboard Construction), Hull Art Lab, Hull, UK // 2005 *Hearing Voices*, Installation, Botswana National Museum, National Art Gallery of Namibia, Brunei Gallery, London Hearing Voices. Half-hour radio piece, BBC Radio 3 **Selected Group Exhibitions** 2009 *Faster Higher Stronger*, 'Sound Proof 2', independent art space, London // 2008 *Response Time II*, 'Parallax', Fieldgate Gallery, London // *Someone Else and ITU*, Collaborative installations w Tim Wainwright, Deep Wireless Festival, Gallery 1313, Toronto // 2007 *Push comes to Shove*, Collaborative installation w Denise Hawrysio, 'Analogue & Digital', Fieldgate Gallery, London and 'Transcentric', Lethaby Gallery, London Hearing Loss. 'Signal and Noise', VIVO, Vancouver. ████████████ Born in London, UK in 1972 // Lives and works in London, UK **Education** BA (Hons) Fine Art, Central St. Martins, 1991 - 1994 // **Selected Solo Exhibitions** 2009 *Toby Ziegler*, Galarie Max Hetzler, Berlin // 2008 *Toby Ziegler: The ...erals*, Simon Lee Gallery, London // *Toby Ziegler: Danish Pastry / Rose of Mohammed*, Parkhaus im Malkastenpark, Düsseldorf // *Toby ...gler: The Subtle Power of Spiritual Abuse*, Patrick Painter Inc, Los Angeles (cat.) // 2007 *Toby Ziegler*, Longside Gallery, Yorkshire ...lpture Park, Wakefield // 2006 *Toby Ziegler*, Simon Lee Gallery, London // 2005 *Enter Desire*, Chisenhale Gallery, London **Selected ...oup Exhibitions** 2009 *The White Show*, PM Gallery and House London // *Reframing*, CCA Andratx, Mallorca // *Cui Prodest?*, New ...erie de France, Paris (cat.) // *Natural Wonders: New Art from London*, Baibakov Art Projects, Moscow // *Accrochage*, Max Hetzler, Berlin // 2008 *(technhe) TH(episteme)8?*, Hats Plus, London // *Parkhaus*, Kunsthalle Düsseldorf, Düsseldorf // *Hamsterwheel*, Malmö Konsthall, Malmö, ...eden // *Thuring and Ziegler*, 10 Vyner Street, London // *Nature is a Workshop: selected from the Arts Council Collection*, Turner Contemporary ...ject Space, Margate // *35%Vrai 60% Faux*, Simon Lee Gallery, London // *Grotto*, Museum52, London // 2007 *Hamster Wheel*, organised by Franz ...st, Le Printemps de Septembre, Toulouse travelled to Centre d'Art Santa Mònica, Barcelona // *Size Matters: XXL - Recent Large-Scale Paintings*, ...dson Valley Centre for Contemporary Art, Peekskill // *Soufflé*, curated by Franz West, Kunstraum Innsbruck, Austria (cat.) // *How to Improve the ...rld*, Gas Hall, Birmingham Museum and Art Gallery, Birmingham // *Recent Abstraction*, British Art Display 1500 –2007, Tate Britain, London //

~~The Hermitage and~~
~~'problems of linguistics'~~*

~~M.B. Piotrovsky~~
~~Director of the State Hermitage Museum~~

* 'Marxism and Problems of Linguistics'
is an article by Joseph Stalin published in 1950.

This exhibition, which was held in the Nikolaevsky Hall of the Winter Palace I see as a successor to the exhibition of Australian aboriginal art shown there several years ago. The public's – as well as our Australian colleagues' – reaction to that exhibition was extremely positive, because rather than treating aboriginal art as ethnography we presented it as entirely contemporary, with roots stretching back a thousand years, but very much alive now. The idea of displaying such 'exotica' in the Nikolaevsky Hall has come to be seen as wholly acceptable. It is a venue which, in its magnificent way, always holds sway over the exhibits while at the same time raising everything to a certain level.

Now The State Hermitage has shown the very latest examples of British art. In the contemporary art world this is not an unprecedented event, but the Nikolaevsky Hall makes it 'exotic' and exclusive. Exclusivity is an inherent part of the exhibition's organisational paradigm. It opened first in the Hermitage, and only afterwards in London. The Hermitage show included the work of the winner of a special BBC competition. The Hermitage, in its own way, is an active participant in the contemporary art world. We are seeking our own place in it, this being just one such endeavour. There have been various others before, some successful, some less so.

The Hermitage and the Saatchi Gallery have made the selection, nurturing young and mostly little-known artists. They speak a new language, but one expressed using traditional tools. This language conceals a great deal and at the same time reveals much that is hidden. It appears to be free but is in fact shaped by numerous rules, both artistic and commercial.

Charles Saatchi, to whom we are very grateful for his courage and taste, had the idea of calling the exhibition 'Newspeak'. For us the title carries a certain postmodern irony. Orwell's parody was based on the Soviet Union. Nowadays his terminology, images and allusions work just as well in the West as in the East – maybe even better. The sort of 'grammatology of panic' Patricia Ellis contributes to this volume would be much harder to compose in Russian.

Some will regard this exhibition as blasphemy. It is worth recalling that the Hermitage is a universal, encyclopaedic museum. Its exhibition halls have always displayed a great variety of exhibits, many of them quite bizarre. Some withstood the Hermitage test, others did not. How the museum will react to this exhibition is still too early to say. Contemporary art finds a way into the museum through various channels. I well remember the then French President, Jacques Chirac, making a special visit to the Hermitage to see how pictures by his favourite Pierre Soulages looked under the light conditions of the Nikolaevsky Hall. Soulages came through that test. The experiment continues.

It has been said that a museum should not try to build reputations but only keep a close lookout for their emergence. This is right. Having work displayed within the walls of the Hermitage can, of course, enhance an artist's 'capitalization'. But by no means always. As time will doubtless tell.

This exhibition is part of the ongoing project 'Hermitage 20/21'. Its direct predecessors were the exhibition USA Today and others that followed on from it – Chuck Close, Timur Novikov, and Boris Smelov – as well as separate exhibitions of the work of Louise Bourgeois, Wim Delvoye and Anna Zholud. The list is pretty diverse. The challenge for the visitor is to uncover what links these exhibitions, other than the whim of the Hermitage and, maybe, its internal logic.

I like these artists. I hope that our visitors, including our artists, liked them too – although, to be more specific, I hope that it is not so much the artists as the exhibition itself, as a work of art, that they like. However, we shall see.

Newspeak: British Art Now

Inaugural Exhibition

The State Hermitage,

St Petersburg, Russia

25th Oct 2009 — 17th Jan 2010

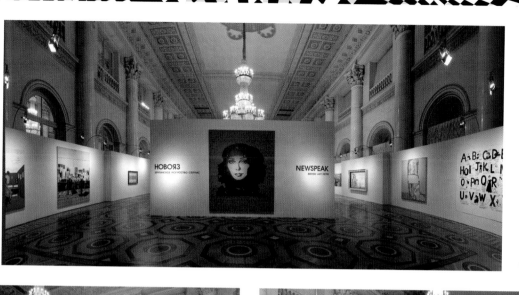

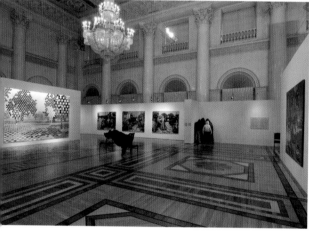

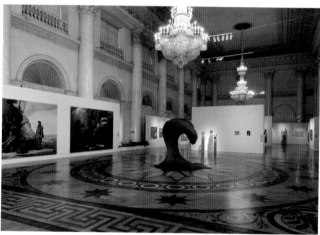

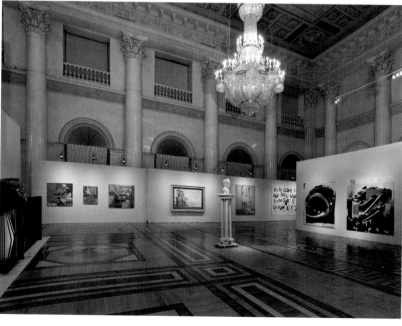

Within the Newspeak: British Art Now exhibition, Charles Saatchi reserved space for one new artist - an individual who represents the very best new creative talent in Britain.

A panel including Tracey Emin, Matt Collings, Kate Bush and Frank Cohen selected 6 exciting undiscovered artists from over 3000 who applied for the TV series on BBC, 'School of Saatchi'.

Based out of a large art studio in East London, with visiting art experts to offer advice, the artists had ten weeks to develop their work to international standards.

In September the six artists staged a group exhibition of their art in London, attended by the art world elite, which they organised and curated themselves

Finally the winner Eugenie Scrase was selected by the panel and Saatchi to be part of the Newspeak: British Art Now inaugural exhibition at The State Hermitage, St Petersburg, Russia.

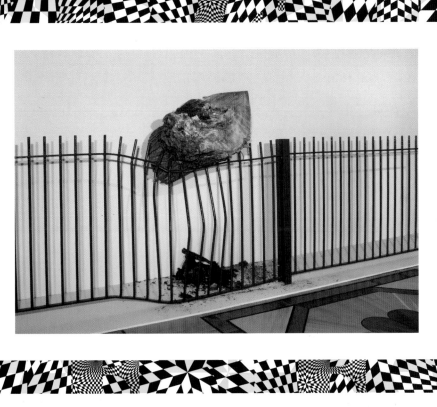

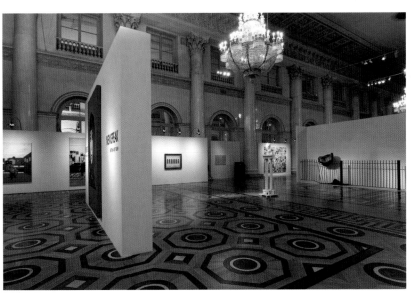